CANADA

Superior

Ottawa

Hiawatha

Chequamegon

Nicolet

Huron

White Mountain

Manistee

Green
Mountain

Allegheny

Midewin
Grassland

Wayne

ES

Mark Twain

Hoosier

Monongahela

A

George
Washington

Shawnee

Daniel
Boone

Jefferson

Mark Twain

Jefferson

Cherokee

Land between the Lakes
National Recreation Area

Pisgah

Ozark

Cherokee

Nantahala

Uwharrie

St. Francis

Croatan

Ouachita

Holly
Springs

William B.
Bankhead

Chattahoochee

Sumter

Kisatchie

Tombigbee

Oconee

Francis
Marion

Delta

Talladega

Bienville

Tuskegee

Kisatchie

Conecuh

Homochitto

De Soto

Atlantic Ocean

THE NATIONAL
FORESTS &
GRASSLANDS
OF THE UNITED STATES

gelina

Apalachicola

Osceola

PUERTO RICO

Ocala

El Yunque

0 100 200 300 400 MILES

Gulf of Mexico

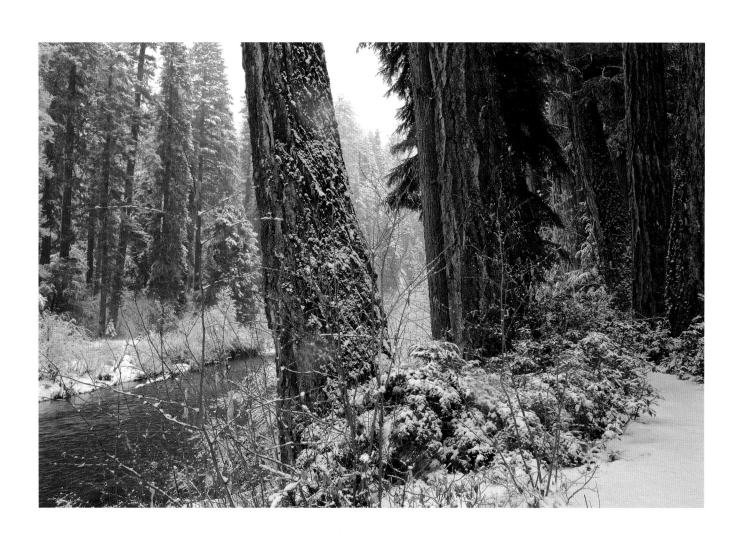

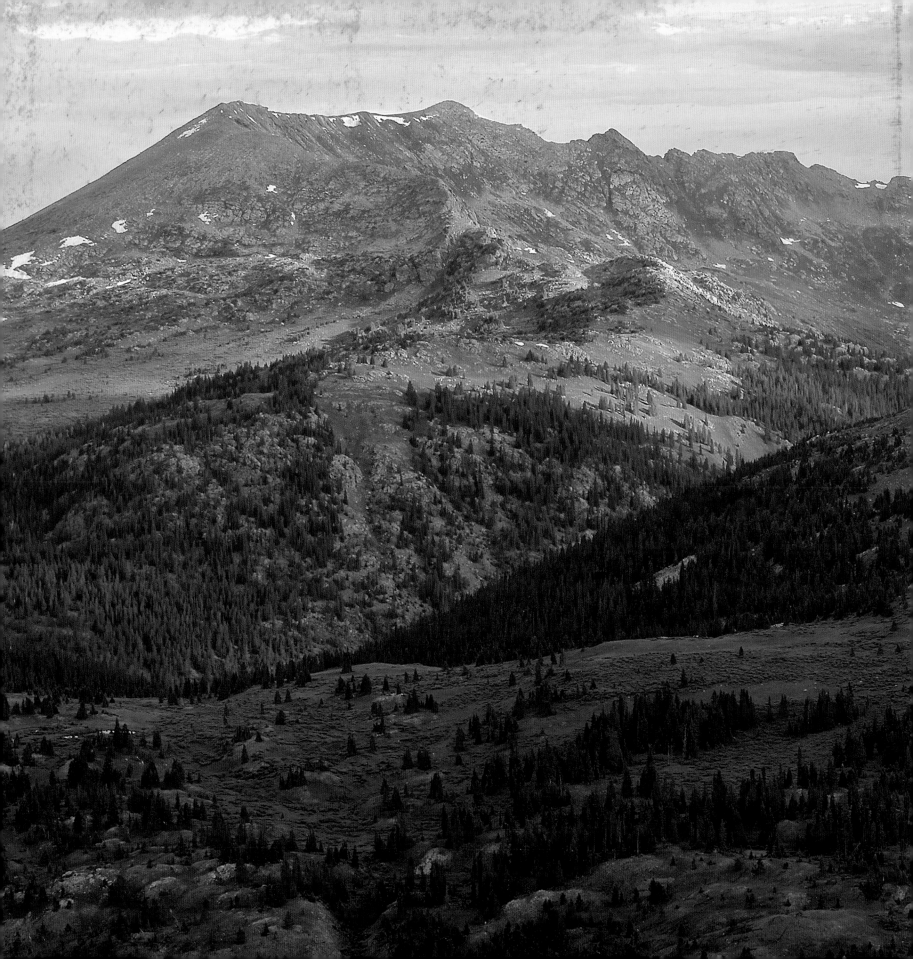

AMERICA'S GREAT NATIONAL
FORESTS, WILDERNESSES, & GRASSLANDS

CHAR MILLER

Photography by

TIM PALMER

Foreword by **BILL MCKIBBEN** • Edited by **SCOTT J. TILDEN**

Contents

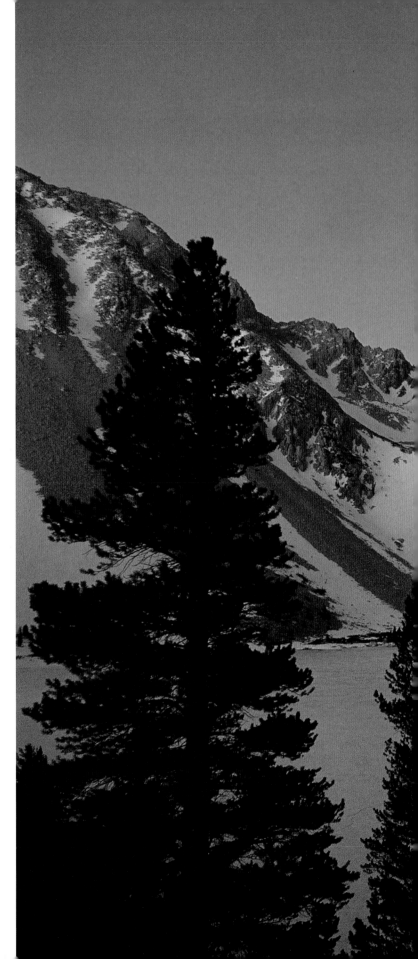

Foreword by Bill McKibben 6

Introduction by Char Miller 8

THE EAST AND MIDWEST 30
 White Mountain National Forest, New Hampshire 44
 Allegheny National Forest, Pennsylvania 50
 Superior National Forest, Minnesota 54
 Monongahela National Forest, West Virginia 58

THE SOUTH 62
 Pisgah National Forest, North Carolina 80
 Francis Marion National Forest, South Carolina 84
 El Yunque National Forest, Puerto Rico 88
 De Soto National Forest, Mississippi 92

THE SOUTHWEST AND GREAT BASIN 96
 Santa Fe National Forest, New Mexico 108
 Gila National Forest, New Mexico 112
 Tonto National Forest, Arizona 114
 Humboldt-Toiyabe National Forest, Nevada and California 118

THE SOUTHERN ROCKIES 122
 White River National Forest, Colorado 138
 Arapaho and Roosevelt National Forests, Colorado 142
 Uinta-Wasatch-Cache National Forest, Utah 146
 Black Hills National Forest, South Dakota and Wyoming 152

THE NORTHERN ROCKIES 156
 Bridger-Teton National Forest, Wyoming 172
 Little Missouri National Grassland, North Dakota 176
 Sawtooth National Forest, Idaho 180
 Flathead National Forest, Montana 184

CALIFORNIA 188
 Angeles National Forest, Southern California 202
 Los Padres National Forest, Central California 208
 Sierra National Forest, Central California 212
 Inyo National Forest, Central California 216
 Klamath National Forest, Northern California 220

THE PACIFIC NORTHWEST AND ALASKA 224
 Rogue River-Siskiyou National Forest, Oregon 244
 Mount Hood National Forest, Oregon 248
 Gifford Pinchot National Forest, Washington 252
 Mount Baker-Snoqualmie National Forest, Washington 256
 Tongass National Forest, Alaska 260

Photographer's Notes by Tim Palmer 264
Acknowledgments 266
Notes 267

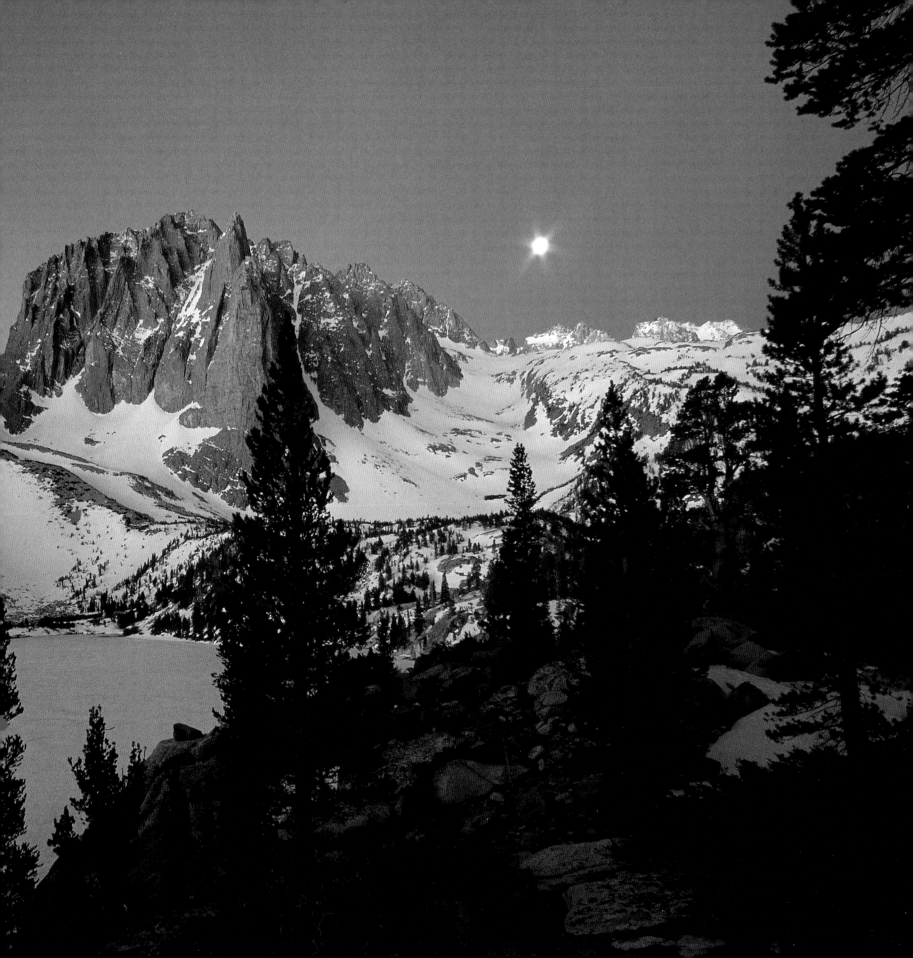

Foreword

I've lived much of my life in the Green Mountain National Forest in Vermont. Every time I drive down the mountain to the valley below I feel a little sadness at leaving our enclave; every time I drive home, up Route 125 along the Middlebury River, it gives me a little pang of pleasure to pass the national forest sign. Every single day I ski or run or bike or hike or just wander on the trails maintained by the Forest Service; a few times every summer I climb up to the Long Trail, and clamber out on a rock ledge that offers a perfect view of this vast forest stretching off in every direction.

The Green Mountain National Forest, of course, is relatively small in the scheme of things at the national forests. I've also wandered its much bigger cousins in Idaho and Oregon, Arizona and California, the Carolinas and the Dakotas. The Sierra, the Rockies, the Alleghenies, the Smokies—just the words conjure up the freedom of this expansive continent. As the pictures in this gorgeous volume make clear, these include some of the most stunning landscapes on Earth.

But maybe not the very most stunning. Those were reserved for the national parks. If the rocks were high enough, the geysers powerful enough, the trees huge enough—it was likely to become a national park. The national forests have huge stretches of what we think of as more pedestrian landscape. And indeed throughout too much of their history that's how their managers and their political overlords tended to think of these lands: as storehouses for national resources. They were

reservoirs of timber, or oil and gas, or grass for the stomachs of cows. This exploitation was often uneconomical, and very often unecological.

Clearly, though, a culture shift has been underway at the Forest Service for years. I remember talking with the former chief some years ago when he visited the Green Mountain National Forest shortly after his retirement. It was clear, he said, that the highest economic value of much of the forestland in the system was water filtration—i.e., the woods were doing far more standing up to filter and retain water than they were doing stacked on a log truck.

Management for recreation, for wildlife, for "ecosystem services"—these are clearly the future for the Forest Service. Timber harvests won't cease—we are, after all, a civilization that uses wood. But increasingly they're managed, constrained, monitored. The giant clearcuts are becoming somewhat fewer; I remember being in the Tongass National Forest in Alaska after new roadless rules began to remove some of the logging pressure. You could almost feel the land relaxing back into its primeval glory. (And what glory! Muskeg melded with bear, morning mist with whale spout. If there's an Eden on our continent, the Tongass must be it.)

The glories here in my home forest are subtler, at least a little. (Moose are heart-stopping in their own way, but not quite like grizzlies.) In spring, it's wildflowers; in summer, the blueberries ripen (and the special designated blueberry harvest hill is crowded with pickers). No one

Two sections of New England's Appalachian Mountain chain were set aside as the Green Mountain National Forest. Here from Grand Cliff, south of Rutland, birches and maples ramp down to blankets of fog in the Champlain Valley.

6 ♦ AMERICA'S GREAT NATIONAL FORESTS, WILDERNESSES, AND GRASSLANDS

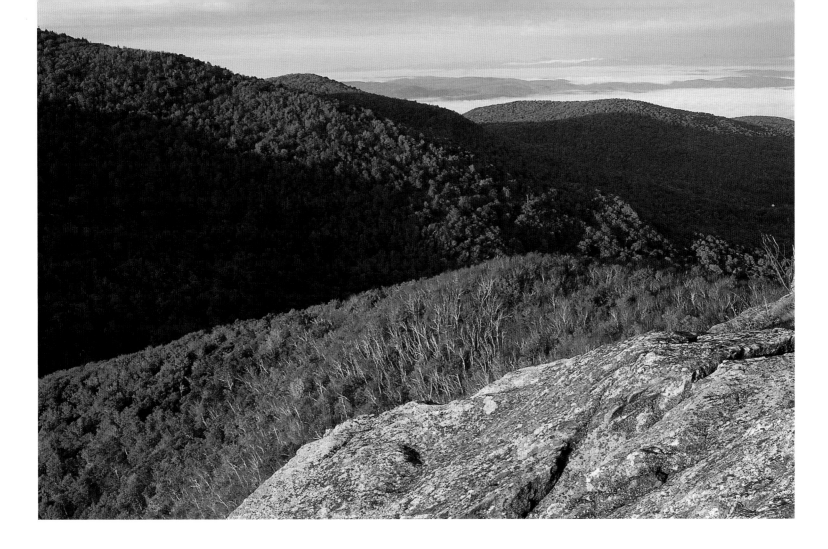

can match a Vermont fall, of course—the neon orgasm that crowns the year. And then comes the winter, which is this forest's natural state: months of quiet, a monochrome beauty transformed on a sunny February day into beauty so intense it lasts year-round. I can wander for an hour and find a series of beaver dams so intricate and dense that it boggles the mind. Or I can wander an hour and find, at the forest's edge, Robert Frost's old writing cabin. The Forest Service has done a lovely job of trail building, running an easily accessible path down by a small creek, and at intervals mounting signs with some of Frost's most important poems, including his most famous work, the one that ends:

Two roads diverged in a wood, and I—
I took the one less traveled by,
And that has made all the difference.

From where I sit, the Forest Service spent much of the 20th century following the easy road, the obvious one. And perhaps that made sense, at least for a time. But now in a maturing country, where we are short of wild and natural, our national forests are tentatively stepping out on that less-traveled path. And in doing so they are offering Americans one of the greatest of all gifts: a chance to know, and to love, these most remarkable of landscapes. It's a "land of many uses," but the most important of those is wonder.

Introduction

CHAR MILLER

FOREST FACTS

44	States
160	Million Visitors
154	National Forests
20	National Grasslands
441	Wilderness Areas
8	National Monuments[1]
136	Scenic Byways
22	National Recreation Areas
11	National Scenic Areas
1	National Preserve
1	National Historic Site
1	National Historic Landmark
1	National Heritage Area

A double rainbow arcs across Medicine Bow-Routt National Forest at Flat Tops Wilderness, south of the popular recreational town of Steamboat Springs, Colorado.

For more than a century, America's national forests have proved an environmental gift and cultural treasure, our spectacular backyard.

Under the management of the U.S. Forest Service, which was founded in 1905, this robust system of public lands encompasses 193 million acres from California to New Hampshire, Puerto Rico to Alaska. Within their embrace are some of our most rugged mountains, including New England's White and the Cascades of the Pacific Northwest, along with the Rockies, Wasatch, Sierra, and Appalachians. As beautiful as this mountainous terrain is, it also serves as the nation's headwaters. The national forests are the single largest supplier of water in the country—more than 180 million of us get our drinking water from these publicly owned lands. Not surprisingly, they are the source of such significant western rivers as the Columbia and Snake, Colorado, Rio Grande, Platte, and Missouri, and, in the east, the Connecticut, Merrimack, Tennessee, and Chattahoochee.

Just as varied are the rich and diverse ecosystems that lie within the national forests—tropical and temperate rain forests, bare-rock tundra and high-desert cactus, and coastal chaparral. Seeking some of Earth's oldest living plants? Then head to Fishlake National Forest in southern Utah, where scientists have estimated that a colony of quaking aspen began its life there in the neighborhood of 80,000 years ago. Or visit 5,000-year-old bristlecone pines in the Inyo National Forest in the eastern Sierra. Or hike along the Trail of 100 Giants in Giant Sequoia National Monument,

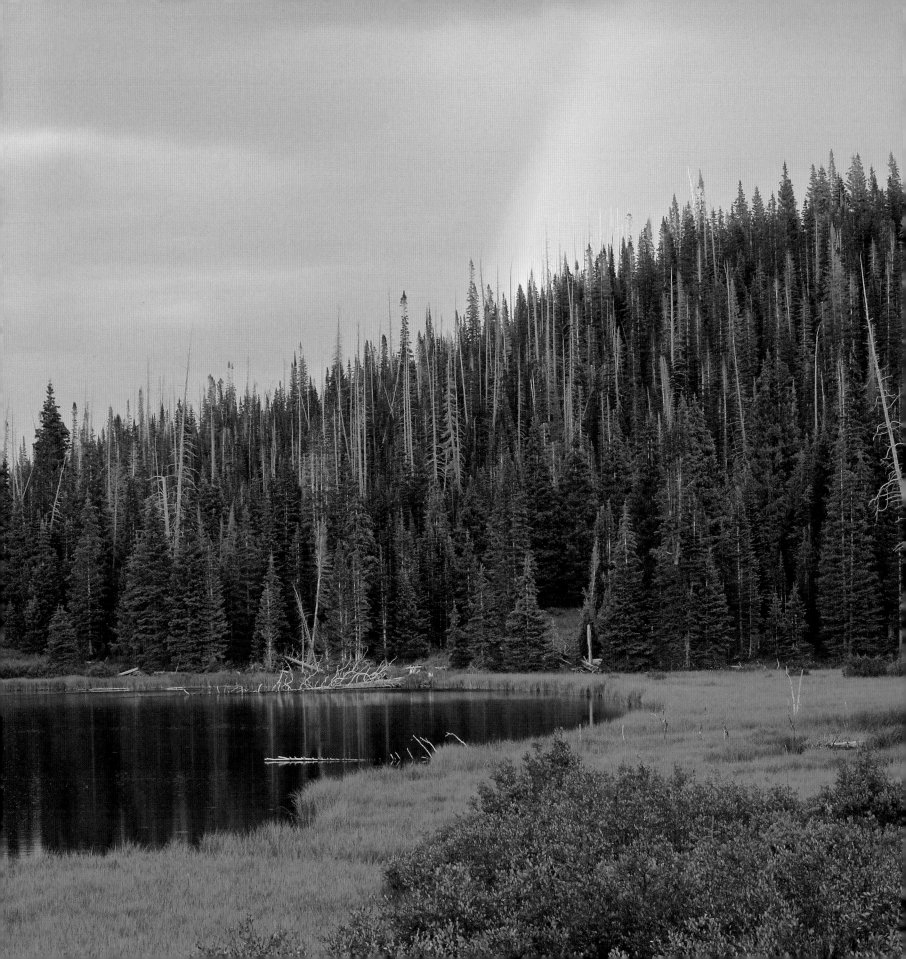

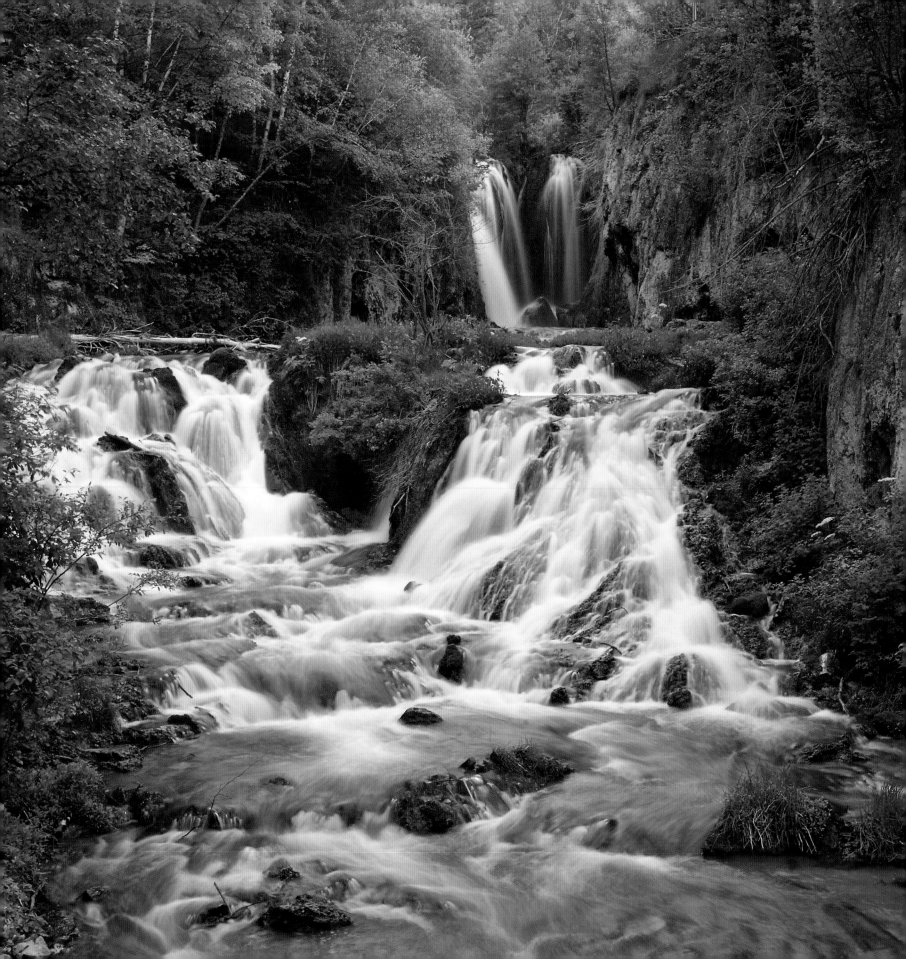

part of Sequoia National Forest, and stand in awe of its soaring groves; some of its colossal, thick-barked trees date back at least 1,500 years.

The national forests are also woven into the nation's sense of itself, essential to our aesthetic, recreational, and spiritual well-being. One way to measure this felt connection is by the sheer number of us who annually go to the forests to commune with nature, with cameras, fishing rods, canoes, or skis in tow. The White River National Forest, located in the Rocky Mountains above Denver, Colorado, welcomes 10 million guests a year, many of whom tramp up or slalom down its steep slopes. Another four million recreate year-round in the Angeles, situated in the San Gabriel Mountains in Southern California. And millions more repair to the Mount Baker (Seattle), Mount Hood (Portland), Cleveland (San Diego), Allegheny (Pittsburgh), Chattahoochee-Oconee (Atlanta), Angelina (Houston), Chippewa (Minneapolis-St. Paul), Mark Twain (St. Louis), and Huron-Manistee (Detroit and Chicago) National Forests. Within these woods, snowfields, meadows, rivers, and lakes, Americans seek repose and reinvigoration.

Even the more remote national forests—Alaska's Tongass, Montana's Kootenai, the Dakota Prairie National Grassland—as well as the smallest—Alabama's Tuskegee, North Carolina's Uwharrie, or Indiana's Hoosier—have their staunch proponents. Whether these visitors live close to their embrace or must travel great distances to reach them, they come to experience their unique terrain, clear skies, and beguiling quiet.

Millions more flock to the wild, to some of the nearly 37 million acres of officially designated wilderness that the Forest Service manages under the provisions of the 1964 Wilderness Act. That legislation's language is instructive, defining "wilderness, in contrast with those areas where man and his own works dominate the landscape, as an area where the earth and its community of life are untrammeled by man, where man himself is a visitor who does not remain." Federal land-management agencies like the Forest Service are required to preserve these areas' "primeval character and influence," so that those who enter into these expanses can experience a "primitive or unconfined type of recreation." These lands, the act's proponents argued in its opening paragraph, would serve as a physical and exacting reminder of the nation's wild heritage, a vestige of a tougher, more natural world, a bulwark against modernization: "In order to assure that an increasing population, accompanied by expanding settlement and growing mechanization, does not occupy and modify all areas within the United States and its possessions, leaving no lands designated for preservation and protection in their natural condition, it is hereby declared to be the policy of the Congress to secure for the American people of present and future generations the benefits of an enduring resource of wilderness."[2]

Beginning with a mere 9.1 million acres in 13 states, the National Wilderness Preservation System has expanded to 109 million acres in 44 states; the Forest Service manages 33 percent of the total system. Although more than half of our wilderness areas are located in Alaska—it's not called the Last Frontier for nothing—equally revealing is that half of the nation's 758 wilderness areas are within a day's drive of our largest cities. These lands' accessibility and their rough-hewn character draw an estimated 12 million visitors a year. Such large numbers would have delighted forester Bob Marshall, who helped start the Wilderness Society in 1935. Its avowed purpose was then and remains today to press the case for wildland protection, sharing with these

Though surrounded by the Great Plains, the Black Hills rise in elevation to catch rain and snow nourishing Little Spearfish Creek with its ornate plunge over Roughneck Falls–a highlight of Black Hills National Forest in South Dakota. Streams flowing from the national forests nationwide yield drinking water to about half of the American population. For two centuries, these headwaters have provided most of the city and farm supplies in the West, and for millennia they've been aquatic habitat to our most valued wildlife and fish–many of them now imperiled.

OPPOSITE, TOP: South of Troy, Montana, a 100-acre stand of ancient western red cedars was set aside in 1959 through the vision of a local forest ranger as the Ross Creek Cedars Scenic Area of Kootenai National Forest. Secluded at this rare site among forestlands that have otherwise been thoroughly logged, trees eight feet in diameter and 1,000 years old can be seen.

OPPOSITE, BOTTOM: Pictographs in New Mexico's Gila National Forest have survived for 700 years and attest to the importance that these and other public lands have had through the ages, dating to the first people who explored and settled the North American continent.

many hikers a conviction that trekking into backcountry is a "psychic necessity," a human need: "To us the enjoyment of solitude, complete independence, and the beauty of undefiled panoramas is absolutely essential to happiness."[3]

To make certain that others in the future can encounter what Marshall called "that glorious adventure into the physically unknown" requires management, ironically enough. One manifestation of this management is the three-word imperative that the Forest Service and the other federal land-management agencies have adopted to remind visitors of their environmental obligations: Leave No Trace. This phrase is printed on agency literature picked up at ranger stations, splashed across relevant web pages, and emblazoned on signs posted at wilderness trailheads. More concise than the 1960s mantra from which it is derived—take only photographs, leave only footprints—Leave No Trace, as policy and prescription, is an apt ethos guiding our experience of the untrammeled. The fewer marks we leave behind when hiking through or camping within the Bob Marshall, Joyce Kilmer-Slickrock, or John Muir Wilderness Areas, the more memorable the outdoor experience will be for those following our path.

Those trails, real and metaphorical, cannot help but leave their mark on the land and in our cultural imagination. Through photographs and words, *America's Great National Forests, Wildernesses, and Grasslands* unearths these traces in the landscape. By focusing on the national forests—some wild, others managed—it tracks the late 19th-century ambition to create the national forest system and the U.S. Forest Service to administer these far-flung environments. The conditions under which these lands are administered are a key feature in this narrative. When Congress enacted the Organic Act of 1897, which

stipulated that these forests would protect the flow of water and the supply of timber, it established them as agents of economic development. So they remain in places as disparate and distant as El Yunque National Forest in Puerto Rico, the Tongass in southeastern Alaska, Southern California's San Bernardino National Forest, and the Green Mountain in Vermont.

The working nature of these forests is what distinguishes them from national parks. The National Park Service's mission is to preserve "the natural and cultural resources and values of the national park system for the enjoyment, education, and inspiration of this and future generations." The distinction between the two agencies is often sharply drawn between the Forest Service's utilitarian focus and the Park Service's preservation ethic. But it can be overdrawn. The Forest Service pursues many of the same management goals as the Park Service because it too is required to protect endangered species and Wild and Scenic Rivers and to manage national monuments, national recreation areas, and wildernesses according to the same regulatory statutes. The key difference is that the Forest Service's congressionally mandated multiple-use focus means the national forests are also locations of production for timber, power, water, grazing, and minerals.

That orientation was what the system's founders intended. For them, conservation assumed use under strict regulation, a regulatory framework that entailed a cross-generational obligation to protect these invaluable resources across time. Gifford Pinchot, the founding chief of the Forest Service, framed this relationship as the pursuit of "the greatest good for the greatest number in the long run." His was a reasoned argument for sustainability. It set each era's legitimate needs—"From birth to death, natural resources, transformed for human use, feed, clothe, shelter,

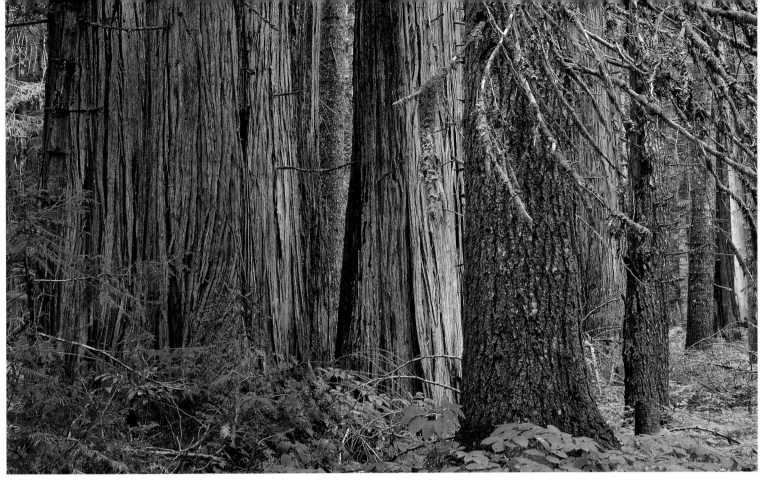
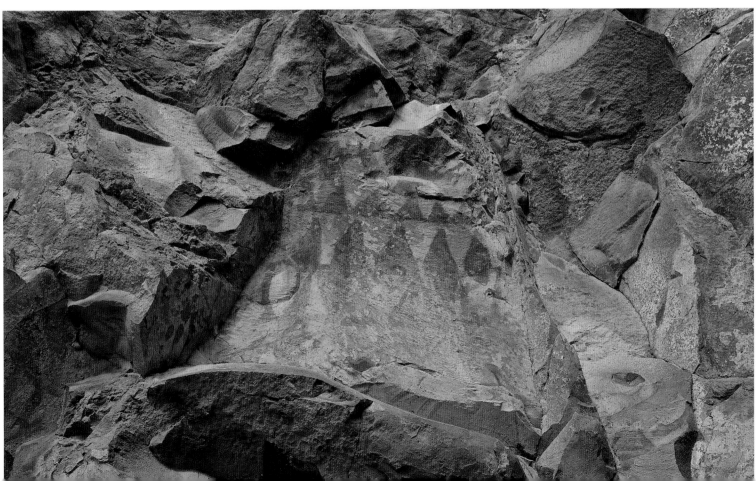

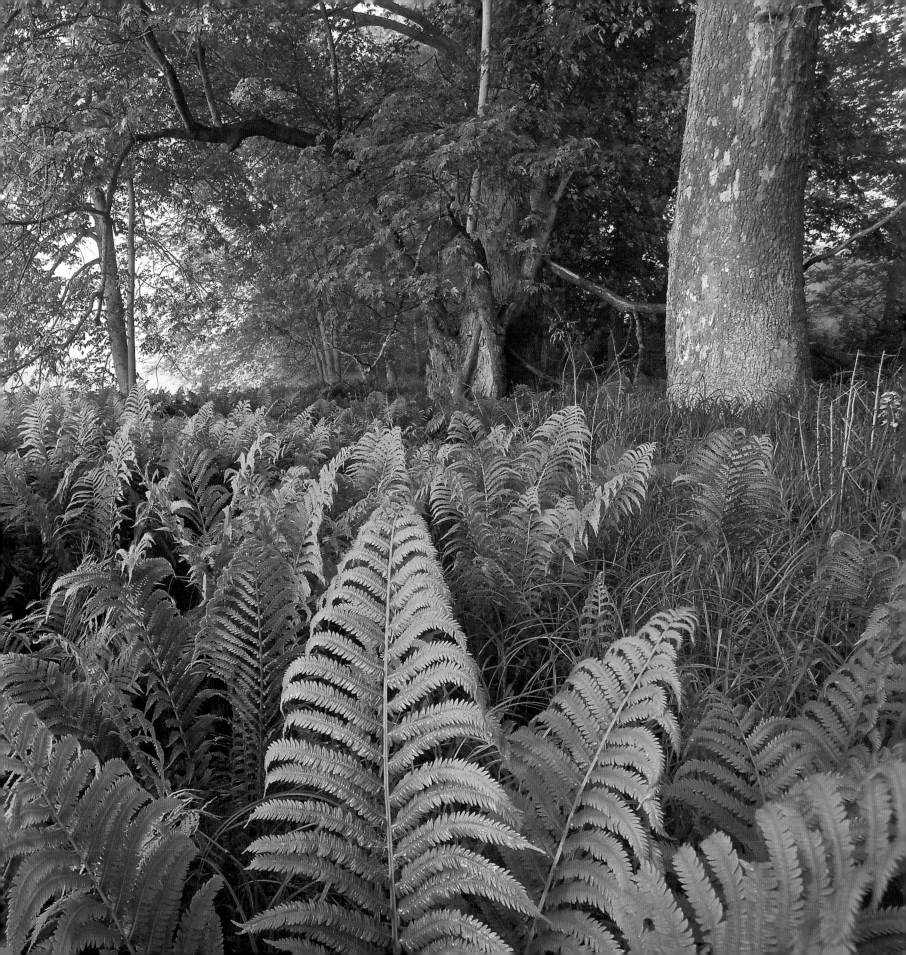

and transport us. Upon them we depend for every material necessity, comfort, convenience, and protection in our lives. Without abundant resources, prosperity is out of reach"—within a binding social responsibility. Parents had no right to rob their children or their children's children of their access to necessary resources. This balancing act, enforced through regulation, would ensure, or so Pinchot hoped, the continued well-being of the land and the people who depended on it.[4]

He knew that these demands, these greatest goods, would change over time, and that management policy must respond to shifts in what the society wanted the public lands to provide. *America's Great National Forests, Wildernesses, and Grasslands* explores these transitions and embeds them within their shifting historical contexts. Some of the national forests, for example, illustrate how this form of management repaired lands devastated by the Industrial Revolution. Other sites reveal myriad ways the Great Depression and the Dust Bowl disturbed the environment, human and natural. To deal with that era's disordering of people and place, President Franklin Roosevelt's New Deal underwrote the establishment of new national forests and grasslands in the South and Great Plains and sent in the Civilian Conservation Corps to put things right. Still other national forests highlight changes in postwar American environmental culture, with its growing emphasis on wilderness values, biodiversity and ecosystem resilience, water quality, species protection, and recreational opportunities.

That these "lands of many uses—and many users," as former Forest Service Chief Richard McArdle once dubbed them, continue to perform an important national service would cheer the early proponents. Thrilled too would be President Theodore Roosevelt, who was one of the national forests' greatest champions. He

built off the work of his presidential predecessors—Benjamin Harrison, Grover Cleveland, and William McKinley, who established the first set of forest reserves—by designating roughly 150 million acres of national forests. They were a guard against greed. "There can be no greater issue than that of conservation in this country," he said. "We do not intend that our natural resources shall be exploited by the few against the interests of the many, nor do we intend to turn over to any man who will wastefully use them by destruction, and leave to those who come after us a heritage damaged by just so much." Establishing national forests was part of a moral crusade for a more progressive America: "We stand at Armageddon, and we battle for the Lord."[5]

Roosevelt's assertion that the Forest Service emerged out of a divine struggle—surely a first in the annals of American bureaucracy—begs the question: Why did he and his contemporaries conceive of these forests as bulwarks against the ravages of industrialization and monopolistic power? Where did these ideas come from?

The intellectual genealogy of the national forests and the Forest Service is fairly straightforward. Although there were important grassroots initiatives in land-use management during the antebellum period, the idea did not engage national attention until after the Civil War. That is when a war-weary society realized it was starting to make war on nature. "Between 1850 and 1910, forests were being cleared for agriculture at the rate of 13.5 square miles per day," noted forester Douglas W. McCleery, amounting to roughly 190 million acres. The key figure in sounding the alarm and energizing a broad-based conservation coalition was George Perkins Marsh. In *Man and Nature: Or, Physical Geography as Modified by Human Action* (1864), he argued that the human impact on the earth was accelerating in force. If

From the flank of Mount Roberts, towering above Juneau, Alaska, a small portion of Tongass National Forest's vastness can be seen with Douglas Island nearby, Admiralty Island in the distance, Chichagof Island to the right, and peaks farther south rising from the Alexander Archipelago.

RIGHT: Grand Island in Hiawatha National Forest is reached only by ferryboat from Michigan's northern coast. Splendidly isolated in the deep waters of Lake Superior, the island's 27-mile perimeter offers trails perched above cliffs and beaches— once a private game reserve but now open to the public.

OPPOSITE: With Nez Perce-Clearwater National Forests on its east side and Wallowa-Whitman to the west, Hells Canyon has been carved by the tumultuous flow of the Snake River—the largest tributary to the Columbia, best reached by white-water raft. Together, portions of these forests are managed as the Hells Canyon National Recreation Area and Snake Wild and Scenic River, designated in 1975 to prevent the flooding of the canyon by a 670-foot-high dam proposed just above the Salmon River confluence. Steep slopes soar skyward through successive ecological zones of a canyon that's 8,000 feet deep on the Idaho side and 5,000 on the Oregon side, topping out in forests of ponderosa pine and Douglas fir.

not controlled, there would be catastrophic consequences. Americans needed only to look at what had happened to the grazed-over Mediterranean basin and cut-over Vermont. These landscapes, he asserted, were symptomatic of a global problem that could be corrected only if human societies embraced an ethic that harnessed their consumption of natural resources. "Man is everywhere a disturbing agent," Marsh declared, and "wherever he plants his foot, the harmonies of nature are turned to discord." To return harmony to the land and the human communities that depended on it was the stated purpose of *Man and Nature*. Marsh wrote his 586-page tome in hopes of generating a deeper appreciation of the dilemmas that humanity confronted, encouraging his many readers to embrace stewardship—conservation— as the only sure means of survival.[6]

Marsh's claims proved indispensable to creating the scientific basis and the political will necessary to practice forestry in the public domain. This transformation did not happen overnight. As with any reform movement, motivating concepts require institutional support. The American Forestry Association (AFA), founded in 1875, gave Marsh's ideas a crucial national platform. At its annual meetings, some of those who would in time become most closely associated with the next stage of forestry's development— Franklin Hough, Nathaniel Egleston, and Bernhard Fernow—invariably cited Marsh when they proposed scientific management of the nation's woodlands. It is not incidental that these three men would succeed one another as heads of the small division of forestry in the Department of Agriculture, itself established in 1876 after

intense AFA lobbying of Congress. When in 1898 Pinchot became the division's fourth chief, he occupied a place these pioneers had cleared.[7]

Pinchot, who was born the year after Marsh's book appeared, received his first copy of it on his 21st birthday. On that August day in 1885, his family gave him a gilt-edged edition of *Man and Nature*. The gift was designed to further encourage his already deep interest in conservation and the cause that he would make his own; he would later declare the book to be "epoch making." Pinchot owed a debt as well to another set of formative influences whom he met, worked with, and whose writings he consumed avidly. Harvard arborist Charles S. Sargent published an exhaustive, multivolume study of North American trees that gave him a cachet that no peer could match. Naturalist John Muir's rhapsodic odes to nature's glory were essential to generating eastern urban support for western land management. Just as influential was George Bird Grinnell, publisher of *Forest and Stream*, founder of the first iteration of the Audubon Society, and a staunch proponent of Yellowstone and Glacier National Parks.

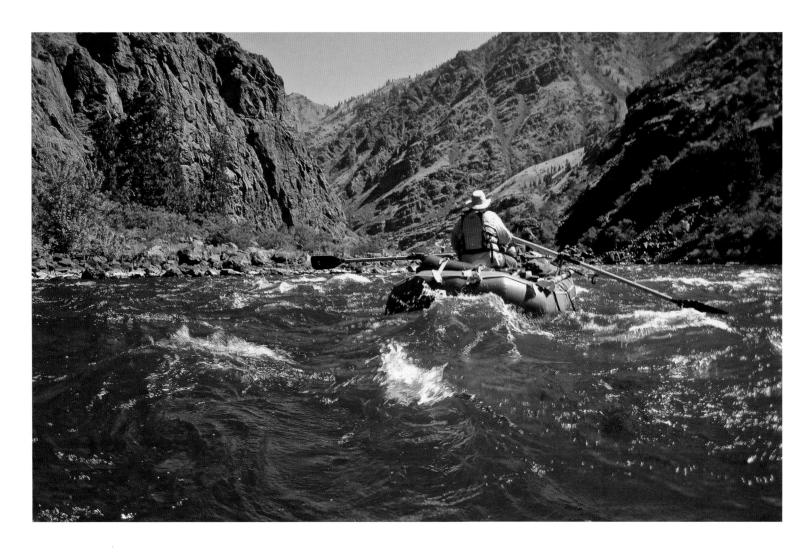

Indeed, no one made a more succinct case for why American forests must be protected than Grinnell. In an 1882 *Forest and Stream* editorial advocating the establishment of "forest reservations," he used but 13 words to make his concluding point: "No woods, no game; no woods, no water; and no water, no fish." Conservation was a matter of ethics and ecology, principles on which the nation's future depended.[8]

For all the importance of these individuals, a conservation ethos would not have emerged without the Industrial Revolution itself. The celerity with which it consumed timber, coal, water, and other resources, when linked to the simultaneous and massive migration of labor into the country's burgeoning cities, sparked an ever-intensifying clearing of the country's forested estate. This despoliation prompted public outcry even from those who benefited most from these lands' rapid exploitation.

The national demand for wood, which was perfectly pegged to unparalleled population growth, helped set the context for 19th-century forest reform. The United States zoomed from 7.2 million people in 1830 to 31.5 million in 1860, and then hit 74.8 million by 1899. Timber-harvest levels jumped as sharply: in 1801, a mere 0.5 billion board feet (BBF) was cut; in 1880 more than 20 BBF was harvested, topping out at 46 BBF in 1906. The railroad industry, for one, feasted on wood. In 1879, locomotives burned nearly two million cords as fuel. The very next year, to lay down an expanding track system, lumberjacks cleared 300,000 acres so that mill workers could turn out the 58 million crossties that road crews then sledgehammered into place. Thirty years later, 620,000 acres of wood were cut down to produce 124 million crossties. Put another way, railroad construction and repair ensured that industry was responsible for "at least

one-fourth to one-fifth of the annual U.S. timber production during the latter part of [that] century." If you add to these figures the amount of forest cleared for agriculture, and wood used to shore up mines, build ships, bridges, homes, and roads, it is understandable why European visitors dubbed the United States a "Wooden country."[9]

Little wonder, then, that mid-19th century Americans feared a timber famine. Or that they worried that the loss of the nation's forested mantle would produce an economic disaster. Or that they listened to those writers, critics, naturalists, and scientists who gave voice to the culture's growing anxiety by advocating conservation land-management techniques to restore devastated environments. Evidence of that need was scored into eroded New England hillsides, the cut-over Upper Peninsula of Michigan, and mangled and charred Rocky Mountain ridgelines. Out on the Pacific coast, the news was just as grim. The "exhaustion of the forest growth in the Sierra is only a question of some ten years," the *Sacramento Daily Union* warned in 1878; "if the rate of consumption is increased the catastrophe will occur considerably sooner." As conservationist F. P. Baker put it, Americans are "famous destroyers of the forest," devastating "thousands of acres of noble forest trees . . . merely to rid the earth of them. The Western pioneer has passed his life in toilsome labor of chopping and burning trees which his descendants would gladly replace."[10]

Baker and many of his peers looked east for answers. They read European scientific journals and popular magazines, toured the continent's well-managed forests, and a small number, including Pinchot, studied with its leading experts. Yet absent the strong central state that existed in England, France, and Germany, and lacking the cultural support for conservation, American forest advocates were left with

Pilot Peak rises to its landmark summit just east of Yellowstone National Park in Wyoming's Shoshone National Forest. This was America's first national forest, designated by President Benjamin Harrison in 1891 as the Yellowstone Timberland Forest Reserve and later renamed Shoshone.

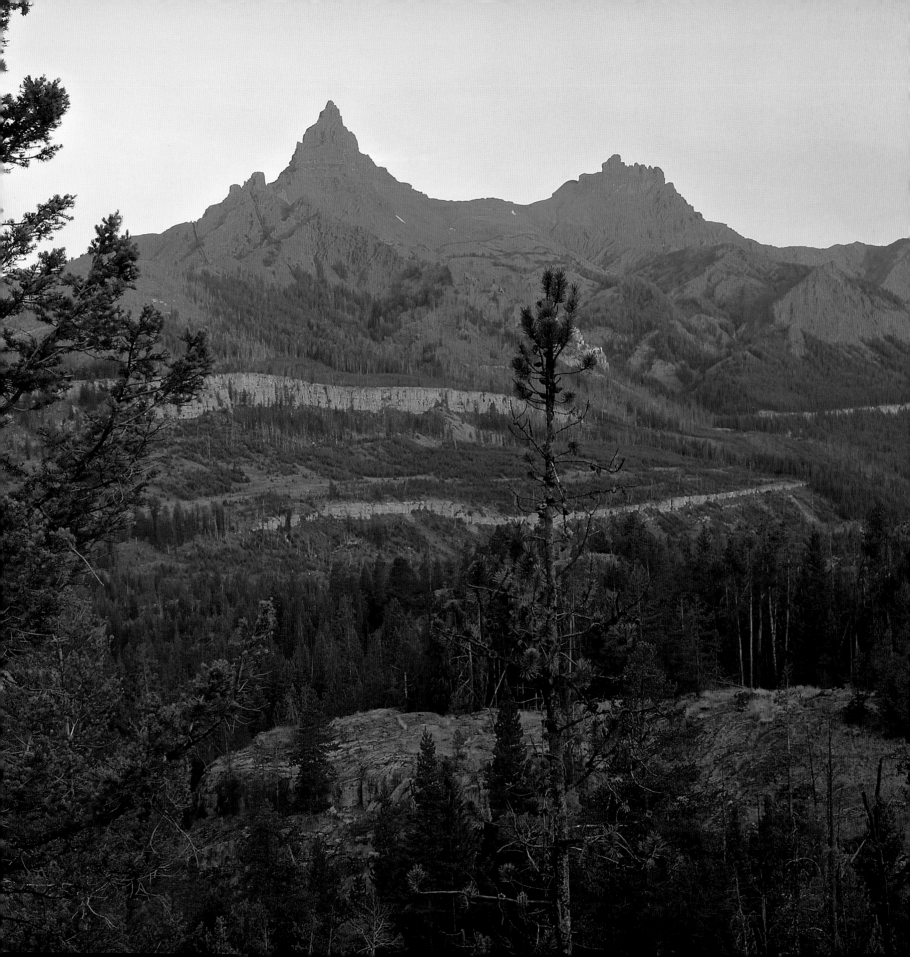

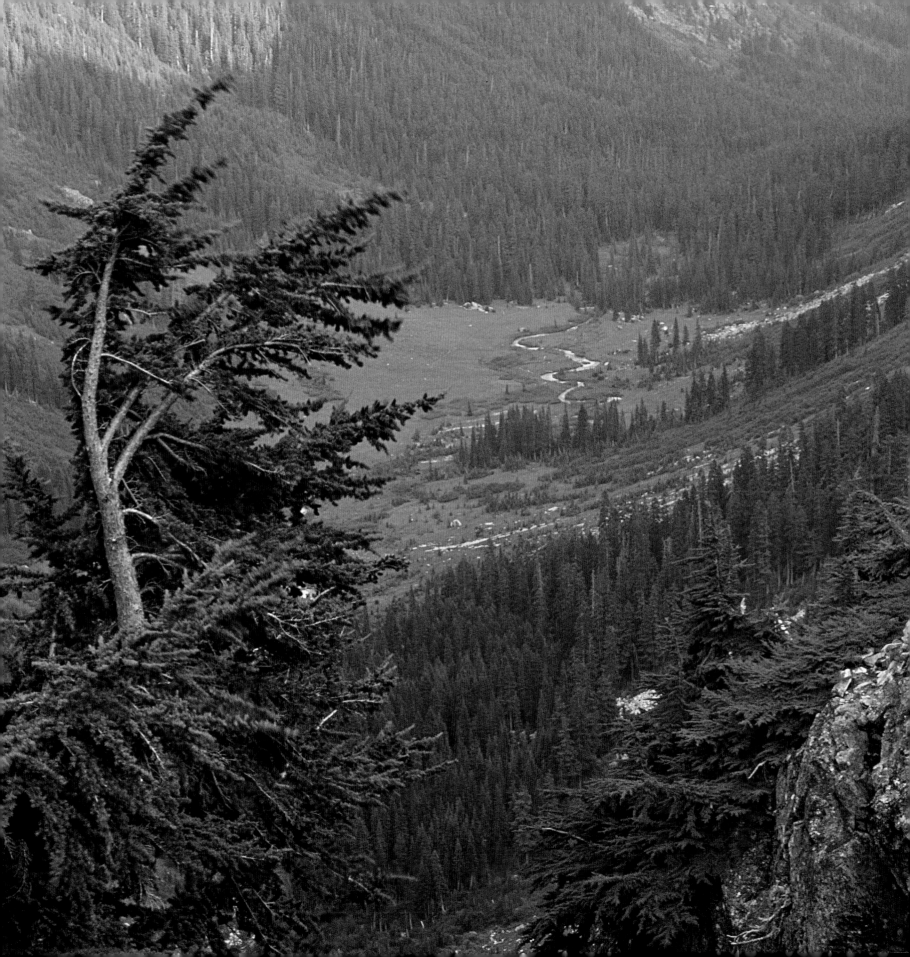

more questions than answers. What "can we do to preserve and restore our forests, to repair the waste of the past, and provide for the needs of the future?" Baker's attempt to answer his query was couched in language that revealed the limitations he believed would prevent European-style forestry from flourishing in the New World. While he acknowledged that among his contemporaries "a growing sentiment has sprung up in favor of the preservation and cultivation of trees both for ornament and use," he suspected many other citizens would not support the level of governmental "interference" that gave European foresters such unrestrained authority to manage landscapes under their purview. Baker doubted the efficacy of the legislative process as well: "few statutes have been more persistently violated," he noted wryly, than the already extant ones prohibiting "cutting timber on government land."[11]

By the late 19th century, it became possible to mount a more effective challenge to the status quo. A new cohort of forest reformers took up this challenge, though their subsequent achievements, including the establishment of the national forest system, was predicated on the previous generation's intellectual commitments and political activism. It was Marsh, Hough, Baker, and their contemporaries who initiated the fertile transatlantic exchange of ideas. It was they who discovered just how complicated it would be to introduce forestry's scientific principles to an industrializing America. In sparking a civic debate over the future of the nation's forests, they proved instrumental to the later success in securing national regulation of public lands. These early "lovers of the forest," Pinchot confirmed, "deserve far more credit than they ever got for their public-spirited efforts to save a great natural resource."[12]

Part of their legacy is embedded in two pieces of congressional legislation that fundamentally altered the conditions on the ground. Indeed, it is fair to say that without the 1891 Forest Reserve Act and the 1897 Organic Act there would be no Forest Service and no system of national forests for it to manage.

The former law gave the president the right to set aside forest reserves out of the public domain, those millions of acres the federal government owned in the western states and territories. President Benjamin Harrison used this authority to designate 13 million acres, the first of which was the Yellowstone Timberland Forest Reserve (portions of which are now the Shoshone National Forest) in northwestern Wyoming; the second, in Southern California, was the San Gabriel Timberland Reserve (now part of the Angeles National Forest). Following Harrison's lead, Grover Cleveland established 25 million acres as reserves, and his successor, William McKinley, denoted another seven million. For the first time in the nation's relatively young history, it had decided that some public lands and the resources they contained were too valuable to be disposed of, a radical shift in policy.

Conservationists were thrilled by these 45 million acres set aside. But until the 1897 Organic Act became law, there was no formal mechanism for determining how these new forest reserves could be used, by whom, and under what conditions. Neither was there any indication of who would regulate and manage these new entities. The fact of the reserves, as well as the incompleteness of the legislation that created them, angered many resource exploiters who for years had had essentially free access to the public land's resources. Across the 1890s, these farmers, ranchers, loggers, and miners went public with their grievances, stirring up an extensive debate that continues to this day over the principles and purposes of federal land management. The Seattle

OPPOSITE: With a classic U-shaped valley carved by glaciers, Phelps Creek drops from a tangle of mountain hemlocks at Spider Gap in Mount Baker-Snoqualmie National Forest in Washington.

FOLLOWING SPREAD: The valley of the Little Missouri River recedes in the distance from this sandstone ridge south of Madora, North Dakota. The Little Missouri is one of 20 national grasslands covering four million acres administered by the Forest Service. Most were acquired in the early 1900s to reclaim windblown prairies that had been decimated by the plow and by heavy grazing. As with other national grasslands, public land here is mixed with private ranches.

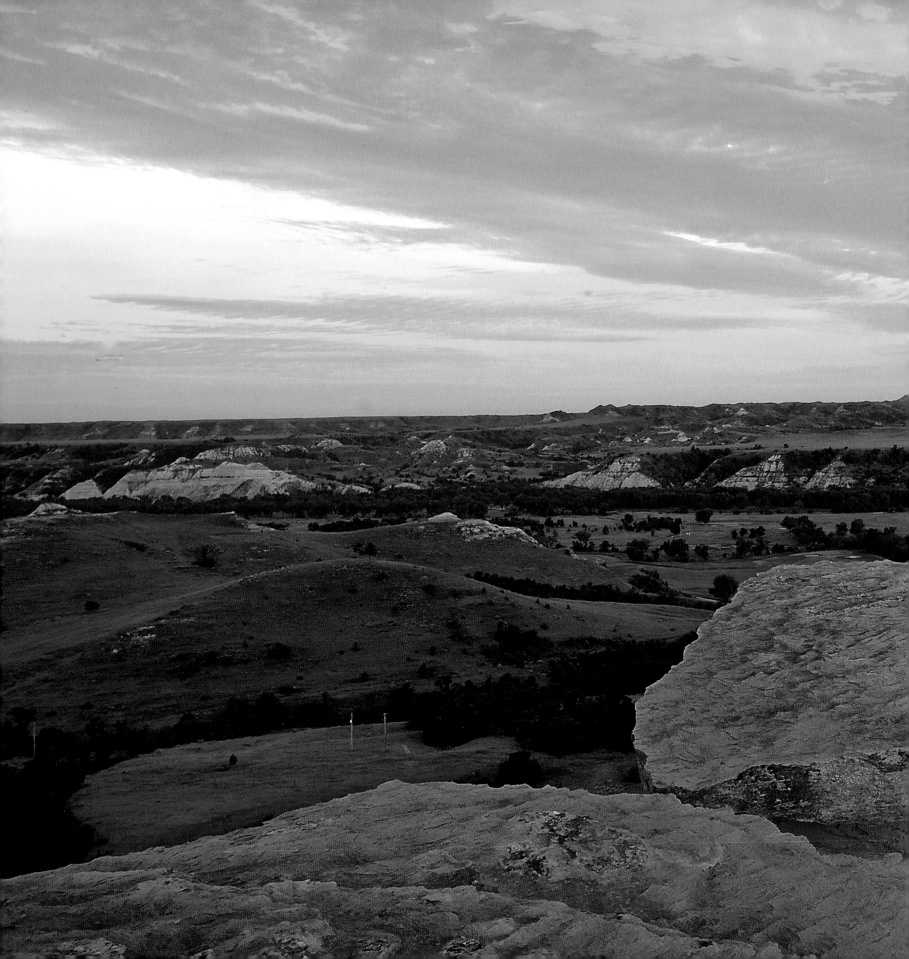

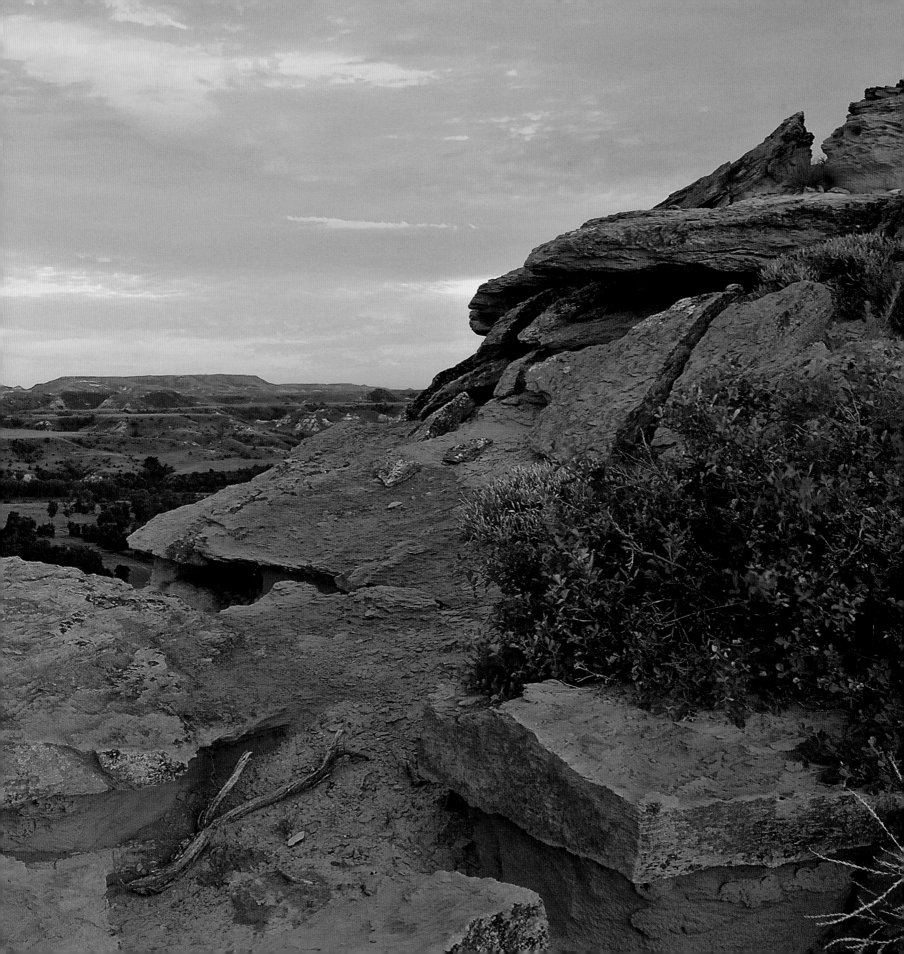

Chamber of Commerce, for instance, slammed President Cleveland's creation of 13 such reserves shortly before he left office in 1897. Denouncing his action as a "galling insult to local sovereignty," it railed that even "King George had never attempted so high-handed an invasion upon the rights" of American citizens.[13]

The 1897 Organic Act took the steam out of some of this hyperbolic rhetoric. "No national forest shall be established," the legislation affirmed, "except to improve and protect the forest within the boundaries, or for the purpose of securing favorable conditions of water flows, and to furnish a continuous supply of timber for the use and necessities of citizens of the United States." The bill also authorized the Secretary of the Interior to write rules and regulations that would govern their use and hire employees to enforce these codes, and tap the U.S. Geological Survey to map the reserves' boundaries. The national forests were becoming federalized.

One year after the passage of the Organic Act, Pinchot replaced the retiring Fernow as the head of the forestry division in the Department of Agriculture. His arrival marked a watershed moment in the bureau's history. It did so because Pinchot was convinced that this then-tiny agency should manage the forest reserves that were located in the Department of the Interior. His was an ambitious political strategy—to pluck millions of acres away from one cabinet secretary and transfer them to another required finesse and luck. Pinchot, it turned out, had plenty of both.

Politically connected and savvy about the ways of Washington, he assiduously worked the cloakrooms and hallways of Congress seeking support for his concept of a robust federal land-management agency. Pinchot's diligence gained considerable momentum when Theodore Roosevelt ascended to the presidency in 1901,

following McKinley's assassination. Of one mind about the virtue of conservation, and certain that the federal government should implement the principles of scientific management on the public lands, they lobbied inside and outside the corridors of power to advance their claims. Four years later, Congress passed the requisite legislation transferring 62 forest reserves containing more than 63 million acres to the newly created Forest Service. Like a good subordinate, Pinchot gave credit where credit was due. Under President Roosevelt, he wrote, "great progress has been made by the government in bringing about the practice of forestry by forest owners and in awakening the great lumber interests, as well as the people in general, to the dangers of forest destruction."[14]

It was up to Pinchot and his colleagues to use this new legislative mandate to hire and train rangers to establish the boundaries of the national forests. They also had to resolve legal challenges to the agency's existence. In 1911, a pair of Supreme Court decisions affirmed the Forest Service's statutory standing and legitimate authority to manage the forests and grasslands. On Pinchot's already crowded agenda was the annual lobbying of Congress for budget increases to match the Forest Service's expanded duties. At this he proved masterful.

With an increasing number of employees and money, the Forest Service could move on its central task of repairing abused land. From 1905 until World War II, its energy largely was focused on the regeneration of cut-down, burned-out, and overgrazed terrain. During the Great Depression of the 1930s, its charge widened to include eroded farmlands, located principally in the South and Dust Bowl–damaged grasslands in the Great Plains. The central labor of a generation of foresters was to plant trees and grass. Their handiwork is brilliantly on display to everyone flying over

Mountains of the northwest coast intercept saturated rainstorms that nourish the most productive temperate rain forests on Earth. Here local logger-turned-conservationist Jim Rogers has guided us to a sequestered grove of giant Port Orford cedars and Douglas firs that were bypassed in an earlier era of logging when virtually all of the Coast Range was cut. Nearly 14,000 acres here are now protected in Oregon's Copper Salmon Wilderness.

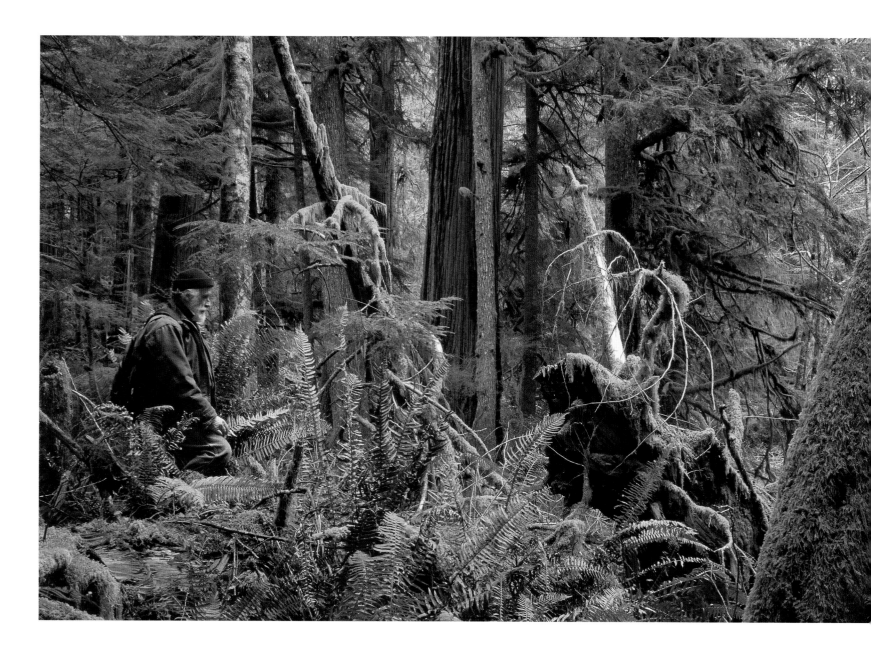

the now-reforested southern states or driving through amber waves of grain in the prairies. During this era, the Forest Service mended what others had torn asunder. It was the soft-hatted custodial agent of the public domain.

Its hat hardened in the aftermath of global war and the advent of postwar prosperity.

Because privately owned timberlands were largely exhausted to meet the wartime demand for wood, starting in the late 1940s the national forests took up the slack. Prewar logging in the national forests had amounted to no more than two BBF a year. By 1960, that figure had risen to more than eight BBF and it reached a peak of more than

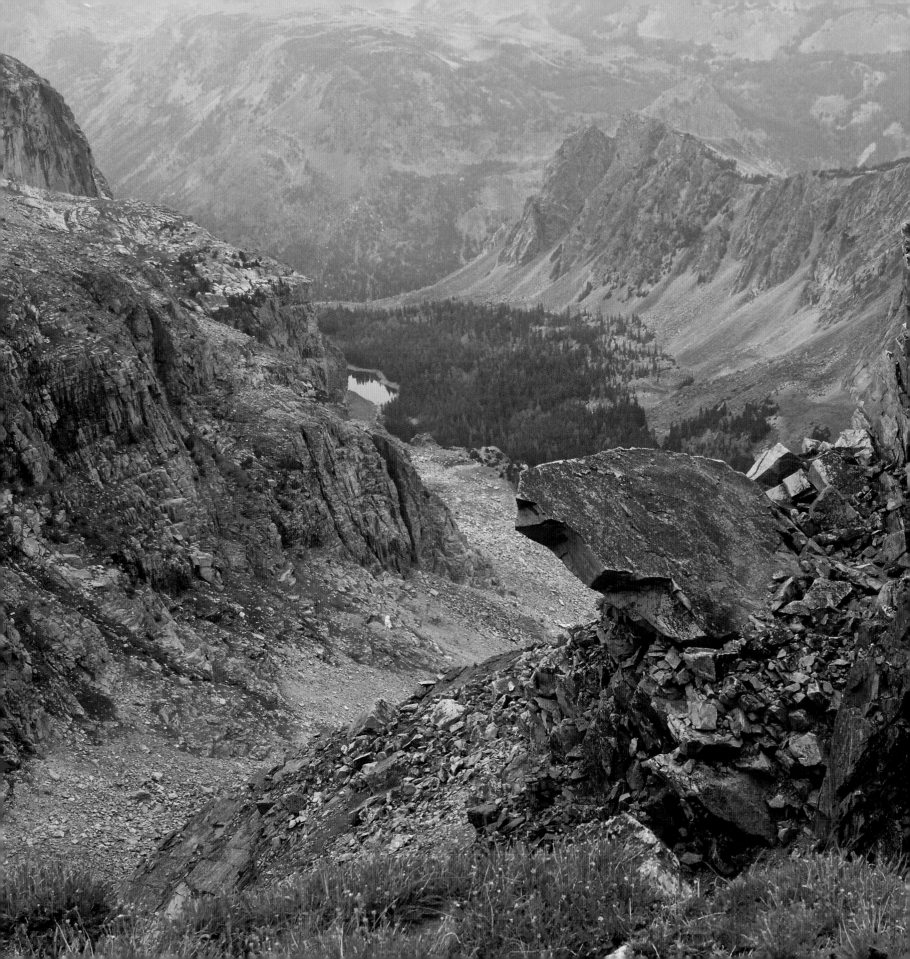

12 BBF by the late 1980s. This shift in the Forest Service's actions was of incalculable importance. Formed as a reaction to late 19th-century worries about woodland devastation, in the postwar years the Forest Service had become the central agent of timber productivity in the United States.

This change did not sit well with some inside and outside the agency. An internal task force in the early 1970s chided employees in the Bitterroot National Forest in Montana for acting as if "resource production goals come first and land-management considerations take second place." The complaint was understandable. One of the forest's aggressive harvests came to be called the "Oh My God" clearcut and it set off a round of public protests. Protesters simultaneously challenged the Forest Service's clearcutting agenda in West Virginia's Monongahela National Forest. These were the first of a two-decade-long backlash against the Forest Service's get-out-the-cut campaign. During this period dozens of federal lawsuits were filed, countless demonstrations held, and an array of state and congressional inquiries conducted. When the dust had settled, a new legal environment had emerged. Amongits most critical components was the 1976 National Forest Management Act. It gave an angered public a much stronger role in determining forest-planning procedures.[15]

The National Forest Management Act was the last in a remarkable series of landmark environmental initiatives that began in 1964 with the Wilderness Act. Collectively, these bills—including the Clean Air Act and Clean Water Act amendments, the Endangered Species Act, the Wild and Scenic Rivers Act, and the National Environmental Policy Act—constitute the second great wave of environmental activism in U.S. history. These new laws were designed to regulate the very land-management agencies, such as

The U-shaped, glaciated canyon of Rock Creek yawns beneath the Beartooth Plateau, just northeast of Yellowstone National Park in Montana. Nearby, the Beartooth Highway through Custer Gallatin and Shoshone National Forests is one of the most spectacular mountain roads in America. National forests here and around the other edges of America's most famous national park constitute the majority of land in the Greater Yellowstone Ecosystem—an assemblage of mountains and valleys essential to wildlife as iconic as buffalo, Rocky Mountain elk, and grizzly bears.

the Forest Service and the National Park Service, that had been born during the Progressive Era.

Whatever their intent, the new laws did not immediately transform Forest Service management. Since the 1980s, ongoing legal challenges, budget cuts, and sharp reductions in personnel have complicated the agency's actions. Jack Ward Thomas, who served as chief from 1993 to 1996, has argued that the rigorous and occasionally cross-purpose oversight of the Forest Service has led to an analysis paralysis. His concerns are part of a broader struggle to define the agency's contemporary mission in light of radical declines in timber harvests, escalating population pressures along the wildland-urban interface, increased recreational use, intensifying forest fires, and serious water-management issues confronting the South and West.[16]

That struggle is revealed in a series of mission-seeking initiatives that have emerged since the 1980s. "New Perspectives," which advocated for a more ecological approach to forest management, was succeeded by a more direct framing of that orientation in a 1990s policy known as "Ecosystem Management." Relatedly, Chief Michael Dombeck promoted the formal designation of roadless areas throughout the national forest system, noting that they "provide clean water, habitat for wildlife, food for hunters and amazing recreational opportunities." These wildscapes, 58 million acres of which were ultimately set aside to be managed as unroaded, are "critically important for the long-term sustainability of the nation's forests." In the early 2000s, Chief Dale Bosworth created a new strategy for addressing the 21st century's major environmental challenges. Called the "Four Threats," Bosworth committed the agency to manage in response to habitat fragmentation and loss of open space, new fire regimes, an uptick in

invasive species, and a rise in unregulated recreation. None of this work could be accomplished without partners, a collaborative ethos that ever since has gained traction. For the past decade or so, the Forest Service has been seeking collaborators at the local, state, and national level to help build more fire-resistant environments and fire-safe communities in fire-prone regions. It has mounted multiorganizational efforts to regenerate damaged forest ecosystems after hurricanes, floods, and conflagrations. In conjunction with major cities and small towns, it is restoring riparian corridors and forested headwaters to protect local water supplies. If these alterations in the agency's approach to landscape management deepen and increase over the coming years, they will signal a new era in its oft-tumultuous history.[17]

The Forest Service's ability, however constrained, to adapt to alterations in politics and policy, ideas and imagination, is a healthy sign of its organizational flexibility and institutional maturation. Being nimble is how all organisms survive and endure.

There may be no better way to exemplify this complex process than through the lens of a camera—especially if the camera in question is in the hands of Tim Palmer, author of 24 award-winning books about rivers, conservation, and adventure travel. As you leaf through his photographs that grace this book, note his keen instinct for the telling detail, the sense of intimacy his wide-angled views create. Whether he struck off into the arid mountains of the Southwest, hiked through an eastern hardwood forest, got his feet wet in a southern bottomland, or pushed into a northern boreal thicket, his goal has been to bring you along with him. To show you what he saw, when and how he saw it. Such a quiet attentiveness long has been the hallmark of his work.

The Grande Ronde River winds northeast along the border of Umatilla National Forest in Oregon and nourishes endangered salmon and steelhead of the Snake River basin.

"I have tried to capture images of nature as it exists"—his ambition is deeply personal, his reach universal—to "signify nature in the ways it has nurtured the world since the beginning of time."[18]

America's Great National Forests, Wildernesses, and Grasslands carries the same aspiration. Our wish is that it will enrich your appreciation of these spectacular landscapes and the collective inheritance and cultural legacy they represent. Once inspired, may you head out into a nearby forest, wilderness, or grassland. These are our lands. Make them your own.

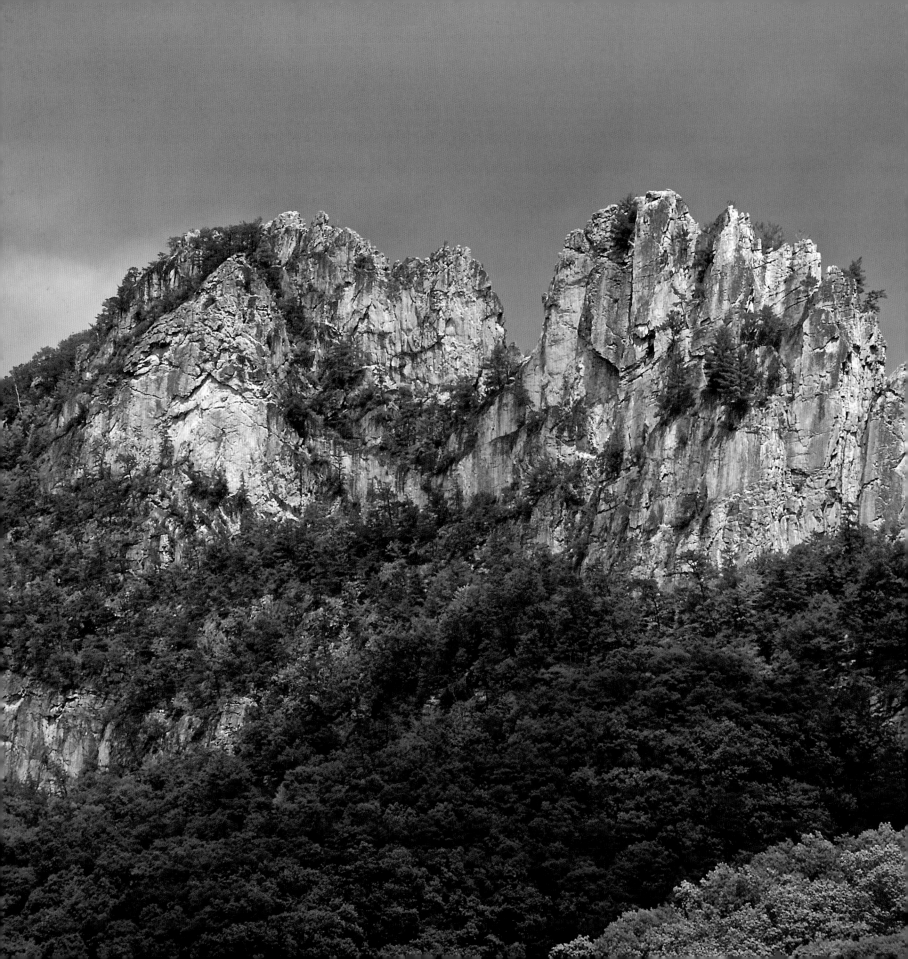

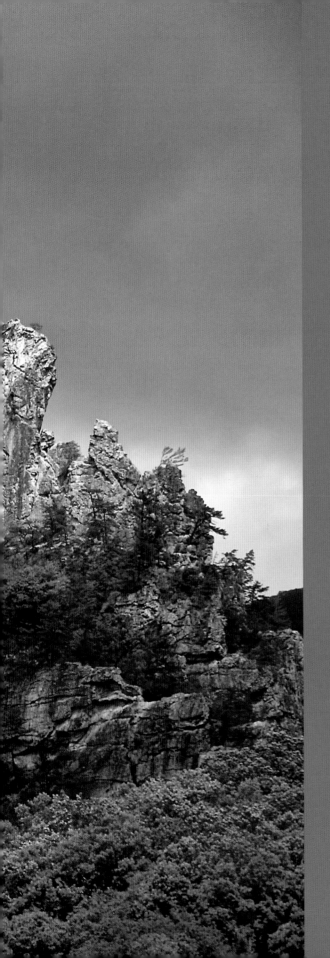

THE EAST & MIDWEST

▲

13 STATES

17 NATIONAL FORESTS

1 TALLGRASS PRAIRIE

12 MILLION ACRES

13 MILLION VISITORS

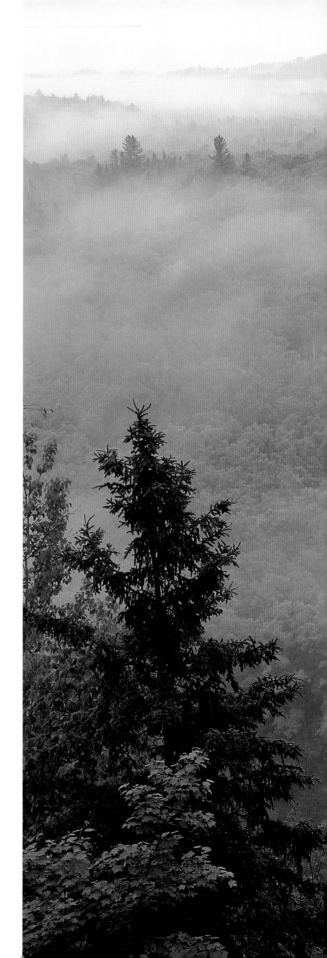

Forests of the East and northern Midwest include some of the most familiar and iconic scenes of rural America. These national forests harbor ridge upon ridge of Appalachian greenery, the blaze of autumn foliage in New England, and a shading broadleaf canopy with soft filtered light that graces common woodlands for much of the nation's population.

Reclaimed from private hands when many landowners fell into default during the Great Depression, the eastern forests are studies in restoration—their second-, third-, or fourth-generation timber regrowing in stature by the decade. With encroaching suburban sprawl and a boom of vacation homes, with exotic insects and pathogens running amok, and with air pollution raining down as acid from coal-fired power plants, the eastern forests also present their own set of nettlesome challenges to the Forest Service.

Nonetheless, the timeless beauty of these backyard open spaces can inspire many to reconnect with nature and to engage in the future of a national forest system that—as we see in photos on the following pages—includes far more than the archetypal wilds of the West.

As a native son of Pennsylvania (literally "Penn's Woods") now living in Oregon, I set out to collect these photos on a nostalgic journey through home grounds that filled my heart with both delight and sadness. Touring from the boreal wilds of New Hampshire to the Appalachian hollows of West Virginia and the springflows of Missouri, I reveled along paths of new discoveries and temperate abundance, but I also despaired at the mountainsides of hemlocks and beeches now ravaged by exotic insects and disease. In the end, enduring images of these forests as wellsprings of life and deeply satisfying scenery inspire me to hope that a new, informed, and selfless stewardship can overcome the errors and misfortunes of the past.

— TIM PALMER

PREVIOUS SPREAD: One of the most spectacular and exposed mountain faces in the East, Seneca Rocks in West Virginia's Monongahela National Forest draws hikers to its trails and climbers to its world-renowned vertical cliffs. OPPOSITE: Red pines, balsam firs, and mixed hardwoods are nourished by morning fog above the Sturgeon River Valley of Ottawa National Forest on the Upper Peninsula of Michigan.

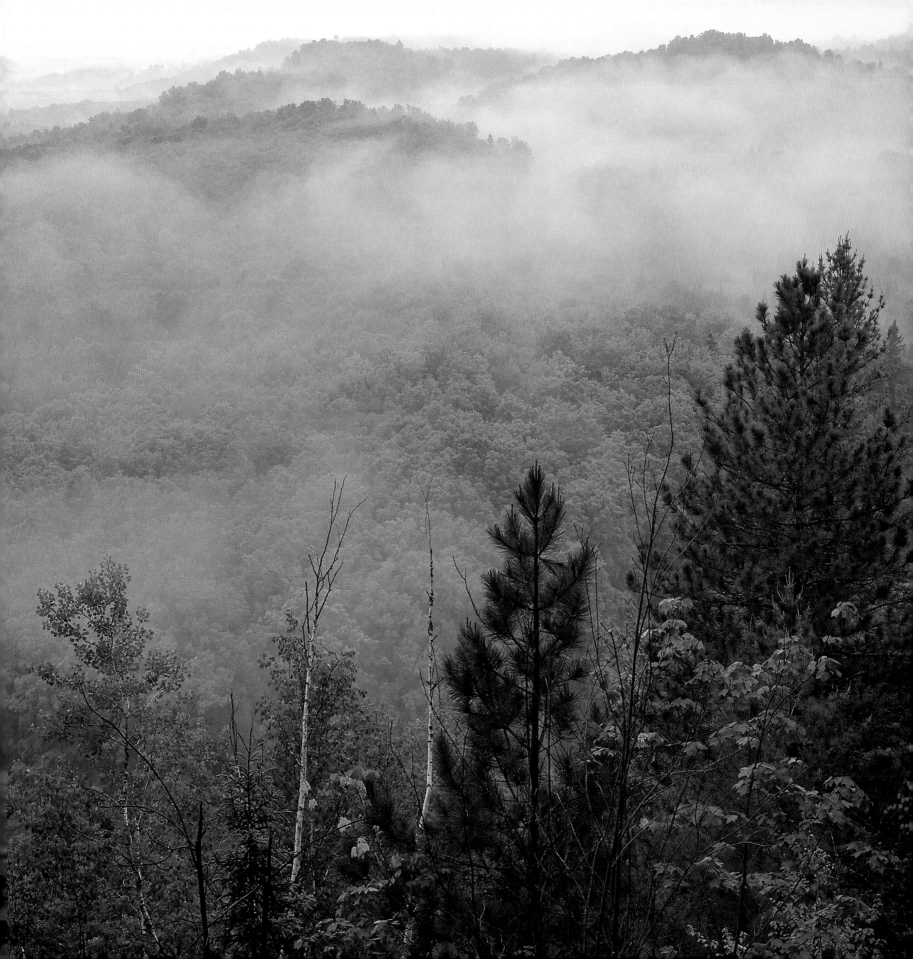

G auging a forest's resilience may start with something as simple as a berry, whether blue, straw, huckle, or cran. Or wild leeks or wild rice, fiddleheads or morel mushrooms. Their flourishing presence or regrettable absence can signify much about an ecosystem's health and not a little about the human attention to such small, delectable details.

Sand dunes buffer the shoreline of Manistee National Forest at Lake Michigan Recreation Area. While parts of the Huron, Hiawatha, Ottawa, and Superior National Forests also front the Great Lakes, this is one of the best sites for beach walking along a once-logged and once-burned forest that's now reclaimed by pines and hardwoods.

The gathering of such "special forest products," as they are known in the Forest Service's official lexicon, is an essential feature of how people interact with the eastern national forests, a region that encompasses roughly 12 million acres ranging from the Chippewa in Minnesota and Mark Twain in Missouri to West Virginia's Monongahela and New Hampshire's White Mountain. Despite the massive differences in their size (the Superior National Forest at 3.9 million acres dwarfs the Finger Lakes at 16,176 acres), for all their varied recreational opportunities across four seasons, and notwithstanding differences in commodity production—timber, energy, minerals, and grazing, among others—these public lands share a close relationship with their surrounding communities in good part because of their active support of the local traditions of picking fruit and nuts, harvesting herbs, tapping sap, and cutting burls and branches for craftwork.

These communal uses long predated the creation of national forests. Native peoples gathered in the bogs, meadows, upland slopes, riparian zones, open space, and thickets, reveling in the warm season's delectable edibles. "*Niibin*, we call

it in Potawatomi, summer, 'the time of plenty,'" noted Robin Kimmerer, a botanist and tribal activist. For her and her people, berry-stained fingers are a reflection of an indelible connection to the land, *emingoyak*, "that which has been given to us," and the reciprocal responsibility to sustain its bounty.[1]

Such abundance caught the calculating eye of Europeans intent on occupying North America. Explorer John Smith was not alone in detailing, almost ledger-like, the land's plentitude—"the herbs and fruits are of many sorts and kinds: currants . . . mulberries, vines, respices [spices], gooseberries, plums, walnuts, [and] pumpkins, gourds, strawberries, beans, peas, and maize"—a paradise, he wrote, for "these plenties have each their season." To capture this natural wealth, new settlers made ready use of flax, berry patches, tree nuts, and grasses to supplement their imported provisions, agricultural productivity, and hunting, consumption that escalated with a booming population and led to increased tensions with indigenous communities. Through warfare, land expropriation, and resource competition, settlement expanded west such that by the mid-19th

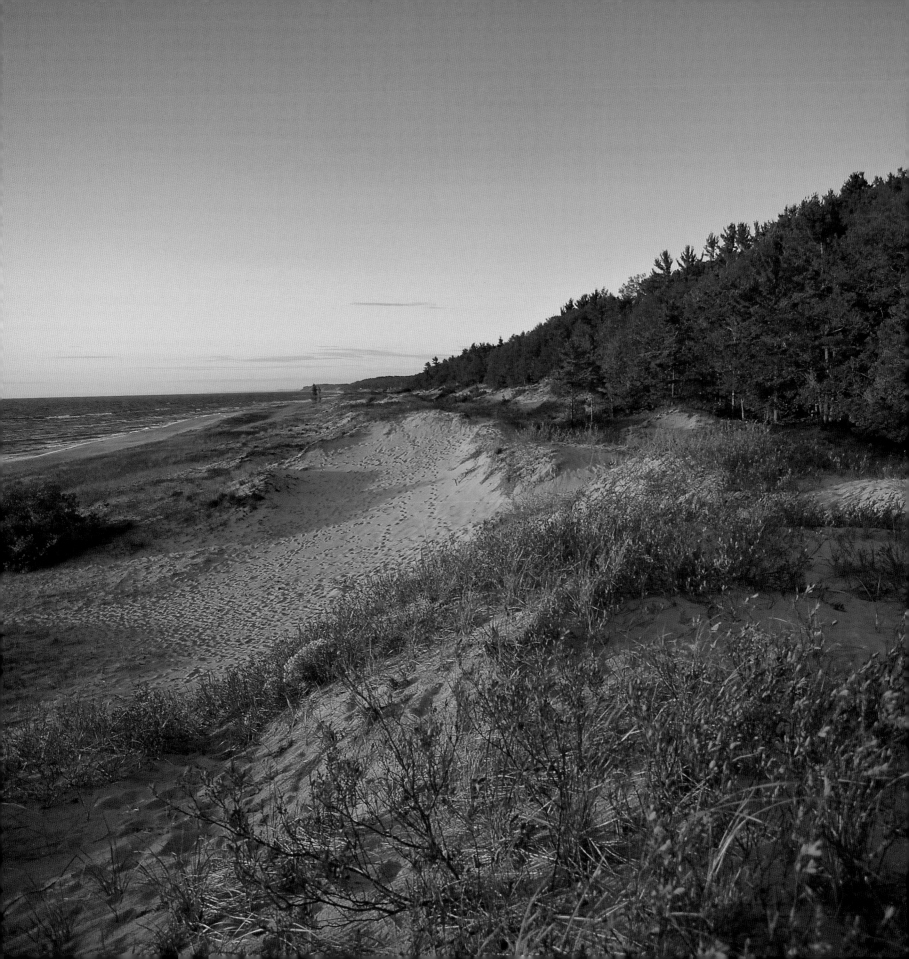

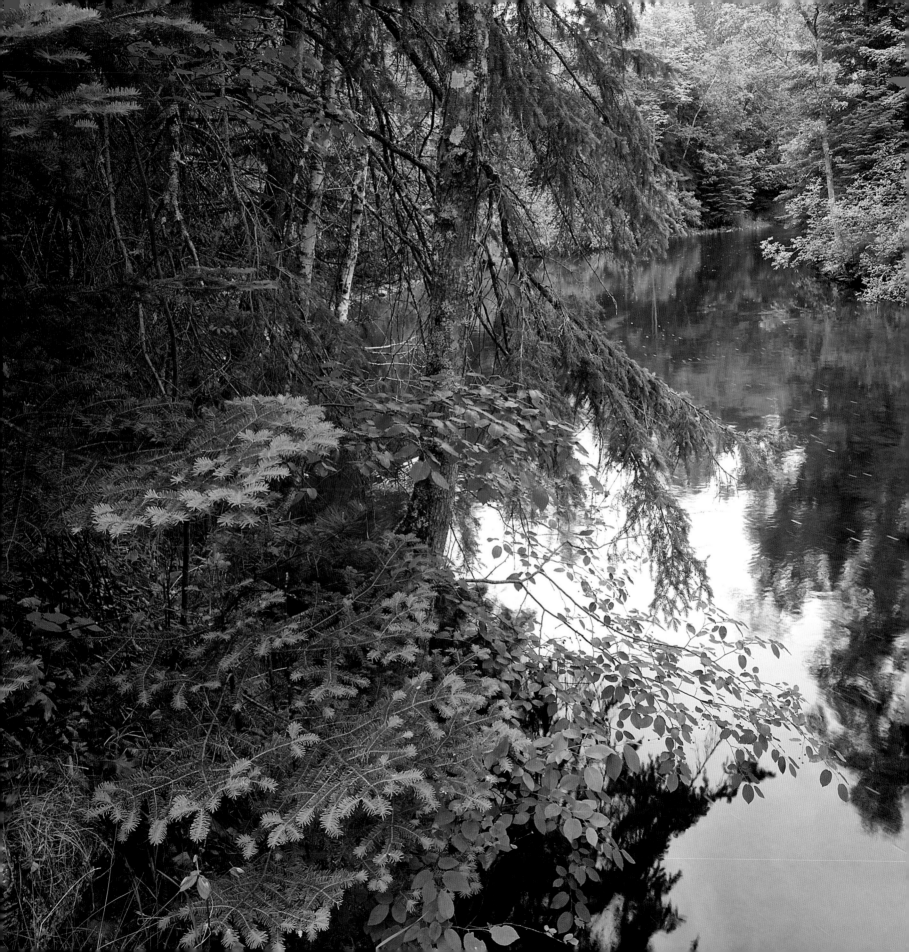

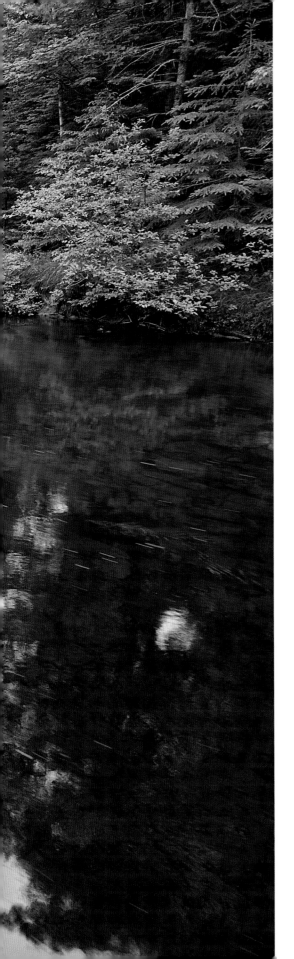

century the new nation dominated most of the territory in which the eastern national forests are now located.[2]

However much they had reduced the extent of what Smith called an "abounding America," the republic's citizens maintained traditional gathering practices. Henry David Thoreau, after being released from his one-night stand of civil disobedience, left jail to lead a berry-picking party into the hills above Concord, Massachusetts, "and in half an hour—for the horse was soon tackled—was in the midst of a huckleberry field, on one of our highest hills, two miles off, and then the State was nowhere to be seen." For him, berrying was a form of freedom.[3]

So it remained even after the arrival of the eastern national forests, largely because of the way they were created. The passage of the Weeks Act (1911) allowed the federal government to purchase acreage from willing sellers to protect mountainous watersheds; over the years, the act helped create or expand the national forest system in the East and South. These new public lands have constituted a critical landed resource in the East especially, given that 40 percent of the nation's population lives within the region stretching from New England and the Mid-Atlantic states to the Midwest. The manner in which these federal forests were developed also helped usher in a cooperative dynamic between those now managing these forests and those who seek out their plants, roots, fungi, and herbs. Wild rice is a much-sought-after staple in the Chequamegon-Nicolet in Wisconsin; the Green Mountain in Vermont is a rich source of fiddleheads; locals gather up rose hips, pecans, hickory, and walnuts in the Hoosier in Indiana; and although you may no longer pick the red sour fruit in the Cranberry Glades Botanical Area, a 750-acre National Natural Landmark

OPPOSITE: At Michigan's Upper Peninsula, two separate Sturgeon Rivers flow from national forest land. Balsam fir, black spruce, and speckled alder grow thickly on the banks of the amber-tinted Sturgeon, bound southward to Lake Michigan through Hiawatha National Forest.

FOLLOWING SPREAD: Michigan's Ottawa National Forest is laced with rivers spilling into and out of lakes and wetlands and flowing across ancient granite outcrops of the continental shield. Here the Cisco Branch of the Ontanogan River foams through rapids hiding native brook trout as it winds north of Highway 2 near Kakabika Falls.

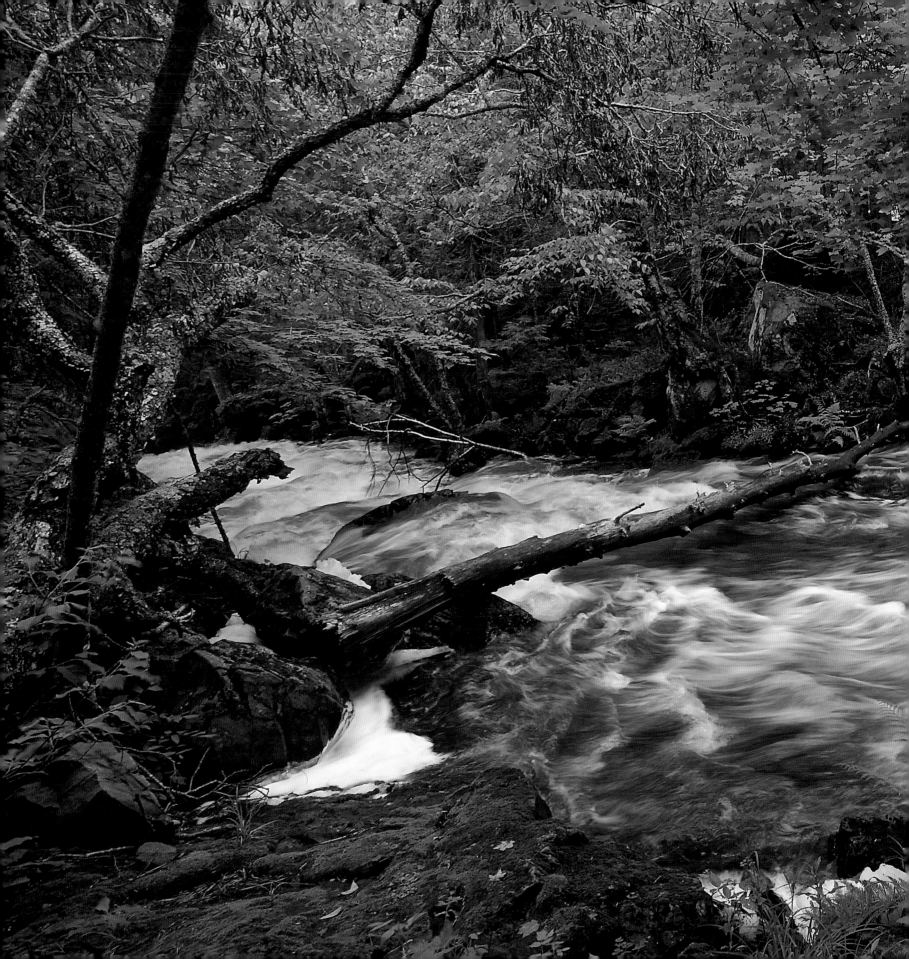

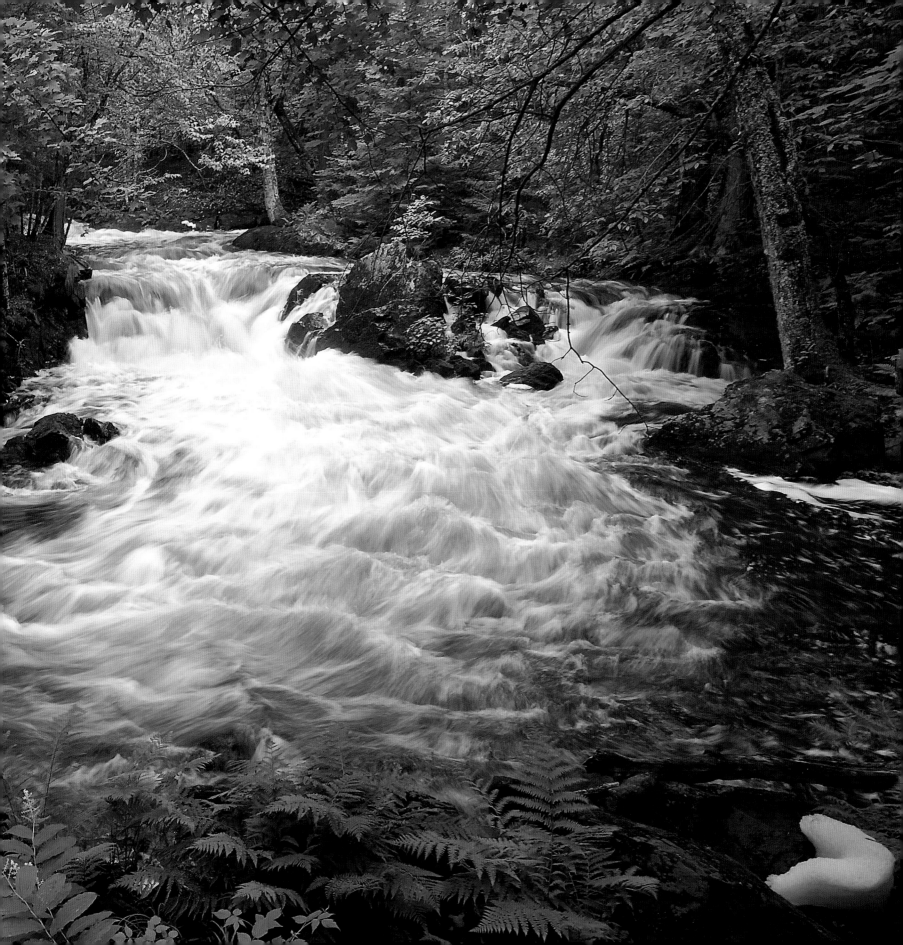

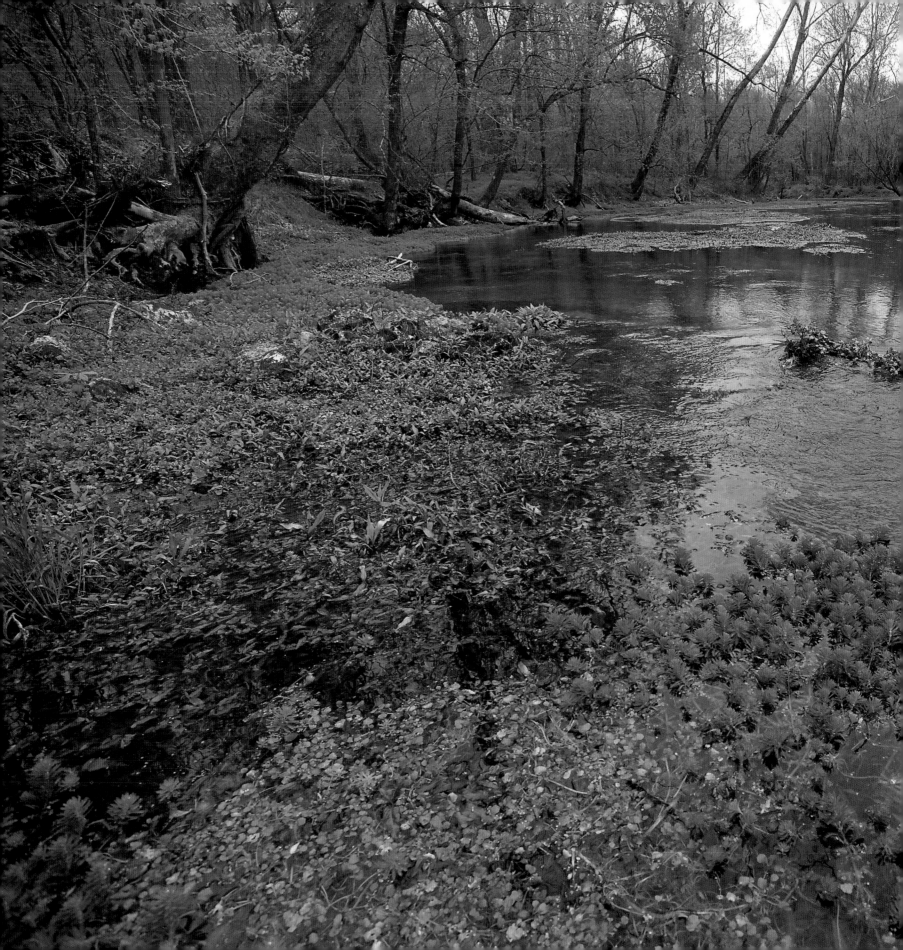

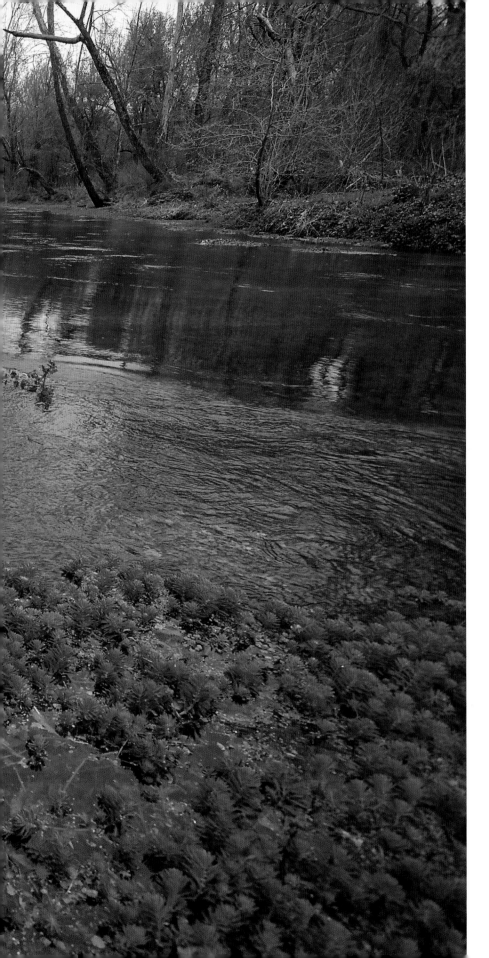

that West Virginia's Monongahela stewards, visitors can learn all about these ancient, protected bogs. No such restrictions apply in New York's Finger Lakes National Forest, which actively manages five acres of blueberries for recreational collection.

However free these materials may be, their preservation requires, in Kimmerer's words, "a moral covenant of reciprocity [that] calls us to our responsibilities for all we have been given, for all we have taken." The eastern national forests, as elsewhere, offer manifold opportunities to embrace this commitment, one berry at a time.[4]

OPPOSITE: The Eleven Point River through Mark Twain National Forest draws from bubbling springflows of clear cold water that typifies the streams of Missouri's Ozark Mountains. This was one of the original 12 rivers designated for protection in the National Wild and Scenic Rivers System.

FOLLOWING SPREAD: In central Minnesota, the upper Mississippi wends through Chippewa National Forest—two-thirds of it lakes or wetlands, evident here between Cass and Winnibigoshish Lakes. As part of the Prairie Potholes complex of tens of thousands of lakes across the northern plains, national forest wetlands are critical to waterfowl of the North American Flyway.

White Mountain National Forest

In the chill of late autumn, birches, maples, and red spruces await the heavy snows of New England. Here Square Ledge looks down on Pinkham Notch, which lies at the base of Mount Washington in the Presidential Range. Infamously harsh winters and virtual tundra above timberline make the 6,288-foot summit a landmark of the East. Seventy million people live within a day's drive of this national forest.

Wilderness can be regenerated. For evidence, just put boot to ground along the Appalachian Trail as it threads up and over the Presidential Range in New Hampshire, weaving through the heart of the White Mountain National Forest. A summer's day hike, running north from Mounts Eisenhower and Monroe to Jefferson and Adams, offers a delightful mix of cool shade and dappled light beneath an enveloping green canopy that allows but occasional glimpses of the rolling vistas stretching out east and west. Only when you crest Mount Washington, the tallest peak at 6,288 feet (and the site of the highest winds ever recorded on the planet), will you gain an unobstructed perspective on the sweep of forest that extends to the horizon. No wonder more than six million tourists a year visit the White Mountain National Forest to ski, hike, fish, boat, and hunt, or to revel in the varied forms of solitude its five federally designated wildernesses offer each season.

A century ago, no one would have called the White Mountains "unspoiled," unless they had a penchant for the cut over, farmed out, and burned up. These mountains' devastation and the public outcry it sparked was one of the main reasons why in 1911 Congress enacted the Weeks Act. It gave the federal government permission to purchase eastern forested lands for conservation purposes, including what would become the White Mountain National Forest.[5]

Congress protected these bruised environments only after sustained grassroots pressure. A key figure in this fight in New Hampshire was the Reverend John E. Johnson. For years, Johnson had ministered to hardscrabble families throughout the rugged White Mountains region and had come to know their struggles intimately. A definitive factor in their poverty and despair, he believed, was the New Hampshire Land Company, "a corporation chartered to depopulate and deforest" a wide swath of mountainous country. It was, Johnson wrote in a 1900 pamphlet, the "Worst 'Trust' in the World." What made it so egregious was the sweetheart deal with the state legislature that had allowed its investors "to acquire for a song all the public lands thereabouts, and later 'take over' all tax titles, until finally there [were] no considerable tracts in the vicinity which it did not own." Once it became the region's dominant landowner, the company began a process Johnson dubbed "refrigeration." It froze out local loggers by refusing to sell them the timber they needed to keep their milling operations running. This had troubling implications for the rising generation, Johnson declared. Because they were "robbed of their winter employment, [they] took no longer to the woods but to the cities, leaving the old folks to fall slowly but surely into the clutches of the company which took their farms from them or their heirs, in most cases for a dollar or two an acre."[6]

Johnson recognized that zealous rhetoric alone would not stop the land company's depredations. Local organizing, statewide activism, regional support, and federal engagement were essential to the successful launch of a reform crusade that would ensure social justice in, and environmental protection for, the White

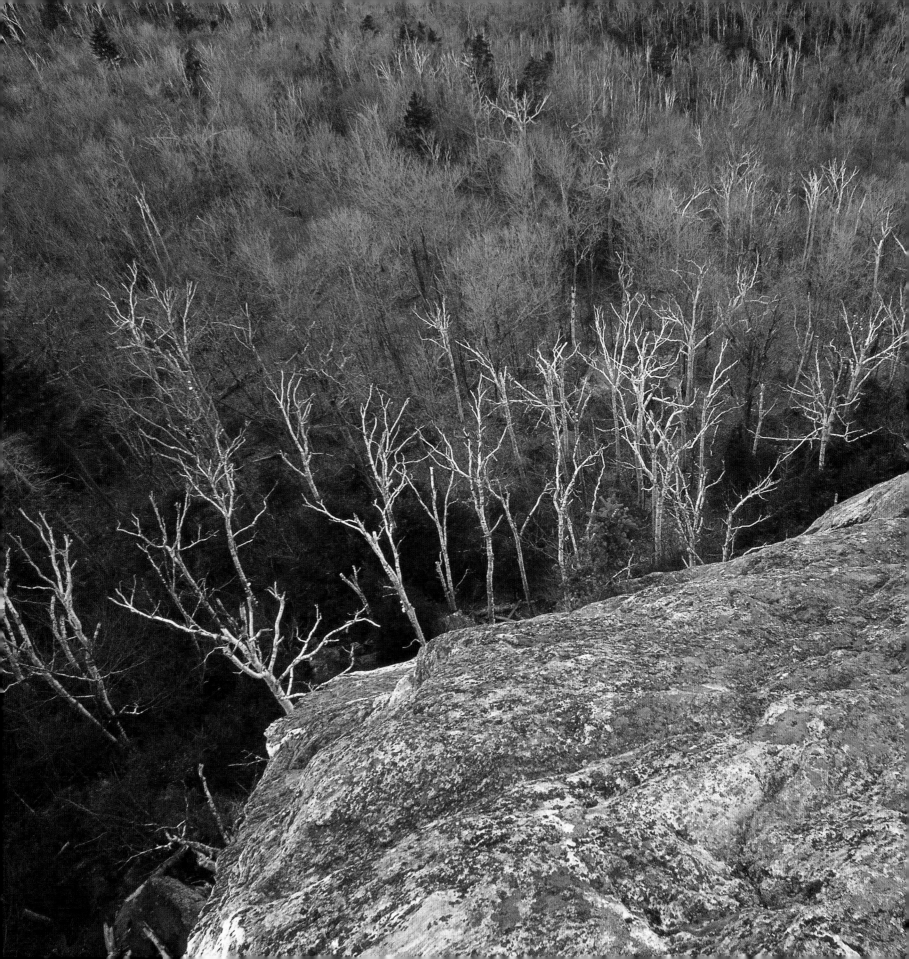

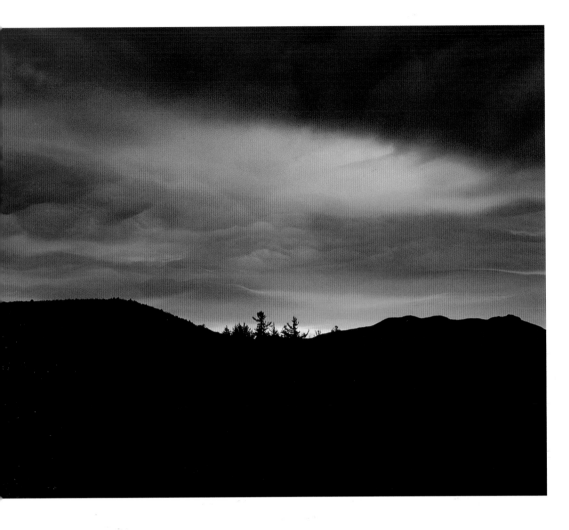

ABOVE: In the Swift River basin of White Mountain National Forest, an eerie sunrise in the earliest moments of dawn illuminates the swirls of ominous yet mesmerizing clouds brewing with the first storm of winter.

OPPOSITE: South of Gorham, the clear waters of Rattle River bubble down through the White Mountains. With awareness that clean water is critical, Congress in 1897 cited the protection of watersheds as one of the three main reasons for creating the forest reserves that later became our national forests.

Mountains. "In the evolution of righteousness," the minister asserted, "political economy precedes piety. The Law goes before the Gospel."[7]

Johnson and his supporters orchestrated a massive public uproar to force the state legislature to pay attention to the ineluctable connection between the people's plight and the despoiled environment. The movement's next step was to establish an organization devoted to the regeneration of the local economy and the restoration of the denuded White Mountains. Johnson was among those who organized the Society for the Protection of New Hampshire Forests (1901). Its

first president was the state's outgoing governor, Frank Rollins.

The final stage of the battle, a skeptical Johnson predicted, would involve a trade-off. "To get a bill through the state legislature to purchase these deforested areas for a public reservation" would only occur "at a price ten times as great as that originally paid for the lumber lots." But he and other conservationists believed that repairing the land, and the communities it once supported, was worth the inflated costs.[8]

Ultimately, the federal government would pick up the tab via the Weeks Act, which enabled "any state to cooperate with any other state or states, or with the United States for the protection of the watersheds of navigable streams." It remains one of the most significant pieces of environmental legislation in U.S. political history.[9]

The act, named for Representative John W. Weeks, who was born in New Hampshire but shepherded the legislation through Congress as a Massachusetts-based member of the United States House of Representatives, owed much of its popular support to another local boy made good, Philip W. Ayres. A Harvard-trained forester of the Society for the Protection of New Hampshire Forests, the indefatigable Ayres spoke throughout New England in support of the bill. He also forged links with southern and midwestern conservationists to advance the larger cause. After a 10-year campaign, the Weeks Act became law.

Fittingly, some of the earliest Weeks Act purchases occurred in the White Mountains. The resulting White Mountain National Forest (established May 1918) was not the first eastern national forest—that honor goes to North Carolina's Pisgah (1916). Together, these forests laid the foundation for subsequent purchases throughout the Appalachians. In the next decade, the federal government was able to buy lands

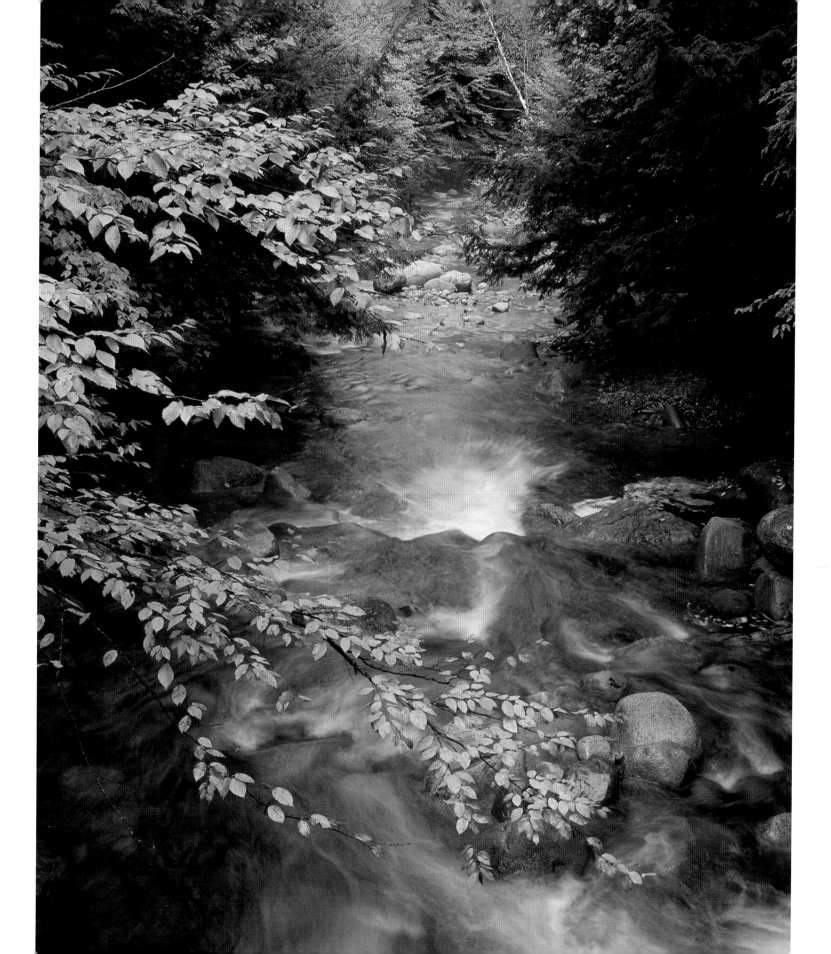

forming the Nantahala, Cherokee, George Washington, and Monongahela National Forests. In the mid-1930s, following a massive infusion of New Deal funding, additional sites came on line, including Vermont's Green Mountain National Forest. To date, the Weeks Act has added more than 22 million acres to the national forest system.

The act, by expanding the U.S. Forest Service's ability to protect watersheds, regenerate heavily logged forests, replant overgrazed prairie, and develop innumerable recreational opportunities, enabled the agency to operate in the east much as it had done in the west. Put another way, the Weeks Act made the national forests *national*; through it, conservation went continental.

This seminal piece of legislation also sanctioned cooperation between Washington and the states in the shared pursuit of environmental regulation. As a bonus, it helped rearrange political relationships within the union, strengthened intergovernmental relations, and engendered more uniform land-management regulation. Sherman Adams, a former governor of New Hampshire, said the Weeks Act succeeded because it "was a coalescence of the public interest in natural resource protection and management, the public concern over forest depletion, and the public appreciation for the unique array of goods and services which emanate from the forest."[10]

The Weeks Act also initiated the creation of a robust firefighting regime that began the process whereby state interests were integrated with the Forest Service's fire-management strategies. The Clarke-McNary Act of 1924 intensified this process, making "possible the extension of national standards of fire protection," histo-

rian Stephen Pyne has argued. With that, the Forest Service was "well on its way to dominating every aspect of wildland fire management." This dominance in time would lead to arguments over the value of excluding fire from diverse forested ecosystems.[11]

Linked to these developments was the post-war campaign to "get out the cut" that accelerated timber harvests in the White Mountain and other national forests. Sherman Adams was among those taking the federal agency to task. In 1986, during the 75th anniversary celebrations of the Weeks Act, he questioned the agency's embrace of clearcutting: "After decades of using locally-modified selective and selection cutting programs, the Forest Service had by 1962 incorporated in a wholesale, indiscriminate manner this aesthetically disruptive and, in forest conditions such as those prevalent in the White Mountains, scientifically questionable system." This "ill-advised national edict" was, Adams averred, a "disturbing threat to our New England tradition of consensus building." For a time, "public confidence in the Forest Service was seriously shaken."[12]

Yet the land's natural and human-aided regeneration continued despite the tense debates over its condition and management. Surely one mark of its successful revival is the unreflective quality of a 2010 advertisement urging tourists to visit leafy New Hampshire. By coming to this verdant and scenic state, it promised, visitors could "embrace the natural wonder of our land." This alluring claim would not have been possible without the Weeks Act, which made New Hampshire's White Mountain National Forest wild by law.[13]

Razor Brook nears its confluence with the Saco River. Brilliant red, orange, and yellow paper birches, red maples, and especially sugar maples make New England's flaming autumn foliage a showcase of woodland America. National forests constitute only six percent of the woodlands of the East, but they include many of the most popular recreational areas. Unlike most national forest lands of the West, which always belonged to the original federal estate and had escaped the otherwise ubiquitous claims of homesteaders, railroads, miners, or logging companies, White Mountain National Forest was assembled through the acquisition of 500 private parcels in the early 1900s.

Allegheny National Forest

Minister Creek riffles elegantly past black birches and hemlocks in Allegheny National Forest. With the proliferation of thousands of natural gas wells and now with extraction through the controversial method of fracking, this region and its streams are imperiled by water withdrawals and pollution from undisclosed chemicals used in the drilling process. Access roads and gas facilities now fragment vast acreage that had been improving on the long arc of recovery from a previous wave of timber and mineral exploitation. The incursions also come from private parcels interspersed with public tracts and from mineral rights that—even in the national forest—are often privately owned.

Pennsylvania's only national forest is a study in contrasts. Centered in the rural northwestern corner of the Keystone State, where it spans more than 500,000 acres of the rugged Allegheny Plateau, the forest is easily accessed from the nearby metropolitan centers of Buffalo, Cleveland, Cincinnati, and Pittsburgh. Expand the radius to a full day's drive, and half the nation's population is within striking distance of the Allegheny National Forest. Although it contains some old-growth forest, the Allegheny had been so heavily logged by the late 19th century that locals jokingly referred to it as the Allegheny Brush Patch. Living within it is a number of rare, threatened, or endangered species—among them the bald eagle, small whorled pogonia orchid, Indiana bat, and clubshell mussel. Yet the Allegheny also bristles with oil and gas wells. This heavy industrial presence is a reminder that the world's first oil strike occurred in nearby Titusville, a historical reference that has been updated as the forest and environs became one of the epicenters of the 21st-century boom in hydraulic fracturing (or fracking).[14]

The Allegheny's other major resource, water, is just as complicated. Juxtapose the Kinzua Dam, behind which backs up the 7,410-acre Allegheny Reservoir, with the fact that two of the East's premier Wild and Scenic Rivers, the Clarion and Allegheny, are located in the forest. Together, these two waterways offer nearly 140 miles of free-running flow. Even a data point seemingly as straightforward as the Allegheny's size is not entirely clear. The forest's official proclamation

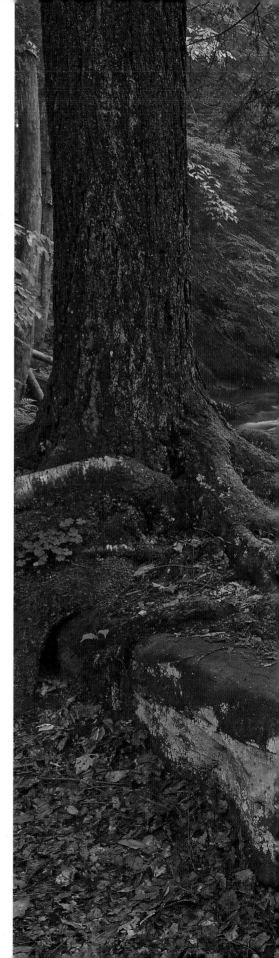

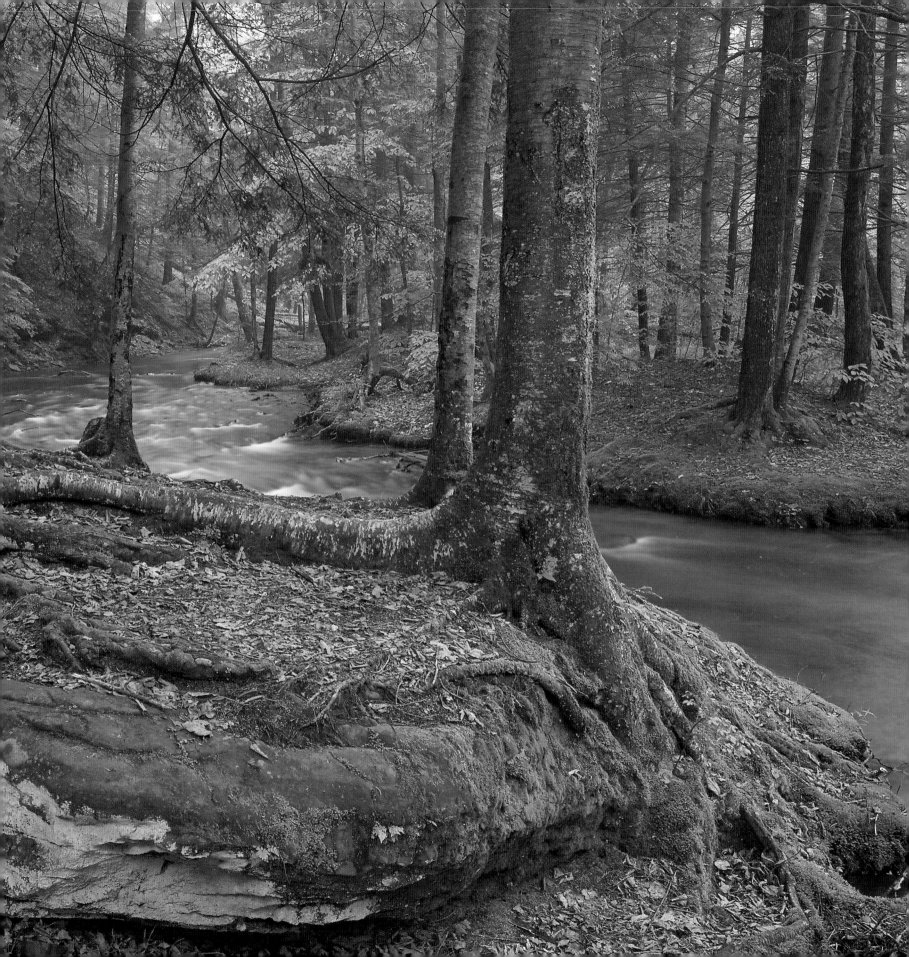

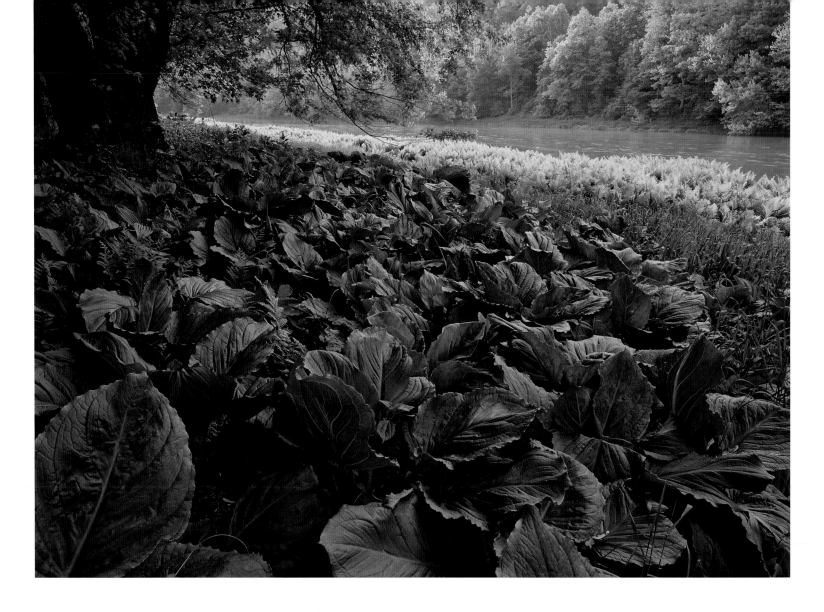

boundary, which President Calvin Coolidge designated in 1923, indicates that the forest encloses roughly 700,000 acres. But 200,000 of these are inholdings, private properties that remain surrounded by public land that is also contiguous with lands of the Seneca Nation and a set of state parks, a pattern of interleaved ownership consistent with other eastern forests. In the Allegheny, nothing is quite what it appears to be.

This is even true of the forest as a forest. Today the Allegheny is composed of black cherry, maple, ash, and oak, a thriving hardwood ecosystem that supports local milling of such products as furniture, paneling, and veneer. In the mid-19th century, however, these species made up a minority of trees growing on this rolling terrain. Then, the forest supported impressive stands of chestnut, hemlock, sugar maple, and beech; their thick canopy shaded out competitors and nurtured a dense understory sustaining a rich layering of biodiversity. Although punctured by natural disturbances such as windthrows, and opened up in places by indigenous peoples' use of fire, this original forest remained intact until the Industrial Revolution's voracious appetite for natural resources led to its rapid exploitation.

Tanners stripped off hemlock bark because its tannin was critical to leather-curing processes, demand for which spiked during the Civil War. These despoiled trees were then harvested by loggers. Then, in the postwar era, lumber companies built railroads across the plateau and through its narrow valleys to harvest millions of board feet (a unit of quantity for lumber equal to the volume of a board) destined to shore up mines, fuel factories, and construct cities. Wildcatters scoured the region seeking petroleum deposits, and in 1859 they struck black gold. For the next 20 years, production skyrocketed, from 2,000 barrels in 1859 to 10 million in 1873. This boom also sparked a parallel surge in population and a spike in demand for lumber, iron, and other resources found within the plateau's stiff folds. By the early 20th century, this economic juggernaut largely had run its course, leaving behind a shredded landscape.

Taking full advantage of that stump-filled devastation were black cherry and other shade-intolerant tree species. So opportunistic has the cherry been that it now dominates, creating a new forest subtype aptly known as Allegheny Hardwood. But that regenerative process had only just begun in the mid-1920s when the Forest Service, with appropriations available from the Weeks Act, began to purchase land to form the national forest. As its acreage grew over time, so did the reach of the agency's regulatory authority and the impact of its conservation stewardship. From this emerged a number of ecological benefits. Water quality of the Allegheny River watershed improved markedly, an outcome central to the national forest's initial establishment. Wildlife recolonized the once-denuded landscape, and the reviled brush patch grew into a resilient forest—a fully functioning ecosystem, however different the forest's composition might be. That the Allegheny contains two desig-nated wildernesses, with proposals to expand this important protection to other sites, is a testament to the forest's dynamic regeneration.

Still, threats abound. Deer, reintroduced after being hunted out in the early 20th century, have proliferated. Their browsing has devastated the understory and the capacity of hemlock and beech to regenerate. Where the hemlock, which is the state tree, remains—such as in the Heart's Content Scenic Area—some of the trees are thought to be 500 years old. But they may not live another century. The species is under attack from the hemlock woolly adelgid, a voracious aphid-like insect that feeds on sap. Controlling these varied biological challenges has not been easy.[15]

Just as difficult is managing the explosive growth of energy production in the Allegheny. This is made even more complicated because the subsurface mineral rights are privately owned. The Forest Service is thus obligated to work with the individuals and corporations who control more than 90 percent of these rights within the forest, in hopes of moderating drilling's impact on forest health and on air and water quality. These environmental challenges are intensifying. In 2007, there were 8,000 conventional well sites in operation, which, when combined with related pipelines, roads, and electric lines, consumed 50,000 acres (equal to one-tenth of the forest's extent). Two years later, with the deployment of hydraulic fracturing technology, the number of wells jumped to an estimated 11,000, with more expected in the race to tap oil and gas reserves in the Marcellus Shale Formation that underlies the Allegheny.[16]

How the balance between the needs of critical forest ecosystems and economic development is struck will determine the nature of the Allegheny's contribution to the state and nation during its second century.

Skunk cabbage and bracken ferns ripen in the fruitful days of summer on the Allegheny River's floodplain. This scene and others along the river are protected within a unique complex of islands designated as wilderness in Allegheny National Forest.

Superior National Forest

Ann Vileisis plies glassy waters of the South Kawishiwi River in her kayak at sunset. Superior National Forest is the destination of 200,000 canoeists per year on pilgrimages to America's premier lake-paddling location. The irreplaceable values of this region were recognized by Forest Service landscape architect Arthur Carhart. In 1926, he led his agency to abandon plans to build roads to hundreds of lakes and then line them with private cottages. The vast lacustrine region was further protected as the Boundary Waters Canoe Area in 1964.

Its name almost seems redundant, an unnecessary brag, and yet what else could it be called? Abutting the rocky coast of the eponymous (and vast) lake, at 3.9 million acres the Superior is the largest eastern national forest and contains the greatest acreage of the boreal ecological community in the region. Scoured down to ancient bedrock during the most recent ice ages, it is home to 2,000 lakes and countless rivers and streams, embracing an estimated 445,000 acres of water. Many of these riparian systems make up the interconnected waterways flowing through the Boundary Waters Canoe Area. This designated wilderness sprawls over one million acres, and doubles in size when you add in the adjoining Quetico Provincial Park in northwestern Ontario. As big as the place are its insects. Minnesotans joke that the state bird is the black fly (with apologies to the official holder of that title, the common loon, which inhabits the Superior in considerable number). Black flies have the run of the forest during warm summer months.[17]

Their stinging presence notwithstanding, the Superior attracts more than a million visitors every year and does so in good measure because Arthur Carhart thought they should. Trained as a landscape architect, Carhart became the first recreational planner for the Forest Service, joining the agency in 1919. He made his mark immediately. Assigned to develop a plan for roads into and cabins surrounding Trappers Lake in Colorado's White River National Forest, he devised instead the first articulation of wilderness recreation, advising his supervisor that the best and highest use of the lake and its environs was, surprisingly, no use at all.

His advice was accepted, news of which reached another wilderness advocate, Aldo Leopold, then assistant regional forester in region three (New Mexico/Arizona). He, too, had been pondering how to protect wildlands, and arranged to meet Carhart in Colorado in December 1919. Afterward, Carhart drafted a memorandum capturing the essence of their discussions that described how imperiled these lands were and how democratic their preservation would be. "There is a limit to the number of lakes in existence; there is a limit to the mountainous areas of the world," he affirmed, and "there are portions of natural scenic beauty which are God-made." Such divine terrain, uncluttered and primitive, "of a right should be the property of all people."[18]

Carhart felt just as strongly in 1921 while on assignment to the Superior National Forest. As he toured its wet, green expanse, it became obvious what the forest should support and what it should not. "There is one outstanding feature found in the Superior National Forest which is not present in any other nationally owned property," he noted. "This is a lake type of recreation. The Superior is unquestionably one of the few great canoe countries of the world." That being so, it "would be illogical . . . to make the Superior a foot, horseback, airplane or auto playground for this would mean non-utilization of existing natural advantages."[19]

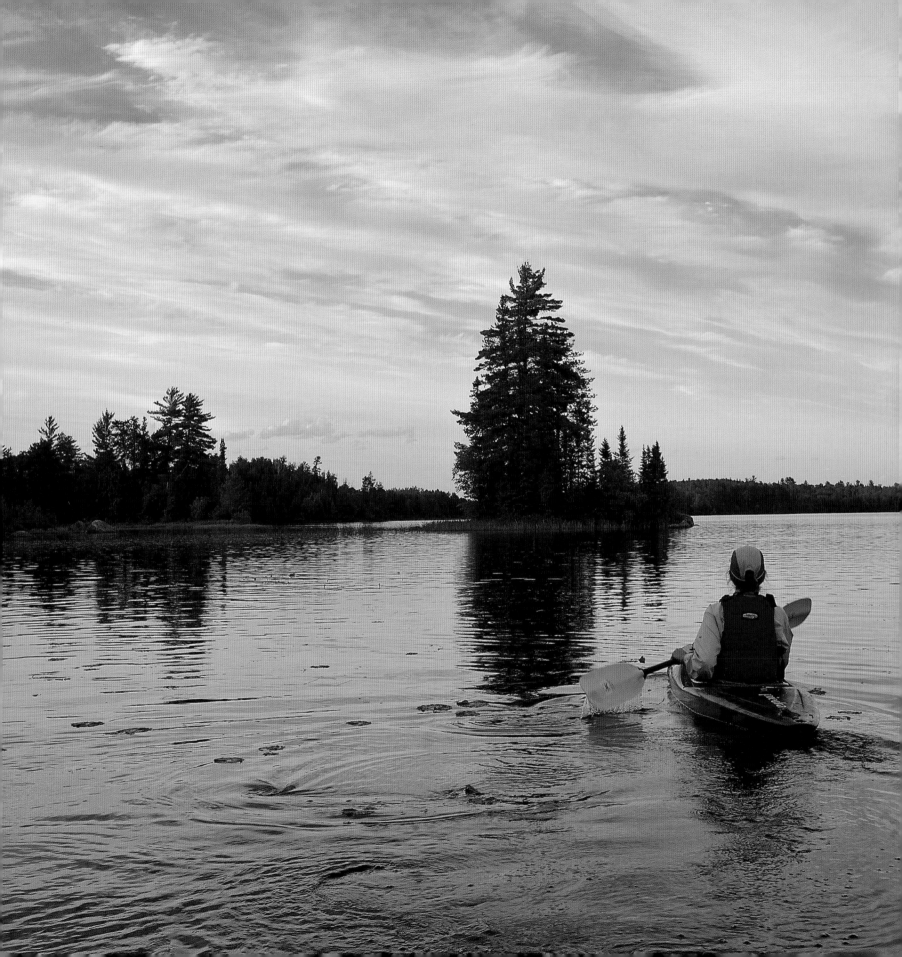

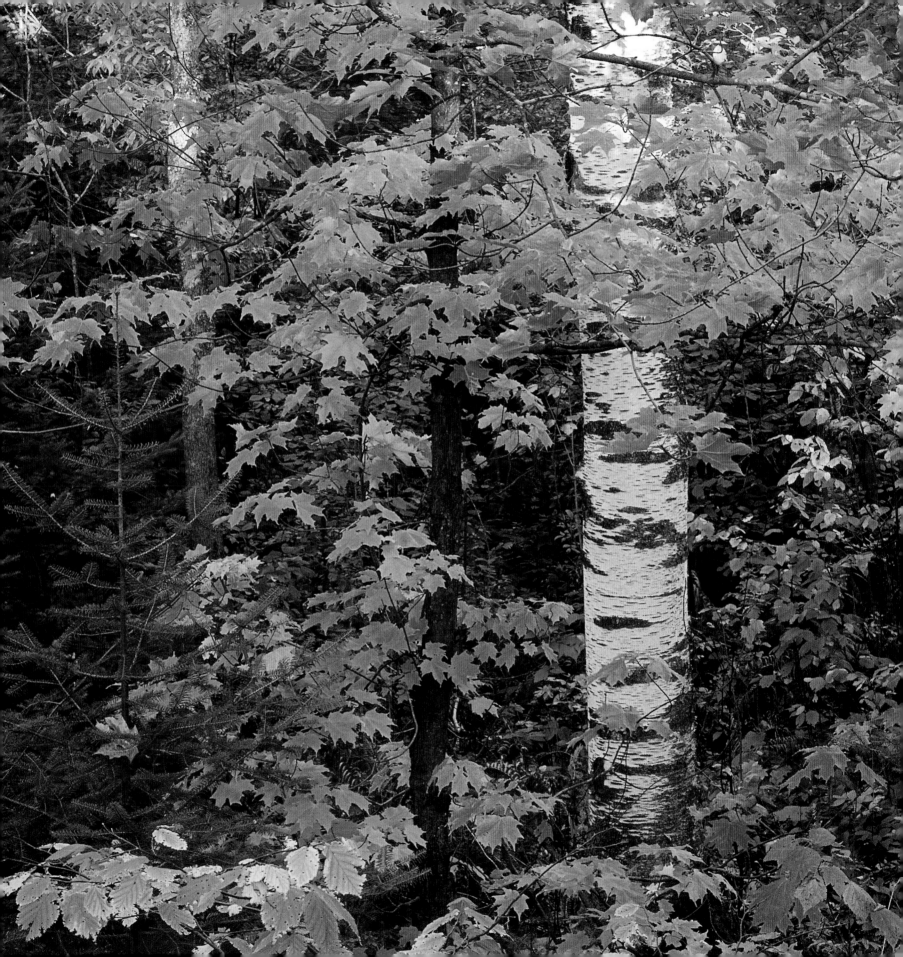

Carhart, however, was ahead of his time, or at least ahead of the Congress of his day. Despite the abundant recreational opportunities that the Superior offered, this "National playground of National service" would go unfunded because "Congress [had] not made any appropriation for recreation in the National Forests." That lack of allocations would be resolved in the coming years, and the multiple-day-long and lengthy canoeing trips that Carhart anticipated were realized.

By then, he had left the agency to launch a landscape-design practice, yet his report is rightly credited with laying the foundation for all subsequent recreational planning in the forest. In 1926, for example, Agriculture Secretary William Jardine signed off on the Superior Roadless Area (the forerunner of the Boundary Waters Canoe Area). Its singular purpose was to "conserve the value of the Superior National Forest as a game and fish country and as a national playground offering a virile and wholesome form of recreation off the beaten paths." This new and all-encompassing designation ensured that "not less than one thousand square miles containing the best of the lakes and waterways will be kept as wilderness recreation areas." Additional legislation over the years would beat back efforts to erect hydroelectric dams in the forest and promote linkages between the Superior and the Quetico. The Boundary Waters Canoe Area is also the only wilderness with a provision prohibiting airplanes and helicopters flying below 4,000 feet. As a result, this national forest has maintained its wildness, allowing it to become what Carhart believed it could be, a "magnificent play area."[20]

Another who shared Carhart's sensibility and who wrote movingly of the Superior's natural virtues was Sigurd Olson. Years of canoeing its limitless reaches led him to pick up his pen to convey to those who had never paddled its cold waters what makes the experience so beguiling. "The movement of a canoe is like a reed in the wind. Silence is part of it, and the sounds of lapping water, bird songs, and wind in the trees," he wrote in a 1956 essay. "It is part of the medium through which it floats, the sky, the water, the shores." Maintaining this silence, and the solitude it promotes, required a fierce defense, which Olson mounted by blocking the noisy intrusion of aircraft over the glittering lakes, shutting off the angry buzz of chainsaws in the deep woods, and protecting the habitat of loon and lynx. The question for Olson was how Americans wanted to experience nature and under what conditions. Must the beloved North Country become just another Main Street?

In the face of our burgeoning population and industrial expansion we can draw courage from the knowledge that in the saving of places of natural beauty and wildness we are waging a battle for man's spirit. No task is more important, for the wilderness we save today will provide moral and spiritual strength and balance in a world of technology and frenzied speed.[21]

Olson's convictions have spawned generations of activists, especially throughout his home country of the upper Midwest. They have propelled as well small bands of hardy souls to canoe as far along the narrowing waterways and swamps as possible, portaging over downed trees, shouldering 60-pound packs, and then bedding down exhausted but happy in dense wilderness—a tangible, sweat-stained connection between idea and action that has also made the Superior *superior*.[22]

In the Temperance River basin west of Lake Superior, a reddening sugar maple, yellow birches, spruces in deep green, and paper birches with their fine articulation brighten the north-woods scene. Autumn colors are a highlight of all eastern national forests; October's brilliance here in Minnesota rivals that of New England.

Monongahela National Forest

Morning fog settles in a temperate hollow beneath the Forest Service's historic fire tower on Bickle Knob east of Elkins, West Virginia, along the backbone of America's oldest and longest mountain range—the Appalachians. While coal mining dominates the state's landscape farther west, including devastation from mountaintop removal large enough to see from space, the Monongahela National Forest occupies verdant waves of ridges and valleys on the eastern side of the state. Established in 1920, when it was entirely cut over and plagued by floods and erosion, this forest continues on a remarkable path to recovery.

How does a forest of unsurpassed beauty also become the source of political debate and policy change? In the case of the Monongahela, its very beauty is the key.

The Monongahela National Forest is one of the most strikingly diverse and breathtakingly beautiful terrains in the eastern United States. The Nature Conservancy has declared the 919,000-acre forest, with its steep ridges and narrow valleys, to be of global ecological import. You will understand why when you start counting the number of species it harbors—225 different bird populations call the "Mon" home, 75 varieties of trees root into the soil, and more than 70 different species of fish swim in its creeks, rivulets, and streams. It is no wonder that more than 1.3 million people annually flock to this rugged country to camp, hike, fish, and hunt.

It was a clutch of turkey hunters, in fact, who sparked one of the important discussions about the management of this national forest. The banner headline on the front page of West Virginia's *Elkins Inter-Mountain* for November 8, 1973, captured the initial outcome of the lawsuit they filed challenging logging in the Monongahela: "Maxwell Says Clearcutting Forbidden in National Forest by Organic Act." Months before, Federal Judge Robert Maxwell had heard arguments in *West Virginia Div. of the Izaak Walton League v. Butz*. The plaintiffs alleged that the Forest Service had violated provisions of the 1897 Organic Act by clearcutting large swaths of the Monongahela National Forest. That late 19th-century act had granted the president the right to

establish national forests and had identified the objectives by which they would be managed—"to improve and protect the forest within the boundaries, or for the purpose of securing favorable conditions of waterflows, and to furnish a continuous supply of timber for the use and necessities of citizens of the United States." More crucially in this case, it also stipulated that only "dead, physically mature and large growth trees individually marked for cutting" could be harvested. Judge Maxwell concluded that the agency's clearcutting practices violated these provisions of the Organic Act, a decision that the Fourth Circuit Court of Appeals upheld two years later.

The Monongahela Controversy, as it came to be known, was linked to an array of legal challenges to the Forest Service's postwar get-out-the-cut campaign, a pattern of accelerated harvesting designed to bring large quantities of wood to market in response to the nation's construction boom. Scientific research indicated that even-aged management of forests (that is, clearcutting) would produce a better quality and higher volume of timber. Accordingly, the agency conducted large-acreage sales on its forests east and west, north and south. Wielding more powerful chainsaws and firing up military surplus bulldozers to build roads deep into the backcountry, loggers in the Monongahela and elsewhere removed billons of board feet (BBF) every year. In 1940, they cut approximately 2 BBF, in 1960 the total was 9.3 BBF, and by the mid-1980s the amount had reached 12.7 BBF. Even one of its staunchest proponents agreed that clearcutting

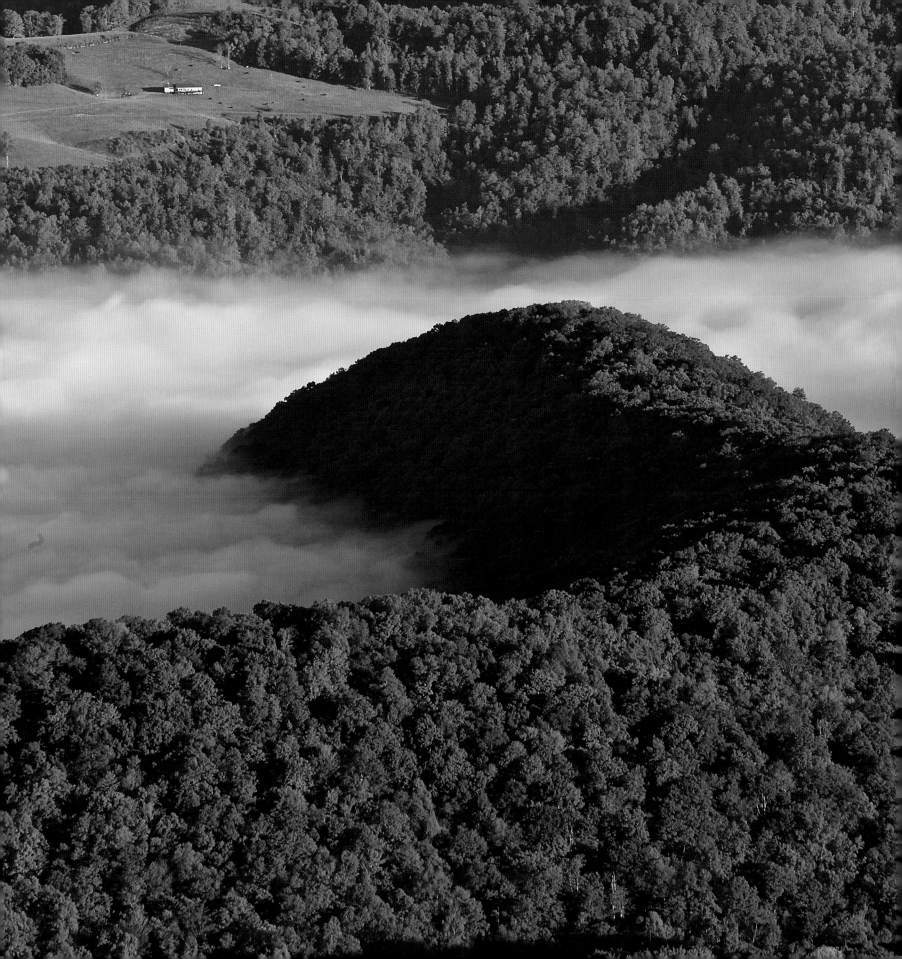

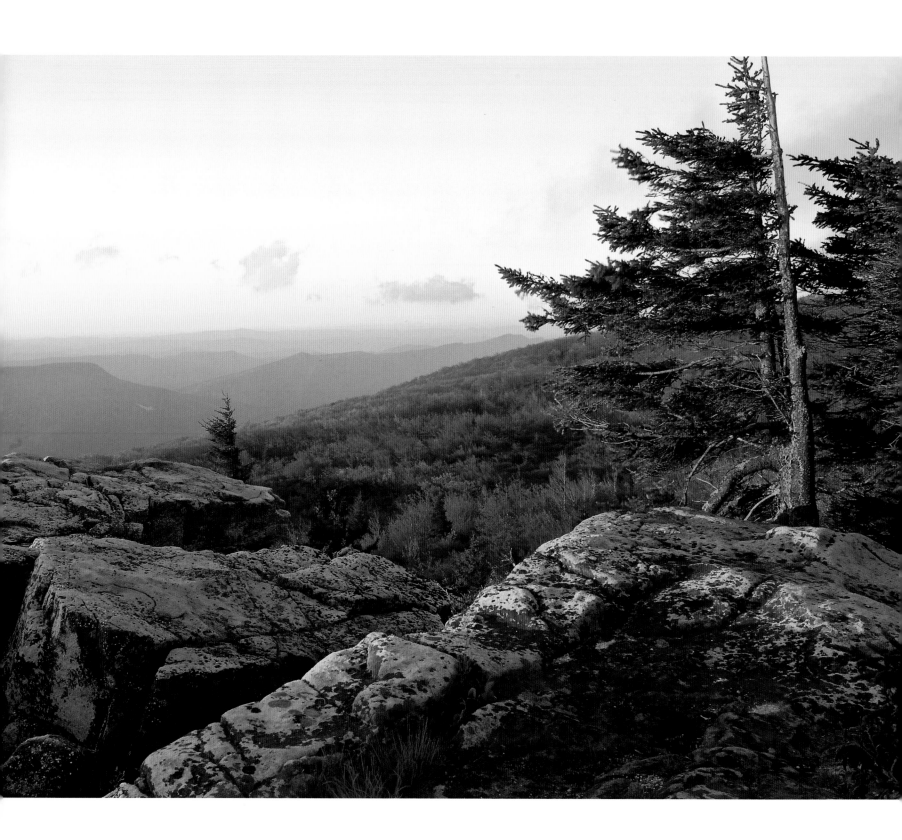

could leave behind "an aura of total devastation, an appearance of total ruin."[23]

Among the first to blow the whistle were hunters in West Virginia. Their protests were not aimed at the aesthetic consequences of clear-cutting, but at the way the splintered forests disrupted their traditional hunting grounds on the Monongahela. To them, the Forest Service had effectively handed over this communal, multiuse resource to single-use timber companies. They were worried that the agency, which had done so much to restore what in the early 20th century had been a badly burned up and cut-over landscape on the Allegheny Front Range, was damaging these now-healthy, resilient forests. The hunters lobbied the West Virginia legislature to secure redress, and during the 1960s state representatives responded with a series of hearings and resolutions. The agency initially ignored these proceedings. Chief Edward Cliff dismissed the pleadings of a visiting delegation of West Virginia hunters, conservationists, and politicians, later declaring them "a very self-centered protest from a very small segment of the population who wanted the national forest to be managed just for their own personal pleasure."[24]

Rebuffed, the West Virginians sued in federal court through a local branch of the Izaak Walton League, a national conservation organization, a suit that gained considerable support throughout the state. Joining the fray were the recently formed National Resources Defense Council and the Sierra Club. Judge Maxwell's decision in support of their legal challenge, and the appeals court's sustaining of it, caught the Forest Service off guard. It was the first time that its expertise had been adjudicated and found wanting.

Although the appeals court's decision applied only to the Fourth Circuit, its decision effectively, if temporarily, shut down the agency's timber-sales program nationwide. Aware that the Organic Act might be outdated, this court advised that "the appropriate forum to resolve this complex and controversial issue was not the courts, but Congress." With that, the battle that had erupted in the Monongahela shifted to Capitol Hill, and two legislative initiatives were the result: the Resources Planning Act (1975) and the National Forest Management Act (1976). These legislative fixes required every national forest to produce a management plan accompanied by an Environmental Impact Statement (EIS) taking into account ecological, hydrological, and social values. Additionally, the public must have the right to vet these documents. For the Forest Service, which hitherto had determined how the national forests would be managed, these new laws signaled the beginning of a more collaborative, open, debate-filled, and transparent process.[25]

The controversies did not stop, however. Instead, individual plans have been challenged in public venues and federal courts. These long-running battles are one of the costs of a more democratic process. From a certain perspective, this process has also created a sense of gridlock, leading some to argue that such debates are antithetical to sound management, locally and system-wide. But the Monongahela and other national forests are public lands and require public scrutiny to ensure that their management adheres to what the citizenry values. The Forest Service has accepted that this complicated process can be messy and incomplete, and has acknowledged that top-down management of the forests is as outdated as the 1897 Organic Act. As a result, the agency has undergone a vital transformation since that day in the early 1960s when turkey hunters headed up into the Monongahela National Forest and came down ready to fight for the land and their rights in it.

Dolly Sods Wilderness is a geographic and botanical anomaly with expansive meadows, sphagnum bogs, and red-spruce thickets more typical of New England or Canada than the central Appalachians. The 1975 designation of wilderness halted plans for massive strip mines to extract deep seams of coal. Here at Bear Rocks, the morning temperature was only 12 degrees in early May.

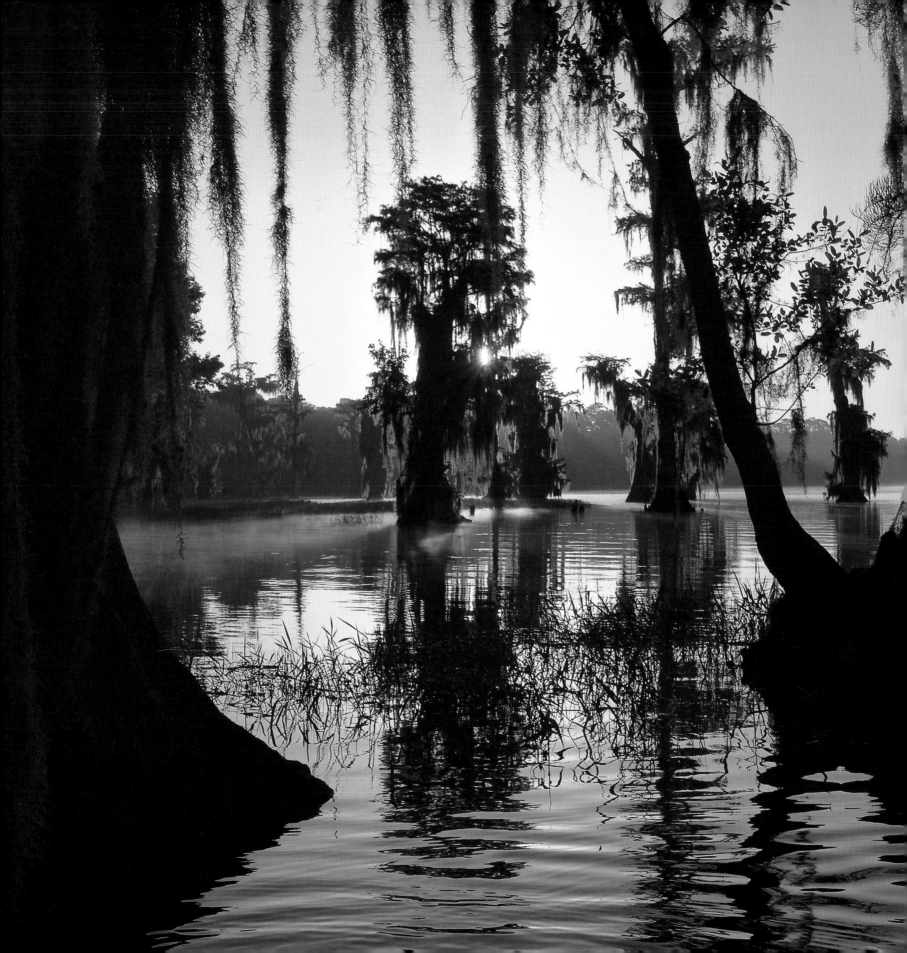

THE SOUTH

13 STATES AND PUERTO RICO

14 NATIONAL FORESTS

1 NATIONAL GRASSLAND

13.3 MILLION ACRES

28.4 MILLION VISITORS

Spanning two-thirds of the nation's width from the Atlantic Ocean to Texas and also stretching from the highest mountain east of the Mississippi to the darkest southern swamps and even to Puerto Rico—1,000 miles seaward from Miami—the national forests of the South nourish an astonishing abundance and diversity of life. This includes our greatest number of tree and plant species, more kinds of freshwater mussels than anywhere else in the world, and freshwater fish that rival those of tropical reefs in their colors and variety. The forests of the southern Appalachians boast many of the largest specimens of tree species, including the champion red oak and tulip poplar. On the coastal plain, the charismatic bald cypress, with its buttressed base as an anchor of stability, thrives as the keystone species of blackwater swamps.

Here also are our most fragmented national forests; as an artifact of their creation from depleted and foreclosed lands early in the 20th century, these cut-over tracts are intermingled with private land where use and management is often incompatible with goals of long-term sustainability and restoration. Longleaf pines, for example, once blanketed much of the Deep South but have been reduced to pockets of woodland curiosity where foresters and ecologists are trying to bring the towering conifers back. But that's difficult owing to the prerequisite of frequent fire that was once ubiquitous but is now suppressed for the neighboring investments in homes, businesses, and farms.

Photographing these forests was challenging due to their swampy inaccessibility, their droves of mosquitoes and lurking cottonmouths, and their flatness that prevails across the Atlantic and Gulf Coastal Plains and prevents you from seeing very far. Yet each day was rewarding in the abundance of life, fecundity of a southern climate, and lushness of springtime in a fruitful land.

—TIM PALMER

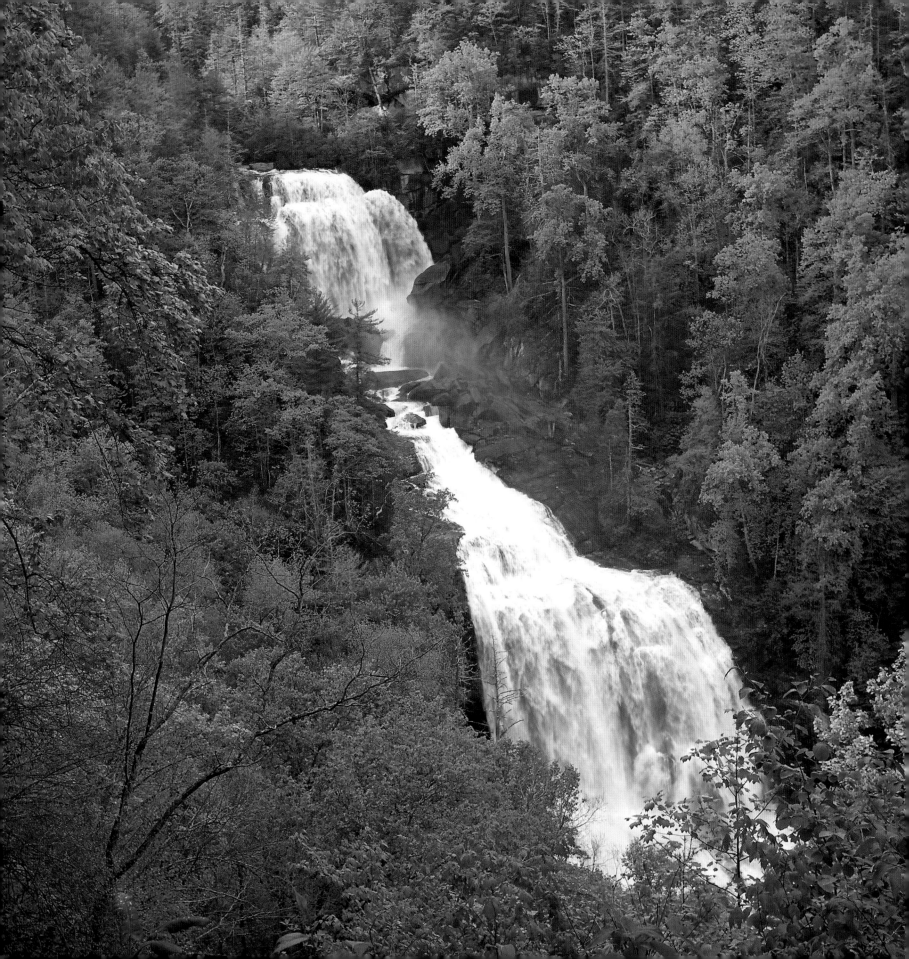

L ate one winter afternoon in 1927, a "strangely mellow light" played across George Washington Carver's desk. "I looked up and out of the window toward the setting sun which was just disappearing behind the horizon leaving a halo of a never to be forgotten glory and beauty behind it," he wrote a friend. "The variety, brilliancy of color and arrangement was

awe inspiring." This ecstatic moment stood in stark contrast to the condition of the land that lay outside his window and across much of the South. As Carver, one of the nation's foremost proponents of scientific agriculture, knew full well, intensive cotton farming and the rapid liquidation of the region's forests had, by the 1920s, laid waste to soil, water, and habitat. The environment surrounding the Tuskegee Institute, Carver's academic home base, was among the most battered. Its subsequent recovery speaks to some of the reasons how and why the land became more verdant, more resilient.[1]

Reforms that Carver promoted to his students—new seeds, less dependence on a single cash crop, and contour plowing—were important to maintaining arable land on the small-scale farms many of them hoped to own. But these management techniques would do little to counteract the deleterious impact of industrialized and large-scale agriculture and logging. This devastation became even more pronounced with the Great Depression. The loss of invaluable topsoil, erosion that deeply gullied the terrain, and increased damage from floods spurred a historic out-migration of poor blacks and whites from rural areas to metropolitan centers. Shortly after his inauguration in 1933, President Franklin Roosevelt and his congressional allies launched a series of farm-relief measures that included funds to purchase abandoned property and resettle its inhabitants.

The Bankhead-Jones Farm Tenant Act of 1937 was one of these initiatives. Its funding, combined with money available from the 1911 Weeks Act, which authorized the government to buy land to restore eastern watersheds, helped purchase acreage across the South. This led to the formation of a bevy of new national forests, from the Carolinas and Florida west to Texas and Oklahoma. One of these was Tuskegee National Forest, located only a few miles from Carver's campus office. Known originally as the Tuskegee Land Utilization Project, 80 percent of its original 10,358 acres had been cut over when the government bought the land between 1935 and 1937. "The absence of trees on the hillsides is a constant reminder of the exploitation of the forest resources of the purchase area," noted a Resettlement Administration report. "Creeks where fish abounded twenty years

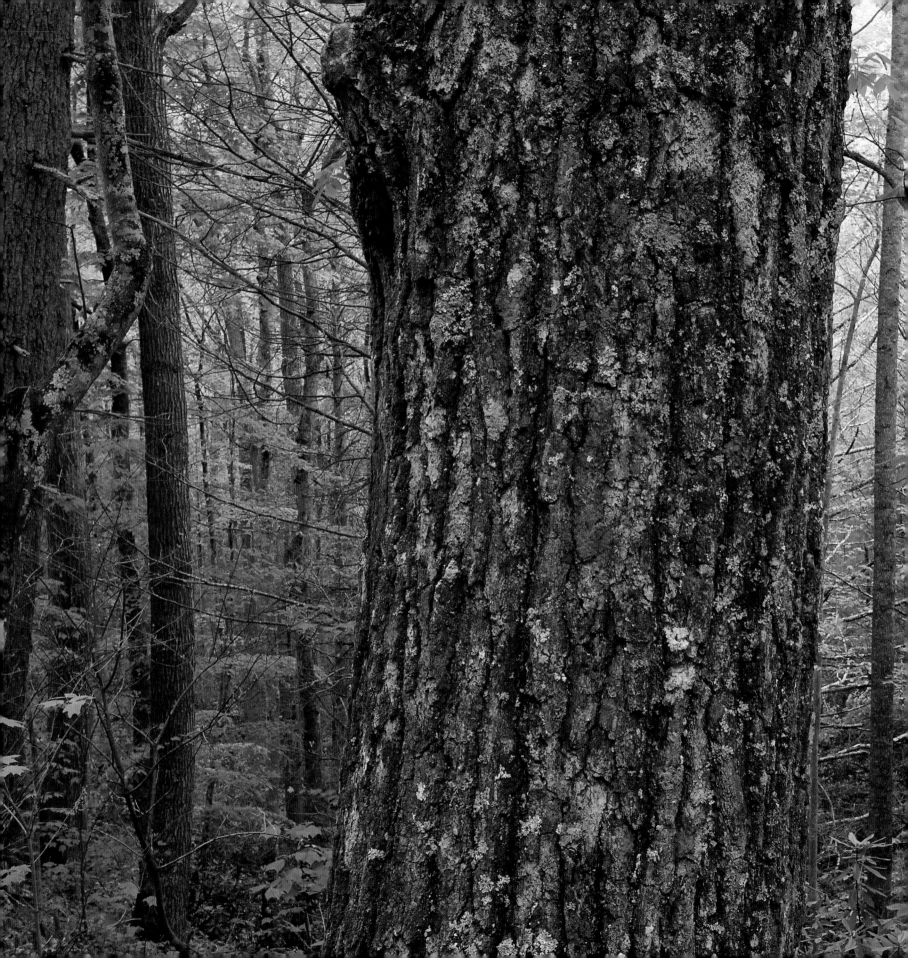

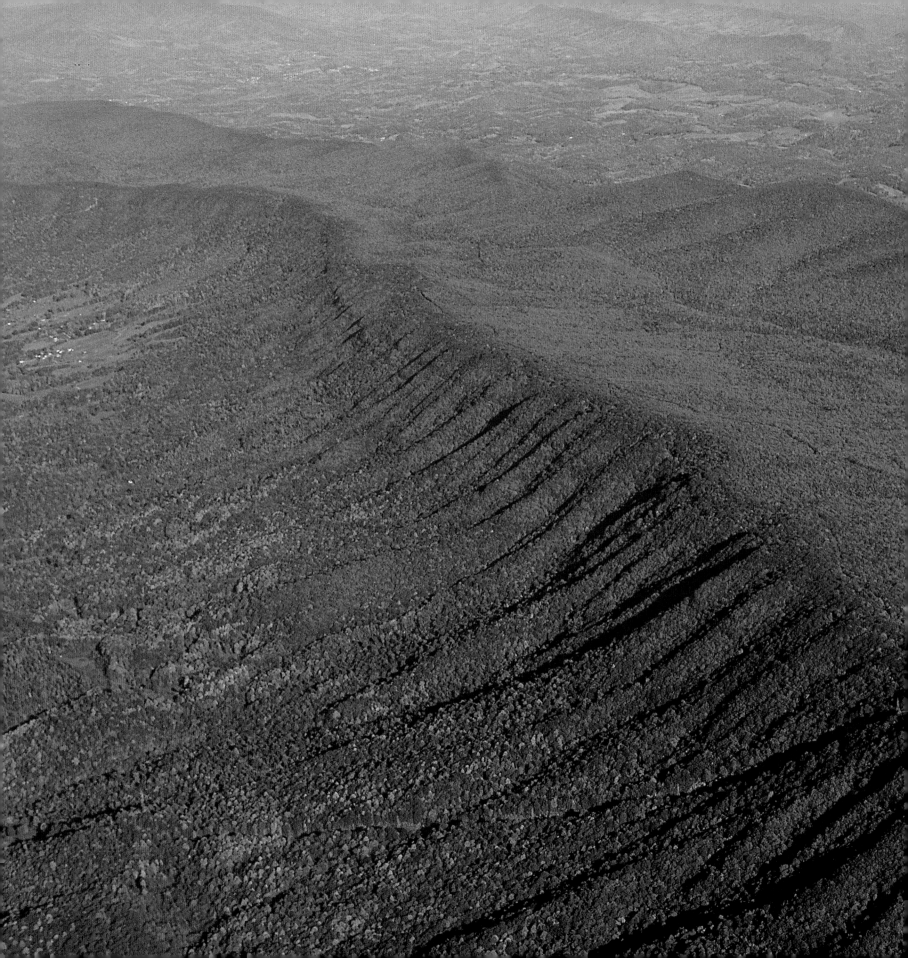

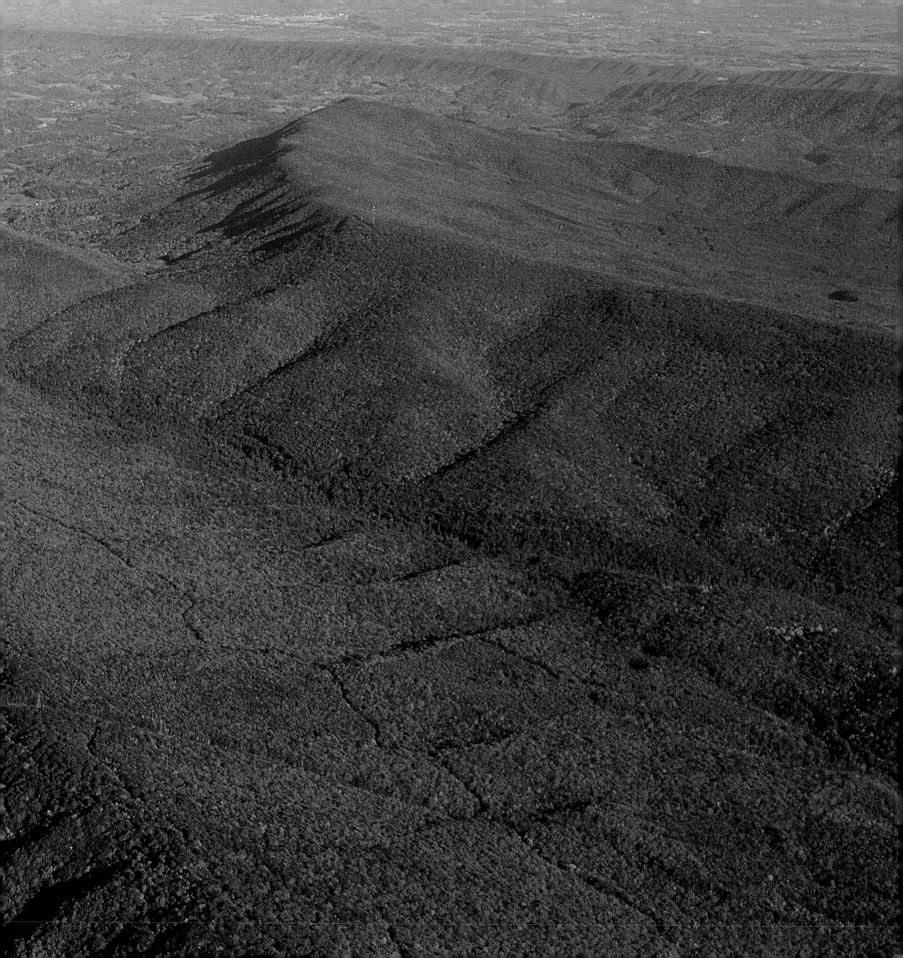

ago are virtually sand beds or mud holes." The people were as distressed as the environment: "The homes and the land on which they live are rapidly decaying—poverty is common in the area." With the Tuskegee Institute serving as the project's administrative agency, a large work crew of unemployed men by March 1936 had planted an estimated 350,000 longleaf, loblolly, and slash pine, and had built roads and trails for transportation and recreation.[2]

Although originally managed by the Soil Conservation Service, and then transferred to the Forest Service in 1959, Tuskegee's experience was similar to that occurring in Alabama's new

national forests. They included the Bankhead National Forest (named for the Alabama senator whose legislation generated the funding for these lands' purchase), as well as the Sam Houston in Texas, Louisiana's Kisatchie, and the Ocala in Florida. It would take decades to regenerate these worn-out landscapes, but the region's 13.3 million acres have regained much of their biological integrity and offer unbounded recreational opportunities to millions of visitors each year. That so many play within these reclaimed lands reinforces another of Carver's insights: a healthy environment is a precondition for, and synonymous with, a free and resilient people.[3]

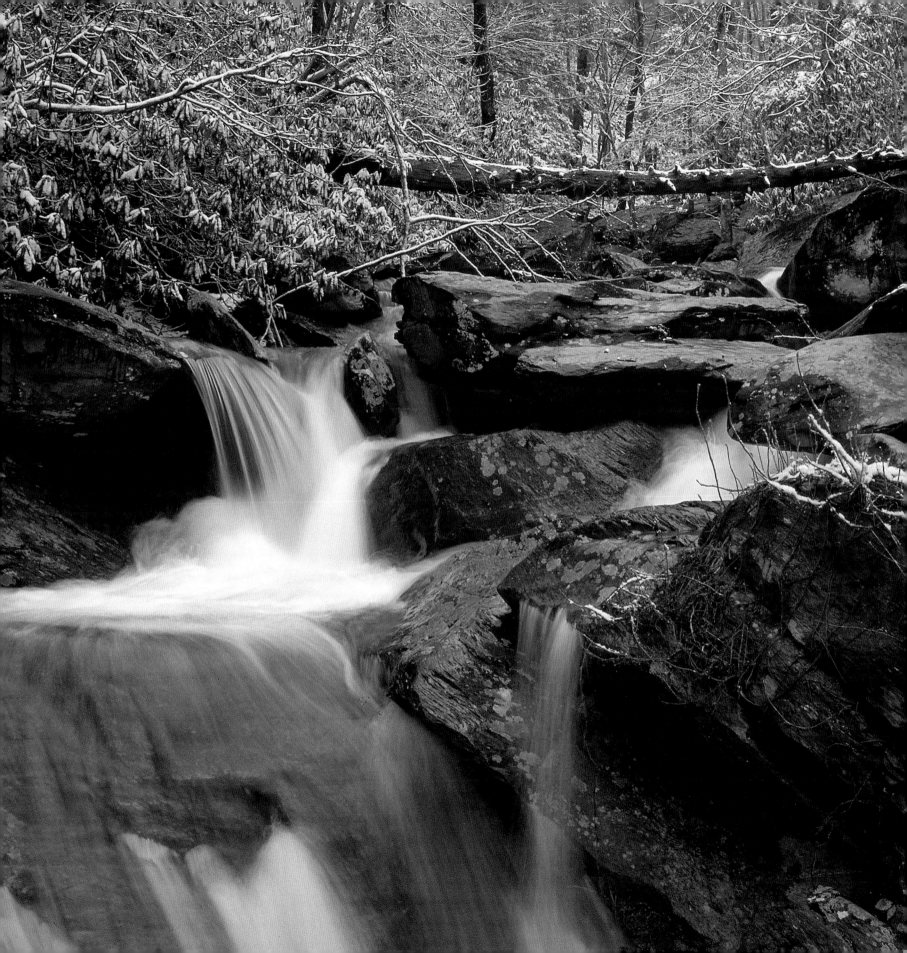

OPPOSITE: Whittleton Arch in Daniel Boone National Forest, Kentucky, is one among dozens of arches in Red River Gorge, designated as a national geological area. Lower reaches of this terrain, replete with rare plants, were threatened in 1975 by a dam proposal that was later defeated by citizens motivated to protect their unique valley.

FOLLOWING SPREAD, LEFT: Just north of the resort burg of Highlands, North Carolina, Whiteside Mountain rises to 4,930 feet in Nantahala National Forest. The mountain was taken from the Cherokee Nation, given away as a land grant, exploited as a private estate, developed as a tourist attraction, logged again in 1947, and only in the 1970s acquired by the Forest Service for public protection and use.

FOLLOWING SPREAD, RIGHT: Rhododendrons line the banks of a Chattooga River tributary upstream from Highway 76 in Chattahoochee-Oconee National Forest in Georgia.

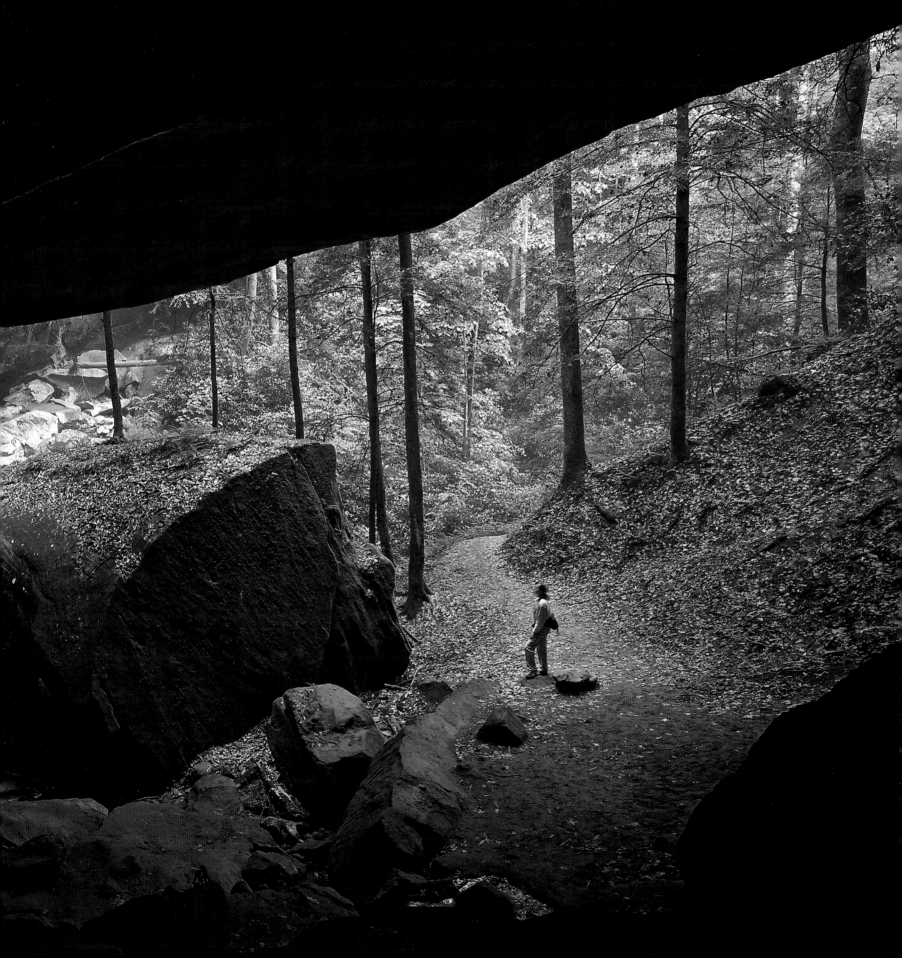

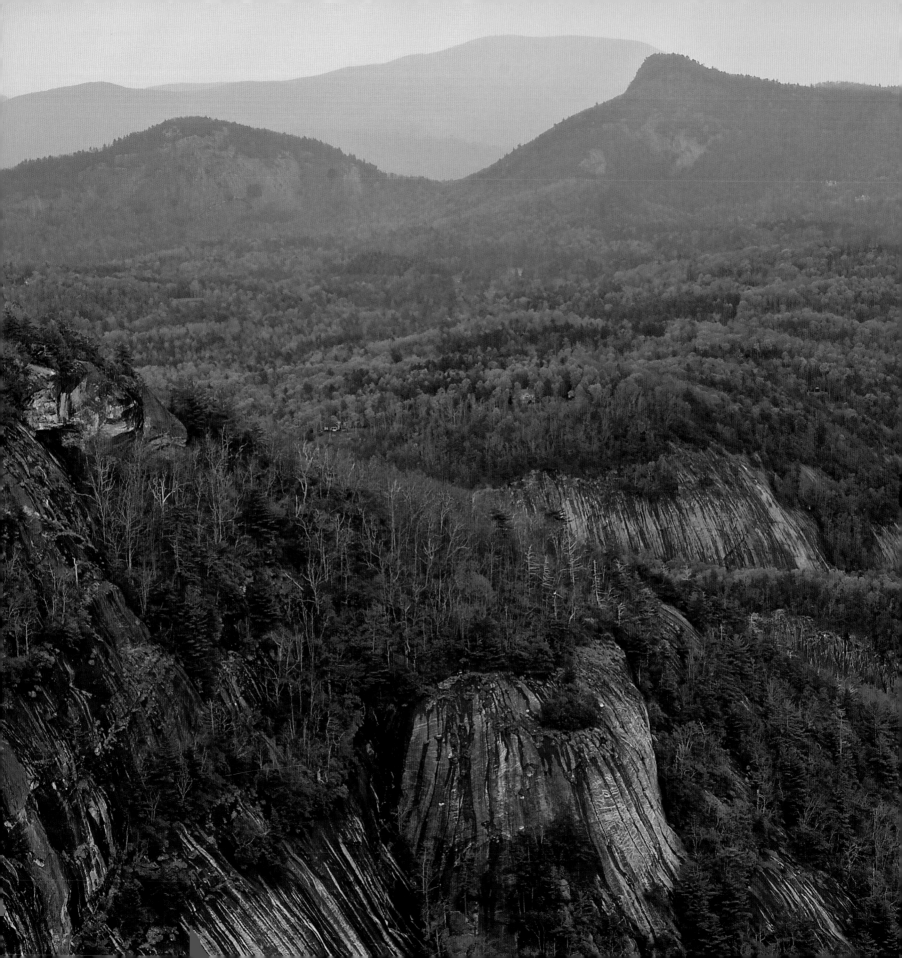

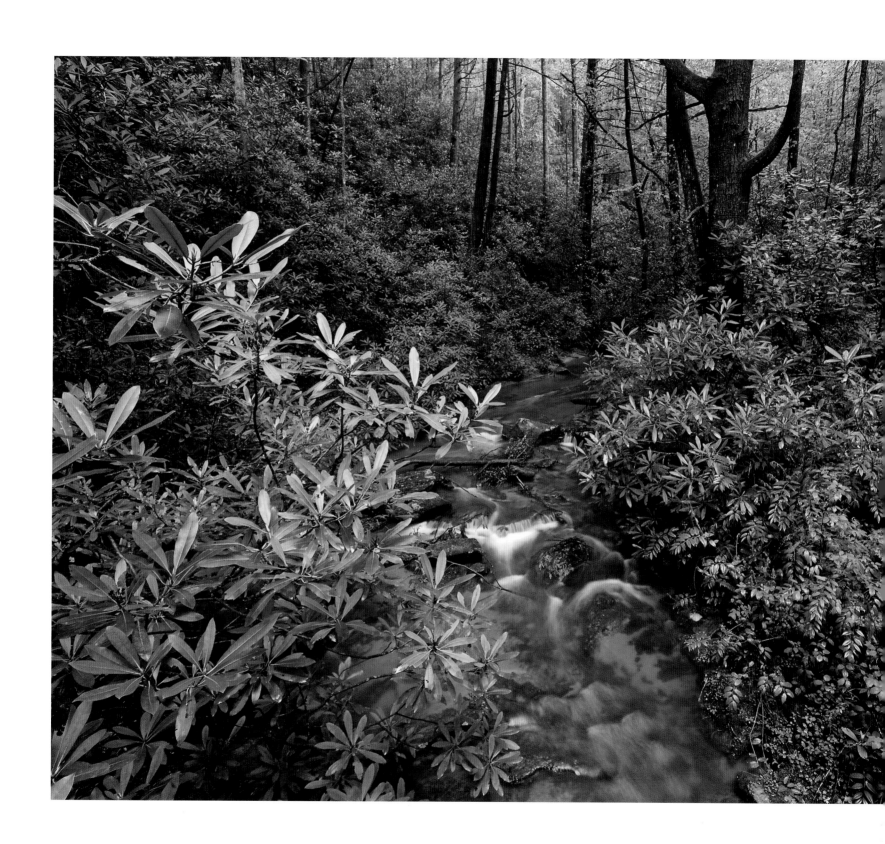

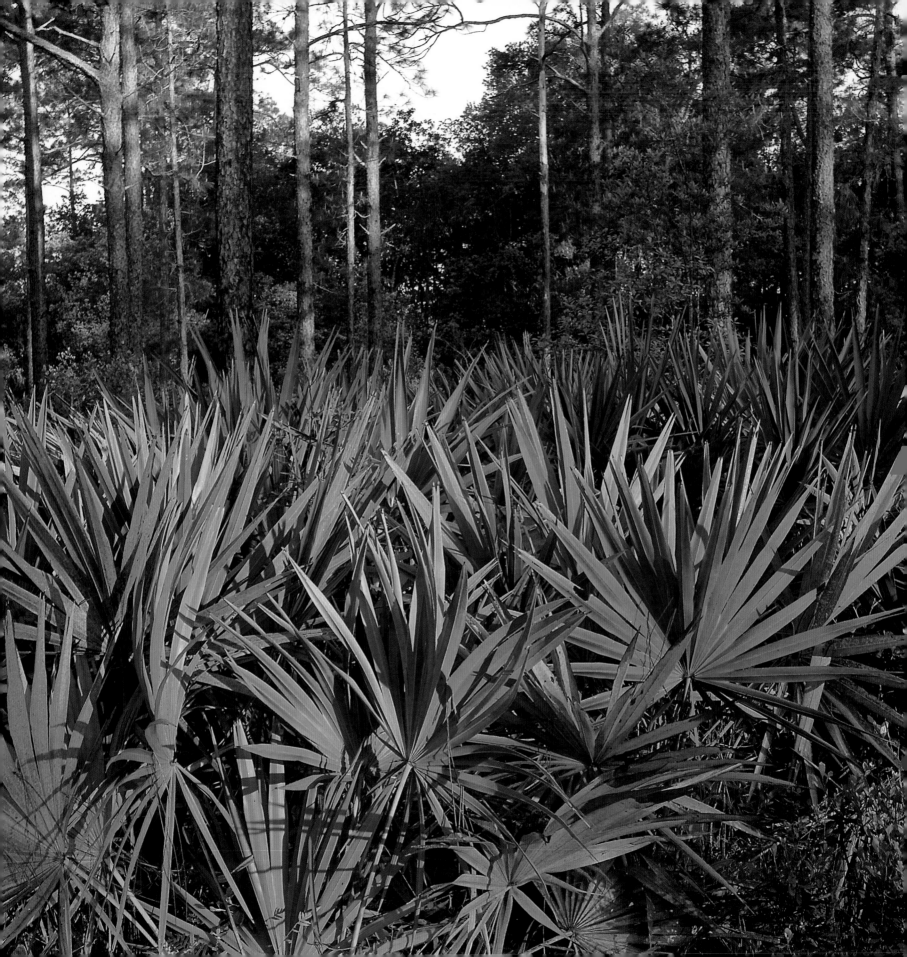

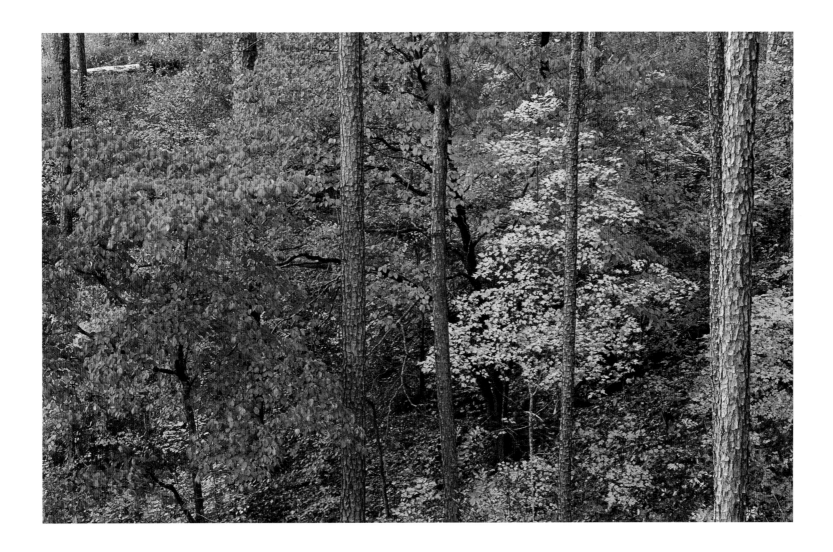

OPPOSITE: Longleaf pines, loblolly pines, and palmettos of Apalachicola National Forest create a distinctly southern woodland west of Sopchoppy, Florida. Longleafs once covered up to 90 million acres of the South—one of the largest forest ecosystems in America—but were reduced to three percent of their original extent by comprehensive logging of the clear-grained wood. The largest longleaf tracts survive in the national forests of Florida, and efforts are underway to restore a remnant of these once-magnificent woodlands. Other national forests with longleaf stands include Francis Marion in South Carolina; Ocala in Florida; Talladega and Conecuh in Alabama; De Soto, Homochitto, and Bienville in Mississippi; Kisatchie in Louisiana; and Angelina and Sabine in Texas.

ABOVE: Fire-resistant trunks of longleaf pines rise among red maples and dogwoods at the height of autumn color in Talladega National Forest, north of Heflin, Alabama. Dependent on frequent wildfires across a southern landscape that's highly prone to lightning strikes, the longleafs are a keystone species nourishing a rich understory and abundance of birds, including bobwhites. Endangered red-cockaded woodpeckers need large, live, longleaf trunks for drilling nesting cavities, which are protected from marauding rat snakes by the sticky sap of the trees. Another 27 vertebrate species use the red-cockaded's cavities after they've been abandoned. Reinstating fires as controlled burns is an essential step in the Forest Service's recovery effort for the magnificent pines.

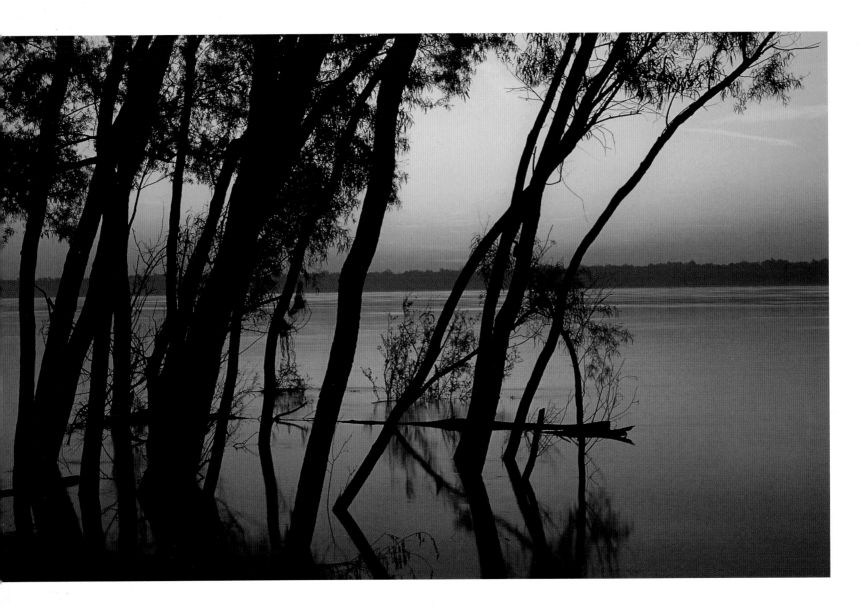

ABOVE: The sun rises across the Mississippi River in Ozark-St. Francis National Forest in Arkansas. High water from this river draining 42 percent of the United States (outside Alaska) floods a willow forest near the mouth of the St. Francis River.

OPPOSITE: Riparian trees thrive along the Mulberry River in Ozark-St. Francis National Forest. Biologists report that waterfronts such as this are the most important habitat for wildlife. Overhanging trees provide shade to the stream, roots stabilize riverbanks, and corridors along the streams create essential linkage to other forest areas. Natural riverfront buffers—spared from soil disturbance that otherwise comes with logging, farming, and development—act as filters that collect silt and purify storm-water runoff before it reaches the streams.

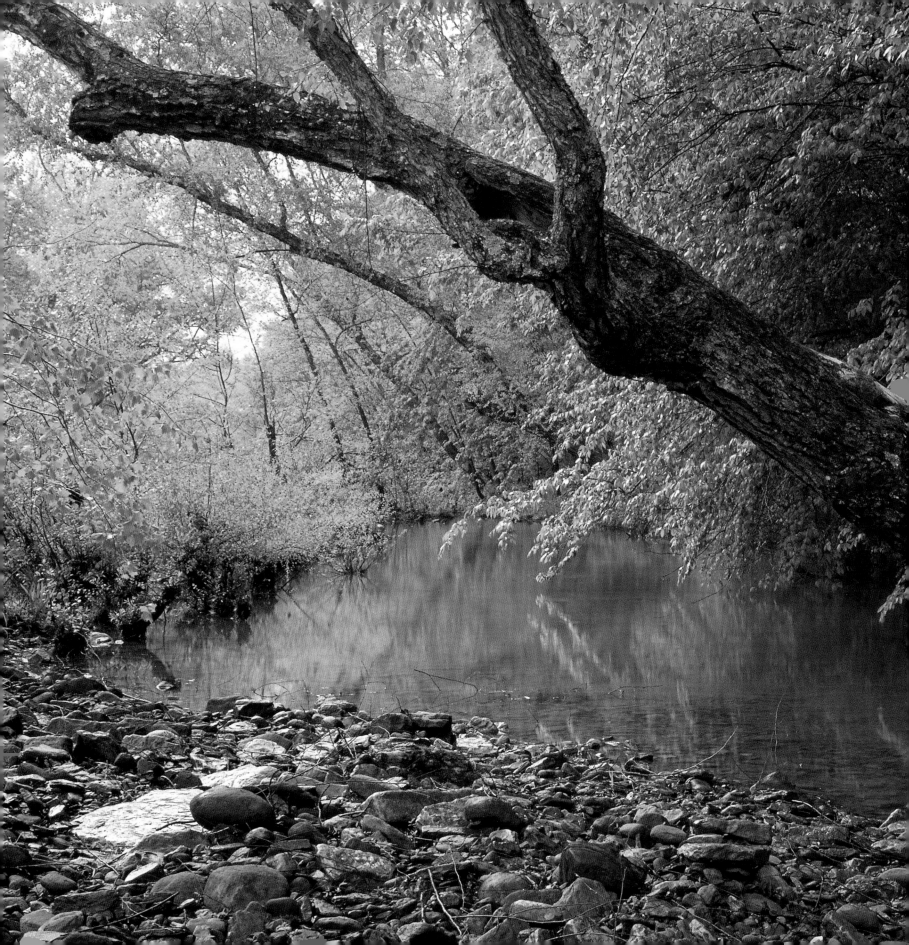

Pisgah National Forest

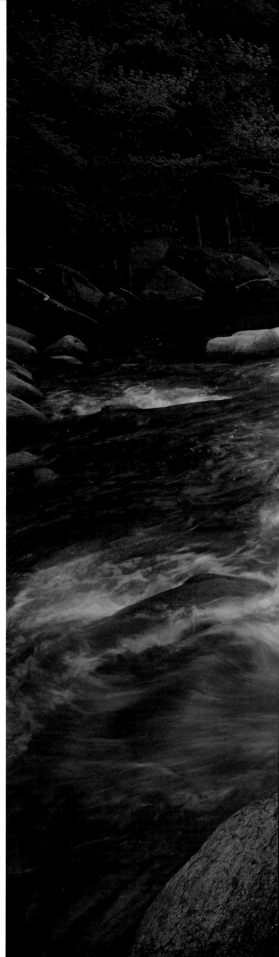

Gifford Pinchot had never seen anything like it. In 1892, the future first chief of the Forest Service was working for George W. Vanderbilt and his landscape architect, Frederick Law Olmsted, on Biltmore, Vanderbilt's extensive estate outside Asheville, North Carolina. The multimillionaire wanted to evaluate whether he should purchase 80,000 acres of woods as an add-on to his 25,000-acre property. Hiking through the "superb region of sharp ridges, steep slopes, and narrow valleys" left Pinchot breathless. "Bounded by water courses and high crests of mountains," he wrote his parents, "there is probably less than a square mile of cleared land on the whole tract, and that chiefly along the streams." As he wandered through the "exceedingly fine," rough, isolated terrain, chowed down with moonshiners, slept under the stars, and stood in mute awe before sweeping vistas and stunning sunsets, Pinchot marveled over coves studded with red and white oaks, chestnuts, and yellow poplar; the young forester estimated the dimensions of one downed poplar at an astonishing "thirty-three feet in circumference, breast high, while it stood." That his employer should buy the land was not in doubt: "To say that I am delighted with the whole area," Pinchot reported to Vanderbilt, "is to put it mildly."[4]

Acting on Pinchot's enthusiasm, Vanderbilt bought the land and named it Pisgah Forest after the mountain range through which Pinchot had bushwhacked. Shortly after Vanderbilt's premature death in 1914, his wife sold 86,700 acres of the forest to the federal government for well under its appraised value. "I make this contribution

Wilson Creek in Pisgah National Forest tumbles from Appalachian heights. The gorge section of this stream south of Blowing Rock appeals to expert kayakers while trout anglers cast in headwater reaches.

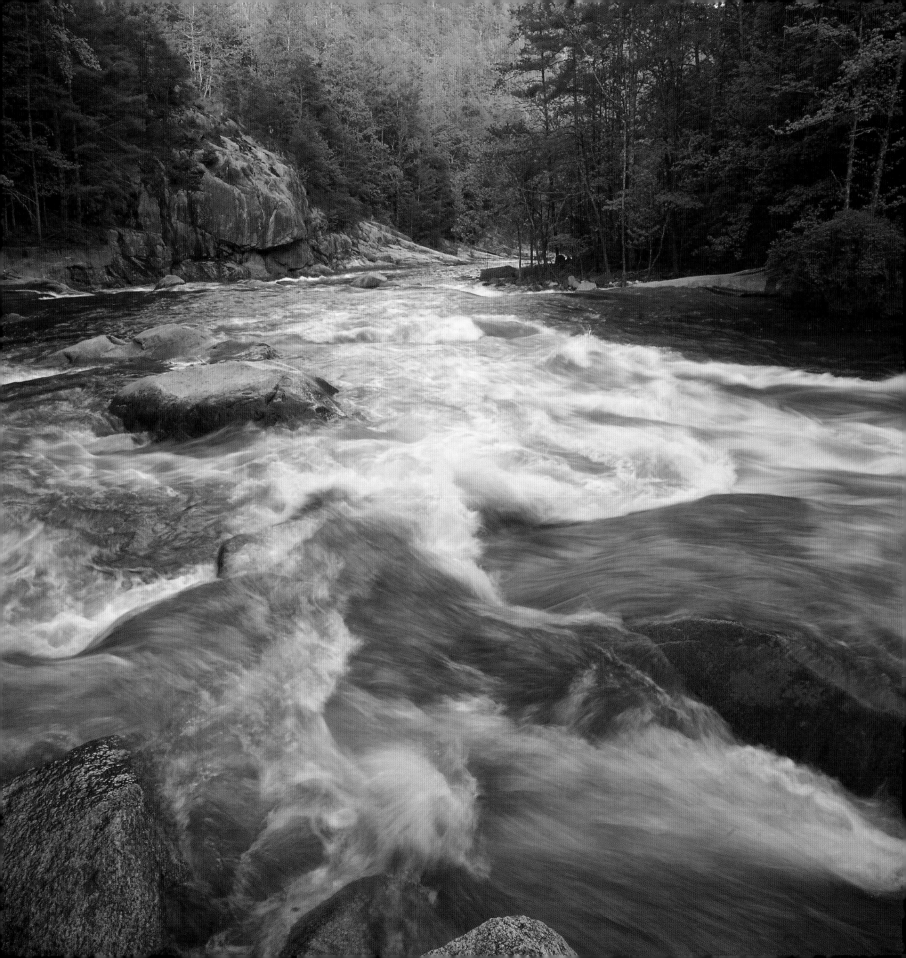

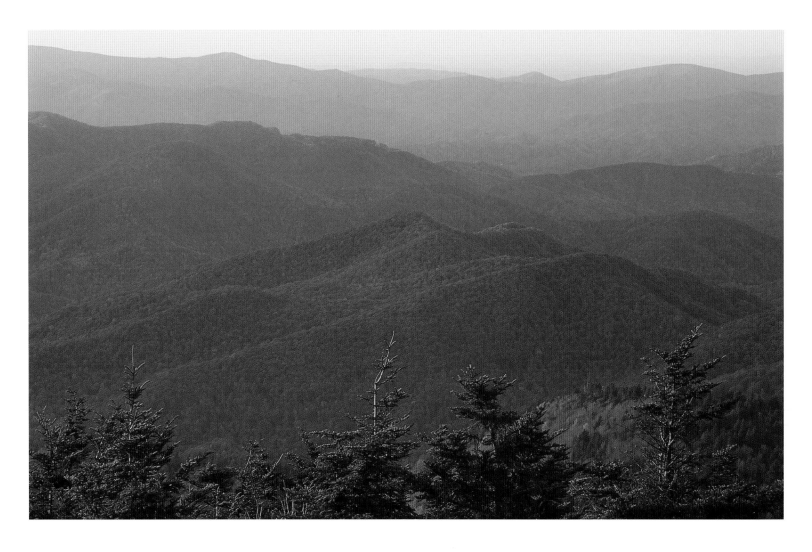

towards the public ownership of Pisgah Forest with the earnest hope that in this way I may help to perpetuate my husband's pioneer work in forest conservation," she wrote to the National Forest Reservation Commission, "and to insure [*sic*] the protection and use and enjoyment of Pisgah Forest as a national forest by the American people for all time." The commission, composed of the secretaries of war, interior, and agriculture, and two members each from the House and Senate who were charged with the disbursement of Weeks Act appropriations, readily agreed to her terms. In 1916, the Vanderbilt property was combined with additional units to form the Pisgah National Forest (which now contains 512,000 acres). It was the first Weeks Act–funded forest in the eastern United States.[5]

But this priority is not why the Pisgah is dubbed the Cradle of Forestry. In addition to Vanderbilt's and Pinchot's initial land-management efforts, the forest was also the site of the Biltmore Forest School. German forester Carl Schenck, who in 1895 had replaced Pinchot on the estate, founded the school three years later.

It offered a one-year immersion in the principles and applied techniques of forestry, an approach that contrasted with the four-year curriculum that Cornell University launched that same autumn. Not to be outdone, in 1900 the Pinchot family endowed Yale University's graduate-level Forest School. Schenck's non-degree-granting program differed from its Ivy League competitors. "My boys worked continuously in the woods," he once quipped, "while those at other schools saw wood only on their desks." In educating some of the nation's first foresters, the school's legacy lives on in some of its original buildings still located in the Pisgah National Forest.[6]

This heritage of close study and active management also suggests that those sections of the Pisgah that had been heavily harvested or overgrazed began to recover before similarly devastated terrain in such early eastern national forests as the Monongahela in West Virginia and the White Mountain in New Hampshire. Pisgah's relatively mild winters and plentiful precipitation aided the natural regeneration of oak, pine, and poplar that had been cut out or burned up. Pinchot was delighted when he returned to the Pisgah 40 years after he had left. "I tramped down from Pisgah Ridge through the Big Creek operation," he wrote about a major harvest he and Schenck had executed, the "poplar reproduction we had tried for was there in great abundance." This was affirmation, he believed, that practicing forestry did not destroy the forest.[7]

Yet even the Pisgah's beneficent conditions—soil, water, and climate—have not counteracted all challenges, whether human or natural in origin. When the Civilian Conservation Corps set up camp in the forest in the 1930s, for instance, it cut new trails and laid down roads, built cabins, campgrounds, and lodges, and stocked ponds with fish and woods with deer. The goal was to encourage tourism, and it succeeded in doing so, but as the number of visitors soared after World War II so did the pressures on the forest. The region's late 20th-century population surge exacerbated this stress. New housing subdivisions have absorbed or degraded wildlife habitat. More cars on the road have led to greater animal displacement and mortality, and the introduction of powerful off-road vehicles has further carved up the land. These woods are also affected by extensive deer browse, as are most forests along the Appalachian range.

Managing these impacts on a landscape scale is tricky, especially given one more problem that is particularly difficult—the hemlock woolly adelgid. Like eradication efforts in the Allegheny and other eastern national forests, treatments in the Pisgah involve a combination of pesticides and biological controls to rein in the sap-sucking pest that can kill a tree in as little as three years. To increase their chances of success, researchers are collaborating with an international consortium of scientists to decode hemlock genetics. They are also developing seed banks with the goal of introducing hybridized species more resistant to the infestation.

This research is of particular concern to the Pisgah because of *Tsuga caroliniana*, a variety of hemlock more closely related to Asian hemlocks than the regionally dominant Canadian or eastern strain. The Carolina version, found only in the southern Appalachians, grows in small, isolated populations, a narrow range and number that heightens its risk should the adelgid strike. Occupying a special niche in the forest, the hemlock escapes competition from hardwoods by rooting in rocky outcroppings and exposed ridgelines, standing sentinel-like above the canopy. Saving this signature tree is an integral part of protecting the visual and ecological integrity of the Pisgah's forested estate.[8]

Bordering Great Smoky Mountains National Park and seamless with its celebrated ecosystem—one of the richest in the temperate zones of the world—Pisgah National Forest boasts a wealth of biological diversity. This is the view southward from the forested summit of Mount Mitchell, highest peak east of the Mississippi.

Francis Marion National Forest

SOUTH CAROLINA

The palmetto tree may take pride of place in South Carolina, rooted as it is in the state flag, but those living within the lowland coastal forest, or up in the rolling Piedmont, know how ubiquitous and emblematic is the pine—loblolly and longleaf. So valuable was this species that, beginning in the late 19th century, lumber companies leveled large swaths of the state's pineries, rapidly and without thought to environmental and social consequences. Everywhere in the region, the story was the same: loggers pulled up stakes, abandoning the disrupted land and the people it had supported. By the 1920s, the "end of the South's inexhaustible timber was in sight," forest historian Henry Clepper observed. "As the tide of logging swept onward, it left in its wake hundreds of thousands of acres, cutover and burned over, that nobody wanted at any price. The little sawmill towns disintegrated among the charred stumps."[9]

A century later, the woods have largely recovered, as have the communities located within the revived pine-savannah ecosystem. Given this, it would be easy to conclude that the Francis Marion National Forest's establishment in the mid-1930s was crucial to this recovery and that the Forest Service and the conservation principles guiding management of the forest catalyzed this process. There is some truth to this claim, but the successful regeneration of once-battered and -charred forests also required community engagement, state sanction, and luck—good, bad, and unexpected.

Not long after the timber boom crashed in the 1920s, for instance, so did the national economy, magnifying the pain felt in South Carolina's sawmill country. Yet the state's devastated forests and collapsed commerce proved a lifesaver of sorts. The Civilian Conservation Corps (CCC), an initiative of President Franklin Roosevelt's New Deal, promised funding to pay unemployed men to work on landscape-scale restoration projects, setting the context for the Francis Marion to emerge, phoenixlike, out of these metaphorical and literal ashes.

Since the Weeks Act's passage in 1911, and with the consent of the South Carolina legislature, the Forest Service had been investigating the possible purchase of cut-over lands in the state. Until the Great Depression, however, it had not been able to complete any purchases, as landowners and corporations jacked up their price per acre hoping for a windfall. That strategy failed amid a free-falling economy; by October 1933, the federal government was able to acquire nearly 100,000 acres in Berkeley and Charleston counties at $4.00 per acre.

The ink was barely dry on the contracts when several companies of CCC enrollees arrived from New Jersey, the composition of which unsettled their southern supervisors. "It is my impression that much of the trouble that exists between the foremen and the enrolled men lies in the fact that the foremen are unused to directing white labor of foreign extraction," a CCC inspector observed, "but instead are more familiar working with Negro labor." In deference to segregation, the Corps shipped the New Jersey men north and replaced them with local African Americans, a telling conciliation.[10]

Bald cypress stand in several feet of water pooled in Guilliard Oxbow along the Santee River as it drifts past Francis Marion National Forest.

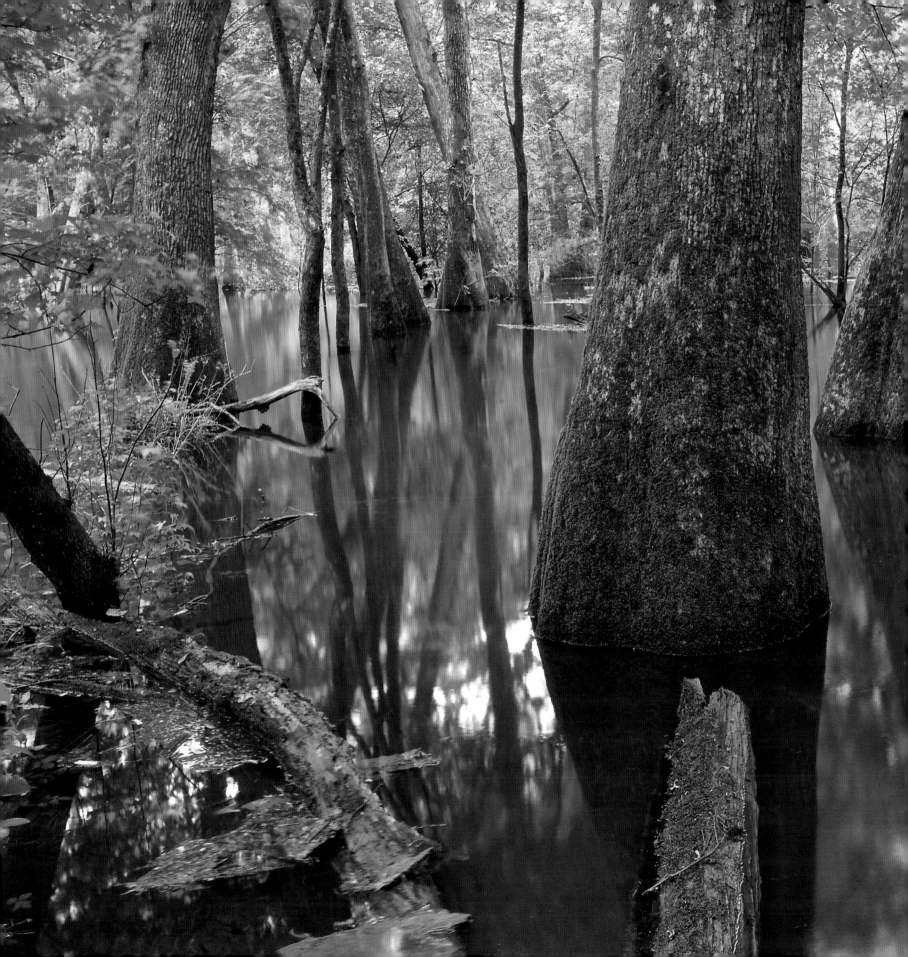

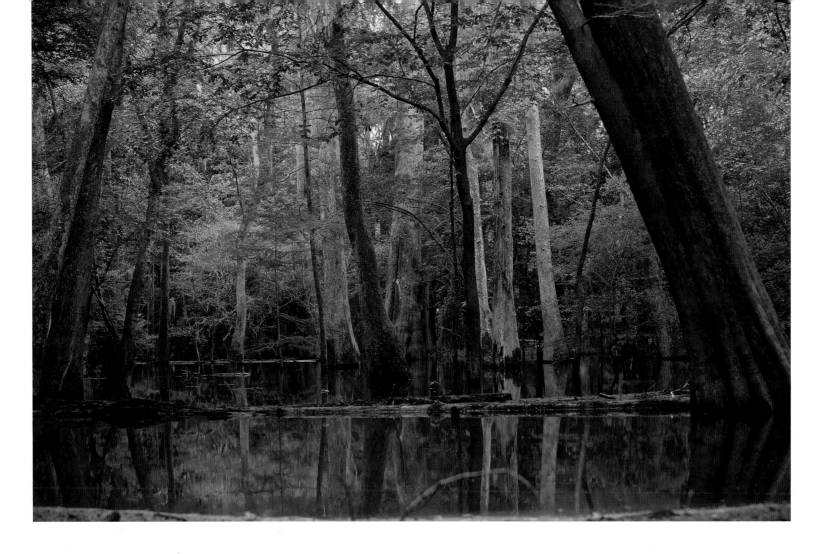

For a close-up view, canoeists can slip through a forest of bald cypress mirrored in Guilliard Oxbow. Once covering bottomland expanses of the Deep South, these trees were cut for their valuable lumber; harvest continues for garden mulch that is chipped from the iconic trees. Though small, this little-known national forest grove rivals the grandeur of nearby Congaree National Park.

Not compromised, however, was the Forest Service's commitment to repairing the forest. In the Francis Marion, as elsewhere, CCC laborers, known affectionately as Roosevelt's Tree Army, cut trails, built log-framed picnic shelters, erected fire-lookout towers, cleared brush and snags, contoured eroded slopes and gullies, and planted seedlings by the thousands. Loblolly was the tree of choice due to its fast growth and merchantable qualities, priorities that altered the forest's composition.

This era of intense management paid dividends, economic and ecological. Within 50 years, the Francis Marion was conducting annual timber sales, supporting the local wood-products industry. It contained as well four designated wilderness areas. Located in blackwater swamps, these areas are replete with soaring bald cypresses and water tupelo, orchids and water moccasins. The forest also offers habitat for such endangered species as the red-cockaded woodpecker, swallow-tailed kite, and American alligator. The land, productive and fertile, had recovered.

But it was not to last. On September 21, 1989, three days after Hurricane Hugo and its 135-mile-per-hour winds tore through Puerto Rico's El Yunque National Forest, the Category 4 storm slammed into South Carolina, splintering the Francis Marion. Acre after acre of trees, most of which dated back to the CCC era, were snapped in two, uprooted, debarked or stripped of their foliage, and doused with damaging salt

spray, leaving behind a tangled mess. The Santee Experimental Forest, located within the Francis Marion, was particularly hard-hit: more than 80 percent of its trees were destroyed. Cleanup began almost as soon as the storm pushed inland. While crews cleared roads and repaired battered facilities, others conducted aerial surveys of the damage or built firebreaks. For the next nine months, the forest ran salvage-logging operations that produced large quantities of biomass to fuel local production of electrical power, renewable energy operations that have continued ever since.[11]

For all its destructive power, nature's fragmenting force is episodic, partial, and regenerative. Not so the human. The most serious long-term threat to the Francis Marion and its environs comes in the concrete form of urbanization, stretching out from Charleston to the south and Beaufort to the north, and paralleling U.S. 17 and 52. The growth in the region's population, and the demand for housing ever farther out on an expanding periphery, has broken up once-intact woodlands that surround the Francis Marion, threatening these adjacent lands' capacity to sustain indigenous biota. Species threatened and rare will only become more so. This fraught situation underscores the Francis Marion's increasingly important role as an ecological safe haven for those whose habitat is shrinking—a nurturing stopover for migratory birds and a refuge for the flora and fauna endemic to its bottomlands, rivers, ponds, and coastal plain.

South Carolina's low country of Francis Marion includes wildlife-rich marshlands and this sprawling live oak at the lap of Atlantic tides. Much of the forest is wetlands reclaimed from antebellum rice plantations.

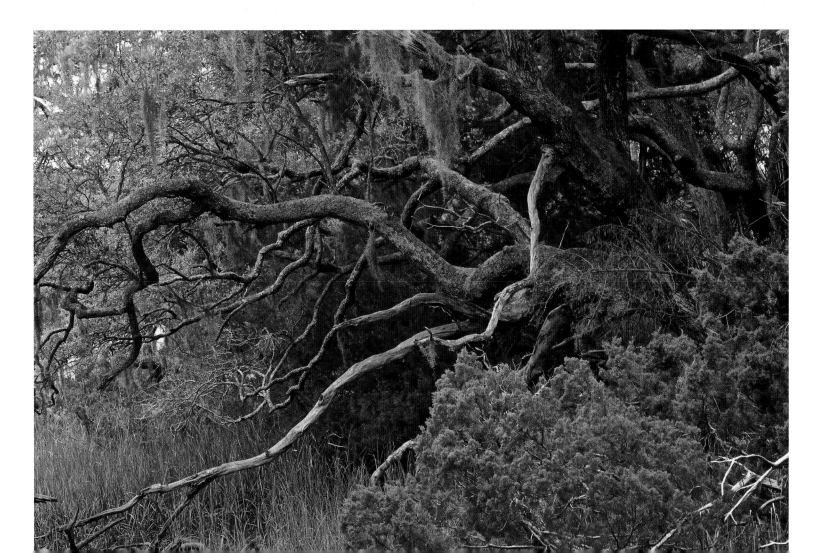

El Yunque National Forest

You should not expect vivid prose from a government report, especially not an early 20th-century technical paper crammed with scientific data for agency administrators. For the most part, John C. Gifford's on-the-ground survey in Puerto Rico of what is now known as El Yunque National Forest, but then was named the Luquillo Forest Reserve after the area's dominant mountain range, remains true to form. Submitted to his Washington-based supervisors in 1905, Gifford's report offered the first overview of the 5,000-acre reserve that the United States claimed in the aftermath of the Spanish-American War. It is chockablock with details about the site's geology, soils, and hydrology, its forest types, grasslands, and riparian systems—comprehensive, to be sure, but not exactly a compelling read.

Except for that moment when Gifford let his scientific guard down. "Seen from a distance, the Sierra de Luquillo is strikingly serrated," he wrote. "These high mountains are flanked by numerous lateral ridges which extend in every direction. These ridges are very sharp and are called 'cuchillas.' The word cuchilla means blade; and nowhere in the world could it be more aptly applied. The crest line is often so sharp and the sides so steep that traveling, even by foot, is exceedingly difficult."[12]

El Yunque's terrain is not the only thing that sets it apart from its mainland peers. It is one of the first forest reserves set aside in the entire Western Hemisphere, and is thus the oldest national forest in the U.S. system. El Yunque is also the only one not established by a president. In 1876, King Alfonso XII designated the remote mountainous region as a crown reserve that the Spanish Forest Service would manage for the conservation of its soils, timber, and water. Twenty-two years later, after Spain ceded Puerto Rico to the United States, the U.S. Bureau of Forestry took over supervisory authority. Under its aegis, Gifford inspected the forest and wrote of its razor-sharp topography.

This brief history of the forest reflects the global character of forestry in the late 19th century. The profession's origins are in Europe, and that continent's land-management concepts and practices were quickly transplanted to its far-flung colonies. The U.S. experience mirrored this trend. The Forest Service's first two chiefs studied forestry in Europe, as did Gifford. He is credited with being the first American to earn a PhD in the field, receiving the degree from the University of Munich in 1899. One year earlier, as empires old and new clashed for control of Puerto Rico, what was not in dispute was the value of forest management—the Americans simply picked up where the Spanish had left off.

That said, the land itself was unlike anything U.S. foresters had encountered on the mainland. Instead of oaks, pines, and firs, they now worked with ausubo, Palo Colorado, and Tabunuco trees. And they did so in a terrain doused with more than 200 inches of rain annually. As a tropical rain forest (the only one the Forest Service stewards), its "most prominent feature is its diversity and the great number of little-known species in mixture," Gifford observed. Its composition "makes

La Coca Falls sprays down with runoff from El Yunque's 100 inches of annual rainfall, keeping the mountains cloud capped and the waters surging high. Three streams in this territory of the United States are designated for protection in the National Wild and Scenic Rivers System.

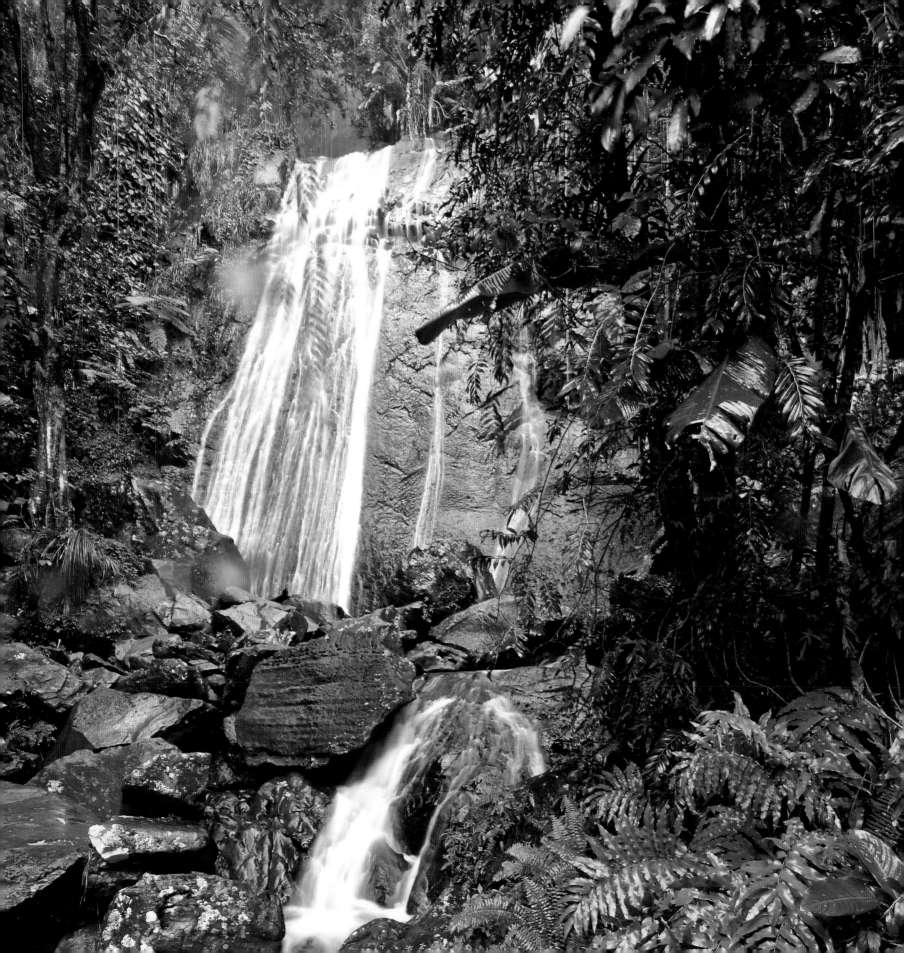

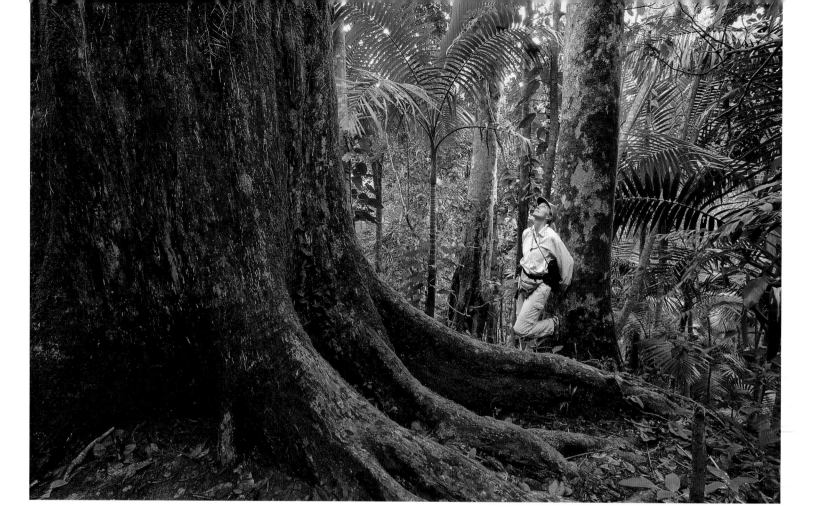

Big Tree Trail leads to this ausubo tree of massive girth. Though El Yunque is among the smallest national forests, with 28,000 acres, it shelters 225 species of trees—more than are found in all other national forests combined. In my photo expeditions here I didn't see a single species of tree that also grows on the mainland; everything was delightfully different. Though lowlands were heavily cut, some trees at mid and high elevations have lived 1,000 years. There are 23 species that grow nowhere else.

it extremely difficult to divide into silvicultural types and to estimate the amount of timber, and would make it still more difficult, if not impossible, to determine annual accretion." In other words, this tropical woodland did not function like those in the United States, and could not be managed in the same way, so Gifford's professional peers would need to adapt to this new and confounding set of conditions.[13]

They could succeed in this adaptive process only if they understood the Luquillo Forest's dynamics, and that required research. It was not until 1939 that Congress provided the necessary funding to launch the Tropical Forest Experimental Station (now the Institute of Tropical Forestry). Its mission ever since has been, among other things, to study the 225 species

of trees growing in the forest, virtually every one of them different from any found on the mainland, a variety emblematic of tropical rain forests worldwide.

El Yunque supports as well a bewildering array of flora and fauna endemic to the island, and in some cases is the last known home of particular species. The most celebrated of these is the Puerto Rican parrot (*Amazona vittata*), the sole parrot extant on the island. The beautiful bird—its vivid green plumage offset by white eye-rings and a bright red forehead—is now endangered, though that was not always the case. A century and a half ago, it could be found in great squawking numbers, feeding on the fruit of the abundant Sierra Palm (which Gifford had dismissed as having no commercial value). The

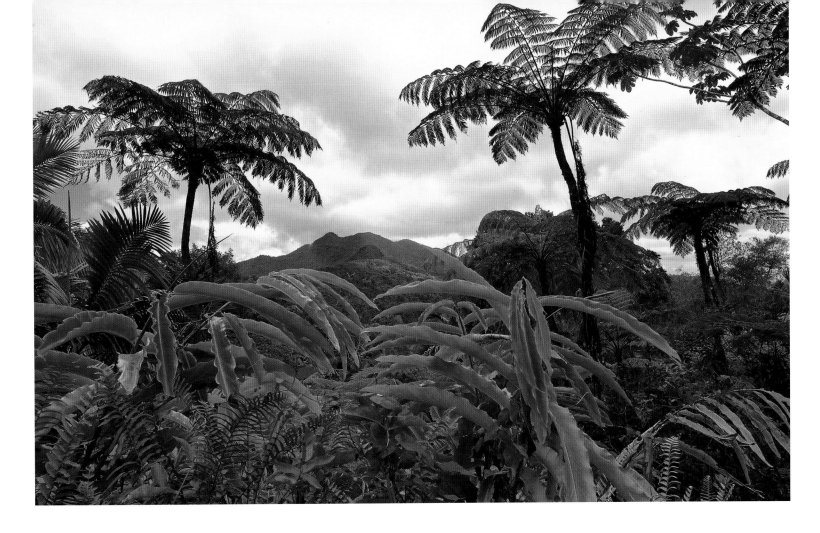

bird's numbers began to shrink, however, with the spread of large-scale agriculture—coffee and tobacco primarily—into its cooler, higher habitat. Its life chances were further compromised in the mid-20th century as the swiftly growing human population penetrated the forest's perimeter. Hunters also bagged the bird for sport, and others captured immature parrots to feed the pet industry's hunger for exotica. When simultaneously the Pearly-eyed thrasher invaded its niche through aggressive nest predation, the Puerto Rican parrot population crashed.

By the late 1940s, scientists had begun calling for the establishment of parrot reserves in the national forest. These and other conservation efforts have shown some success. From a low of roughly 20 adults in the early 1970s, by 2013

an estimated 100 adults lived in the wild, with another 400 bred and living in captivity.

Whether these numbers signal that conservationists have managed to pull the parrot back from the "edge of oblivion," as a 1987 report described its then-precarious position, is unclear. The authors of that study recognized the difficulty of the task ahead. The "preservation of biotic diversity on earth surely ranks as one of the most difficult challenges facing our generation and the generations to come." Nowhere is this more true than Puerto Rico, given its dense population and deeply modified environment. There, as elsewhere in the national forest system, battles "to save endangered species have to be won over and over again, but once lost there are no second chances."[14]

Sierra palms blanket upper elevations in El Yunque National Forest—the only tropical rain forest in the national forest system.

De Soto National Forest

After it pummeled New Orleans and obliterated Mississippi's coastal communities, Hurricane Katrina tore through the Gulf Coast, ripping apart streetscape and landscape. Yet for all its damage to urban areas, the August 2005 Category 3 storm may have had a more profound impact on rural areas. In Mississippi, Louisiana, and Tennessee alone, Katrina damaged upward of five million acres of forest, four million of which were in Mississippi. Nowhere in the Magnolia State was harder hit than the De Soto National Forest. Situated just north of Biloxi and Gulfport and stretching north to Hattiesburg, it lay to the east of the hurricane's path and thus bore the brunt of the storm's fury: more than 300,000 acres, roughly 60 percent of the forest, received either heavy or moderate damage, numbers that cannot adequately convey the devastation. Hundreds of thousands of trees—mostly long-leaf, loblolly, and slash pine—were mowed down, torn up, bent over, or sheared off.[15]

Figuring out how to restore what nature had upended required forest managers to think broadly. Their strategies had to incorporate removing a thick maze of downed timber, a hazardous situation made all the more complicated by the simultaneous need to recover, even rebuild, the habitat of two key species: the red-cockaded woodpecker and the dusky gopher frog, the latter of which is among the most endangered amphibians on the planet. They also had to deal with non-native invasive plants, such as Japanese climbing fern and cogongrass, as well as such tree-killing pests as pine bark beetles, weevils, and borers, all of

Morning fog paints a monochrome of loblolly pines and water oaks along the Janice Boat Ramp of Black Creek in De Soto National Forest.

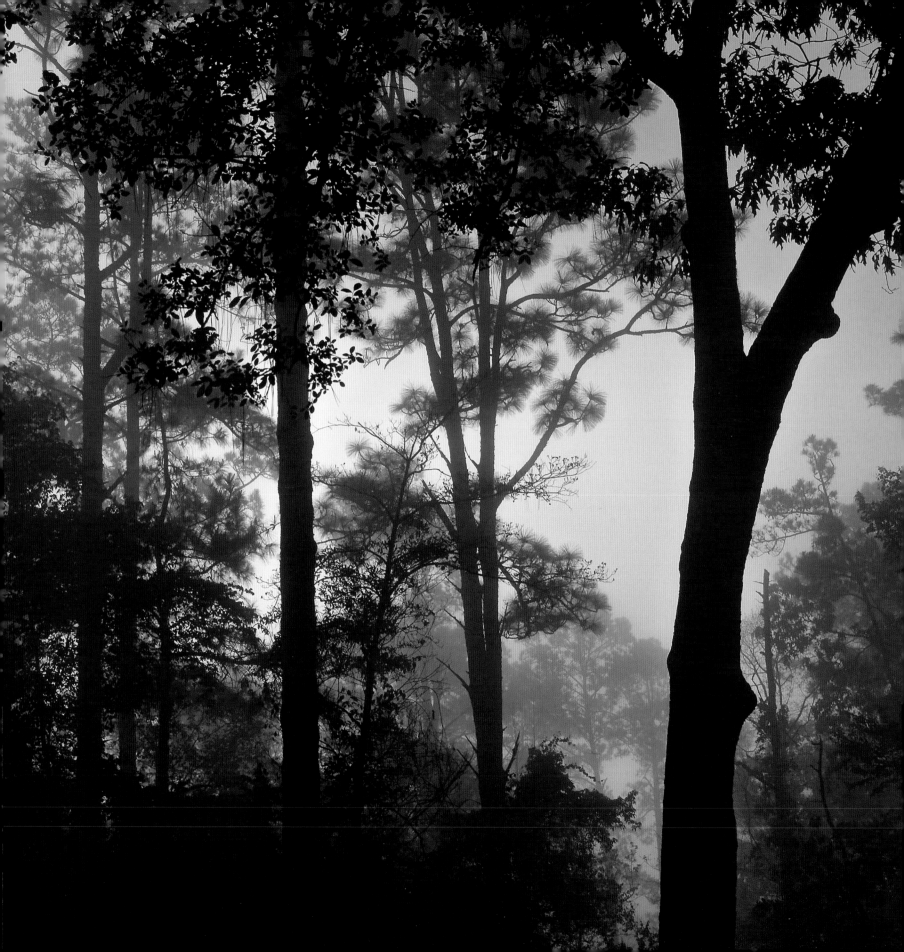

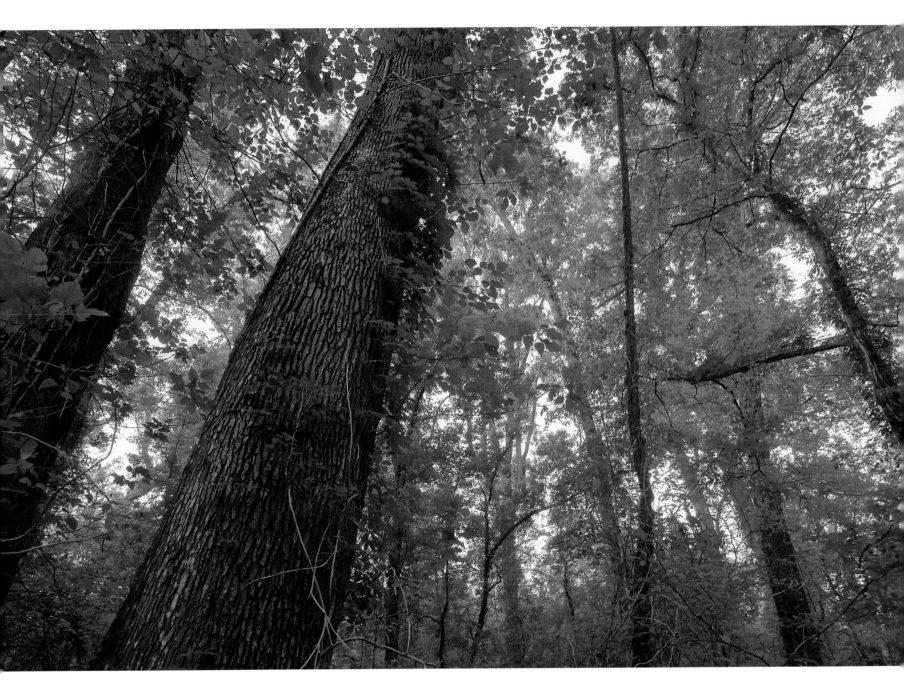

which immediately took advantage of Katrina's destructive force. More complicating still, they had to resolve these issues quickly by drawing on the same resources that the five other national forests in Mississippi required to repair their damaged domains—all in a state in severe crisis.

The catastrophe unlocked the forest staff's creativity. By working closely with the broader

public and surveying the rapid uptick in beetle infestation, officials secured considerable support for a massive salvage logging operation. Their goal was not to return the forest to its prestorm state, in which loblolly and slash pine dominated. Rather, they hoped to reestablish its historic longleaf pine overstory, a project that would allow them to bring back historic fire regimes. They hoped as well to expand habitat essential to the forest's most threatened birds, tortoises, and frogs, and maintain and restore the bogs that are home to such sensitive plant species as orchids and the carnivorous pitcher plant. In collaboration with the Nature Conservancy and a lengthy list of public agencies and nonprofit organizations, the forest staff's goal was to bring back the landscape's past to make a more resilient forest able to weather a climate-changed future.[16]

This ongoing effort marks the second great restoration era in the De Soto. The first occurred during another period of intense crisis, the Great Depression. That economic collapse mirrored the sharp decline in the land's health. Beginning in the late 19th century, loggers started "cutting up the pine forests like locusts cutting a swath through a field of wheat," one contemporary observed. Owners tried to convert the land to agriculture and grazing, a badly managed process that inhibited forest regeneration, stripped the soil of its fertility, increased erosion, and impoverished land and people. "The gullies were so big," a Mississippi forester recalled, that "you could drop in a building as big as our office." President Franklin Roosevelt's commitment to expanding the national forest system in the South was designed to fill that void.[17]

Mississippians were eager to cooperate with the New Deal, to judge from the lobbying efforts of local timber companies, who, burdened by debt and a disappearing market for their lumber,

pressed their congressional representatives for relief. In response, the Forest Service tapped Ray Conarro as the first supervisor of the nonexistent National Forests of Mississippi. Within a year of his July 1933 arrival, he and his small staff had surveyed, proposed, and gained approval of the National Forest Reservation Commission for the purchase of some 600,000 acres.[18]

Scattered across the state, these lands served as the foundation for six national forests (now under unified administration as the National Forests of Mississippi, which encompass 1.2 million acres): the Bienville, Delta, De Soto, Holly Springs, Homochitto, and Tombigbee. Their original poor condition enabled the federal government to buy the land for as little as $1.25 an acre, and, through the energetic efforts of the Civilian Conservation Corps (CCC), to rebuild the forests. But it did so at the cost of the original forest cover. Convinced that faster-growing loblolly, slash, and shortleaf pine would more quickly reclaim eroded lands than longleaf, the agency sent CCC enrollees out to pick up bushels of pinecones (more than 6,000 of them by the end of the decade). To aid this project, the Forest Service set up a nursery in the De Soto that by 1937 had produced 20 million seedlings. Within a decade, the once-shorn state was regaining its forest cover.[19]

Over the next 60 years, Mississippi's national forests, like their private counterparts, contributed to a booming wood-product industry that boosted the state's economy by an estimated $40 million annually. By the 1990s, after legal challenges to its harvesting practices in Holly Springs National Forest, the agency agreed to reduce cutting levels, embrace a much greater degree of public collaboration, and prioritize ecological restoration as a primary management goal. This critical policy shift became even more urgent after Hurricane Katrina roared ashore.[20]

The National Forests of Mississippi are a composite of the small and isolated Holly Springs, Tombigbee, Bienville, De Soto, Homochitto, and Delta National Forests. Here on the western flank of the state, Delta boasts the only extensive "bottomland" hardwood stands in the federal forest system. North of Holly Bluff, the Sweetgum Research Natural Area's hardwood medley includes sweet gum, Nuttall oak, overcup oak, and water hickory—some 300 years old. A virgin stand of 13,200 acres was bought for the national forest in 1936 but then reduced by logging to 160 acres, which are now protected in three diminutive natural areas. The greater bottomland forests of the Mississippi Delta once stretched across four states—nearly all of it cleared for farms and soybean fields.

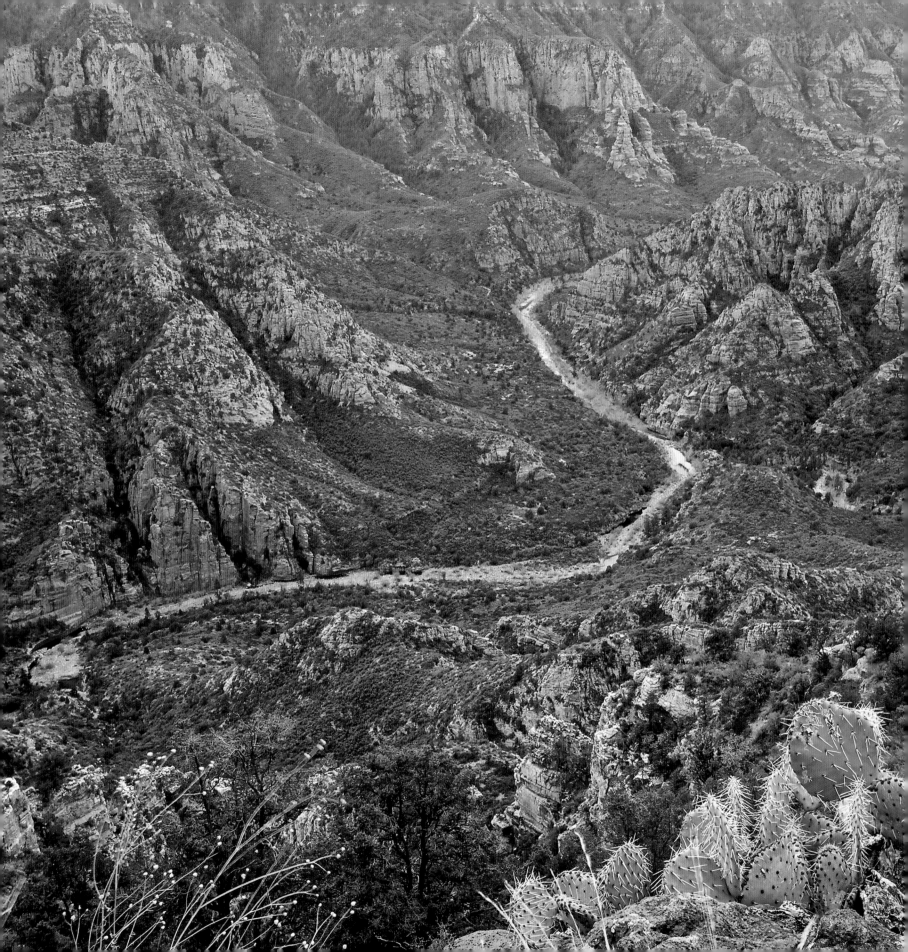

THE
SOUTHWEST &
GREAT BASIN

6 STATES

17 NATIONAL FORESTS

3 NATIONAL GRASSLANDS

54.6 MILLION ACRES

38.6 MILLION VISITORS

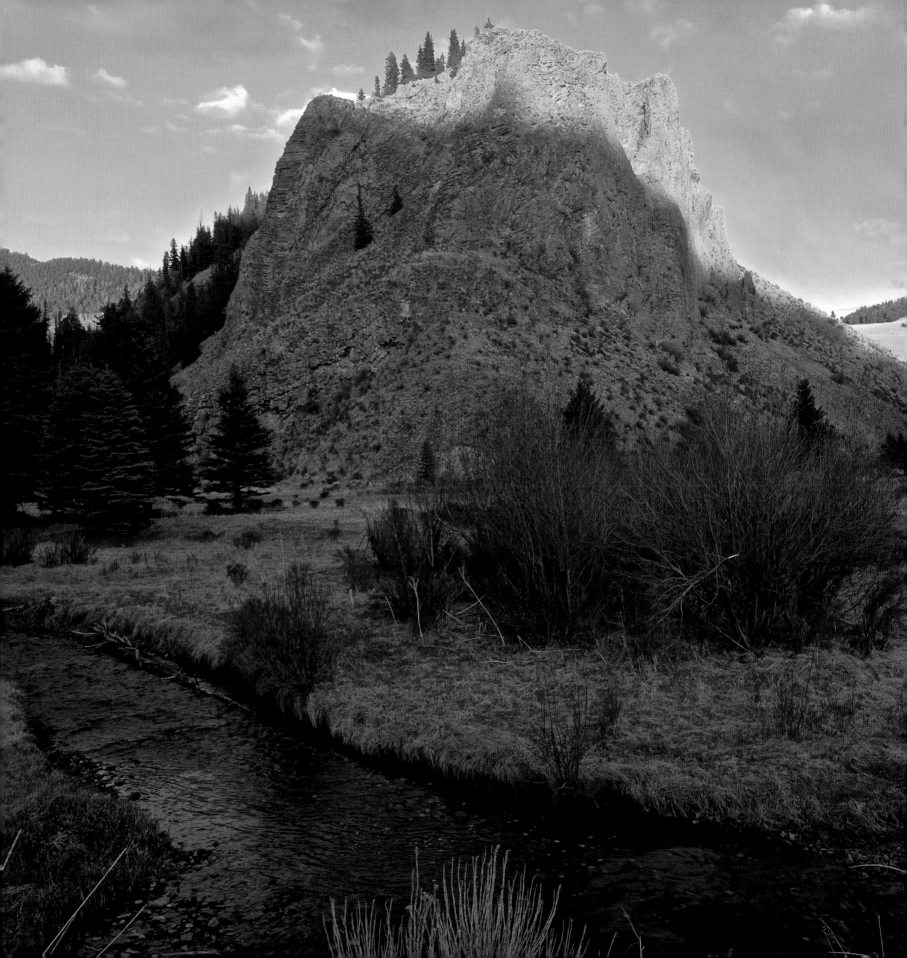

Idealized for red-rock deserts, glowing light, and austere geologic and biologic wonders, the Southwest and its kindred drylands reach with marathon throws of distance beyond New Mexico and Arizona and into the mountains, steppes, and canyons of Nevada and Utah. National forests in this region have an edginess like no other. Glades of ponderosa pines are interwoven with curiosities of alligator junipers and wind-sculpted arches of rock, with the startling contrast of beaver dams up high and desert tortoises down low. Mountain ranges climb skyward to take a remnant of moisture from storms originating to the west and south and grant a revered suite of national forests an extra measure of life.

Scarcity is the byword here, and so the forests were raked clean for the timbers they provided for mines dug or blasted without restraint into opportune deposits of ore, and the waters were tapped by wells, dams, and canals destined for Phoenix, Las Vegas, and—far beyond the bounds of this region—Southern California. But the mountainous national forests can be likened to islands in the sky, and canyons fingering out from them vein the plateaus and the washboards of ridges that seismically rift in the continent's tectonic interplay. It's a hot landscape, and the national forest outposts shown here are destinations for a cooler escape to an elegance that's all the more precious for the great gulfs of distance in between.

Catching the early morning and late evening light is a rule of thumb in photographing landscapes anywhere, but here it was both essential and irresistible. Nothing in America matches the low light filtered through dry air and the sharp shadows of a phenomenon as striking as a saguaro cactus or a bristlecone pine that has been casting that same shadow for 4,000 years.

— TIM PALMER

PREVIOUS SPREAD: A Grand Canyon in miniature, Sycamore Creek's sculpted sandstone hides in the backcountry of Kaibab National Forest west of Flagstaff, Arizona. OPPOSITE: In Carson National Forest of New Mexico, Costilla (left) and Comanche (right) Creeks flow from the heights of the Sangre de Cristo Range and join together beneath Comanche Point, reached by gravel roads south of the Colorado border. Native Rio Grande cutthroat trout survive in only 10 percent of their native range, including Comanche Creek, where restoration efforts of the Forest Service seek to reinstate riparian habitat that is critical to keeping the stream cool and silt-free.

Tom Outland, the protagonist of Willa Cather's *The Professor's House* (1925), is a stand-in for his literary creator in at least one vital sense. Like Cather, he reveled in New Mexico's stark, arid beauty. The landscape was also the source of his novel-defining discovery of a hitherto unknown ancient set of cliff dwellings he called Blue Mesa, a site Cather

The Canadian River cuts through a gap west of Roy in Kiowa National Grassland in New Mexico. Scattered through western reaches of the Great Plains and Rocky Mountain foothills, 3.8 million acres on 20 national grasslands were typically bought during the Dust Bowl years from cattlemen who had gone out of business. Most of these lands, under Forest Service administration, are now leased back to ranchers.

based on her visits to Colorado's Mesa Verde and Arizona's Walnut Canyon. Hoping to secure the federal government's protection for the site, Outland headed east, only to discover that the nation's capital was a depressing place. Its "sad sunsets" were as disconcerting as the life its residents lived. "I wanted nothing but to get back to the mesa and live a free life and breathe free air, and never, never again to see hundreds of little black-coated men pouring out of white buildings."

The haze lifted the moment an empty-handed Outland returned to the Southwest, or more precisely when he reached the foot of the fictional Black Canyon, and began to hike up a trail through the narrow ravine, every inch of which "was dear to me." And, like a homecoming, glorious: "When I pulled out on top of the mesa, the rays of sunlight fell slantingly through the little twisted piñons—the light was all in between them, as red as a daylight fire, they fairly swam in it." But it was the dry air most of all that signaled he was on home ground, "Soft, tingling, gold, hot with an edge of chill on it, full of the smell of piñons—it was like breathing the sun, breathing the color of the sky."[1]

There are any number of elevated spots in the Southwest and Great Basin—biscuit boards, mesas, overhangs, and natural bridges—where the feeling of standing "in a world above the world," as Outland puts it, is part of what makes the region so beguiling. Start with the region's signature mountains. The crystal-clear air offers unparalleled vistas, whether from Nevada's 11,949-foot Mount Jefferson in the Humboldt-Toiyabe National Forest or New Mexico's Wheeler Peak (13,161 feet) in the Carson. Arizona's Humphreys Peak (12,633 feet) and Agassiz Peak (12,356 feet) anchor the San Francisco Mountains rising above Flagstaff, Arizona, to the north. Sacred to the Hopi, Navajo, and other southwestern native peoples, this particular range is also beloved by mountaineering groups for the rigorous trails to the summits and the astonishing views to be won by climbing them. Agassiz contains its own special challenges because of the San Francisco groundsel, a perennial herb that grows in its tundra alpine ecosystem. Pushed to the brink due to the thousands of boot-shod feet that have pounded the mountain's niche, the Forest Service has limited hiking up the peak to the winter,

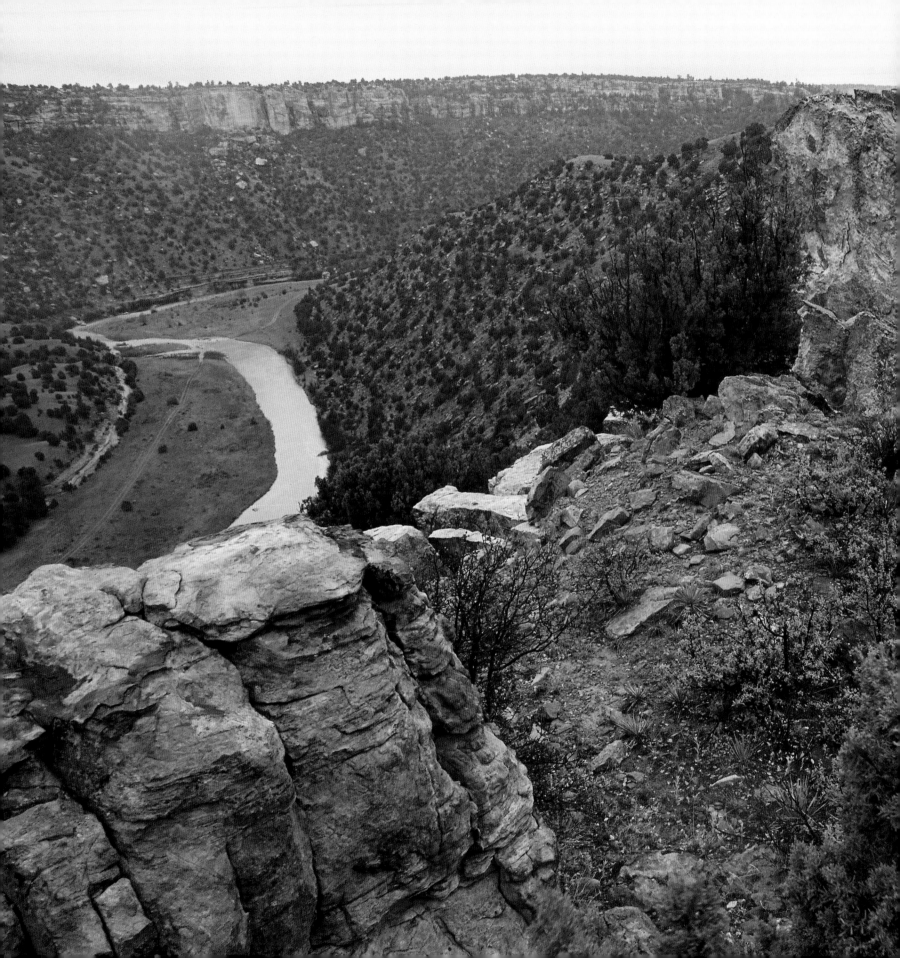

increasing the difficulty of bagging the southern-most 12,000-foot mountain in the United States.

Less strenuous but no less rewarding are the countless scenic vistas along the Mogollon Rim, an east-west escarpment through northern Arizona that encompasses portions of the Coconino and Apache-Sitgreaves National Forests, and marks the southwestern edge of the Colorado Plateau. The same visual treat is readily available to those visiting the rugged canyonlands in New Mexico's Gila, Cibola, and Lincoln National Forests. Even running down any of the region's challenging rivers and streams—including the Rio Grande and Rio Chama in New Mexico, and the Verde River and Fossil Creek in the Grand Canyon State—provides a superb, bottom-up perspective of turquoise sky and burnt-orange walls.

These wind- and water-carved landscapes also provide a geological roadmap to the planet's deep time, its physical evolution of upthrust, fold, subsidence, and drift that continues unabated. The human experience of these shifting terrains is as in flux and just as transient. It is recorded in the petroglyphs that ancient people cut into black rock and the cliff houses they carefully built into sandstone and limestone. It was while dig-ging into stony high ground that Tom Outland struck a long-buried irrigation ditch, lined with "smooth cobbles and 'dobe cement," that led him upstream to find the remains of a "little city of stone, asleep." Given his seasonal labor as a ranch hand, he was intrigued by this people's sense of permanence. "There is something stirring about finding evidences of human labor and care in the soil of an empty country," Outland observed. "It comes to you as a sort of message, makes you feel differently about the ground you walk over every day." These faint signals from a distant time ani-mate his present and ours, rooting them in an ever-expanding future.[2]

At the edge of Albuquerque, New Mexico, the Sandia Mountains in Cibola National Forest rise to cloudy heights above Juan Tabo Trailhead. Virtually at the doorstep of suburban homes, this national forest—along with Uinta-Wasatch-Cache, Angeles, Boise, Humboldt-Toiyabe, and others in the West—serves the daily recreational needs of millions of urban Americans.

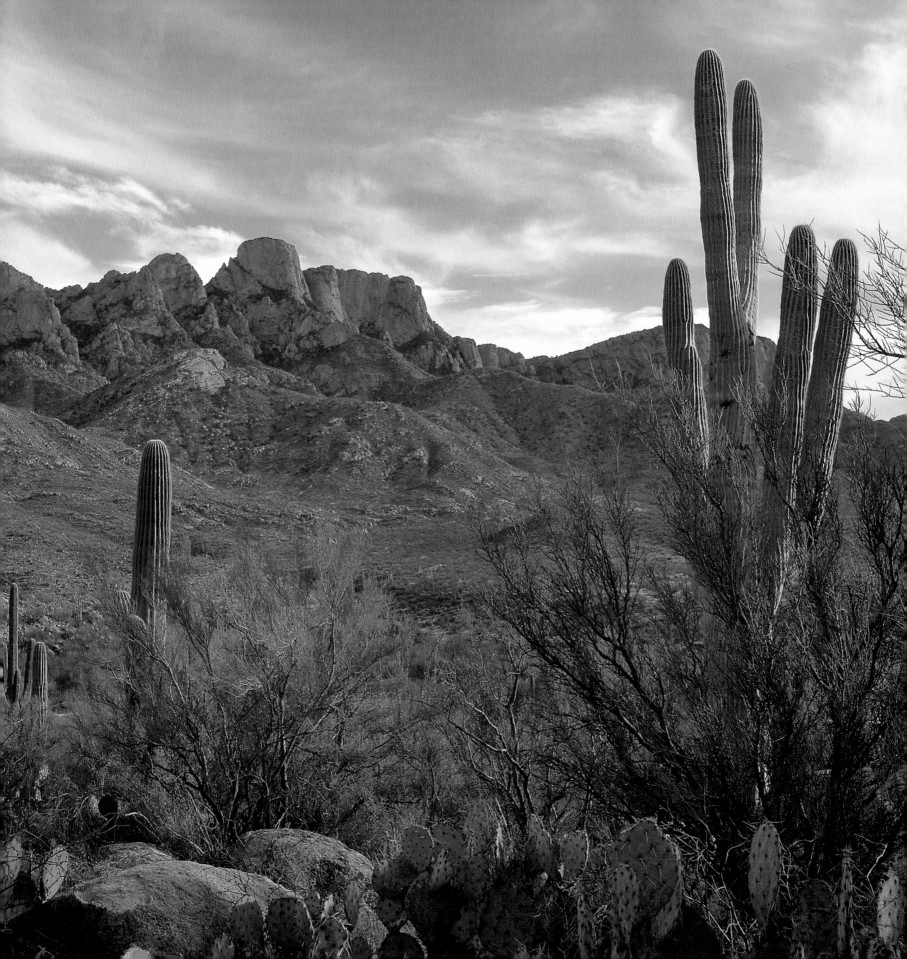

OPPOSITE: The Santa Catalina Mountains of Coronado National Forest jut up from Tucson's urban edge and form the striking backdrop of Arizona's Catalina State Park, bought by the state and spared from a subdivision proposal at the edge of the national forest in 1983.

RIGHT, TOP: A midwinter snowstorm blankets Arizona's Chiricahua Mountains. High terrain here and at most other ranges across the West pushes passing clouds up to where the water vapor cools to its dew point, condenses as rain or snow, and supplies stream runoff and groundwater recharge. Coronado National Forest is made up of 12 "islands in the sky"—isolated uplifts where plants and animals have been sequestered in their own genetically distinct pockets by the surrounding Sonoran Desert for millions of years.

RIGHT, BOTTOM: Native grasses ramp up to steeper mountainsides in Coronado National Forest north of Patagonia, Arizona. Grasslands like these have in many places given way to mesquite infestations and nonnative weeds in the wake of heavy grazing.

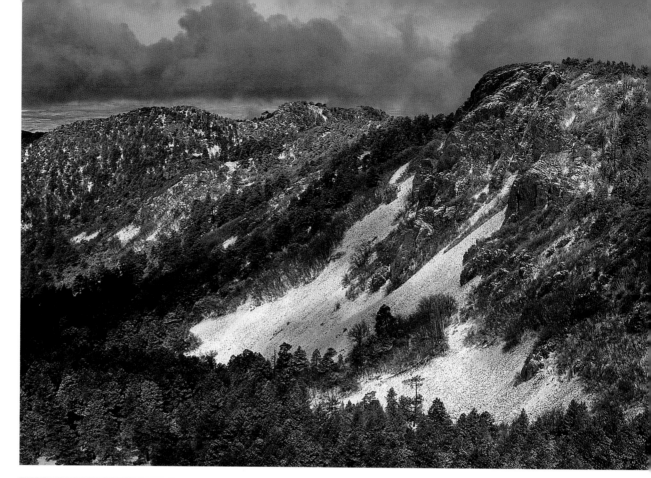

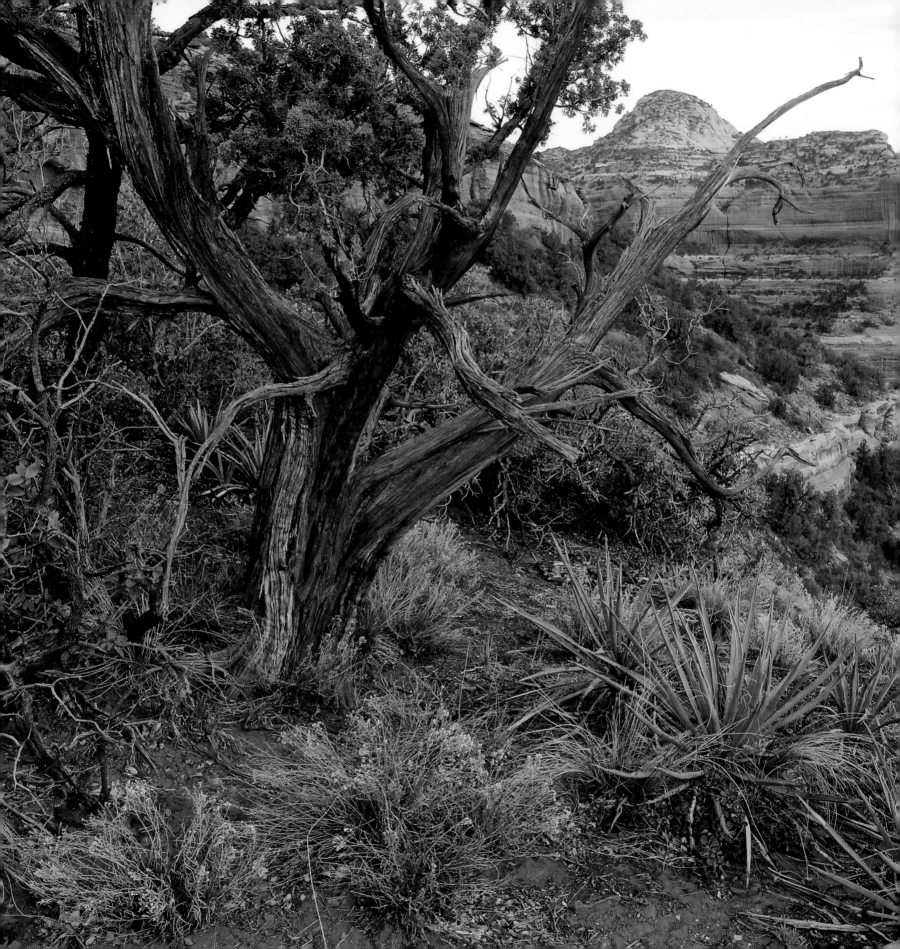

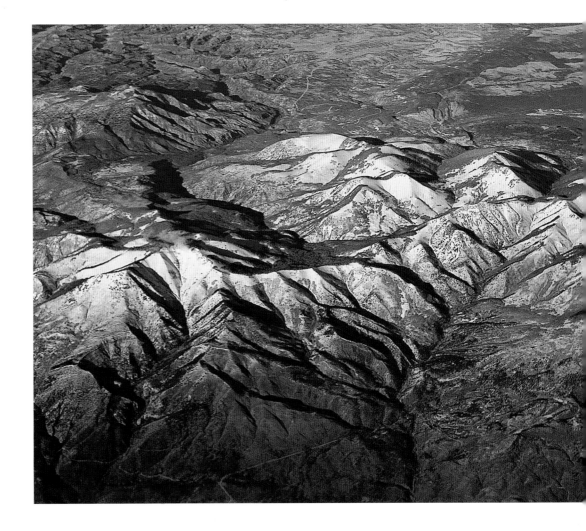

OPPOSITE: The extravaganza of mesas and canyons in Coconino National Forest west of Sedona, Arizona, draws people to trails and mountain-bike passages touring a red-rock wonderland.

ABOVE: Snow-catching topography of the Manti-La Sal National Forest overlooks the southern Utah desert. Here the Abajo Mountains rise west of Monticello. Farther north, a sister range, the La Sal Mountains, similarly towers above surrounding drylands east of Moab.

Santa Fe National Forest

Tucked into the Organic Act of 1897, which broadly authorized the management of the nation's forest reserves, was a definitive phrase about their purpose: "to improve and protect the forest within the reservation, or for securing favorable conditions of water flows, and to furnish a continuous supply of timber for the use and necessities of citizens of the United States." The tight link between forest and water that the legislation identified is cut into the ground, for almost all national forests cover mountainous regions that are themselves the headwaters of innumerable rivers.

These upstream protections have had important downstream effects. Not least was that their establishment was frequently one reason why citizens living in the valleys below agitated for the creation of national forests. That was as true of areas receiving considerable moisture, such as communities neighboring New Hampshire's White Mountain National Forest or the Rogue River-Siskiyou National Forest in southern Oregon, as those in the arid southwest who benefited from the nearby Cleveland in Southern California or the Tonto to Phoenix's north and east. Anyone standing in downtown Santa Fe, New Mexico, in the winter and gazing on the snowcapped Sangre de Cristo or Jemez Mountains should know how important the Santa Fe National Forest is whenever they turn on the shower, water their yards, or wash a car. "From the top of the mountain to the last irrigated acre," observed forester C. Otto Lindh in 1950, "people are affected by what happens on all the land."

This is particularly true in dry country. Because water "is the most precious item of all in the Southwest," noted Lindh, who served as regional forester for New Mexico and Arizona, it was incumbent on the agency and its partners to maintain healthy watersheds. "Devegetated lands, eroding lands, silt-producing lands and sand-dune farming lands are leading to water shortages, clogged channels, declining water storage capacities and eventually, if not corrected, will lead to despair and financial ruin. The land must have care and rehabilitation, regardless of ownership, if society is to survive."[3]

Lindh's emphasis on the impact of grazing on the upper reaches of the region's rivers was understandable. In the mid-20th century, sheep and cattle still constituted a significant presence in the forest, through which flowed water heading to the Rio Grande, Pecos, and Red Rivers. In subsequent decades, timber production took priority, harvests producing millions of board feet and boosting the local economy. But it also damaged hills, slopes, and riparian corridors; as snow melted, and spring and monsoonal rains fell, the cut-over lands eroded and riverbanks gave way.

The social fabric also frayed, a partial consequence of the Forest Service's clearcutting practices, which by the 1960s were met with protests across the country. In New Mexico, as in Washington, Montana, Texas, and West Virginia, people protested timber-management strategies as well as highway, dam, and resort projects. They also sought more wilderness designations and greater communal access to forest resources.

Piñon pine, juniper, ponderosa pine, and Douglas fir green a red-rock canyon of the upper Pecos River in winter.

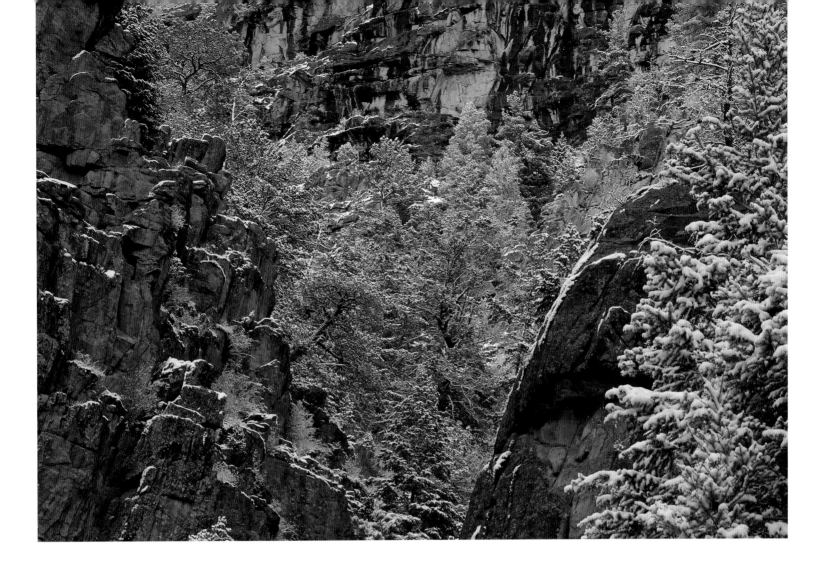

Unique to the Land of Enchantment was a series of tense confrontations resulting from putative Spanish land-grant claims to the lands that form the Carson and Santa Fe National Forests.[4]

A more dynamic and democratic process came out of these engagements. In response to the related passage of the National Environmental Policy Act (1970), public-lands agencies like the Forest Service incorporated the public in its decision making. Although the inclusion of these many and varied voices has not been easy, there is nothing new in this idea. "National Forests are made for and owned by the people," Gifford Pinchot declared in 1907. "This means that if National Forests are going to accomplish anything worthwhile the people must know all about them and must take a very active part in their management."[5]

Consider what happened on the afternoon of June 26, 2011, when a burst of wind dropped a 75-foot-tall aspen on a power line in the Santa Fe National Forest. Sparks ignited an inferno that then raced through the forest with astonishing speed—in its first 14 hours it charred an acre every 1.17 seconds. Within a month the Las Conchas fire had burned 156,000 acres. Then came the summer rains, which let loose dangerous debris flows that befouled the Rio Grande River. One of its tributaries alone deposited 70 feet of ash at its confluence with the river's main

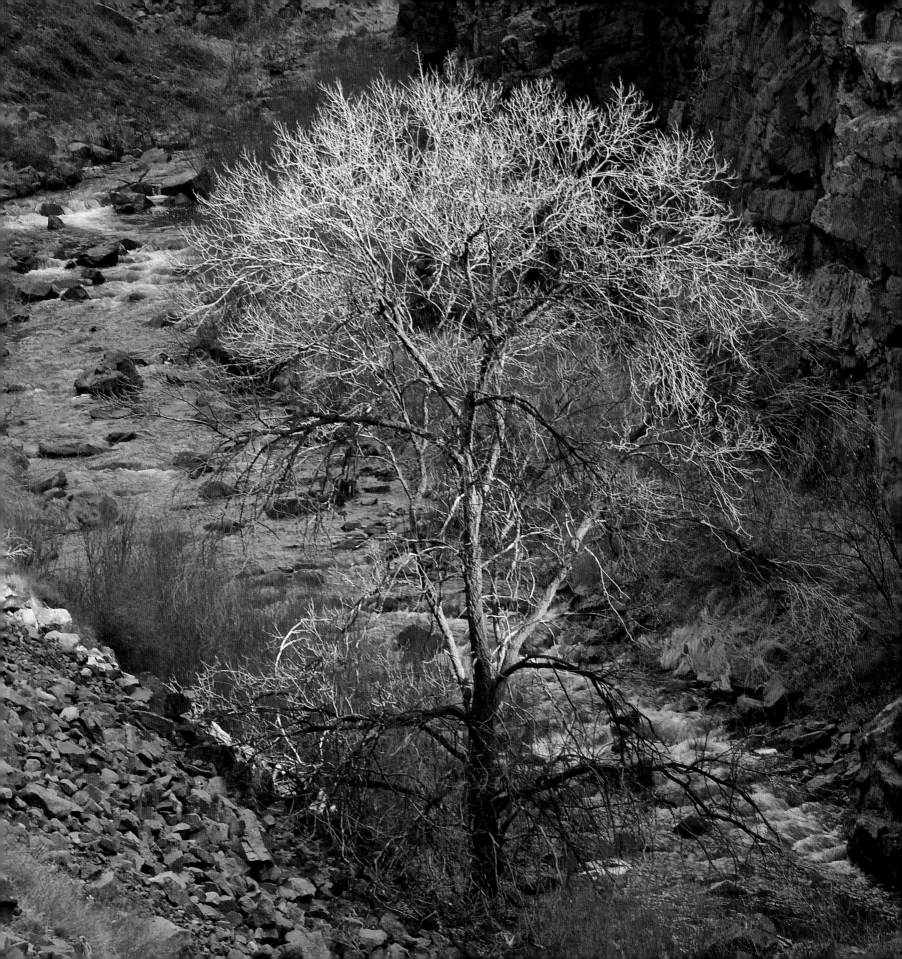

stem. So compromised were its waters that the cities of Santa Fe and Albuquerque had to stop using the Rio Grande for their municipal needs for weeks afterward. What happens in the forest does not stay there.[6]

The City of Santa Fe had already learned this worrisome lesson after watching Denver's national-forest watersheds go up in smoke in 1997 and again in 2002. It was aware too that nearby Los Alamos, New Mexico, had been forced to shut down its water system for four months after the 2000 Cerro Grande fire. In response, Santa Fe's Water Division, in partnership with the Forest Service, received earmarked funds from Congress in 2003 to underwrite forest-thinning operations by controlled burns and mechanical means. To continue this restoration work, the city sought a more consistent and stable stream of money. In stepped the Nature Conservancy, which had been involved in projects in South America testing whether downstream communities would be willing to pay for upstream watershed protection. Santa Fe was intrigued. The city vetted the idea of a taxpayer-supported water fund with its citizens, and with their approval the Santa Fe Water Source Protection Fund—a 20-year-long, cost-sharing initiative with the Forest Service—was born.[7]

That work continues, and is being adopted across the West, a reflection of the ongoing relevance of the 1897 Organic Act's insistence on the ineluctable link between forest health, streamflow, and public welfare.

Santa Fe National Forest includes woodlands at the southern limit of the Rocky Mountains and also golden-lit canyons typical of the Southwest. Here Rio Guadalupe pummels through a box canyon on its way to the Jemez River.

Gila National Forest

An unsung highlight of southwestern deserts, the Gila River begins with three wild forks in Gila National Forest in southwestern New Mexico. Here is the largest wilderness in the Southwest and also the first official wilderness in America, administratively designated in 1924 at the urging of Forest Service wildlife ecologist Aldo Leopold. The National Wilderness Preservation System grew to include 441 national forest areas where motorized use is banned, in contrast to the rest of the national forest system where nearly 400,000 miles of roads have been built. The hiking route pictured here along the Middle Fork of the Gila River includes 30 fords of the shallow stream—also a refuge of threatened Gila trout.

The most famous wolf to trot through the pages of American nature writing died at the hands of Aldo Leopold. Years later, in *A Sand County Almanac*—one of the sacred texts of the modern environmental movement—Leopold revived the mother wolf and her cubs and relived the moment when, "full of trigger-itch," he and his comrades pumped round after round into the "melee of wagging tails and playful maulings." His then-youthful rationale—"In those days we had never heard of passing up a chance to kill a wolf"—no longer convinced him. Leopold would recall climbing down the steep rimrock to where the mortally wounded wolf lay, just "in time to watch a fierce green fire dying in her eyes," a haunting vision. Maybe Henry David Thoreau was right, he mused; instead of extirpating the untamed, we should recognize that in "wildness is the salvation of the world."[8]

This transformative incident is thought to have occurred in the Apache National Forest in north-central Arizona. However, it was in southwestern New Mexico, in the Gila National Forest, that the famed conservationist would act on his emerging understanding of the value of wilderness preservation. Before doing so, Leopold conferred with Arthur Carhart, the Forest Service's first landscape architect, about Carhart's plan to preserve the unspoiled nature of Trappers Lake in the White River National Forest. Drawing on Carhart's ideas for inspiration, in 1921 Leopold published what amounted to a declaration of principles. "By 'wilderness,' I mean a continuous stretch of country preserved in its natural state, open to lawful hunting and fishing, big enough to absorb a two weeks' pack trip, and kept devoid of roads, artificial trails, cottages, or other works of man."[9]

Even in the 1920s, not many places would meet all these qualifications, but the upper watershed of the Gila River did. Its topography—"mountain ranges and box canyons"—had isolated it from development, leaving it in a "semi-virgin state," Leopold affirmed. Its relatively pristine character made it perfect for his purposes: the Gila was the "last typical wilderness in the southwestern mountains. Highest use demands its preservation."[10] With the support of Forest Service Chief William B. Greeley and regional forester Frank Pooler, he submitted a proposal to designate the vast region a wilderness. To that end, on June 3, 1924, the Forest Service set aside 755,000 acres, the world's first such designation; appropriately, a portion of it today bears Leopold's name.

Leopold's remarkable legacy comes with a core assumption that wilderness is absent of, and an antidote to, civilization, a place separate and apart from human impress. This idea emerged in the late 19th century in response to the Industrial Revolution and rapid urbanization. Writers such as John Muir asserted that the call of the wild would be a tonic for those living in cramped, dense cities. That understandable idea only makes sense however in the context of other historic forces that had emptied these lands of the people who once lived within them. The Gila wildlands, which Leopold encountered in the early 1920s, and today draw thousands of hikers every year to

test themselves against the site's sheer cliffs, towering mesas, and frigid waters, is devoid of people as a direct result of the Mexican-American War and the Gadsden Purchase of 1853. To manifest its control over the region, the U.S. Army ultimately defeated the Apache, and relocated them to reservations. Even with their forced removal, evidence remained that what would become a wilderness had supported a series of complex, material-rich societies dating back to the Paleo-Indian peoples who occupied the Gila highlands roughly 11,000 years ago. To declare this land wild, then, was to set aside this past in favor of a new vision of what constituted the wild.[11]

Excluding fire from the Gila has been as complicated a proposition. In response to the 1910 Big Burn, which consumed millions of acres in Washington, Idaho, and Montana, total suppression became national policy. After research revealed that old-growth ponderosa pine, a dominant species in the Gila, "germinated, established, and lived most of their lives under the effects of repeated fire," the Forest Service experimented with allowing lightning-ignited fires to burn or setting prescribed fires to replicate historic fire regimes in the forest. This pathbreaking decision led to a new emphasis on ecological restoration, on managing *with* fire not against it, a policy receiving its most significant test with the 2012 Whitewater-Baldy conflagration. That fire torched 297,845 acres, mostly in the wilderness area, the single largest in New Mexico history.[12]

Accepting the need for a stand-replacement fire was a reflection of an attitude Leopold had urged Americans to adopt, "an intelligent humility toward man's place in nature." Accepting our more humble status comes with the recognition that we "live in a world of wounds." Our task is to repair them—just as Leopold did when he pushed for the creation of the Gila Wilderness.[13]

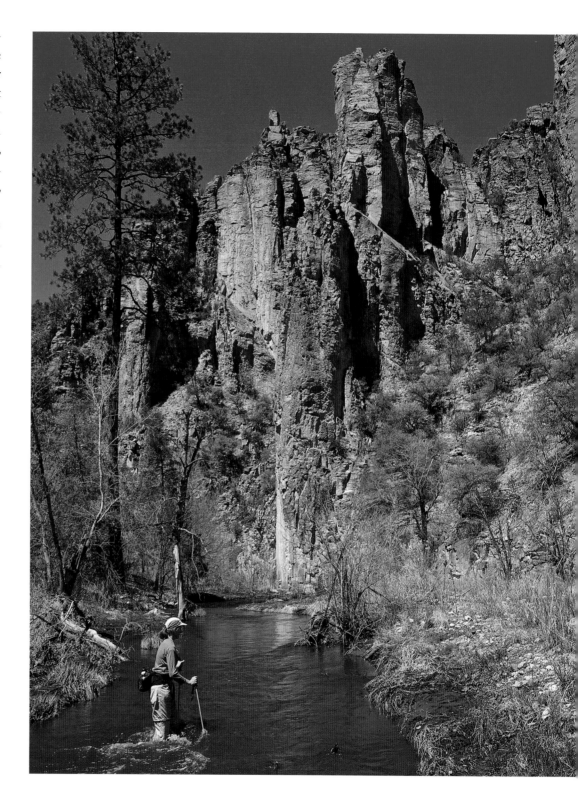

Tonto National Forest

Springtime cottonwoods and willows brighten the Verde River below Saguaro Reservoir. Throughout summer, this river at the eastern edge of Phoenix sees intensive recreational use, challenging Forest Service managers with the full range of urban recreation problems.

Fred Croxen, who became a forest ranger in Coconino National Forest in northern Arizona in 1910, "lived a life out of a Hollywood Western," his niece remembered. "Gary Cooper would have been perfect in the role of my uncle." She may have been referring to the hardships Croxen endured snowshoeing through furious blizzards, riding the range under a broiling sun, or outdrawing a trigger-happy cowpoke. What she may not have known was that her uncle had a keen eye for changes in the land, subtle and dramatic, and left an important record of his insights.[14]

When he transferred to Tonto National Forest in the early 1920s, for example, the alteration in physical environment took some getting used to. Wrapping around Flagstaff, Arizona, the Coconino, with its high-elevation pine forests, was much cooler than the Tonto, with hot and arid Phoenix to its immediate south. Although timber was harvested in the three-million-acre Tonto, grazing was its major economic generator. In the last years of the 19th century, more than two million animals had grazed this range, hammering the soil and depleting native grasses. When Croxen arrived, the Forest Service had whittled the number of cattle down to 85,000, but the damage was done.

Early homesteaders in the Tonto Basin and the Salt River Valley confirmed that the landscape once had been much healthier. In the 1880s, a rancher told Croxen that Tonto Creek had been "timbered with the local creek bottom type of timber from bluff to bluff, the water seeped rather than flowed down through a series of sloughs,

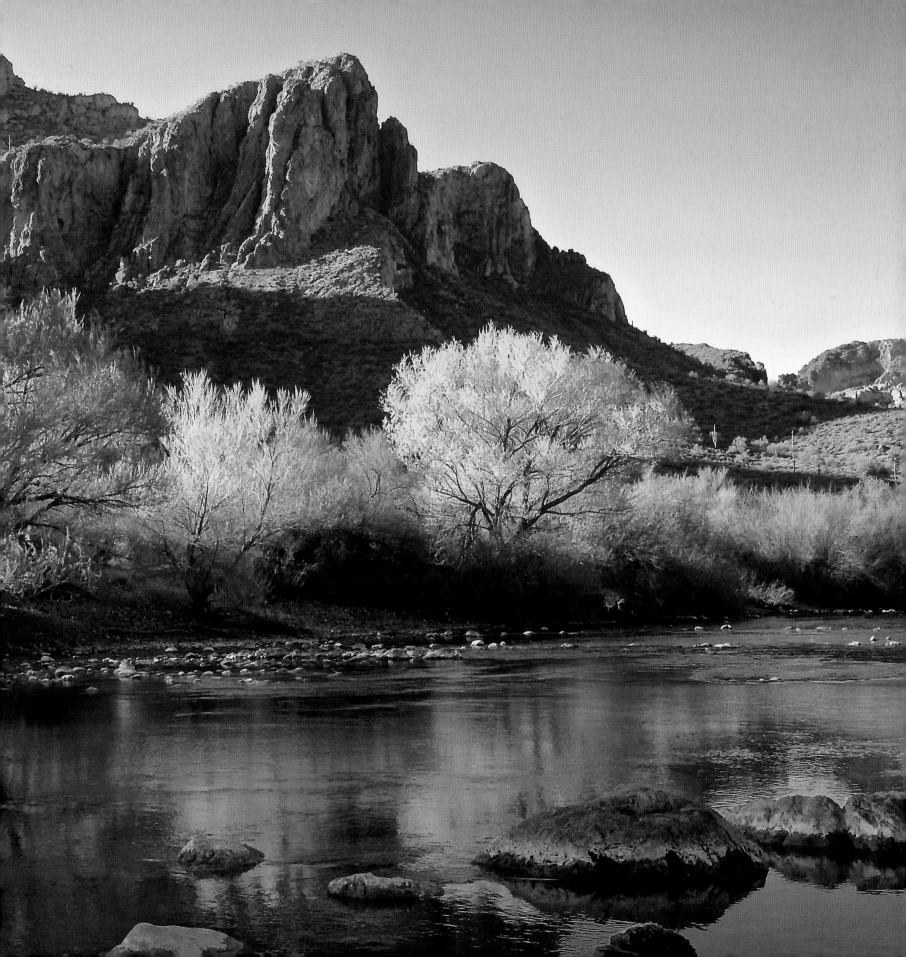

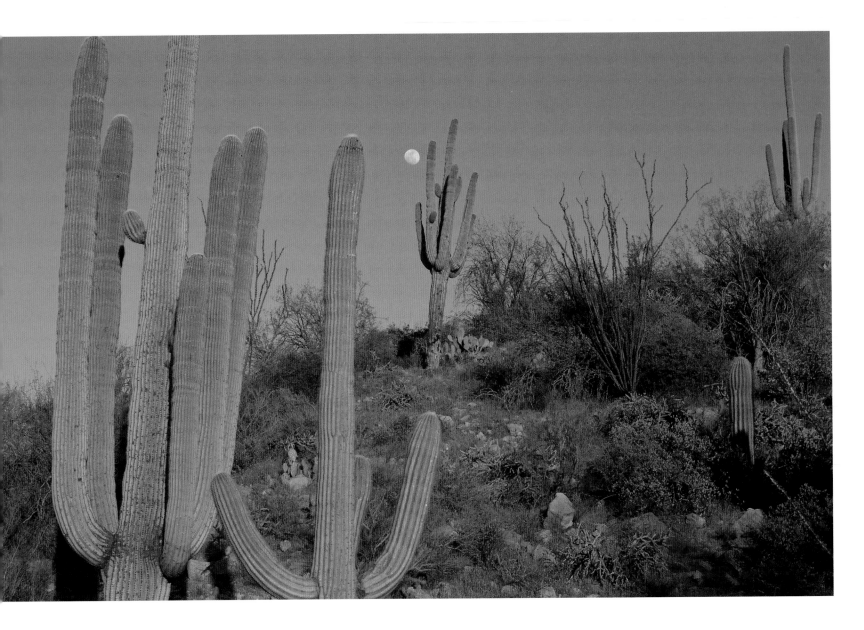

and fish over a foot in length could be caught with little trouble." Nothing like this bounty remained when Croxen arrived in 1910. "Today, this same creek bottom is little more than a gravel bar from bluff to bluff," the Forest Service ranger observed. "Most of the old trees are gone, some have been cut for fuel, many others cut down for the cattle during drouths [*sic*] and the winters when the feed was scarce on the range, and many have washed away during the floods that have rushed down this stream nearly every year since the range started to deplete. The same condition applies to practically every stream of any size on the Tonto."[15]

The level and source of the devastation would not have surprised Gifford Pinchot. In 1900, as head of the Bureau of Forestry, he had investi-

gated grazing's impact along Arizona's Mogollon Rim in the company of local ranchers and irrigators. His conclusion was that by eating and trampling seedlings, sheep in particular inhibited regeneration and increased erosion, harming the forest. Yet for political reasons Pinchot did not exclude livestock from federal lands, believing he faced a simple choice: "shut out all grazing and lose the Forest Reserves, or let stock in under control and save the Reserves for the Nation."[16]

To help regulate the industry, in 1901 Pinchot hired Arizona stockman Albert Potter to lead the newly established grazing division. He charged Potter, who had traveled with the forester on his inspection of the Arizona range, with developing strict regulations to protect forests and grasslands; overgrazing would lead to the forfeiture of the relevant permit. Enforcing these codes, as Croxen's later observations along the Tonto River revealed, proved more difficult than writing them.[17]

Grazing has challenged Tonto National Forest ever since. Indeed, in 1944 forest supervisor F. Lee Kirby mimeographed Croxen's reflections so that his staff would have baseline data by which to evaluate the lands they stewarded. "In the light of range management problems as we now recognize them," he wrote his colleagues, "Croxen's memorandum has a great deal of interest and value. He was doing some very correct thinking."[18]

Correcting the course in the Tonto, and other livestock-heavy forests, has taken time and commitment. During World Wars I and II, the pressure to supply Allied troops with meat overrode environmental concerns. Long-standing disputes between valley farmers, who believed grazing limited their water supplies, and ranchers, who disputed those claims, continued across the late 20th century. Hoping to resolve these tensions, and return the land to health, the forest's managers worked to create consensus in support of moving animals off the range, through voluntary compliance or, when that did not work, by pulling permits or raising grazing fees. At times, political blowback would undermine its more collaborative approach, complicating forest rangers' actions. Restoring the Tonto's environmental integrity has been an almost Sisyphean labor.[19]

Restoration efforts have become even more daunting, as a climate-driven drought, coupled with an extended fire season, has wracked the forest. Beginning in the late 1990s, the Tonto's leadership realized that these pressures were exerting severe stress on soils, on flora and fauna, and on ground and surface water systems. To reduce these strains, in 2004 its managers developed a scientifically derived drought policy framed around the Standardized Precipitation Index. This index monitors the probability of precipitation at any given time as a way to gauge the onset and end of dry spells. Land managers use these data to assess soil moisture levels that then determine when, or if, restocking of the range can occur. In the case of prolonged or severe drought, which has hammered the Tonto Basin and much of the Southwest since the early 2000s, two or more growing seasons would be required before cattle would be allowed back in the forest. A reflection of this restriction's effect is revealed in the number of animals allowed on the range. In the 2010s, the annual allotment of cattle in the Tonto shrank from 26,000 to 21,000.[20]

Whether this policy, or any like it, will bring back the lush grasslands that greeted the first ranchers in the Tonto region is doubtful. The massive ecological transformation that grazing generated—which in 1924 Leopold lamented as the "radical encroachment of brush"—has been entrenched for more than a century. Its hold will deepen further, if, as predicted, these lands dry out across the 21st century.[21]

As quintessential desert terrain, this garden of saguaro and ocotillo in Tonto National Forest is found in the Pine Creek basin of the Mazatzal Mountains north of Phoenix.

Humboldt-Toiyabe National Forest

The Spring Mountain escarpment emerges out of the desert to heights raking snowfall from winter clouds and supporting ponderosa pines and Douglas firs here at Cathedral Rock, within sight of arid Las Vegas, Nevada. Unlike most national forests, Humboldt-Toiyabe occupies seven discrete and isolated locations. Spread across Nevada and California, they constitute the third-largest national forest; only Alaska's Tongass and Chugach are larger. Most of the highest, snow-catching mountains of Nevada's distinctive Basin and Range Province lie within this national forest.

"Possessed of keen sight and scent, and strong limbs," John Muir wrote in unfettered praise of bighorn sheep, "he dwells secure amid the loftiest summits, leaping unscathed from crag to crag, up and down the fronts of giddy precipices, crossing foaming torrents and slopes of frozen snow, exposed to the wildest storms, yet maintaining a brave, warm life, and developing from generation to generation in perfect strength and beauty."

That Muir, a lover of all things wild, had reserved a special place in his heart for this dazzlingly agile creature, or that his words might be read as a reflection of his belief in the fearlessness of his mountaineering self (after all, he had scaled up these same mountaintops), is only part of the story. For him, "the self-reliance and strength and noble individuality of Nature's sheep" also testified to the sanctity of the Sierra Nevada, and to the vast region sweeping east to Utah's Wasatch Mountains. It was, he wrote, home to "more than a hundred subordinate ranges and mountain groups, trending north and south, range beyond range, with summits rising from eight to twelve thousand feet above the level of the sea, probably all of which, according to my own observations, is, or has been, inhabited by this species." It took a tough animal to survive in such tough territory.[22]

Although Muir admitted that humans posed the greatest threat to wild sheep, he expected that the "remote solitudes of the High Sierra" would shield them, offering an impregnable "rocky security" to "the bravest of all the Sierra mountaineers." About this, Muir's optimism was misplaced. The security these remarkable animals may have enjoyed in the late 19th century quickly collapsed, a loss most evident in the high-altitude refuges over which he had rhapsodized.[23]

Many of these windswept outcroppings and boulder fields are located within the Humboldt-Toiyabe National Forest, which at 6.3 million acres is the largest in the Lower 48. It is far from a unified landmass, however, and is scattered across California and Nevada with individual ranger districts separated by wide, arid valleys. From the snow-capped eastern front of the Sierra to the Spring Mountains, which frame Las Vegas's western horizon, the forest stretches out to the Shoshone, Toiyabe, and Monitor Mountains in central Nevada and then to the Ruby, Santa Rosa, and Schell Creek Ranges in the Silver State's north and east. With peaks that climb to 13,000 feet, these remote, thin-air aeries might well have protected the bighorn had not people prized its meat and horns, or coveted the alpine meadows it browsed.

The Paiute and Shoshone people had hunted the sheep, as Muir knew, having climbed up to rock-wall blinds built near the crests of the Nevadan mountains. These artifacts constitute some of the thousands of archaeological sites scattered across the Humboldt-Toiyabe. But the indigenous people did not extirpate the sheep. That was the result of hunters with rifles. So deadly was their aim that they rapidly winnowed the bighorn's numbers, leading the Territory of Nevada in 1861 to establish the first seasonal hunting prohibition.

The losses mounted for another reason. In the post–Civil War era, huge herds of sheep,

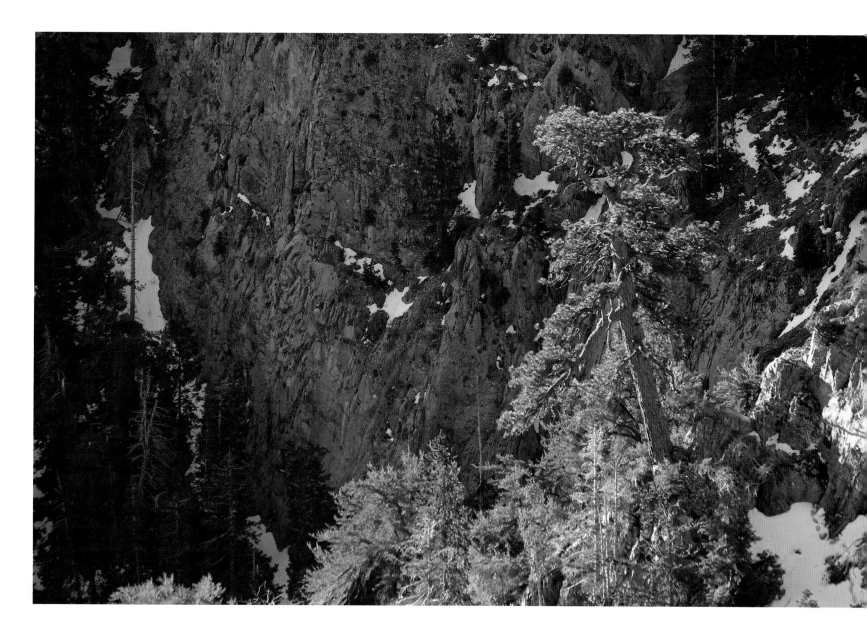

cattle, and goats ranged over nearly every foot-hill and mountain chain in the American West. As livestock mowed the grasslands, they simply outmuscled native sheep for essential nutrients.

In the hope that setting aside sanctuaries would stabilize bighorn populations, Oregon and other states created refuges in the '10s and '20s;

the federal government followed suit in 1936 with the 1.6-million-acre Desert National Wildlife Refuge, covering the desert mountains just north of Las Vegas. These good intentions came to naught. Some western states reported the bighorn's extirpation as early as 1902; they were gone from California in 1913 and Nevada in 1940.

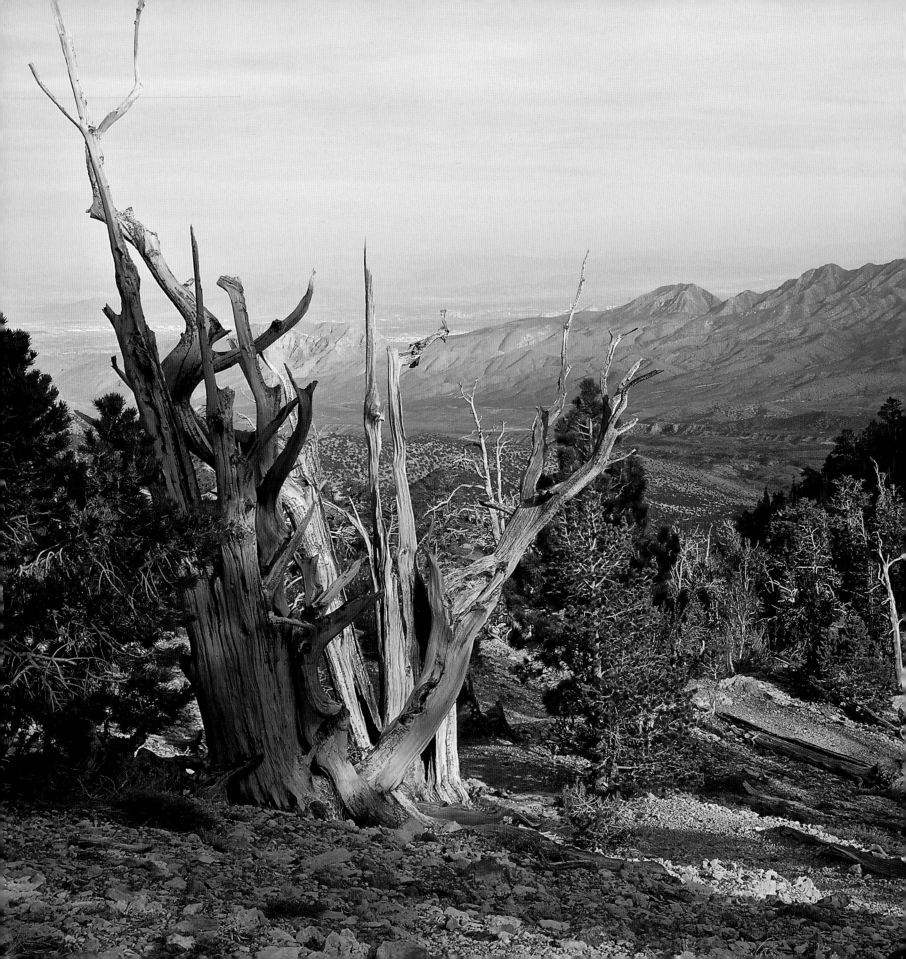

By the 1960s, with a better understanding of the animal's life cycle and needs for habitat, food, and water, conservation biologists and wildlife managers collected healthy bighorn sheep from British Columbia, reintroducing them to their former range. Some of this work occurred in the Humboldt-Toiyabe, and yet despite the best efforts of federal and state agencies, only in select areas did the newly introduced animal recover. By the mid-1990s, in fact, the Sierra population stood at a mere 100. Finally, in 2000, the U.S. Fish and Wildlife Service declared the obvious: in California and Nevada, *Ovis canadensis sierrae* was an endangered species.

By itself, this new status did little to alter the situation on the ground. Much more effective has been research in the Humboldt-Toiyabe and other forests and grasslands beginning in the 1950s that revealed a hitherto unknown factor in the animal's original decimation and its puzzlingly slow, uneven recovery. Livestock, especially sheep and goats, transmit pathogens and parasites to bighorns, which are most susceptible to pneumonia and psoroptic scabies. These, individually or in combination with other pathogens, have been critical to the all-age die-offs in wild sheep populations, past and present.

These data have led scientists and policy makers to consider new management criteria that will reduce range overlap between wild and domesticated sheep and minimize even the potential association between the two populations. If the challenging goal of managing for sustainable grazing and bighorn sheep is successful, we will have returned to their highland domain those animals Muir touted as "the bravest of all the Sierra mountaineers."[24]

Protected by high elevations of the Spring Mountains, bristlecone pines in Humboldt-Toiyabe National Forest have survived for thousands of years. In this cold, semiarid habitat, even dead trees remain standing for thousands of years.

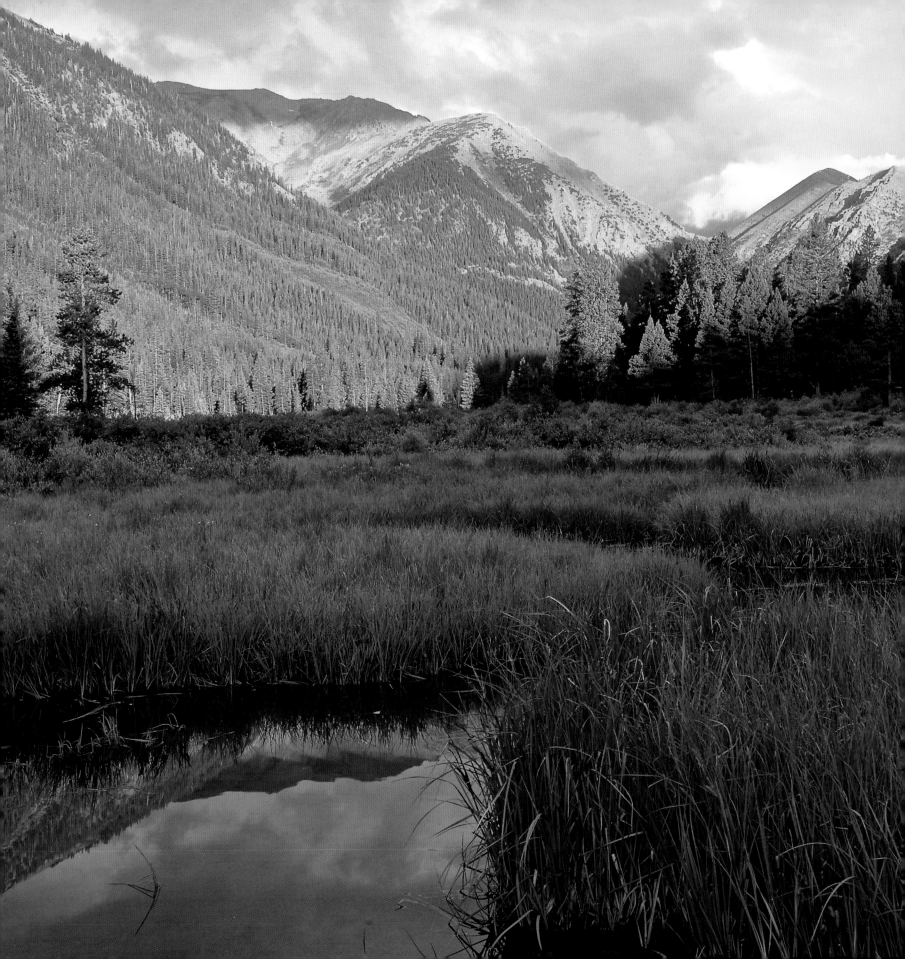

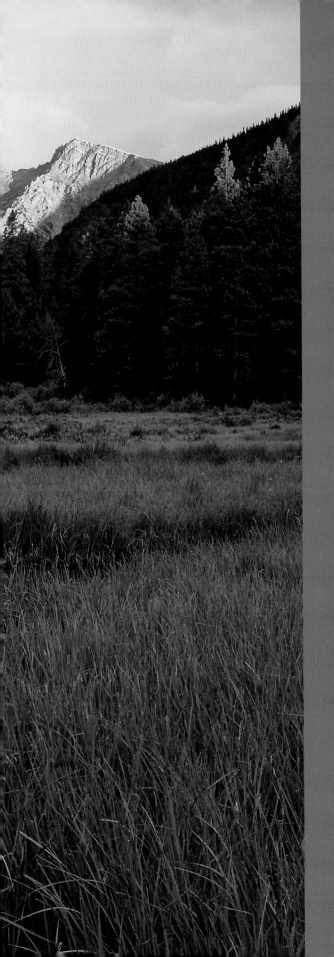

THE
SOUTHERN
ROCKIES

5 STATES

17 NATIONAL FORESTS

7 NATIONAL GRASSLANDS

20 MILLION ACRES

30.7 MILLION VISITORS

"Rocky Mountain High" says it best. The Southern Rockies—here defined as the portion of that greatest American range ramping up from New Mexico's northern border and corrugating the western half of Colorado and eastern third of Utah—are a wonderland in anyone's book. The peaks are tall. Colorado boasts 53 above 14,000 feet. Valleys are wide; in fact, the Southern Rockies are typified not by a continuous mountain crest like we see in the Sierra Nevada or even Appalachians, but rather by impressive sky sweeps of terrain interspersed with ranchland valleys and rivers meandering toward canyons, deserts, and plains. Aspen groves are poster children of beauty, and wildflowers are the best anywhere.

While the perils of global warming are felt elsewhere, few landscapes other than quickly receding glacial remnants expose such dramatic signs of crisis as the pine-covered national forests in the Southern Rockies. Lacking the population-pruning cold snaps of winters past, bark beetles are reducing whole eyefuls of landscape to starkly gray multitudes of dead sticks awaiting a lightning strike. The mountains here are also tinted with minable minerals, and so the roads, scrapings, tailings, and outwashes of poisonous metals have left thousands of miles of streams for the worse. Yet the Rockies remain the Rockies, and few can resist the exuberant feeling that comes when perched on their heights or comforted by their meadows, forests, and canyons.

My regret photographing this medley of topography and light was that I couldn't spare a lifetime for the job. I arrived in June and labored my way through the beauty, canyon by canyon, range by range. The snows of winter were melting fast, the blooms of flowers were climbing the stairs of the slopes, and the peaks and rivers all called out to me at once. — TIM PALMER

PREVIOUS SPREAD: Lodgepole pine forests envelop lower slopes of the Sawatch Range in San Isabel National Forest. Here Halfmoon Creek drifts down in the gap north of Mount Elbert—Colorado's highest peak at 14,440 feet. OPPOSITE: East of Aspen, Colorado, Independence Pass is reached on one of the more spectacular scenic roads in the Rockies. Travelers can step directly out of the car and into alpine terrain for miles of hiking. San Isabel National Forest lies on the east side of the pass; White River National Forest on the west. Lightning accompanying thunderstorms like the one brewing in the background makes it imperative to get off the high peaks before noon.

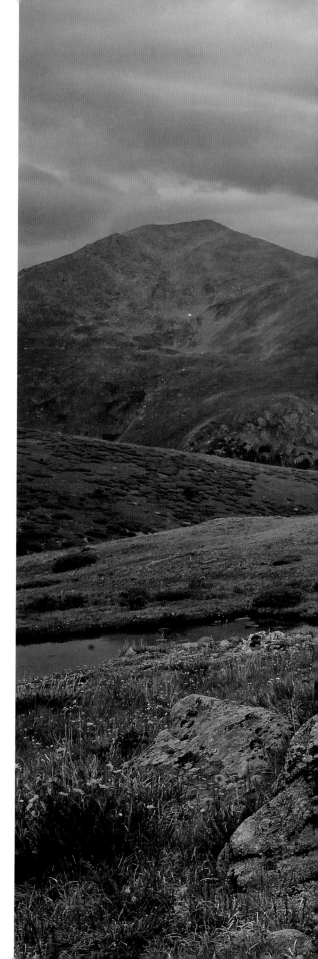

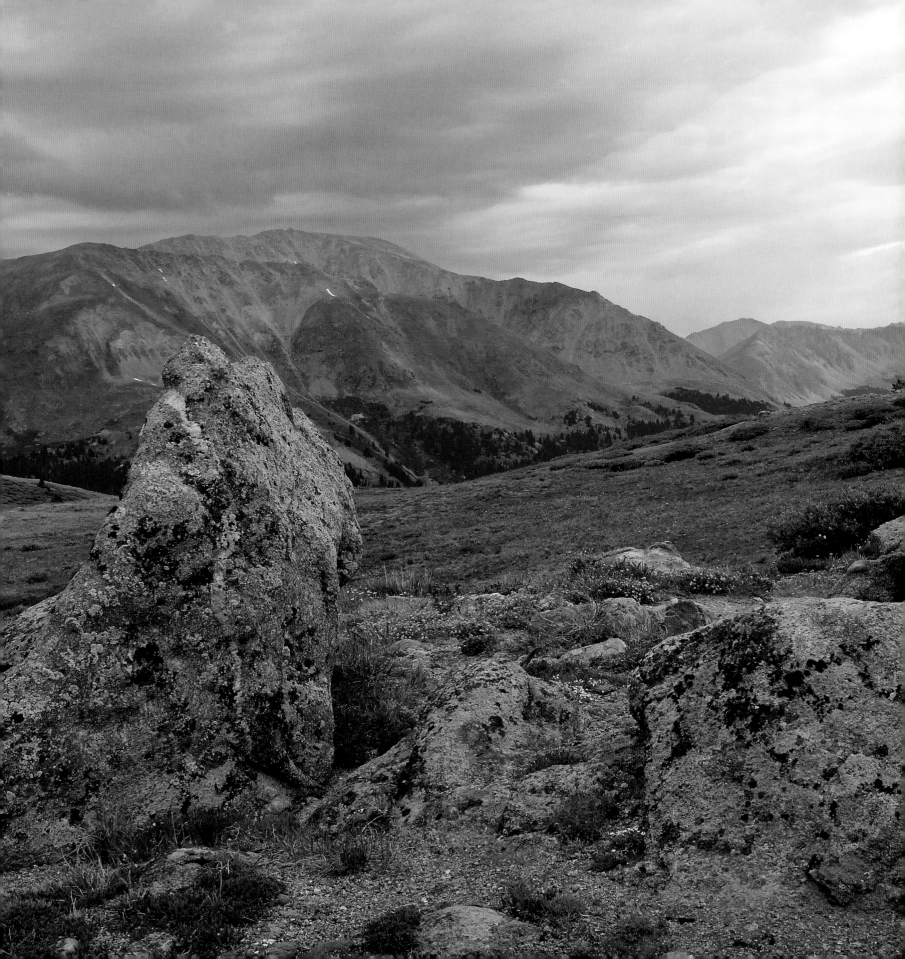

The Sandhills of Nebraska, a vast stretch of rolling prairie in the center of the state, seem an unlikely place for a national forest, let alone one administered in conjunction with the iconic high-elevation forests of the Rocky Mountains. Yet the Nebraska National Forest's very existence is a perfect reflection of the ambition of late 19th-century and early

20th-century foresters to manage landscapes, treeless or wooded, and make them productive.

Botanist Charles Bessey, whose surveys of the Sandhills revealed relic stands of ponderosa pine, concluded that this area could be successfully reforested. In setting forth to prove his point, he wanted to demonstrate, as did other contemporary researchers, that science had real-world, practical applications. The Forest Service wanted to make the same case, which is why Gifford Pinchot promoted Bessey's ideas to an easily convinced President Theodore Roosevelt. In 1902, Roosevelt created the Dismal River, Niobrara, and North Platte Forest Reserves; five years later they were consolidated as the Nebraska National Forest. Congress did its part, providing funding to launch the first federal forest nursery—now known as the Bessey Nursery—to generate the requisite seedlings. Once planted, the 20,000 acres of pine and cedar located in the Bessey Ranger District became the nation's largest human-planted forest.

Contrast this intensely managed terrain with the very wild Shoshone National Forest. It is the oldest national forest in the continental United States, having been set aside in 1891 as the Yellowstone Timberland Reserve, and it surrounds the eponymous national park in northwestern Wyoming. The majority of its 2.4 million acres is designated wilderness, ranging from sagebrush flatlands to snow-capped mountains, among them Gannett Peak, which at 13,804 feet is the Cowboy State's highest point. More than 330 different wildlife species inhabit the forest. Grizzly bears, which have been wiped out almost everywhere else in the Lower 48, roam these wildlands, as does perhaps the largest population of bighorn sheep. By any number of measures, the Shoshone could not be more different than the Nebraska.

Such distinctions are actually the norm for this region, which is spread across Wyoming, Colorado, South Dakota, Nebraska, and Kansas. Each of the region's 24 units has unique features and faces special challenges. It is not easy balancing the conflicting demands of industrial energy production, grazing, and recreation in the Thunder Basin and Shawnee National Grasslands, or controlling invasive species that further damage environmental health. Just as

Quaking aspens dress the mountains at McClure Pass, south of Carbondale, Colorado, in Gunnison National Forest. Frequently germinating after fires, aspens spread by root sprouts; entire cloned masses are genetically identical. Though found on many of the western mountains, aspens thrive best in national forests of the Southern Rockies.

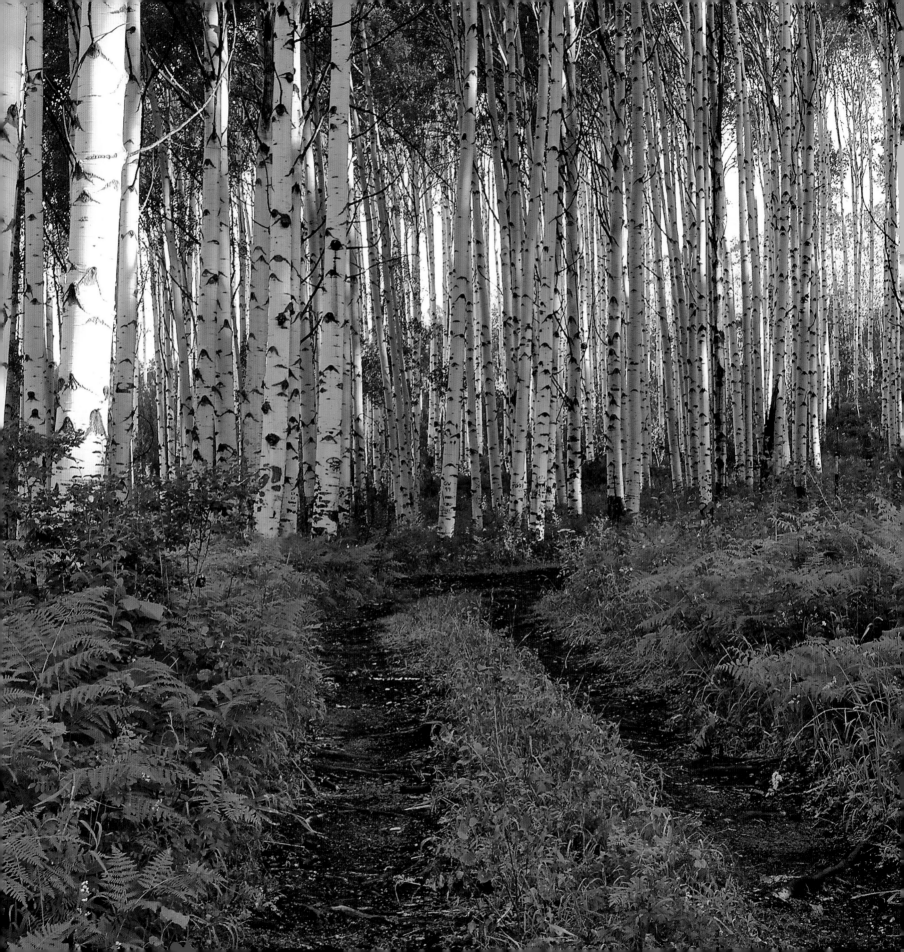

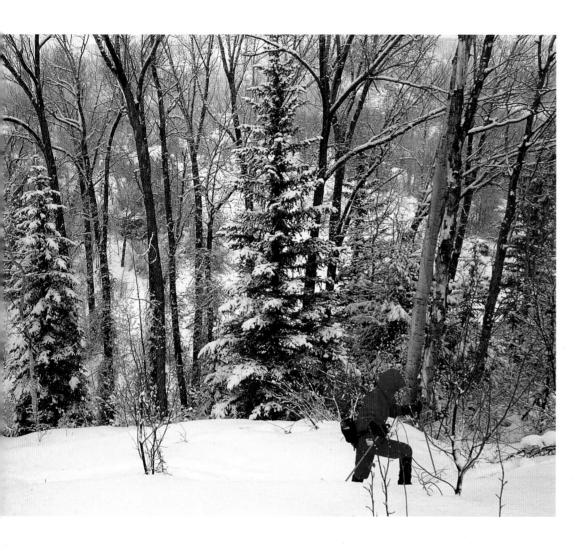

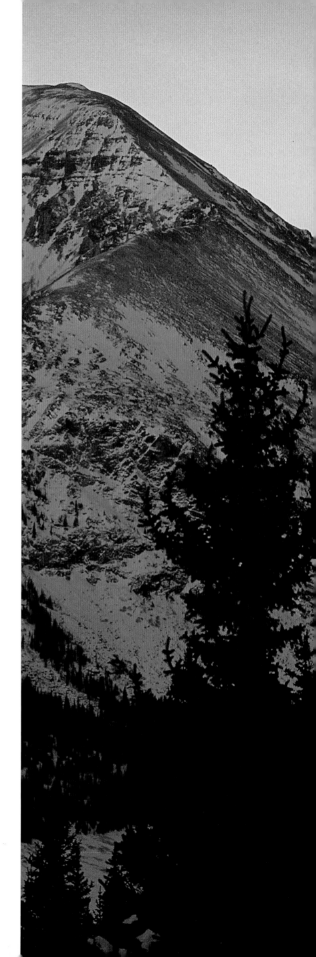

ABOVE: Ann Vileisis breaks trail through accumulating snow along the Smith Fork of the Gunnison River, Gunnison National Forest. Millions of winter enthusiasts flock to ski resorts, not only in the popular hot spots of Colorado, but also on snowy slopes from Waterville Valley in White Mountain National Forest of New Hampshire to Mammoth Mountain of California. Backcountry travel takes others into the heart of snowy terrain.

OPPOSITE: At daybreak, in single-digit cold, the moon sets toward the western horizon seen from Hoosier Pass, in the headwaters of Colorado's South Platte River Basin. Flowing from Pike National Forest, this river is the water supply for Denver as well as other cities on the Rocky Mountains' east slope and onward to vast farm acreages in the Great Plains.

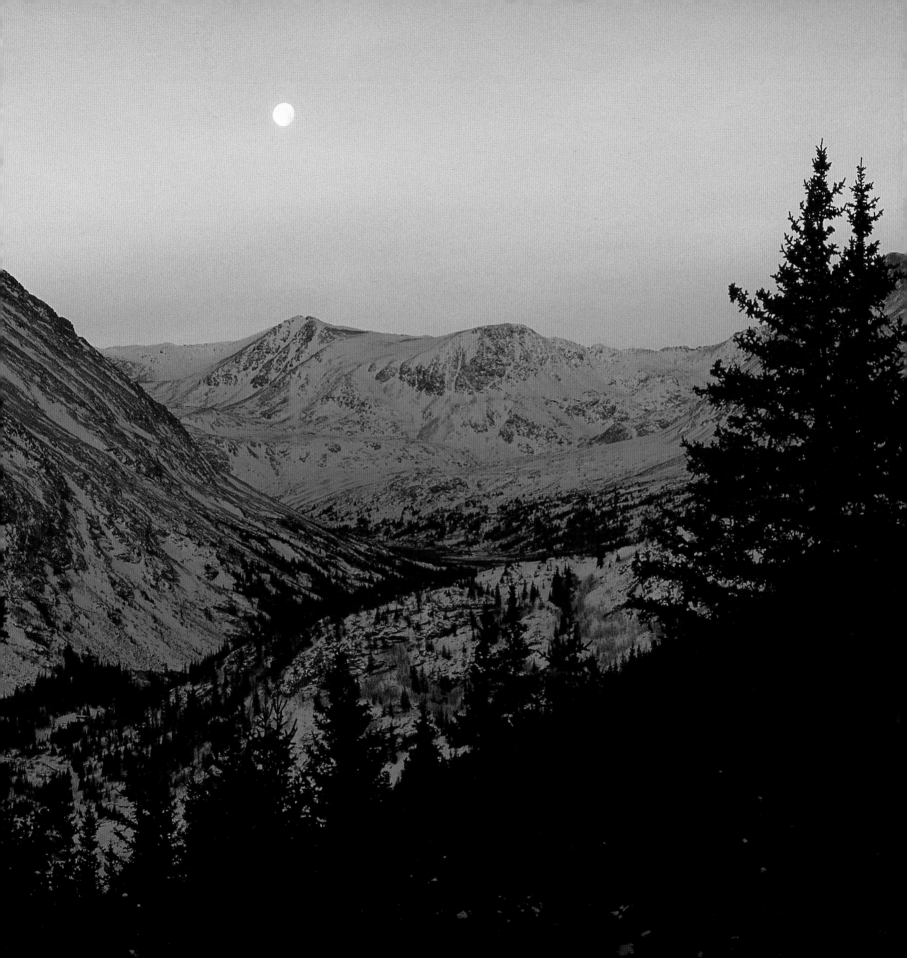

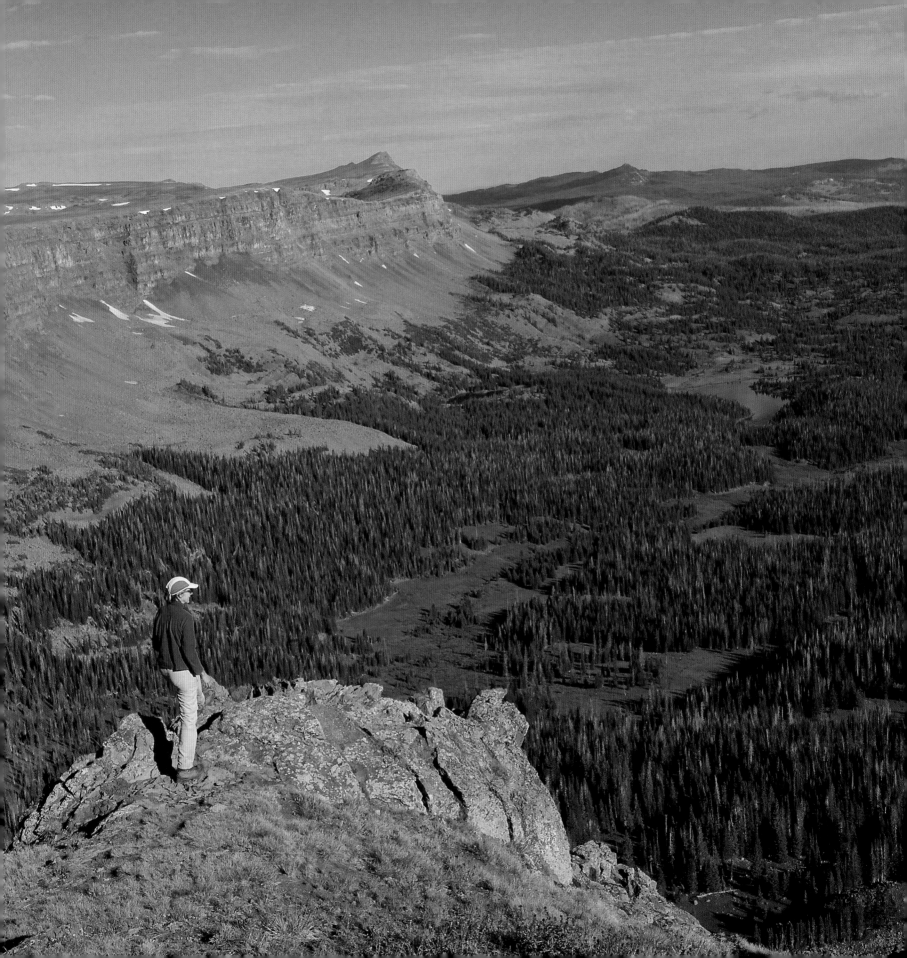

tricky is resolving the heavy impact that recreational users have on the White River, Arapaho and Roosevelt, and Pike and San Isabel, the top three most-visited national forests in the United States. Rock climbing, mountaineering, and off-road vehicles—not to mention the millions of skiers annually schussing down these forests' well-manicured slopes—are altering the physical landscape, ecosystem dynamics, and visitor experience.

The greatest test facing the Southern Rockies, though, comes in the form of the tiny mountain pine and spruce beetles. These bark borers feed on stressed forests suffering from drought and heat or damaged by windthrows and fires. The conditions in the Rockies and the West more generally have proved perfect for these opportunistic pests. Since 1996, the mountain pine beetle has impacted 3.4 million acres in Colorado, an equal number in Wyoming, and more than 400,000 acres in South Dakota. Data from a 2013 aerial survey of the region indicated that the infestation was slowing down. This was attributable to the fact that there were relatively few mature trees that had not already been affected; the mountain pine beetle was running out of food.[1]

The same cannot be said for the spruce beetle, which initially attacks wind-toppled Engelmann and blue spruce. Once locked into these trees, the insect reproduces rapidly and fans out to and bores into live trees. Like the mountain pine beetle, the spruce beetle population has benefited from a warming planet. Because fewer of its population die during the less-frigid winters, the infestation can spread farther. Between

1996 and 2013, for example, more than 1.4 million acres in Colorado were affected, and the number is growing at a rapid rate. This pattern is similar to what is happening on all forested lands in Wyoming, and so swiftly has the outbreak moved that researchers are reporting entire drainages have been consumed within a year.

Add to this devastation the related worry that these vast numbers of dead or dying forests are highly susceptible to catastrophic fire. Indeed, Colorado has experienced intense conflagrations since the early 2000s, some the state's largest and most destructive. The Hayman (2002), High Park (2012), Waldo Canyon (2012), Black Forest (2013), and West Fork Complex (2013) fires tore through more than 370,000 acres, scorching the earth, blackening the skies, compromising water quality, and incinerating neighborhoods. Yet there is a silver lining in these charcoal-dark clouds. These infernos also have generated innovative interagency initiatives on wildland fire management, watershed protection, and forest restoration.

Still, these beetle-damaged forests and thunderous fires have become symbolic of the real limits of human control of natural systems, a reality that Bessey sought to disprove in the early 20th century when he set forth to plant trees in the Great Plains.

On a narrow ridge to the heavens—incongruously called the "Devil's Causeway"—Ann Vileisis looks down at the meadow and forest mosaic of Flat Tops Wilderness Area in Medicine Bow-Routt National Forest.

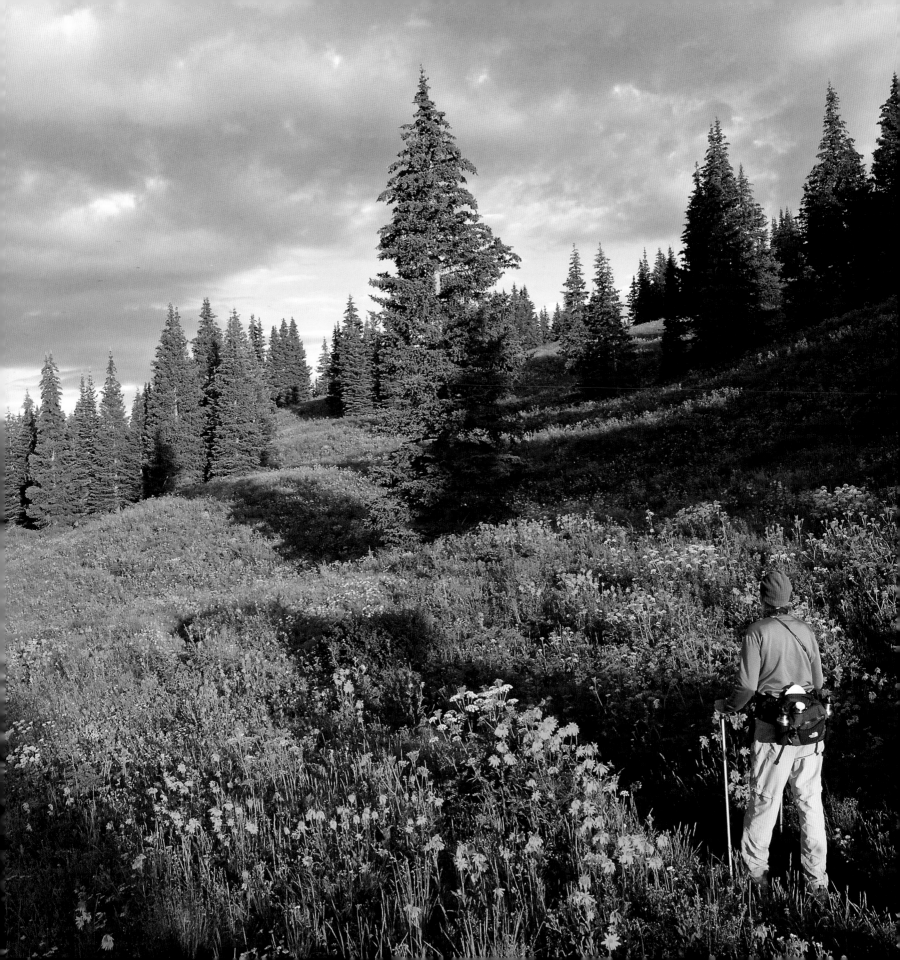

OPPOSITE: July is wildflower season in the Colorado Rockies; at the Yampa River headwaters these meadows bloom with leafy arnica, larkspur, water hemlock, lupine, paintbrush, and aster.

ABOVE: A sandstone butte and prairie dog den relieve the flatness of Thunder Basin National Grassland in eastern Wyoming, administered with Medicine Bow-Routt National Forest. Cattle graze on most of the grassland's acreage, but "multiple use" here also means that this captivating landscape is shared with hundreds of natural gas wells and six coal mines. One ranks as the largest strip mine in America.

FOLLOWING SPREAD: The Bighorn Mountains of Bighorn National Forest rise abruptly as an outlier of the Rocky Mountains above north-central Wyoming's shortgrass prairie.

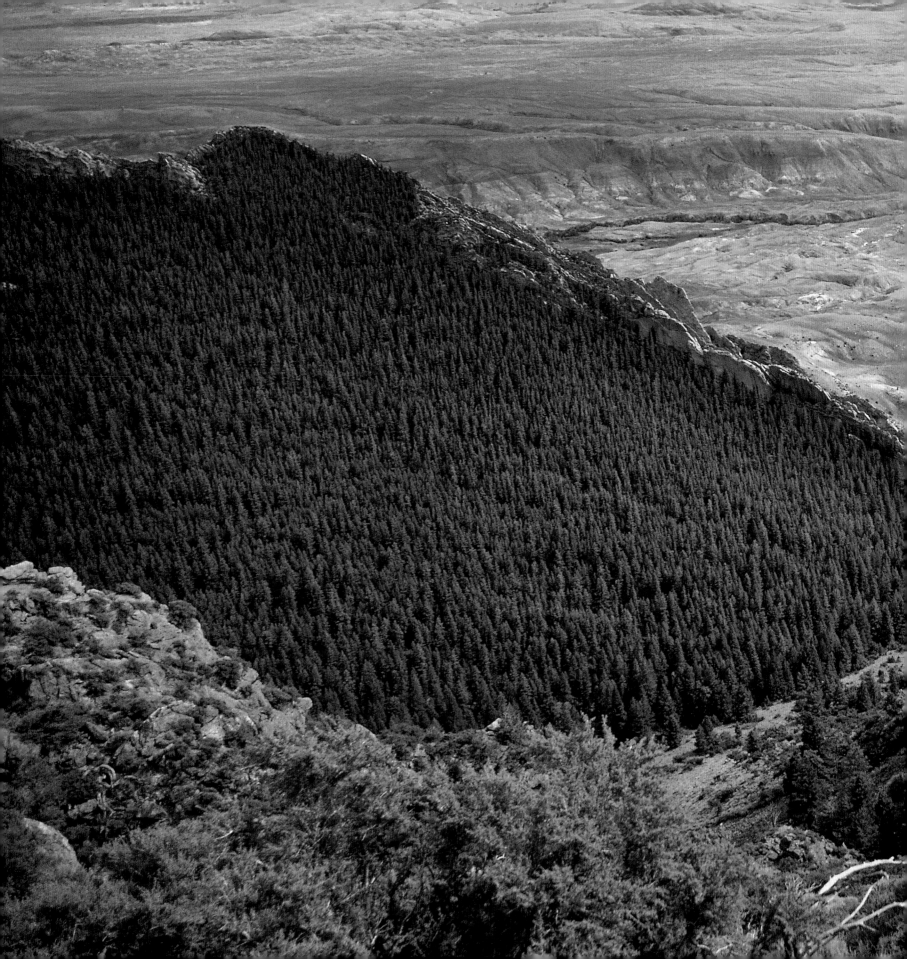

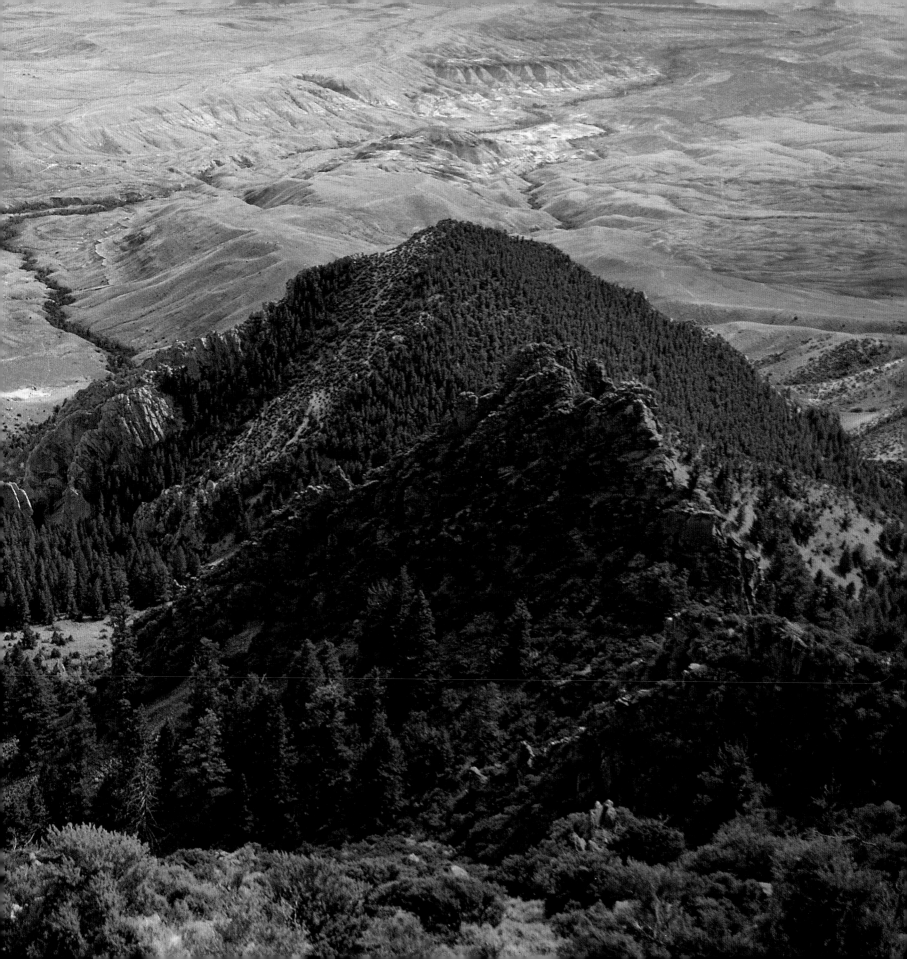

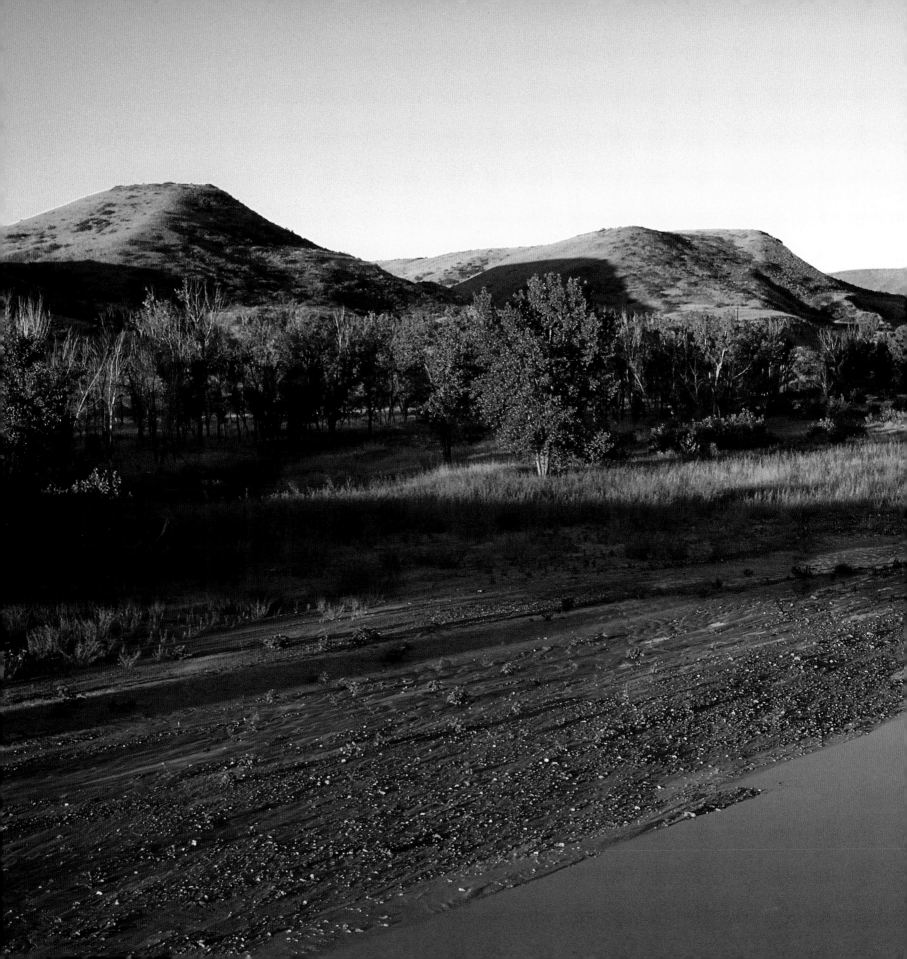

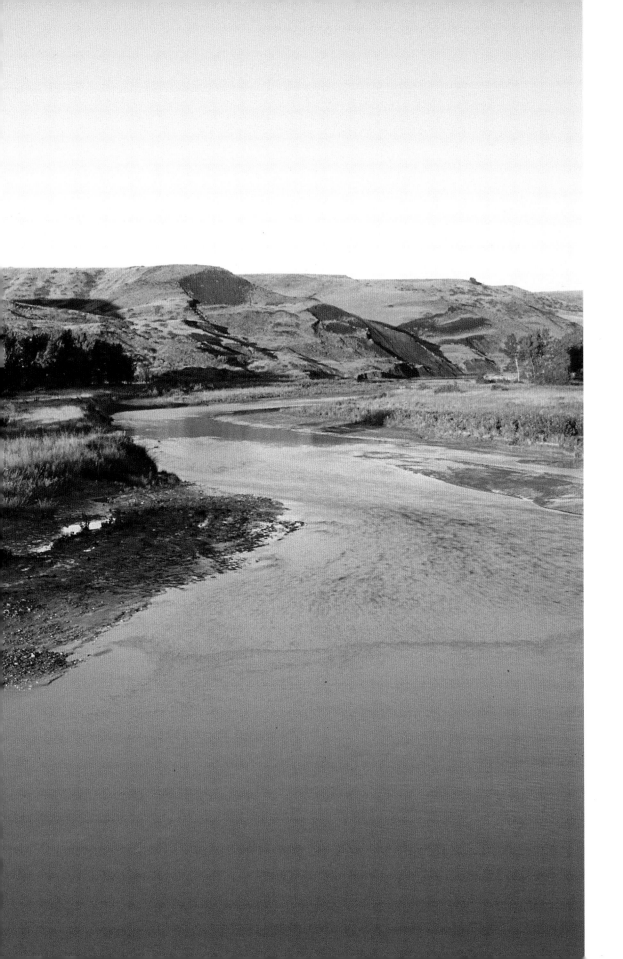

The Cheyenne River meanders through Buffalo Gap National Grassland southeast of Rapid City, South Dakota. A bit of an orphan in the federal lands estate, select grasslands of the western Great Plains are cared for by the Forest Service from its Rocky Mountain stations. At the brink of extinction, black-footed ferrets have been reintroduced here at Buffalo Gap, though these charismatic members of the weasel family feed solely on prairie dogs, which have been reduced to two percent of their range—or less—in the heavily agricultural Great Plains.

White River National Forest

It says something about the demands of the vice president's job that in 1901 Theodore Roosevelt took five weeks off that winter to go cougar hunting in the Colorado Rockies. With his base camp at Keystone Ranch (elevation 9,000 feet), and using horses and dogs to run down his quarry, the sharp-eyed hunter carefully recorded his every kill. He was as diligent in noting the shifting ecosystems through which he and his guide daily rode. "It is high, dry country," Roosevelt wrote, "wild and broken in character, the hills and low mountains rising in sheer slopes and riven by deeply cut and gloomy gorges and ravines." As they switchbacked through sagebrush-dominated flats, worked their way up "open groves of pinyon and cedar," and with greater difficulty zigzagged between tall spruces clustered in "cold ravines," Roosevelt reveled in this strenuous life. "The keen cold air, the wonderful scenery, and the interest and excitement of the sport, made our veins thrill and beat with buoyant life."[2]

Surely contemporary skiers, every time they rocket down any of Keystone Resort's Black Diamond trails, share Roosevelt's excitement. What they probably do not know, but Roosevelt would have, is that Keystone Mountain, and other nearby, legendary ski resorts—including Aspen and Vail, Breckenridge, Copper Mountain, and Snowmass—are located within the now 2.3-million-acre White River National Forest. Already an eminent conservationist and ardent proponent of the forest-reserve system, and a close friend of Gifford Pinchot, Roosevelt would have been aware that President Benjamin Harrison had established the White River Plateau Timberland Reserve in 1891. It was the first such reserve in Colorado and the second in the nation. Within a year of becoming president, Roosevelt again interacted with the White River, shrinking its size in part because his 1901 excursion had revealed that some of its original expanse was more suitable for agriculture.

What Roosevelt could not have imagined was that the very rough ground he had ridden over would become one of the world's most illustrious destinations for alpine sports. Neither could he have anticipated that the ski industry annually generates more than $3 billion for the state (and $17 million for the Forest Service). Or that despite the ongoing presence of extractive industries such as mining, logging, and energy development, which he would have approved of, the White River National Forest hosts more than 10 million visitors each year, the most of any national forest. Recreation is its biggest business.[3]

This boost to the Centennial State's coffers would not have happened had the forest's early detractors had their way. They were infuriated when President Harrison set it aside. Mocked the Meeker, Colorado, *Herald*: "When the Park is established won't that place become famous for hunting and fishing? Oh, yes, Uncle Sam will let you have all the sport you want outside the boundaries." Mockery gave way to shock at how much territory the newly established forest encompassed. "The figures are appalling and it is no wonder that the people are aroused," the *Herald*'s editors thundered, urging its readers to

The Maroon Bells rise above the log-jammed outlet of Maroon Lake in White River National Forest. This cluster of peaks south of Aspen may be the most-photographed icon of the entire Rocky Mountains.

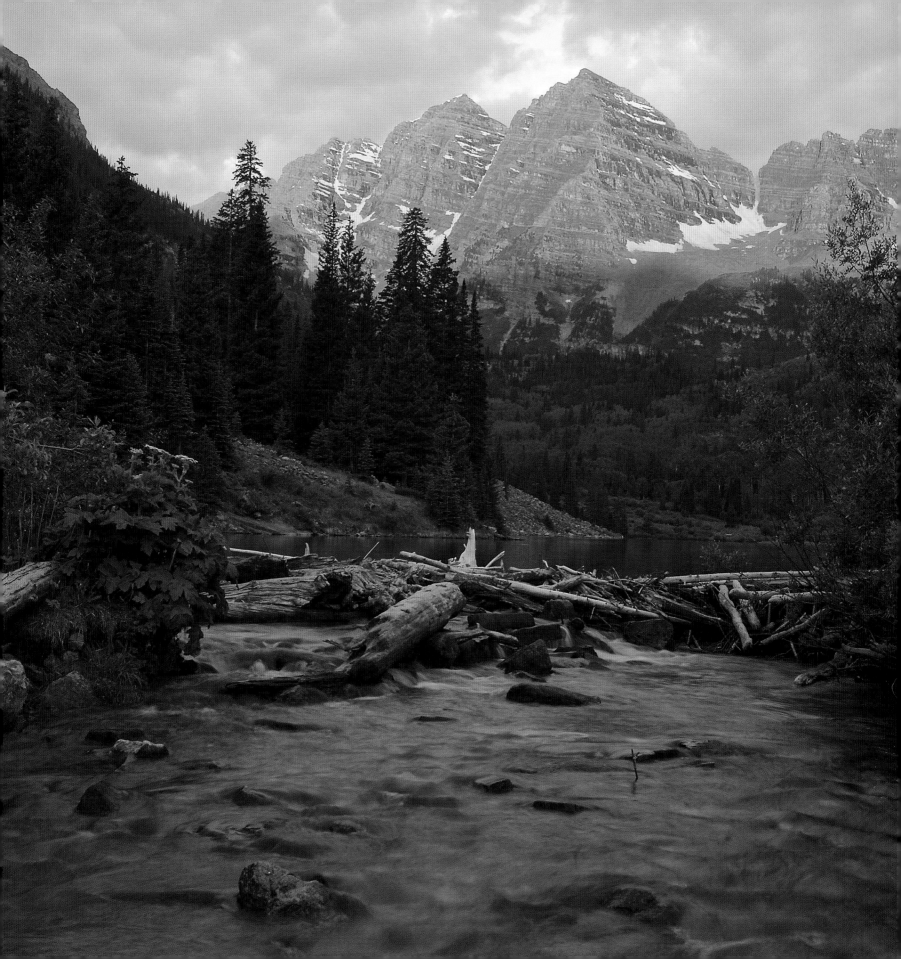

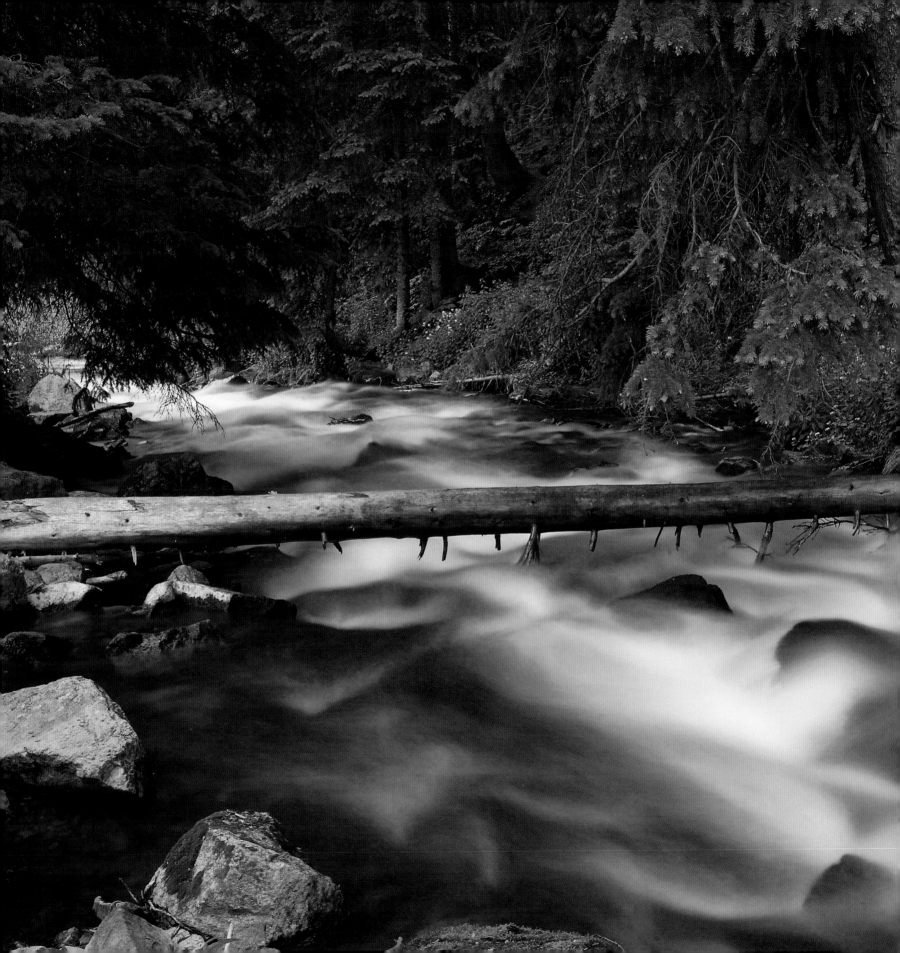

"join hands in a solid phalanx against the dude design for an outdoor museum and menagerie."[4]

However miscast, this characterization of the "park" was another reason President Roosevelt reduced the White River's acreage. Locals were mollified as well by the enactment of regulations that permitted them, for a fee and under supervision, to graze, log, and dig on these public lands. They were especially appreciative of the government rangers' early efforts to control fire. Long an integral part of the forest's ecosystem (lodgepole pine requires intense heat to regenerate), fire had created much of the landscape's open quality that Roosevelt had delighted in. Whatever the source—lightning sparked or human ignited—late 19th-century Coloradans thought suppression was essential to the environment and economy they were building out of the region's resources.

Foresters at this time shared the public's antipathy for wildfire, believing it to be the greatest enemy to achieving their managerial goals. Whenever and wherever smoke swirled up into the sky, they were determined to knock it down. Their efforts were not always effective, especially early on when an individual ranger might oversee hundreds of thousands of acres. In the White River National Forest, however, the small force of forest rangers proved effective. Working with the "cooperation of the citizens of the region," and routinely prosecuting "those who were careless with fires," the forest's managers reported that from 1909, "the first year for which records are available, through 1940, only 779 acres of land" were consumed by fire. Their strategy gained additional force in subsequent decades as staffing increased, firefighting budgets grew, and new technologies such as airplanes, bulldozers, and chainsaws aided the cause.[5]

These foresters acted on what they believed to be true. Subsequent research has demonstrated, however, that all-out fire suppression, when combined with past clearcutting, has produced even-aged, overly dense forests, offering a rich food source to beetles. Their well-nourished population has also exploded due to climate change; nationally, more than 41 million acres have been infested, turning once-green pines a sickly dull red. Warmer winters and intensified droughts have meant more beetles, greater tree mortality, and an extended and increasingly dangerous fire season.

Reversing this dire situation is complicated. It is impossible to treat every infested acre, even if the agency had the requisite funding, which it does not. Given these constraints, the Forest Service instead has focused on collaborating and sharing costs where possible. The goals are to ensure public safety in a terrain full of dead trees and recover forest health. Another aspect of this collaborative effort is to reintroduce fire under certain conditions, with the larger goal of renewing ecosystem resilience such that the White River National Forest can better survive stress.[6]

These interrelated challenges are unlike any that the founding generation of American foresters faced or could have anticipated. But what the two cohorts share is a commitment to act in the world, to make it more vibrant and self-sustaining. In the White River and other national forests, this promises to be a full-time job for the greater good over the long haul.

Shaded by Engelmann spruces, West Maroon Creek begins its animated journey from Maroon Lake to the Roaring Fork River. This and other national forest headwaters nourish the Colorado as the prime water-supply artery for much of the Southwest, Southern California, and northern Baja in Mexico.

Arapaho & Roosevelt National Forests

The abrupt eastern front of the Rocky Mountains marks the beginning of America's vast western cordillera in Roosevelt National Forest above Boulder. South Saint Vrain Creek flows from its Indian Peaks source and begins a staircase drop to the Great Plains.

Mount Evans, at 14,265 feet, is the tallest of the Chicago Peaks dominating nature's skyline to Denver's west. Another of the mountain's defining features is that it was named for a leader of one of the West's most notorious atrocities. As governor of the Territory of Colorado, John Evans had participated in the horrific 1864 Sand Creek Massacre, in which the Union Army slaughtered a peaceful camp of Arapaho and Cheyenne, the vast majority of whom were women and children. When his complicity was revealed, Evans was forced to resign, but in 1895 the state legislature airbrushed Evan's past by renaming the peak in his honor. To his enduring credit, Theodore Roosevelt countered this decision by designating the surrounding 723,744 acres as the Arapaho National Forest.

Now comanaged with the Roosevelt National Forest and Pawnee National Grassland, the 1.5-million-acre forest straddles the Rockies and contains a kaleidoscopic array of topography, habitat, and uses. From the table-flat prairie punctured by oil wells and gas rigs to the Never Summer Wilderness, whose name conveys much about its high-altitude clime, the forest also contains glacial remnants, frigid blue lakes, and gushing streams and creeks that flow into the Rio Grande, Platte, and Colorado Rivers. The Arapaho seems at the center of the continent, a North American break point.

So it was for the Arapaho people, too, who migrated into the region in the late 18th century and who believed, according to one account, that the "Man-Above created the Rockies as a barrier to separate them from the Shoshonis and Utes." As whites pressed across the plains in the mid-19th century, they also understood the snow-capped chain as a barrier, protective and obstructing. For those making their new homes along the Front Range, the mountains' shadow effect made for a gentler winter; if their destination lay farther west, then these imposing landforms were an impediment. But for artists, the Rockies were a treasure of light and color, shape and shade. In the words of painter Albert Bierstadt, who visited the Rockies in 1859 and 1863, they were "the best material for the artist in the world." So frequently did he paint them, a critic quipped, he seemed to have "copyrighted nearly all the principle mountains."[7]

One peak particularly drew the artist's attention. In 1863, he hiked to its summit and gave it the name Rosalie, after a friend's wife (whom he shortly thereafter married); the name stuck until the state legislature changed it 30 years later to Mount Evans. To capture its essence, however, Bierstadt preferred to paint it as seen from the Chicago Lakes below. He sketched rapidly, impressions he hoped would enable him to complete "a great Rocky Mountain picture." Whatever license he may have taken with the site's alpine setting, many of his contemporaries believed that *A Storm in the Rocky Mountains, Mt. Rosalie (1866)* achieved his ambitious goal. Yet, for all the painting's acclaim, observed Bierstadt's guide into the Rockies, "probably few people are aware that the subject, or part of it, is visible from the streets of Denver every time we look upward at the nearest group of snow-capped peaks."[8]

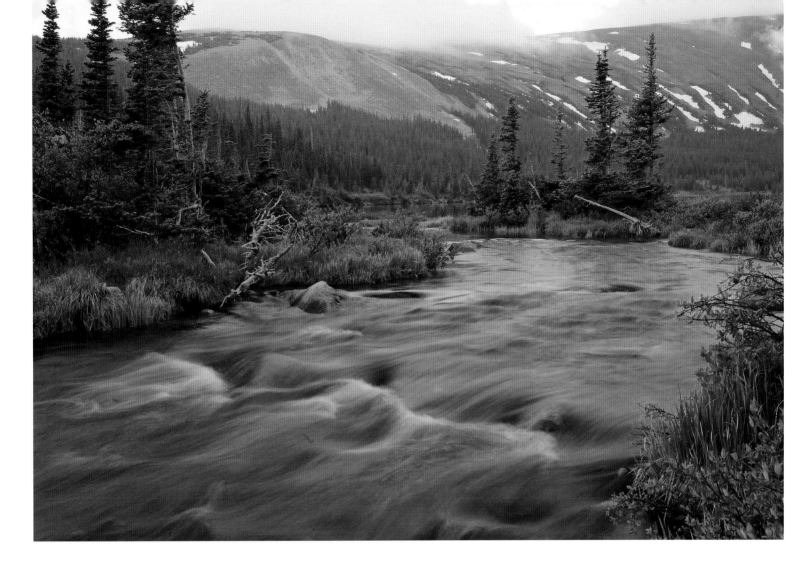

Bierstadt's romanticization of the Rockies, his portrayal of them as nature sublime, impelled others to test themselves against these mountains' walls, cliffs, and canyons. These visitors' numbers grew as Denver swelled in size during the 19th century, a consequence of the natural resources blasted out of, or cut down, from the nearby mountains. The city's well-heeled residents used roads and rail lines (and later, automobiles and buses) to explore this once-remote terrain. One of them, Enos Mills, is credited with galvanizing public support for the creation of Rocky Mountain National Park in 1915, which the Arapaho and Roosevelt National Forests abut. He had a bedrock faith in the Rockies' restor-

ative powers; their bracing air, rugged trails, and chilled waters, he asserted, would reinvigorate enervated urbanites, making them whole.

To aid in that rejuvenation, Mills helped found the Colorado Mountain Club (CMC) in 1912, which has done much to define the physical experience and cultural understanding of these wild lands. Their altitude is central to this discussion, and, once more, Mount Evans figures into the conversation. It is the 14th tallest mountain in the state and one of 53 "fourteeners," that is, peaks exceeding 14,000 feet. Their height and number, and the classification that the CMC conferred on them, established a challenge—how many of these bare-rock peaks could an individual

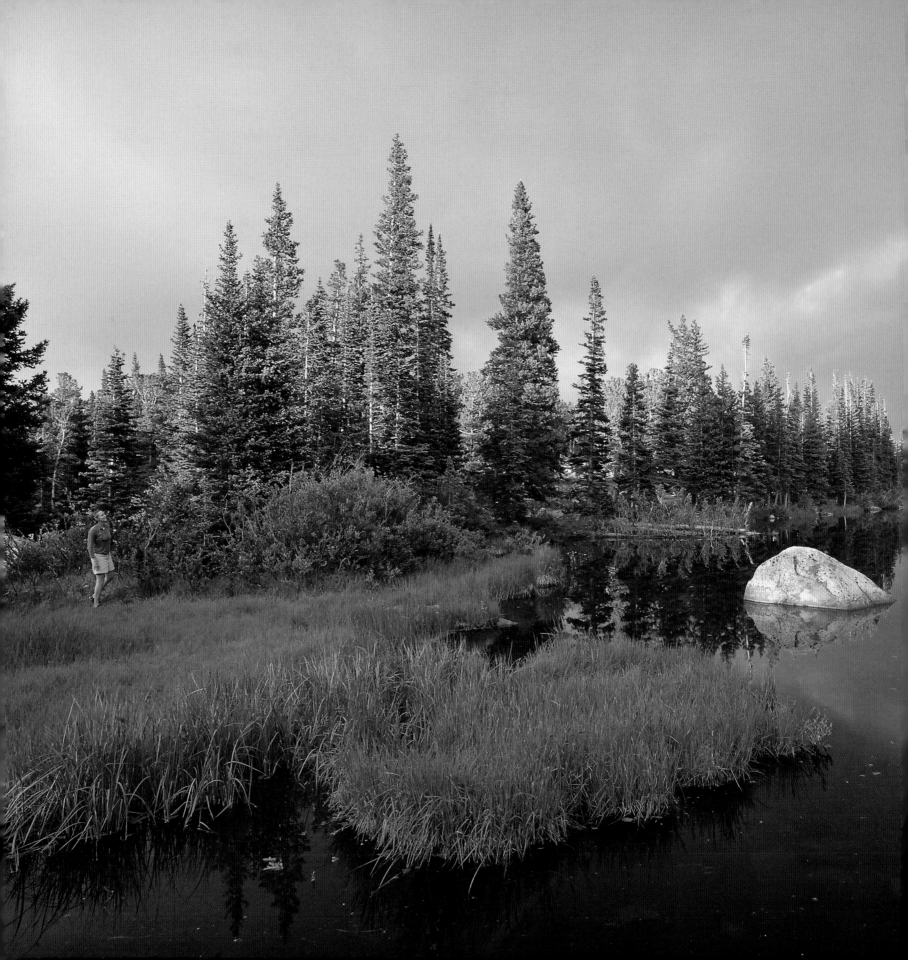

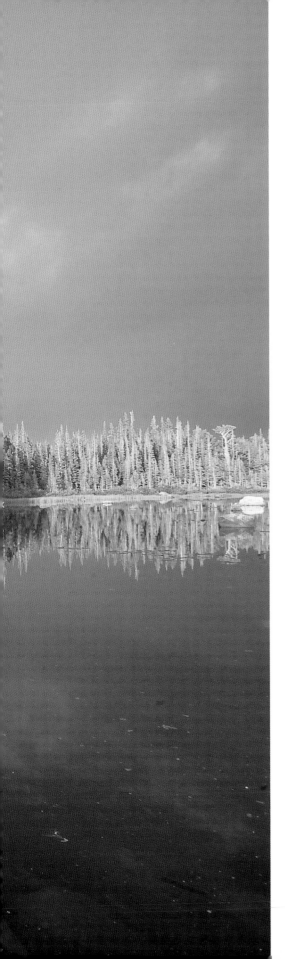

bag? By 1923, Carl Blaurock, a charter member of the organization, along with his climbing partner William Ervin, had an answer: all of them.

Since then, hundreds of thousands of hikers have attempted to summit at least one fourteener, and each season the number grows. Whether it is as high as the Forest Service has estimated—500,000 annual visits to these tall mountains in Colorado—is almost beside the point. These boot-shod feet have been taking a toll, damaging unique and sensitive tundra ecosystems, wearing down trails, and compromising the integrity of alpine basins. The most battered because it is the most bagged is Mount Bierstadt.

The deterioration of this mountain helped spark a 1993 report identifying the larger systemic problem, and the next year the Forest Service, CMC, and like-minded organizations started the Colorado Fourteeners Initiative. Its purpose is to rebuild trails, restore trampled terrain and eroded slopes, and educate the public about the critical need to conserve and protect this invaluable high country. Using volunteer labor and funding from public and private sources, after a decade of work the initiative has completed the construction of 29 sustainably designed routes on 26 peaks, nearly half of the total.

"Preservation of wilderness was not the particular value of the miners," one volunteer observed about her restoration work in the Chicago Basin during the summer of 2013, "and it shows by what they left behind." But she was quite aware that contemporary hikers have left their own record of abuse. "We know so much about the fragility of the alpine ecosystem that it is our responsibility to help maintain the integrity of these places . . . to harden the trail for the mountain, using its own building blocks to ensure that we, in our human nature, do not destroy the very thing we set out to see."[9]

Red Rock Lake glows with evening light in a scenic wonderland that continues northward through Rocky Mountain National Park.

Uinta-Wasatch-Cache National Forest

Salt Lake City, Utah, would not exist without the Wasatch Mountains, a claim as true for Denver and the Rockies, Albuquerque and the Sandias, or Reno and the Sierras. In each case, the local mountains offer a dramatic backdrop framing the urban skyline, but more fundamental is what these peaks offer that the valleys below need to survive—water. Roughly one-third of the water supply of the western United States flows off national forests. Recognition of their invaluable catchment-like function is precisely why these mountains are home to national forests, whose 1897 establishing legislation identified "favorable conditions of water flows" as one of their critical functions.[10]

Congress knew to make this claim because it had funded (and presumably read) John Wesley Powell's *Arid Lands Report* (1876), arguably the most important document detailing the relationship between aridity and economic development in the West. As head of the U.S. Geological Survey, Powell, along with several colleagues, had closely inspected the region. As part of their labors they assessed its geology and topography, climate and precipitation, and the prospects for a sustainable life in this land of little rain.

This latter evaluation required an understanding of the area's physical conditions and related environmental limitations. These data informed geologist G. K. Gilbert's analysis of the Wasatch's impact on the emerging communities nestling against its western slope. The north-south mountain chain, he wrote, consists of a series of "abrupt ranges crowned by sharp peaks," its ridges "severed by transverse valleys,"

a geological structure that drove water westward into the low desert. As a result, the Great Salt Lake and its upper tributary, Utah Lake, "exist by virtue of the presence of the Wasatch Mountains, for the mountains wring from the clouds the waters with which the lakes are supplied."[11]

Gilbert laid out the economic ramifications of this hydrologic connection between upstream and downstream for rural and urban economies. In almost lyrical language, he wrote that the "springs of the cliffs are the fountains of the rivers that are to fertilize the valleys." At the time, Powell and Gilbert argued that rapid clearing of high-country watersheds through logging and grazing were beneficial, increasing streamflow for flatland irrigation. This claim was rebutted two decades later in the enabling language for the national forests, which were expressly created to protect and regenerate vital drainage systems.[12]

Reinforcing this point was a 1902 report that also depended on an on-the-ground examination of Utah's mountainous region and those who ran cattle and sheep in its upland meadows and box canyons. Its author was Albert Potter, an Arizona stockman who helped convince Gifford Pinchot that regulating grazing would be far better than excluding it from the national forests. Pinchot asked Potter to become the first head of what would become the Forest Service's Grazing Division. Among his first assignments was to evaluate rangeland conditions in Utah's federal lands, including the Uinta-Wasatch-Cache, Manti-La Sal, Fishlake, and Dixie National Forests, which drape over the state's key mountain ranges.

Covered with airy powder snow that has made Alta and other Wasatch Mountain ski resorts famous, Twin Peaks etch the skyline above Little Cottonwood Canyon southeast of Salt Lake City.

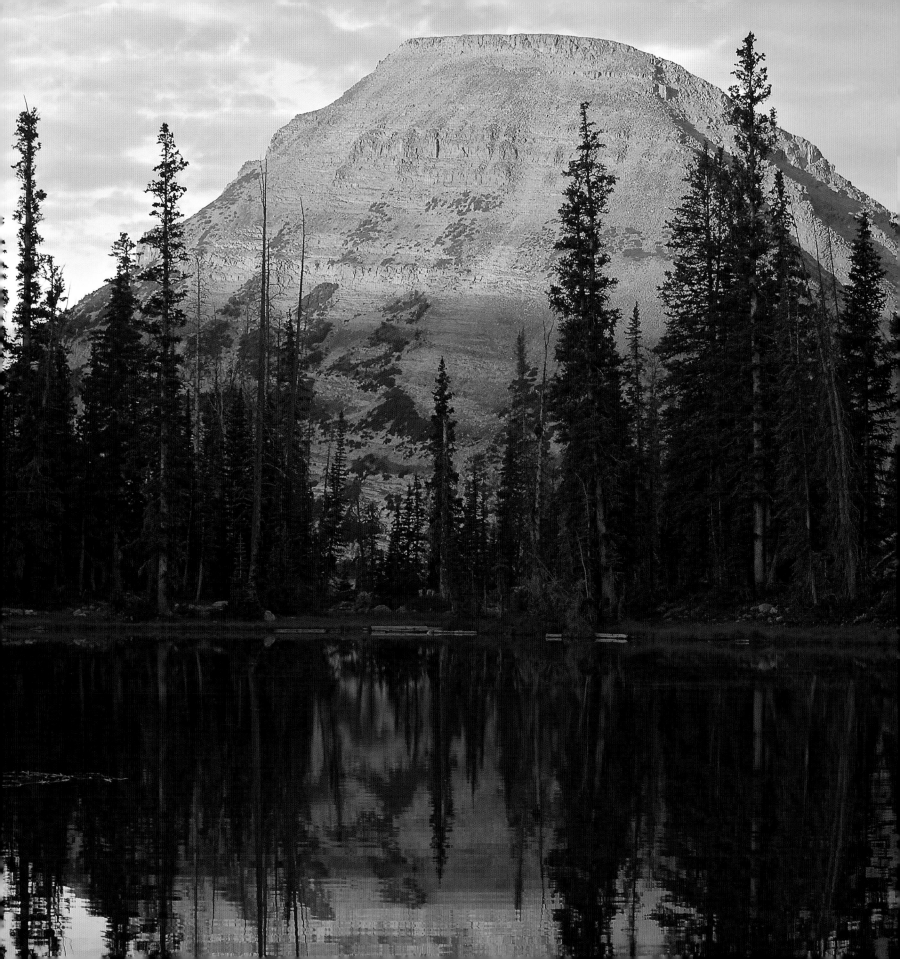

One of Potter's unsurprising conclusions was that intense grazing (and, to a lesser extent, logging) was jeopardizing Utah's natural resources. Everywhere the situation was the same, he concluded after spending four months in the saddle, riding through canyonlands, basins, and foothills. Too many cattle and sheep crowded the range, leading to significant erosion and catastrophic mudflows and flooding in the Wasatch, Uinta, La Sal, and Escalante Mountains. This perilous situation reflected the failure of the Department of the Interior to effectively regulate these lands' use. "The overstocking of the Uinta Forest Reserve this year," Potter concluded, "is a sore blow to the management of grazing by the government."[13]

Because achieving regulatory control would be difficult, Potter suggested leniency. "I would recommend that in all of the forest reserves which are created the general policy already adopted be continued, and that a liberal number of livestock be allowed upon the reserves at first and the number cut down afterwards as found necessary." Although his approach mollified the livestock lobby, what Potter could not foresee was that his strategy would "present challenges and conflicts for decades to come."[14]

These repercussions were not simply a result of the minimal restrictions Potter had proposed. They also grew out of the subsequent development of scientific rangeland management. In 1912 the Forest Service set up the Great Basin Experiment Station located in the Manti-La Sal National Forest. Its scientists demonstrated, among other things, that controlling grazing in watersheds would reduce flooding, managing to maintain ground cover would diminish erosion, and setting standards for carrying capacity would extend rangeland productivity. These findings were then tested and refined throughout Utah, a science-based process with real-world

With dome-like summits, the Uinta Mountains are one of few American ranges oriented not north-south but rather east-west. Here Bald Mountain catches the sunrise glow above Picturesque Lake, off Highway 150's scenic tour east of Salt Lake City.

application—research produced knowledge, knowledge gave its holders expertise, and expertise determined policy.[15]

The data did not convince everyone. Opposition to the scientific basis for policy making and regulatory action came from inside and outside the agency. It was strong enough that John Riis, deputy supervisor in the Cache National Forest and a staunch proponent of professional management, felt compelled to transfer out of the region in 1911. The livestock industry was happy to see him depart, and ever since has continued to buck against agency regulations and to challenge them in the public arena and the courts. In the past, the Forest Service itself also wavered in its commitment to rangeland protection. To beef up production during World War I and World War II, the agency encouraged heavy grazing, nearly destroying the range. Its battered condition in the mid-20th century prompted one critic to predict that Utah would turn into the Sahara.[16]

Fortunately, it did not reach that sorry state in part because the Forest Service and Congress stepped in. To control increased flooding resulting from damaged watersheds, Congress added more lands to the Uinta and Wasatch National Forests. In conjunction with this initiative, the agency shortened the grazing season and decreased the number of animals allowed on allotments. It also collaborated with neighboring landowners and communities to replant the abused terrain.

Regeneration took time, though, a lengthy process that itself became a target of an energized environmental movement. Critics of the Forest Service gained energy after reading Rachel Carson's *Silent Spring* (1962) and its searing indictment of the use of DDT and other chemicals poisoning land and water. They also took advantage of a suite of tough new environmental regulations, including the National Environmental Policy Act (1970), Clean Water Act (1972), and the Endangered Species Act (1973), to file lawsuits against the Forest Service's grazing policies. Intensifying the debate was the related upsurge in sagebrush rebellions, during which rural ranching interests and conservative politicians demanded the dismantling of the national forest system altogether.

To break through all the angst and anger that this highly charged atmosphere produced has required patience. An example of what might be achieved in these northern Utah forests has occurred in the national forests in the south of the state, including the Fishlake, Manti-LaSal, and Dixie. In 2009, a group of academics, ranchers, environmentalists, and state and federal personnel met to discuss the possibility of an accord. Four years later, they announced a series of pilot projects to test a new set of "grazing management principles and practices for Forest Service lands in Southern Utah that provide for ecological sustainability, are socially acceptable, and economically viable." Perhaps a more significant result was that this collaboration decentered the Forest Service. Its representatives attended all the group's meetings as "technical representatives to ensure that the group had accurate information on policies, current activities, and other topics critical to the discussions." But they did not participate in the decision-making deliberations that produced new managerial strategies for the grasslands under their stewardship. In ceding its authority in this instance so that consensus could emerge, the Forest Service may not have finally resolved the ongoing debate over grazing in the national forests. Yet whatever debates next erupt over management of the southern Utah rangelands, the Forest Service's adoption of collaboration as an essential management tool marks a watershed moment.[17]

On the northwestern flank of the Uinta Range, false hellebore and Indian paintbrush brighten meadows of the Stillwater Fork of the Bear River. Below here the main stem of the Bear River scribes one of the most circuitous river routes in America and eventually becomes the principal supplier of Great Salt Lake.

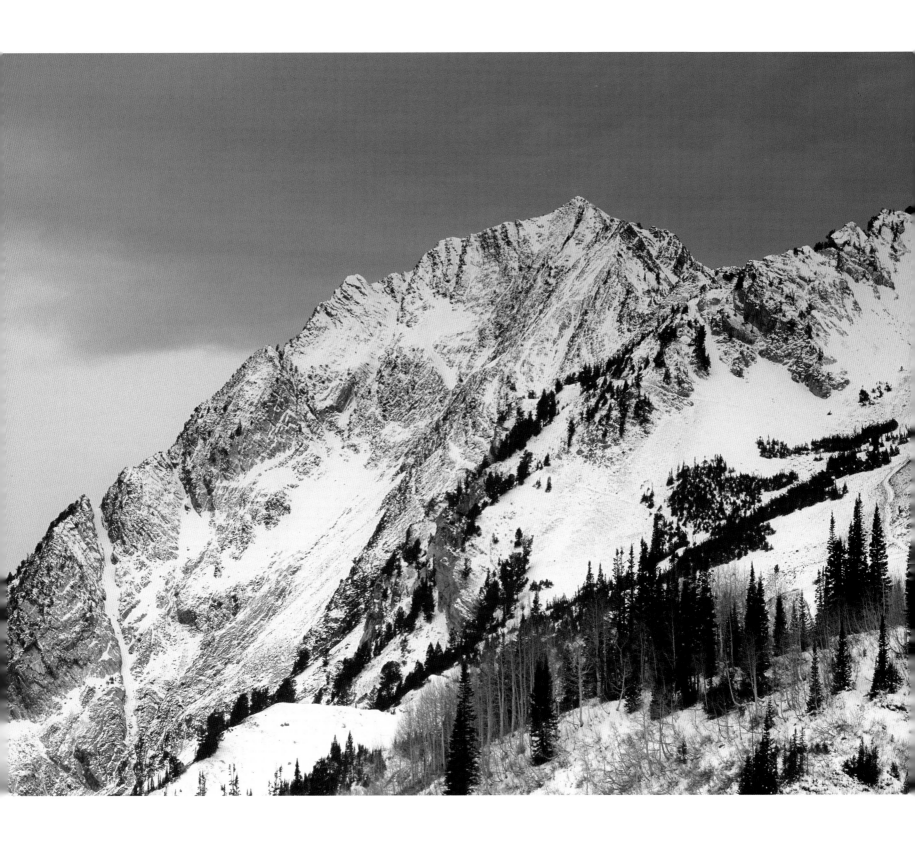

Black Hills National Forest

SOUTH DAKOTA & WYOMING

This pine-clad, jagged high ground of the Black Hills looms over the shortgrass prairie stretching out to the horizon. This land's prominent features and rough form are among the reasons why it has been and remains sacred ground, the spiritual center for the many different native peoples who have claimed the area across time. That the landscape retained its sanctity regardless of who dominated these hills is a result of a process called cultural transference. Each new arrival adopted, appropriated, or absorbed the traditions and practices of those who came before. "Recorded history suggests a complicated series of movements into and out of the Black Hills by various peoples," anthropologist Linea Sundstrom has argued. Yet as "one group replaced another over the last several centuries, these locations continued to be recognized as sacred locales and to operate within a system of ethno-astronomical and mythological beliefs."[18]

That centuries-long pattern was disrupted in the mid-19th century, and a new one emerged born of the bloody conflict between the Plains Indians and the U.S. Army for control of the territory. This war seemed to have been resolved after the army suffered a series of punishing defeats in 1866, leading the federal government to negotiate a treaty setting aside Paha Sapa ("Hills that are Black") for the sole use and benefit of the Sioux people. Then rich veins of gold were discovered there, and prospectors poured in to profit from the rush. The Sioux refused to sell their treaty-sanctioned lands and lose their spiritual inheritance. After yet another round of Indian victories over the U.S. Army—notably

Ponderosa pine savannas of the Black Hills are recovering after complete logging that bolstered a mining boom during the last century. The first timber sale in the national forest system occurred here in 1898.

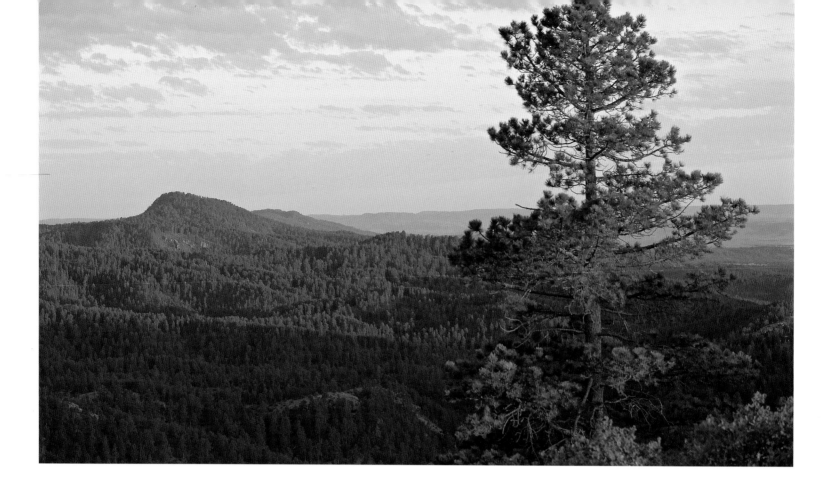

Custer's Last Stand—Congress ripped up the earlier treaty, replacing it with an agreement that confiscated nearly eight million acres from the tribe. Approximately 1.3 million acres of this vast domain remain in federal ownership as the Black Hills National Forest.[19]

To initiate management of these lands required another kind of cultural transference. Because of the destructive energy that the gold rush unleashed, in which 1.5 billion board feet of timber was rapidly clearcut to shore up mines, lay down railroad tracks, fuel machines, and build towns, the hills were denuded and left to erode. While inspecting the northern Black Hills in 1898, Henry S. Graves, who would become the Forest Service's second chief, observed that timber had been "almost entirely cut within a radius of 8 miles from Deadwood." Another observer, gazing over the remaining "stumps, logs, and

underbrush," declared "it will be no wonder if in a short time the dark pine forest is gone and the name 'Black Hills' has become meaningless."[20]

Fixing this environmental damage required understanding it to *be* damage. This perspective within American culture emerged slowly in response to the Industrial Revolution's excesses on display in the Black Hills, New Hampshire's White Mountains, and the Cascades of the Pacific Northwest. Conservationists such as George Perkins Marsh, John Muir, and George Bird Grinnell were among those arguing for governmental intervention to protect the nation's scenic beauty and natural resources. Out of this activism emerged the fledgling forestry profession and the national forest and park systems. It was not until 1897, however, that oversight of the Black Hills was articulated: in celebration of George Washington's birthday, outgoing President Grover

Cleveland created the Black Hills Forest Reserve, one of 13 he set aside that day.

This first step required a second. All public lands were then under the supervision of the General Land Office (GLO) in the Department of the Interior, but the GLO did not have any trained foresters. For that reason, it requested help from the Division of Forestry in the Department of Agriculture to develop a comprehensive "working plan for the harvesting of timber in each of the existing reserves." Gifford Pinchot, the division's head, was delighted to comply, expecting this opportunity would give his tiny office important experience and set the stage for the larger case he intended to make for the transfer of all forest reserves to the Department of Agriculture. It took eight years for him to realize this grand ambition to put the nation's forests and foresters under one roof.[21]

The inaugural management plans for the Black Hills, by contrast, happened almost overnight. That is because the powerful Homestake Mining Company, which hitherto indiscriminately had cut wood on public lands there, and had filed fraudulent mining claims to continue unregulated harvesting, sought direction from the GLO for how to purchase timber under the new management scheme. Its request precipitated the Department of the Interior's outreach to Pinchot's Forestry Division to devise a long-term working plan for the already-developed Timber Case No. 1, the first regulated harvest in a forest reserve. Although the company did not fully comply with the plan's provisions, and the Department of the Interior's local agents did not fully enforce its regulations, nevertheless this plan initiated the presumption of governmental management of natural resources for the present and future.[22]

These lands' future condition has become even more central to their contemporary man-agement. As with the other western forests, the Black Hills National Forest has been badly hit with intense bark beetle infestations resulting from a changed and warmer climate, longtime fire suppression, and a deepening drought. When combined with historic logging patterns—which altered the forest's composition such that a single species, ponderosa pine, now comprises 95 percent of its densely packed and tight-canopied structure—it is extremely vulnerable. This complicated threat has generated an intense examination of how to reverse the loss of biodiversity and repair the forest's ecosystem functions and services. As a result, the Forest Service has adopted a policy calling for landscape-scale restoration projects for this "Island in the Plains."[23]

Adopted in 2010, this initiative was devised in collaboration with the National Park Service (which manages Mount Rushmore National Memorial and nearby Badlands National Park), tribal entities, state and local agencies, and private landowners. Its stated ambition is transformative—"to reset ecosystem trends towards a natural range of variability and to reestablish natural processes" with the goal of approximating how ponderosa pine forests best function. Allowing fire to replicate "natural disturbance regimes"—in short to let it serve ecological objectives—comes conjoined with the need to thin dense forests within the wildland-urban interface to protect neighboring communities. Plans to reestablish aspen and bur oak are coupled with reductions in even-aged ponderosa stands, and enhancement of watersheds and lakes, meadows, and grasslands. Although none of this valuable work by itself will resolve the unjust exiling of the Sioux, it gives Black Hills National Forest a unique opportunity to repair these once-badly abused lands so they might remain the life-affirming foundation at the center of the world.

In South Dakota, the Black Hills loom as the first significant relief one encounters when driving west at that latitude for two days from the Appalachians. Here at the lookout tower on Mount Theodore Roosevelt, a statuesque ponderosa pine glows in sunrise light.

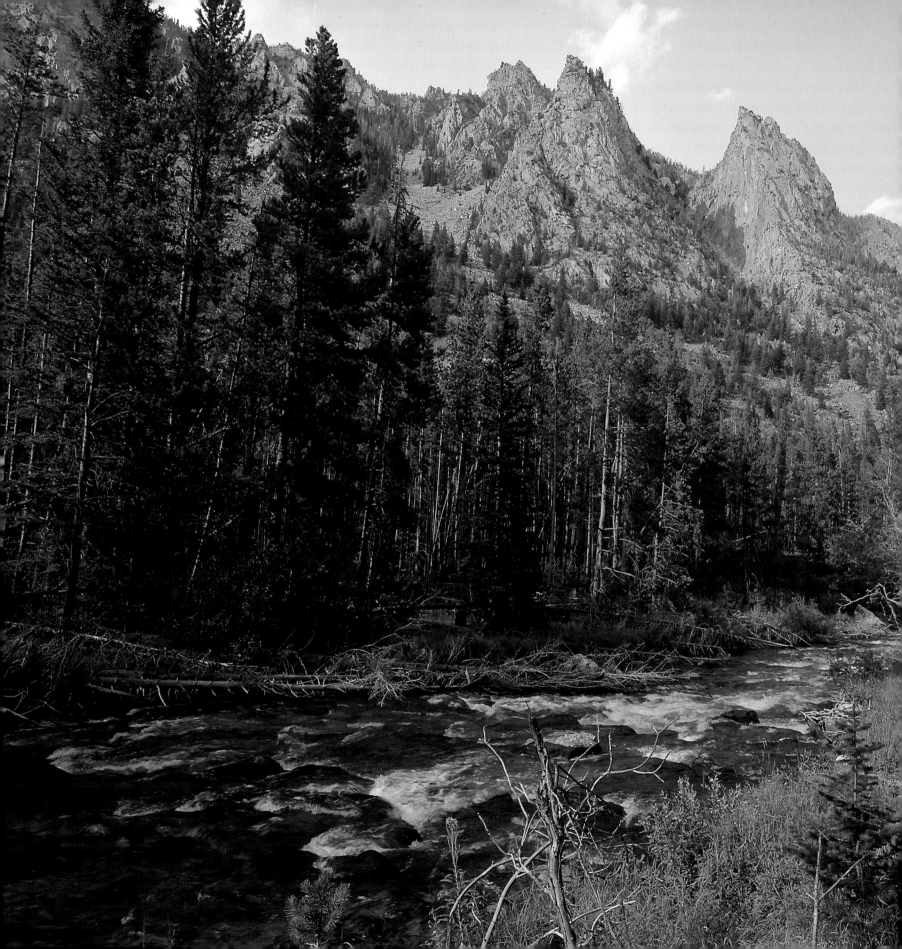

THE NORTHERN ROCKIES

5 STATES

12 NATIONAL FORESTS

1 NATIONAL GRASSLAND

25 MILLION ACRES

8.4 MILLION VISITORS

National forests of the Northern Rockies don't rise as high as the Southern Rockies, but you might never notice that. With their jagged skyline, the Tetons, seen from Bridger-Teton National Forest, emblematize western mountains more than any other range. The national forests surrounding Yellowstone embody America's most legendary habitat for megafauna: buffalo, elk, grizzly bears, moose, and wolves. In Idaho, our greatest expanse of wilderness outside Alaska remains a stronghold. And in Montana, vistas of forested mountains ramp up from postcard-perfect plains.

Here across a geography of endless appeal we see the interior West's greenest forests, largest sweep of wildlands, and whitest waters in rivers where the northern latitudes' increasing increments of rain and snow find their way into canyons as remarkable as Idaho's Salmon and Selway. Perfect.

The Northern Rockies are not exempt from the increasing sear of wildfire. My 400-mile float down the Salmon River in 1983 showed little evidence of fire; a repeat of the 42-day journey in 2008 revealed evidence of kindling at almost every bend. And miners of these northern ranges laid waste to whole mountains, leaving streams as notable as the Clark Fork—the longest waterway flowing wholly within the Rockies—dubiously designated as the longest superfund toxic waste site in America. But the sheer vastness of beauty evokes a sense of hope and optimism that endures in large part because so much land is embraced by the boundaries of national forests. The best of this landscape still belongs to all of us.

Photographing here, in an almost desperate drive to capture the best, I scurried from enchantments at the edge of the Tetons and Yellowstone to the wilds of Idaho, from the Rocky Mountain Front in Montana to the North Fork Flathead River as it rushed down from Canada and found its way to the Columbia River.
— TIM PALMER

PREVIOUS SPREAD: The Lake Fork of Rock Creek drops dramatically from heights of Montana's Beartooth Plateau. Granite peaks, lodgepole pines, and Engelmann spruces are seen here from the Lost Lake Trail. OPPOSITE: Deep in the Bridger Wilderness of Wyoming, Island Lake collects runoff from peaks and granite-walled canyons sculpted by mountain glaciers.

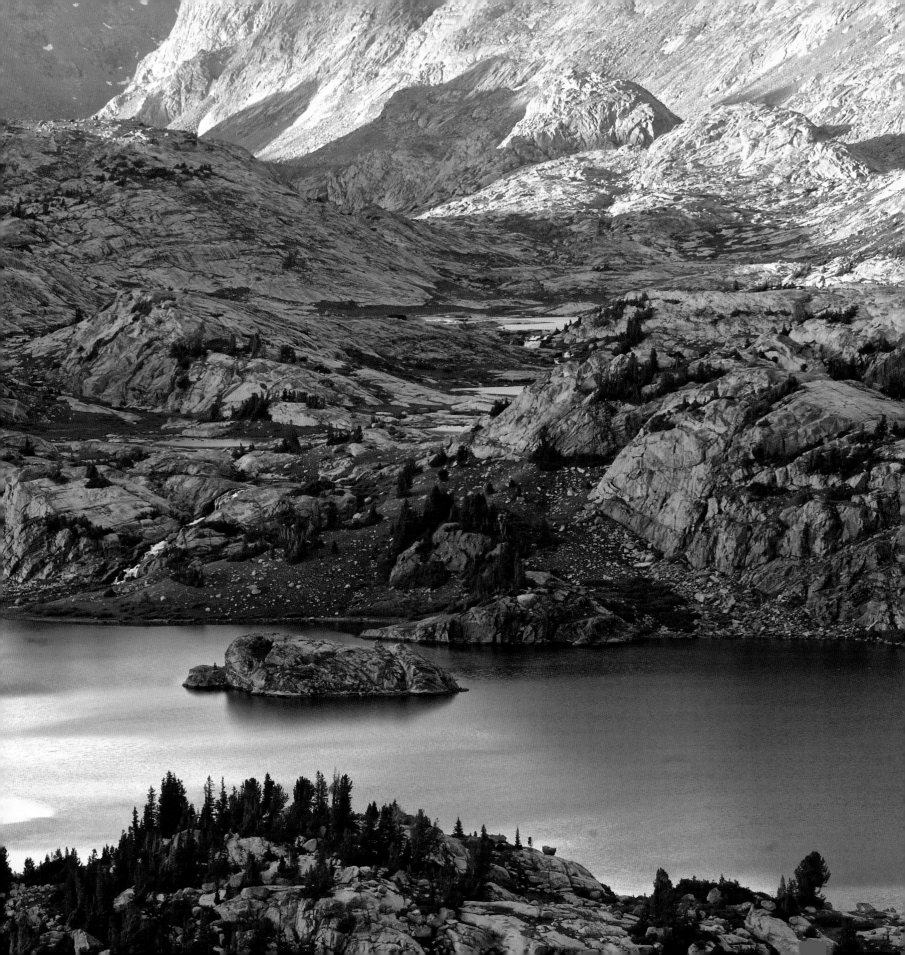

O nly in retrospect does Elers Koch's first job in the Forest Service seem straightforward. A graduate of the Yale Forest School, he secured a job at the Bureau of Forestry in 1902 and was assigned to the agency's Boundary Division. Because the "best public lands were rapidly passing into the hands of the lumber companies," Koch later wrote, agency

head Gifford Pinchot "was sending his young men to ride the forests and mountains of all parts of the West, from Canada to Mexico, to map and report on all the considerable bodies of forest land still remaining in public ownership." Koch was one of the young ones, and over the next couple of years he surveyed millions of acres of some of the most rough and remote terrain in the country. He played a formative role in the creation of Shasta-Trinity National Forest in California, and the Lolo, Bitterroot, and Lewis and Clark National Forests in his home state of Montana, among other tracts. No maps of any merit nor any guidelines for how to complete the work existed, so he rode hundreds of miles, forded rivers and creeks, and cruised through vast forests of unbelievable beauty while surveying the land. Years later, while in a motorboat making their way between the lower and upper Priest Lake in Idaho, near the Kaniksu and Kootenai National Forests, Koch and some colleagues marveled at the stunning landscape. As their craft "slowly wound around the curves of the lovely channel, overhung with virgin white pine, cedar, and hemlock," one of them whispered to Koch, "And to think we are getting paid for this."[1]

They earned their pay, of course, not least because their long hours in the saddle laid the foundations for the national forest system. In Koch's case, that especially meant the establishment of the northern Rocky Mountain region headquartered in Missoula, Montana, for which he worked for the bulk of his 40-year career. The region is immense, extending across portions of five states—Idaho, Montana, North and South Dakota, and a slice of Washington—and contains some of the most wild stretches left in America. Five million acres are in congressionally designated wilderness areas, and another five are oft-adjacent roadless backcountry. Koch had been instrumental in articulating the need for their preservation. In the 1930s, he argued that some of this terrain was so inaccessible that the agency should protect its "primitive nature," this "last frontier." With the 1964 passage of the Wilderness Act, Congress ultimately set aside as wilderness almost all the land that Koch had declared inviolable.[2]

Other acres of forest and grassland within the region have been heavily worked. The Helena and Custer Gallatin National Forests, like the

The summer sun sets behind Island Lake in the Beartooth Mountains of Wyoming's Shoshone National Forest.

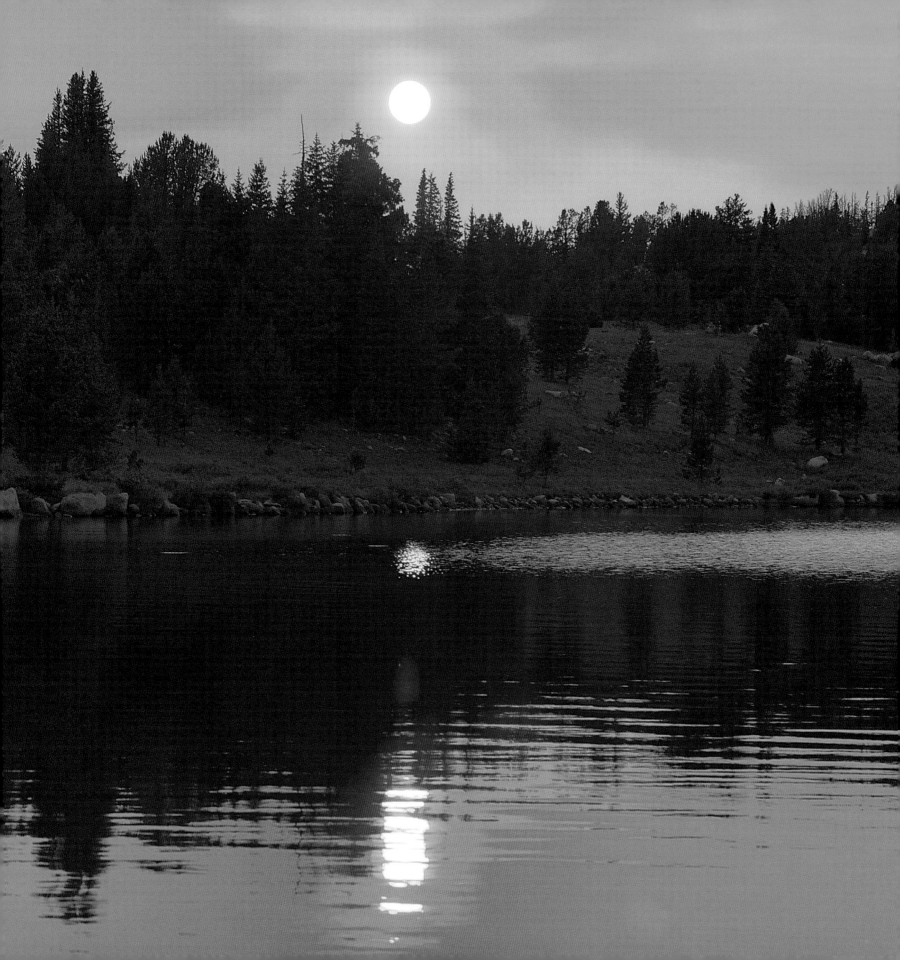

ABOVE, LEFT: Mountain goats graze on high-country forbs of the Beartooth Plateau in Montana's Shoshone National Forest. Thriving above timberline, the goats are threatened by the onset of global warming, which will shift timberline higher and higher on the mountains.

ABOVE, RIGHT: Moose are often sighted along the Lake Fork of Rock Creek in Custer Gallatin National Forest south of Red Lodge, Montana. This largest member of the deer family depends on riparian vegetation at streamfronts and wetlands.

Dakota Prairie National Grassland, maintain a robust grazing program; the latter is also the site of considerable oil and gas production. In the Beaverhead-Deerlodge National Forest, ghostly markers of Montana's mining industry abound. Portions of the Bitterroot and Flathead, as well as the Nez Perce-Clearwater, Custer Gallatin, and Idaho Panhandle National Forests, were also clearcut in the second half of the 20th century.

Every bit as complex has been the region's response to fire. No sooner had the agency set up shop in the Northern Rockies than it started battling summertime conflagrations. As Koch put it, "The year of a forester in the western districts is divided into two parts—the forest fire season, and the rest of the year." That remains true, for lightning-strike conflagrations are routine in this high country. Until recently, the first sign of smoke propelled teams of firefighters to snuff out the blaze, whenever possible. That proved impos-

sible during the Great Fires of 1910, which roared through Idaho and Montana, consuming three million acres. In the charred aftermath, critics second-guessed the agency's abilities, and foresters wondered what went wrong. One resolution the Forest Service reached was to suppress fires as quickly as possible, and over the years poured considerable funds and expertise into developing the skills and technology to do just that. Koch is credited with accelerating the training regimen, and the region was the first to experiment with parachuting firefighters into remote areas to snuff out blazes before they blew up. Much of the agency's commitment to fire-behavior research has been centered in the Missoula Fire Sciences Laboratory.

As they have gained a deeper understanding of how fires respond to weather, wind, and heat, and how forests regenerate after fires, scientists and policy makers have tackled the related questions of when and/or whether to fight fires.

These inquiries have intensified in the face of climate change–driven pine-bark beetle infestations that damaged or destroyed more than 11 million acres in Montana and Idaho between 1997 and 2009. Such intense conifer mortality is fueling mega-fires across the West. Whether all such fires should be suppressed—and at what cost (in 2012 the Forest Service spent almost 50 percent of its budget on fire management)—is a matter of considerable debate.[3]

Here, too, Koch may have had the first and last word. Although he believed that firefighting was an essential element of good forest manage-ment, he also knew from direct experience that stopping small fires could lead in subsequent years to "greater conflagrations" that would roar past fire-line control. Moreover, well-intentioned efforts to control fire in the Northern Rockies were also a little presumptuous, he noted. "After all, this country existed and maintained a general timber cover before man was born and for millions of years before the Forest Service came into being. Surely its existence as wild land capable of sheltering its game and holding its watersheds together cannot now be altogether dependent on the efforts of the Forest Service."[4]

At Hyalite Creek an angler casts for trout south of Bozeman, Montana. Custer Gallatin National Forest includes the Madison, Gallatin, and Absaroka Ranges essentially as a northward extension of Yellowstone National Park—all vital to wildlife of the Greater Yellowstone Ecosystem.

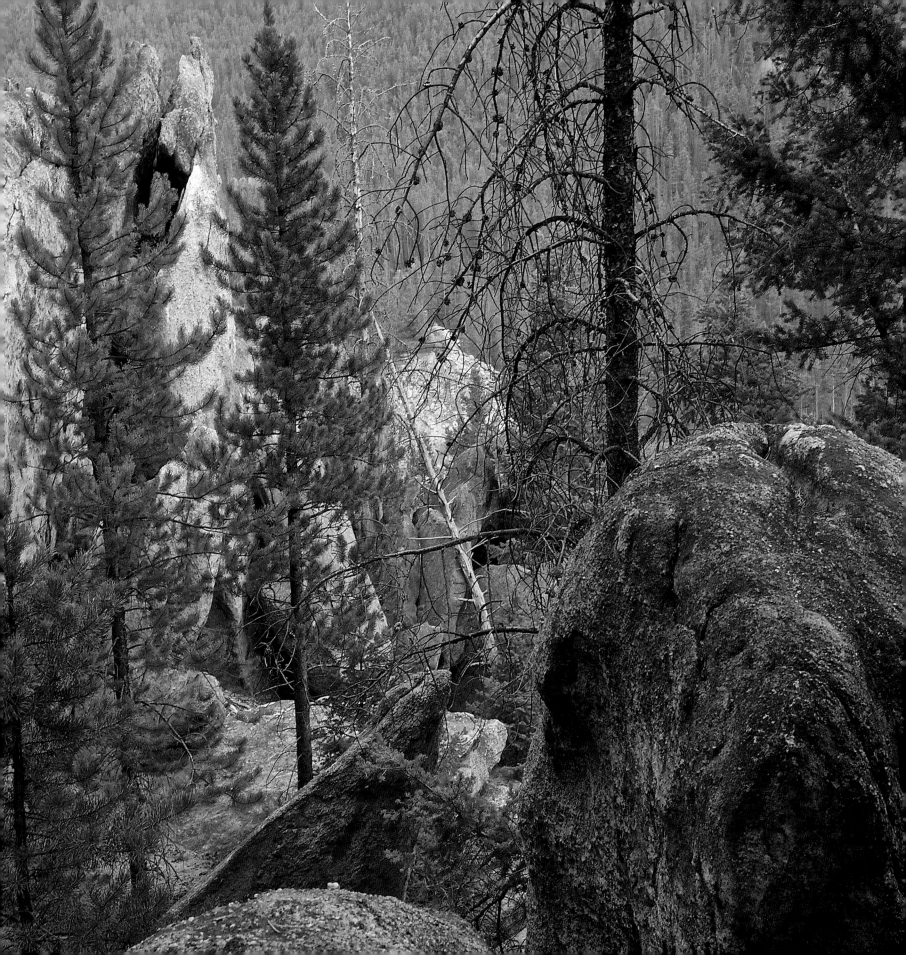

OPPOSITE: Granite outcrops of the Boulder Batholith in Beaverhead-Deerlodge National Forest lie along Interstate 90 east of Butte, Montana.

RIGHT, TOP: A few magnificent ponderosa pine groves remain along Rock Creek in Lolo National Forest southeast of Missoula, Montana. Legendary trout waters here are threatened by rising temperatures and fires that have recently charred the mountainsides. Critically located, the creek's corridor provides semiwild linkage between the great wilderness expanse of the Northern Rockies running north to Glacier National Park and to the truly awesome Idaho wildlands of the Salmon and Selway River Basins extending southward.

RIGHT, BOTTOM: A recently burned lodgepole pine forest of Montana's Lewis and Clark National Forest, south of Glacier National Park, recovers with pearly everlasting, fireweed, thimbleberry, and willows—together a salad bowl overflowing for mule deer and Rocky Mountain elk.

FOLLOWING SPREAD: The Kootenai River west of Troy, Montana, foams over cascades as one of the West's most extraordinary river features. Kootenai National Forest occupies the opposite side of the river. Plans to build a dam here for hydroelectric power in the 1970s were defeated by groups including local tribes arguing for the spiritual values imbued in Kootenai Falls.

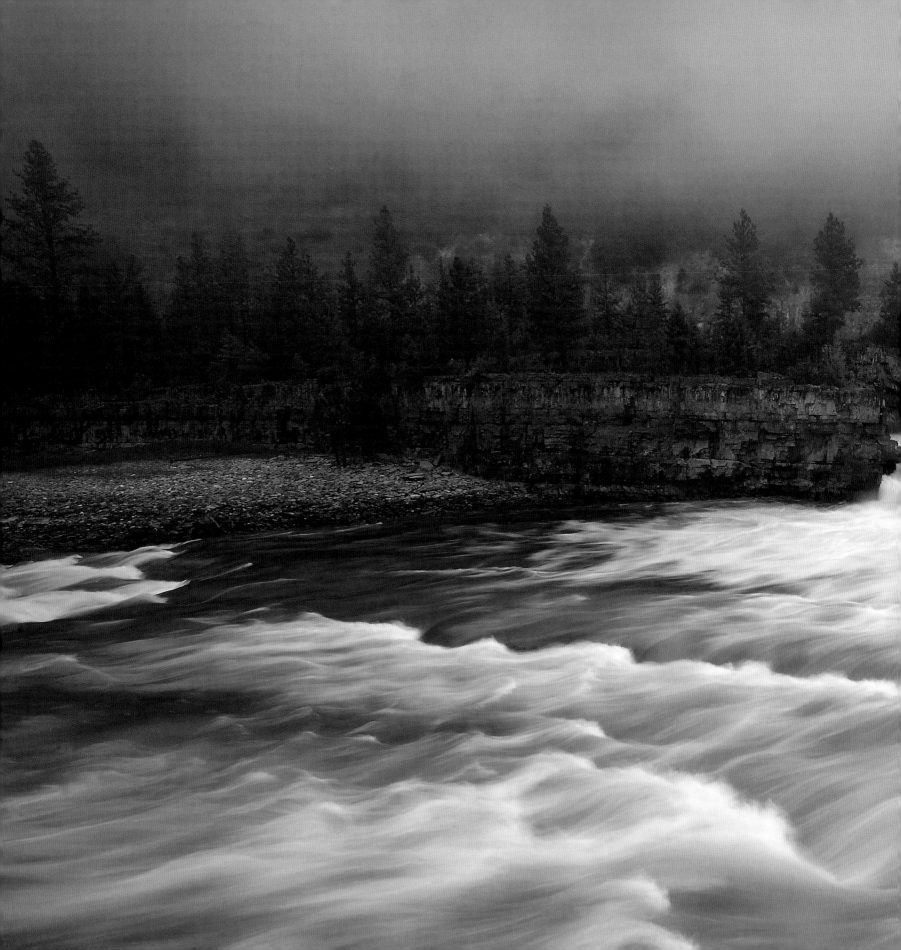

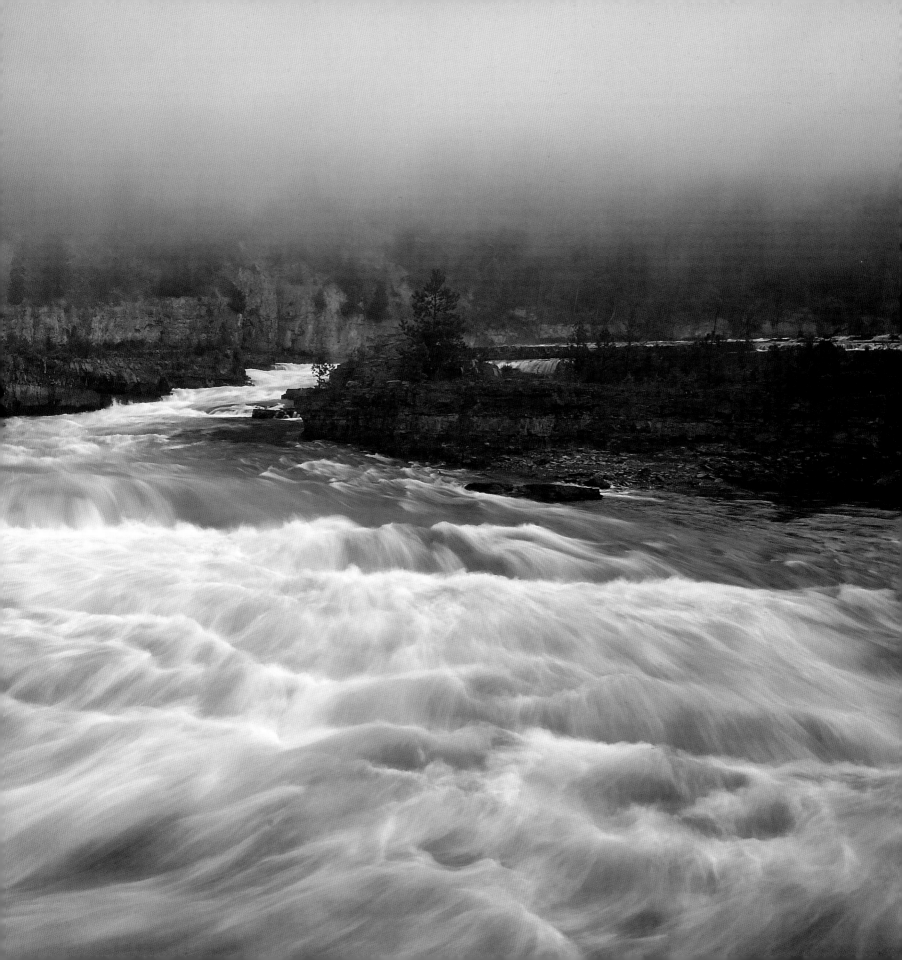

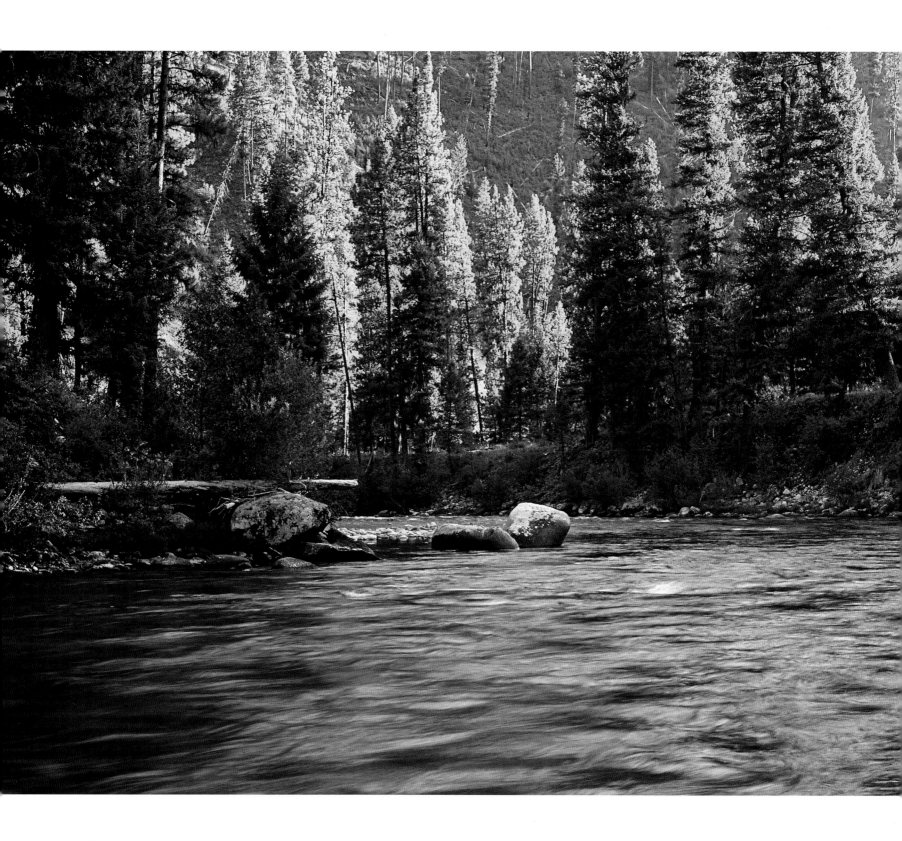

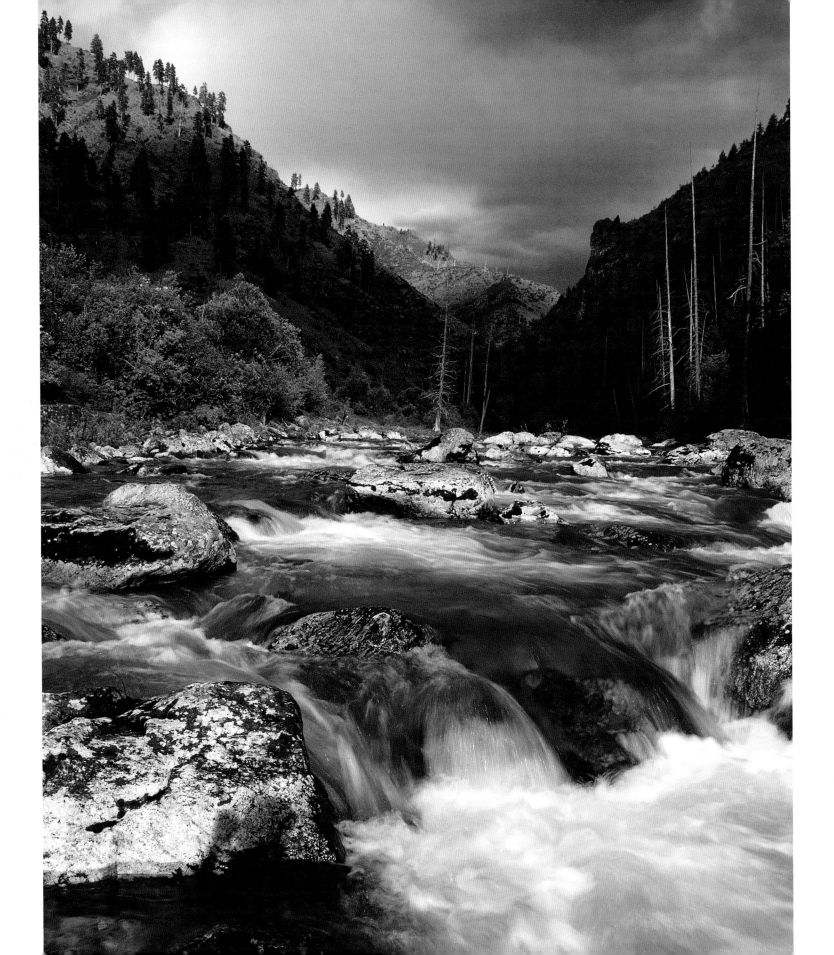

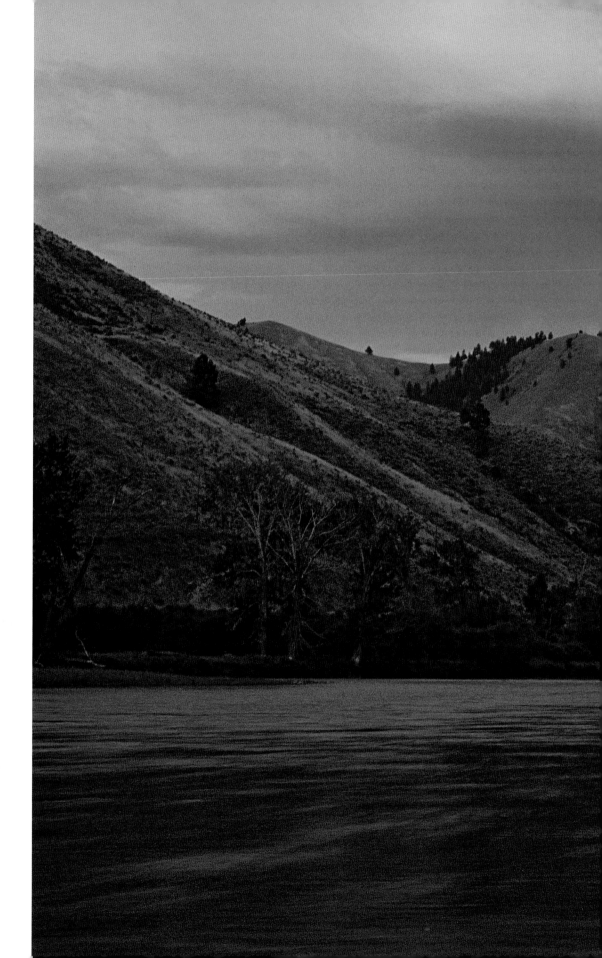

PREVIOUS SPREAD, LEFT: The South Fork Payette River flows from Idaho's Sawtooth Mountains and through a magnificent belt of conifers before entering steep canyons funneling down to the river's main stem and drier country of the Snake River Plain. This refreshing scene is at a Boise National Forest campground upstream from Lowman, Idaho.

PREVIOUS SPREAD, RIGHT: The remarkable Selway of Nez Perce-Clearwater National Forests in northern Idaho was among the original Wild and Scenic Rivers designated in 1968 and offers one of the most sought-after white-water trips in the West. This rapid lies five miles downstream of Paradise, where the access road from Darby, Montana, ends, and hiking or paddling down the Selway begins. Here and in adjacent national forests, the Frank Church-River of No Return and Selway-Bitterroot Wilderness Areas comprise the largest block of protected wild terrain in the 48 contiguous states.

OPPOSITE: Epic in the geography of the West, Idaho's Salmon River is the longest nearly undammed waterway, with only a weir blocking the flow at a headwaters fish hatchery. The river's 406 miles penetrate five national forests plus Bureau of Land Management and private property. Here in Salmon-Challis National Forest, just below the North Fork confluence, twilight descends on the calm waters of the great river.

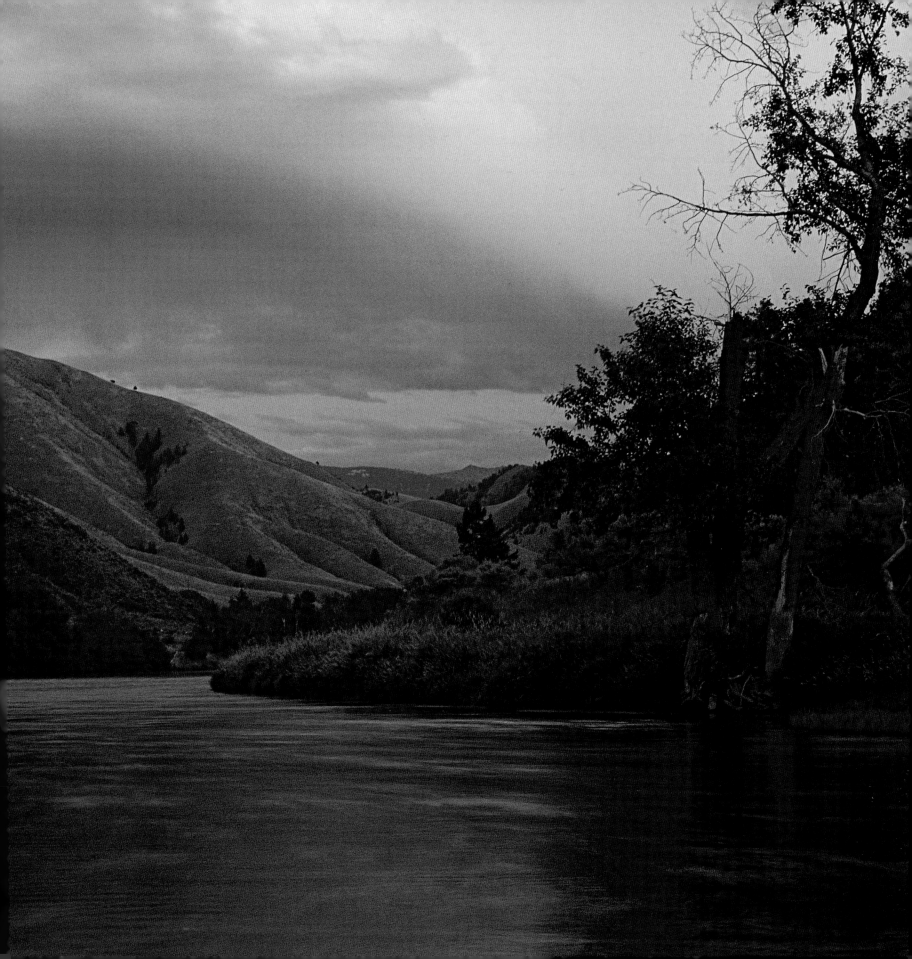

Bridger-Teton National Forest

The magnificent Bridger-Teton National Forest lies at the edges of Grand Teton and Yellowstone National Parks and also includes the incomparable Wind River Range. Here the Gros Ventre River speeds through a cottonwood forest east of Kelly. Boulder gardens date to a 1925 landslide that temporarily dammed the river but soon washed away, leaving the turbulence that lingers today.

It is not for nothing that Bridger-Teton National Forest tags itself with a handy logo—"wild lands, wildlife, and wide vistas." Located in western Wyoming, abutting Yellowstone and Grand Teton National Parks, and covering the western slope of the Continental Divide, nearly a third of its 3.4 million acres is officially designated as wilderness, or is under consideration for that status; another 40 percent is so remote that it might as well be. Living within its varied habitats and ecozones—from sagebrush at lower elevations rising through Douglas fir and Engelmann spruce to lodgepole pine and then above to bare rock—is a who's who of species threatened and endangered. The once nearly extinct, now reintroduced, black-footed ferret ("a bold and cunning foe," John James Audubon called it)—along with wolves (also successfully reintroduced here) and grizzlies—is among the rare mammals inhabiting this mountainous terrain. So many browsers, from elk to pronghorn sheep, inhabit the Gros Ventre River Valley that it has been dubbed the "Little Serengeti." Famed mountain man Jim Bridger, who explored this region in the mid-19th century, and for whom the forest is partly named, would feel right at home today.

To take in this array of landform and life is simple: just climb any one of the forest's 40 mountains rising above 12,000 feet, and be swept away. But dress appropriately, for the forest's promoters should have added a fourth descriptor: wet. Given the western-facing orientation of its high ground, the forest captures a disproportionate amount of precipitation from Pacific fronts pushing east. Hundreds of inches of snow fall each winter, with some sections recording upward of 50 feet. Come spring, the melt tumbles downhill into the headwaters of the Gros Ventre, Snake, and Green Rivers, heading back to the Pacific via the Columbia and Colorado Rivers.

A segment of that return flow was temporarily blocked in June 1925, when heavy rains, combined with melting snowpack, and possible seismic activity, triggered a colossal landslide shearing off of Sheep Mountain. Within three minutes, 50 million cubic yards of sandstone and shale roared down into the Gros Ventre River Valley just east of Jackson Hole, Wyoming, and powered up the opposite slope, creating a dam 200 feet high and 400 feet wide; it blocked the Gros Ventre River and created Lower Slide Lake. Two years later, despite geologists' assurances that this rock structure was safe and permanent, it gave way, blasting into the small town of Kelly, Wyoming, killing six people.[5]

The geologic scar remains visible, a reminder of nature's capacity to forcefully rearrange the environment and confound our expectations of its stability. Visitors may absorb slightly less earthshaking lessons by setting off on any one of the forest's interlacing hiking trails, a network that totals more than 2,000 miles. These trails' very existence speaks to an important development in the management of the national forests. The federal government initially established the Forest Service to regulate the use of the natural resources on these public lands, and the regulations the agency imposed were to make certain

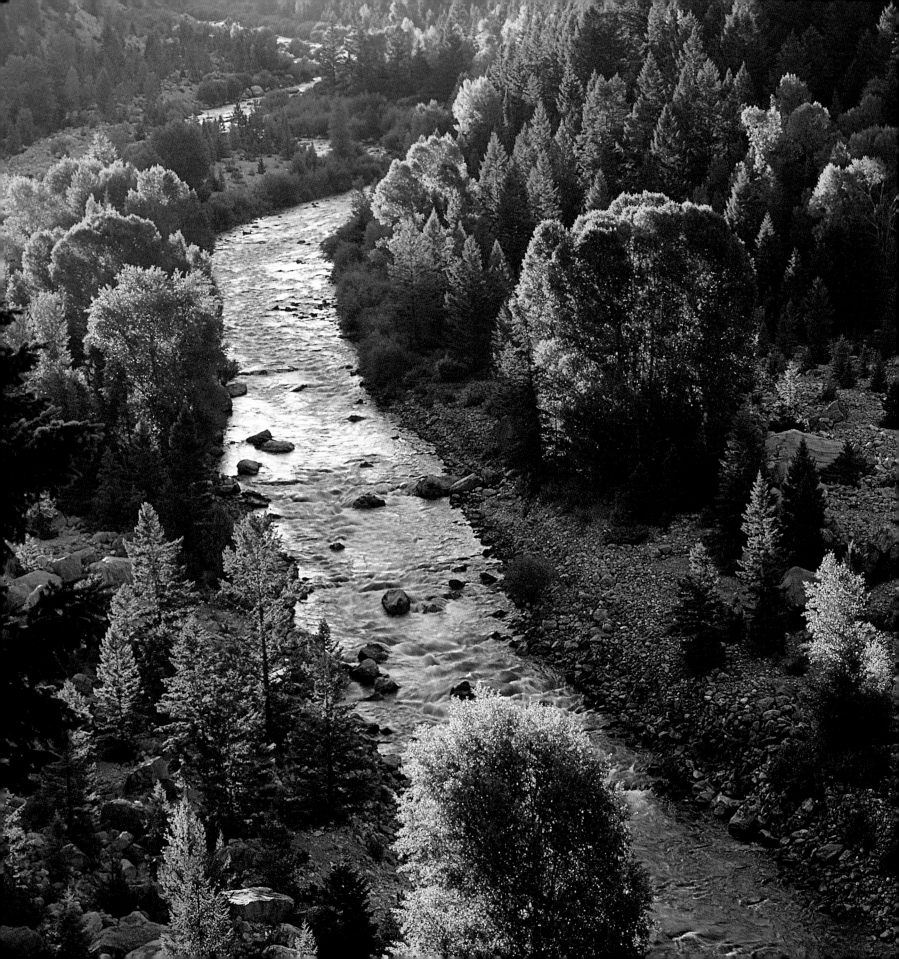

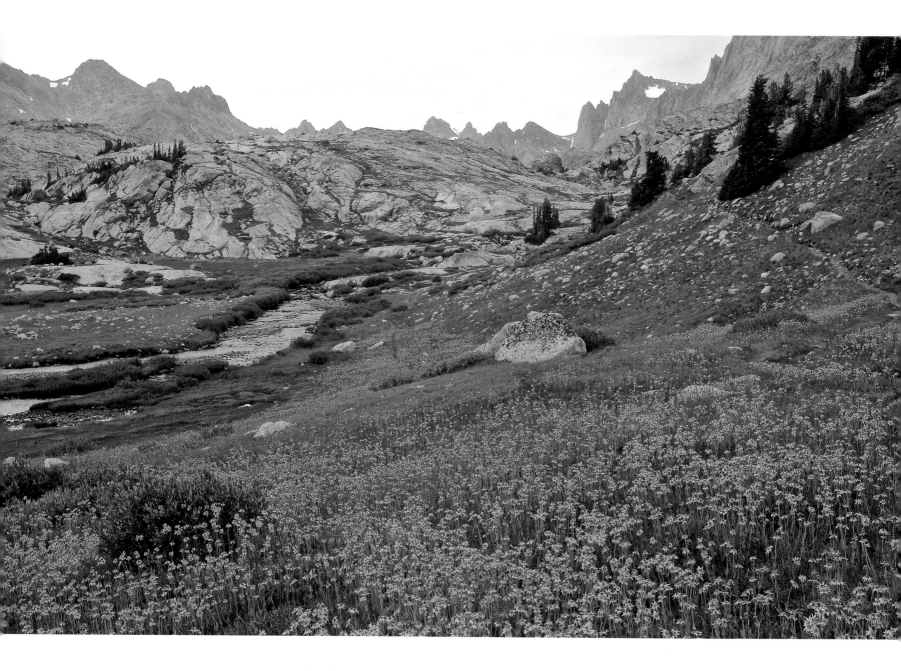

that future generations would be able to profit from these lands' timber, grass, and minerals.

Recreation was not central to this mission, as President Theodore Roosevelt confirmed in a speech to the inaugural meeting of the Society of American Foresters, held in Gifford Pinchot's residence. "First and foremost, you can never afford to forget for one moment what is the object of the forest policy," he told the rapt audience. "Primarily that object is not to preserve forests because they are beautiful, though that is good in itself; not to preserve them because they are

refuges for the wild creatures of the wilderness though that too is good in itself but the primary object . . . is the making of prosperous homes. . . . Every other consideration comes as secondary."[6]

That balance began to shift in the 1920s. Faced with an increasingly mobile society, thanks to the automobile and a growing urban population eager to drive out to revel in nature's glories, and confronted with the newly formed National Park Service's successful lobbying of Congress to transfer landmark sites and scenic beauties away from it, the agency slowly recognized that it needed to broaden its scope of work. It set aside Trappers Lake, Gila Wilderness Area, and a portion of Superior National Forest to appeal to those who wanted to rough it. These first steps would usher in a new perspective within the agency, argued the agency's first "recreation engineer," Arthur Carhart: "The organization of the recreation resource in our National Forests should not be on the basis of something that is delightful for the people of the country, but rather something that is indispensable."[7]

Certainly that is how city dwellers conceived of their relationship to nearby national forests. By the 1920s, the Angeles (Los Angeles), Arapaho and Roosevelt (Denver), Mount Hood (Portland), and Mount Baker-Snoqualmie (Seattle) National Forests were experiencing increased numbers coming to hike, camp, and play. Thirty years later, with an even more urbanized nation seeking respite in the Great Outdoors, the Forest Service was overwhelmed by the demand for campgrounds, trails, and services. Recreation had come of age.

Its maturation was aided by the development of lighter-weight clothing, boots, and equipment—and of specialty stores that sold them. Equally important was the idea of encountering nature face-to-face, hand-to-rock, paddle-to-water. The Bridger-Teton met this escalating demand by laying out new trails of varying difficulty to take advantage of its varied topographies and to offer unfettered access to wide vistas.

An example of the cultural dynamic to which the forest has responded is the growing fascination with thru-hikes. One of these long-distance treks is the 3,100-mile Continental Divide Trail (CDT) running between Mexico and Canada; 200 miles of it are in the Bridger-Teton National Forest. Its older, more renowned peers, the Appalachian and Pacific Crest Trails, had received congressional sanction via the National Trails System Act (1968), which President Lyndon Johnson signed to help beautify the smog-choked nation: "We can and should have an abundance of trails for walking, cycling, and horseback riding, in and close to our cities. In the back country we need to copy the great Appalachian Trail in all parts of America." A decade later, the CDT became the third major trail in the system.[8]

The CDT has attracted less attention than its partners in the Triple Crown of American hiking, if only because the rough terrain and brutal weather along the nation's backbone is daunting. That just makes the rewards, however small or momentary, worth it to those willing to brave the trail. Among the feats Francis Tarpon, the first to complete a yo-yo (round-trip hike in one year), wanted to accomplish while trekking through the Bridger-Teton was to summit Wyoming's tallest mountain, Gannett Peak, without a partner, ice axe, or crampons. After hitting snowfields at 11,000 feet, he changed his mind and hiked along the Green River in the Wind River Wilderness. His new route led him through "the most beautiful valley I have seen on the CDT. It has granite monoliths that rival the ones in Yosemite Valley and the only way to see it is by walking there." His was a fortuitous detour in this land of extremes.[9]

The extraordinary glaciated wild peaks and valleys of the Wind River Range in Bridger-Teton National Forest are a mountainous highlight of the West. Leafy arnica frames this view toward Titcomb Basin. For decades the Winds have been among the top backpacking and horse-packing destinations in America.

Little Missouri National Grassland

In 1973, amid that decade's energy boom in western North Dakota, then-governor Art Link worried about the long-term consequences of extensive drilling in the Williston Basin. "We do not want to halt progress," he acknowledged in an address to the North Dakota Rural Electric Association, but neither did he want the state despoiled after the boom went bust. "When . . . the landscape is quiet again, when the draglines, the blasting rigs, the power shovels and the huge gondolas cease to rip and roar, and when the last bulldozer has pushed the last spoil pile into place and the last patch of barren earth has been seeded to grass or grain," Link wondered, what then? What would subsequent generations say about the impact that industrializing the Badlands and prairies had on people's lives and livelihoods? The answer depended on how resolute the people and their governments were in ensuring that the "most efficient and environmentally sound" extraction methods had been employed. "Let those who follow and repopulate the land be able to say, 'Our grandparents did their job well. This land is as good as, and, in some cases, better than, before.'"

Link's cautionary words are relevant once more as the Williston Basin and the larger Bakken Shale region are experiencing yet another boom, this one energized by hydraulic-fracturing and slant-drilling technologies. One site under production is the Little Missouri National Grassland, an open country of "singular beauty" that wilderness advocate Olaus Murie once extolled for its "chiseled buttes and domes, the clay and prairie grass, the eagle, the prairie dogs, deer,

coyote; the flocks of grouse at heads of the wooded draws." As is happening to Colorado's Pawnee and Wyoming's Thunder Basin National Grasslands, however, heavy industrial activity has also sparked a fractious debate over natural-resource management on the nation's public lands in this age of climate change.[10]

There is nothing new about this controversy, as the history of the Little Missouri reveals. Its past is a complex tale of a competing set of federal policies and local ambitions. Start with the initial impetus for the settlement of the Great Plains, the once-tallgrass prairie sweeping south from central Canada to central Texas. President Abraham Lincoln's 1864 Homestead Act and its legislative successors offered low-cost acreage in western North Dakota to attract new residents and build the region's agrarian economy. The plow broke the plains in every sense. By tearing open the thick, matted sod, it exposed the rich soil beneath; with its cover gone, increasingly the ground lost its capacity to retain moisture. Periodic drought exacerbated this process, reducing the land's fertility. This came to a head in the early 1930s with a devastating drought and simultaneous collapse of financial markets, crop prices, and land value. When the winds blew, thick dust darkened the skies, a terrifying symbol of the environmental disaster afflicting the plains.

North Dakota reeled, suffering the highest rate of foreclosures in the nation and rapid out-migration in its western counties. President Franklin Roosevelt's New Deal for the Peace Garden State and others similarly afflicted was

Sunrise beams on Little Missouri National Grassland south of Theodore Roosevelt National Park. With one million acres, this is America's largest national grassland. Splendid rolling hills and rock scarps green up beautifully in spring with habitat for bighorn sheep, pronghorn, and prairie dogs. Hundreds of wells for natural gas are also drilled here with 15 per square mile in many areas.

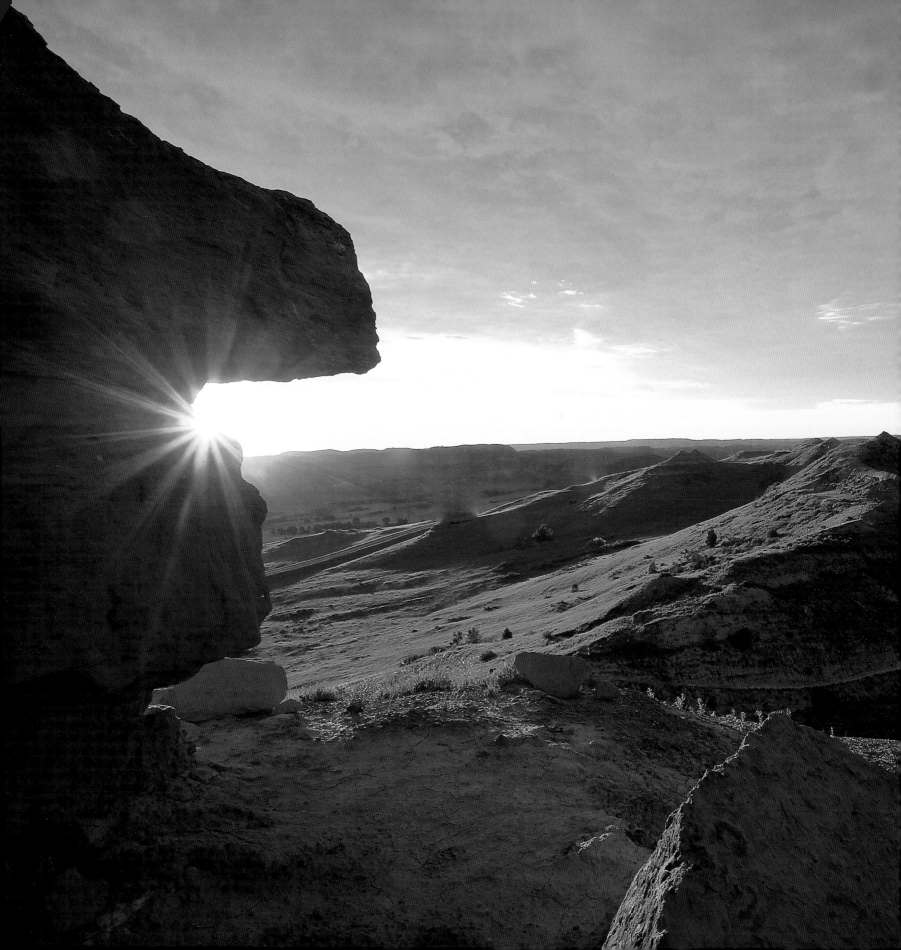

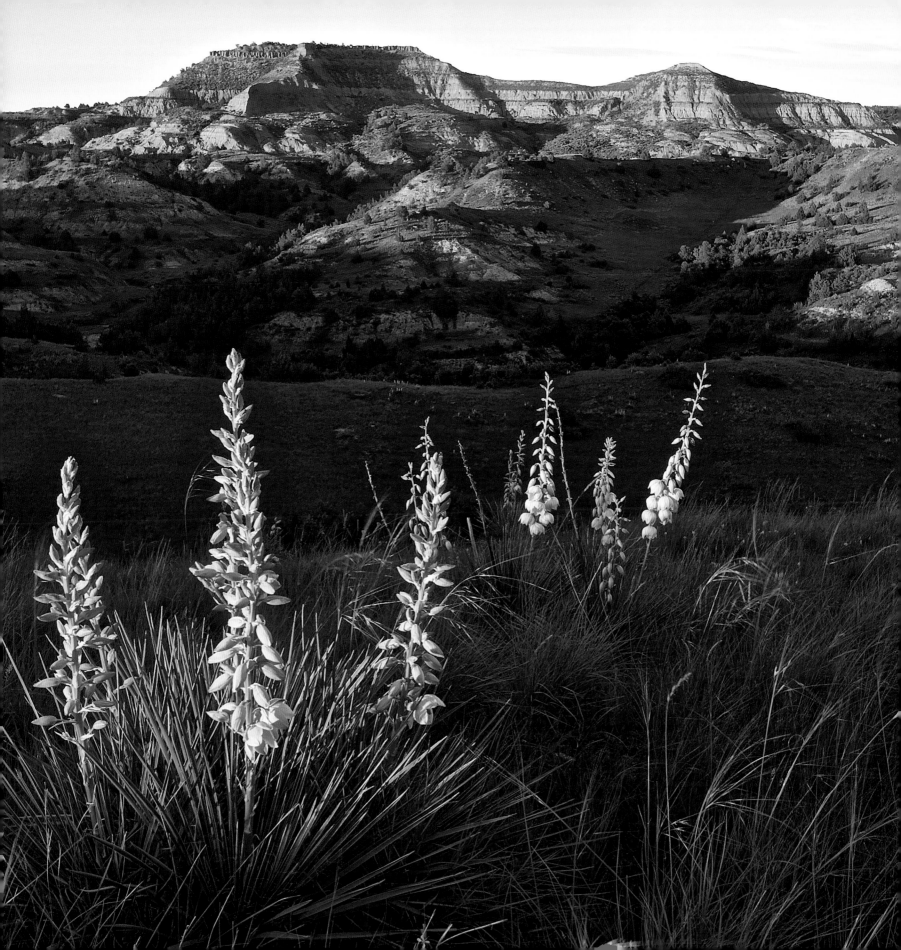

the passage of the Bankhead-Jones Farm Tenant Act (1937). It provided funds to purchase submarginal acreage "to correct maladjustments in land use," retiring it from "unprofitable crop production and [turning] it back to grass and into grazing or forest areas." For $50 million, the federal government bought 11 million acres, including the lands that today form the nucleus of the Little Missouri National Grassland.[11]

Another New Deal creation, the Soil Conservation Service (SCS), initiated erosion control and reseeding in the Little Missouri and inaugurated a new form of shared governance in these restored grasslands with local grazing associations. SCS issued permits to these groups, who distributed privileges to their members and in exchange required that they be responsible for conserving land health or forfeit their permits. The agency's management goal was landscape-scale in orientation, expecting that this system of local control would produce "a better and more complete integration of the use of Title III lands with private and other public lands."[12]

In 1954, the Department of Agriculture transferred some four million acres of these lands to the Forest Service, and six years later the agency designated them as national grasslands. The Little Missouri was one of these 17 new sites, along with Butte Valley in Northern California, Crooked River in Oregon, and Curlew in Idaho, as well as those located across the Great Plains— from the Caddo-LBJ north to the Pawnee, Thunder Basin, and Buffalo Gap. On these lands the agency maintained the SCS's commitment to the earlier-established grazing associations. This management decision represented a break from the Forest Service's usual grazing-permitting practices in the national forests, in which it granted allotments to individuals only. By linking resource conservation with the promotion of community

environmental and economic health, the agency revived its "early spirit of mission."[13]

As for fossil-fuel resources, the Forest Service must defer to the Bureau of Land Management (BLM). An agency in the Department of the Interior, the BLM is the nation's largest landlord. It manages upward of 250 million acres in the West, and has sole responsibility for another 700 million of subsurface mineral rights on public and private land. Since the early 2000s, the BLM has been charged with expediting energy-related development and has driven oil and gas production to such heights that the United States became the world's largest producer of fossil-fuel energy.

Yet the promotion of energy independence has met with sharp resistance, particularly in the Little Missouri. Grazing permittees are challenging the effect that increased drilling has had on their livelihoods. Private landowners with property located inside of, or abutting, the national grassland are deeply worried about their rights and health. These tensions have escalated because of the close proximity of Theodore Roosevelt National Park. The park memorializes Roosevelt's association with the Little Missouri, to which he retreated in search of solace in 1884 following the tragic, same-day deaths of his wife and mother. Roosevelt family members, along with local and national environmental organizations, have protested the threat that energy production poses to the park's environmental integrity, scenic beauty, and cultural value.[14]

How we respond to these critical concerns in the Little Missouri, how we balance one set of national needs with equally important cultural values embedded in other important historical places, will determine, to paraphrase Governor Link's insight, whether we are worthy of our legacy and progeny.

Soapweed yucca catches the sunset light in Little Missouri National Grassland.

Sawtooth National Forest

Public-lands management can be transformed any number of ways. Natural forces can so disrupt policy on the ground that it must be sharply revised. Management plans in the Francis Marion and De Soto National Forests, for example, had to shift after hurricanes ripped through them, as they did in the Gifford Pinchot National Forest after Mount St. Helens erupted and flattened hundreds of thousands of forested acres. Less violent, but no less potent, are human demands for change, whether emanating from top-down decision making, bottom-up pressure, bureaucratic competition, or legislative fiat. In the Sawtooth National Forest, all four of these latter possibilities have occurred, often simultaneously, leading to fundamental recalibrations of the forest's managerial options.

Set within central Idaho, the forest encompasses more than two million acres of glacier-carved, crenelated mountain ranges, including the Sawtooth, White Cloud, Boulder, and Smokies. It is dotted as well with countless lakes, and its 3,000 miles of streams and creeks feed into the Salmon, Big Wood, Payette, and Boise Rivers. These are crucial spawning grounds for sockeye salmon and other aquatic species. This brief tabulation of the national forest's resources explains why people have loved and argued over this treasured terrain for so long, an enduring tug-and-pull.

Shortly after President Theodore Roosevelt signed the legislation establishing the Sawtooth National Forest in 1905, activists in the Idaho State Federation of Women's Clubs began agitating to

Above Stanley, a rainbow arcs over the Upper Salmon early in the river's passage through eight subranges of the Rockies and on its way to the Snake and Columbia Rivers. Salmon here ascend 900 miles to Sawtooth Mountain spawning streams. Once home to the greatest runs of Chinook salmon in the world, the river's fish have been reduced to endangered species owing largely to four dams on the Snake River below the mouth of the Salmon. The Save Our Wild Salmon Coalition works to dismantle those dams.

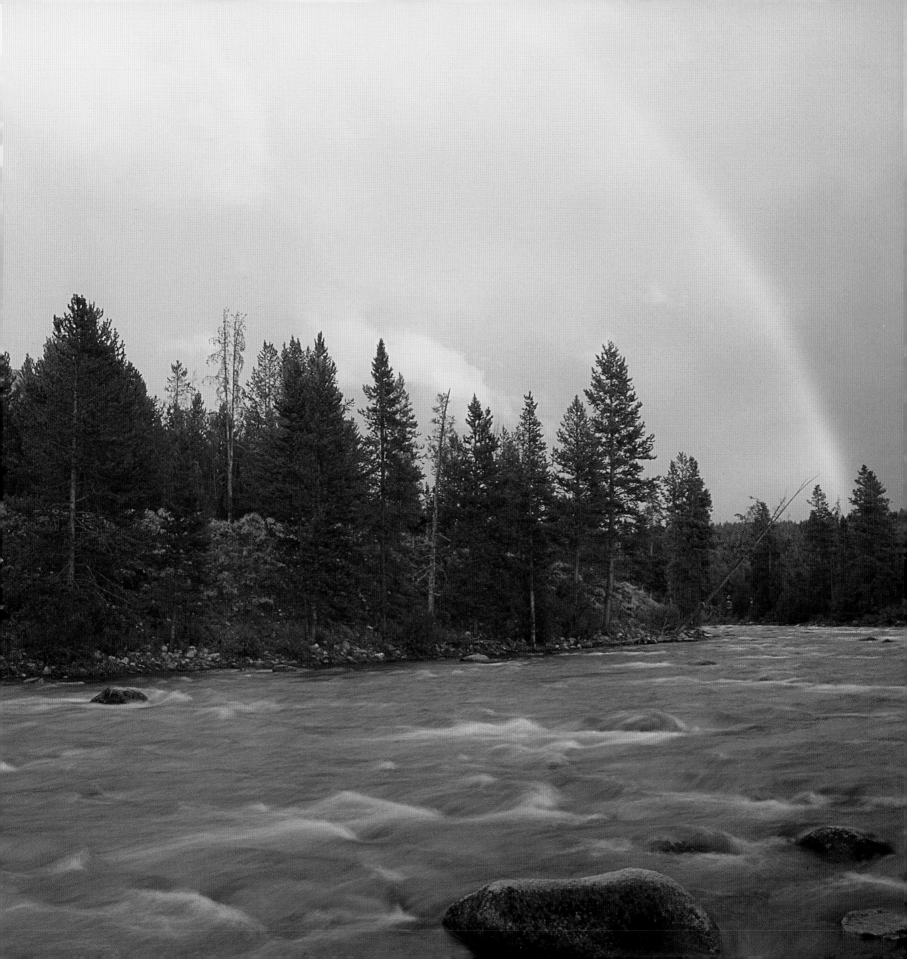

turn the forest into a national park. Drawing on arguments other clubwomen were making around the country in support of Grand Canyon, Mesa Verde, and Rocky Mountain National Parks, Boise resident Jean Conly Smith secured her state organization's endorsement for a Sawtooth National Park. Asserting that the preservation of the region's stunning scenery and the generation of tourist dollars could best be achieved through national park status, she mused, "There will always be wild land not required for settlement, and how can it be better used than by making it a sanctuary for wild things that afford pleasure to all who see them?"[15]

Taken aback by this emerging movement, and its ability to rally public support for enabling congressional legislation, the Forest Service mounted a quiet counterattack. It encouraged commodity interests in the Gem State to speak out in opposition and to lobby their local representatives. Internally, the agency urged its personnel to walk a fine line between acknowledging some lands are best set aside for recreation and suggesting that any such park would be premature because there was no federal agency to administer it. The goal was to delay legislative action, a tactic that had a relatively short shelf life. In 1916 Congress created the National Park Service, and President Woodrow Wilson appointed advertising executive Stephen Mather as its first director, a choice that would prove disastrous for the Forest Service. Mather initiated a nationwide promotional campaign tying the creation of national parks to the increased access the automobile offered. With his assistant director Horace Albright's ability to secure Congress's goodwill, the new agency plucked such landmarks as the Grand Canyon from the

Forest Service's inventory. It also successfully encouraged Wilson and his successors to use the 1906 Antiquities Act, which empowered the chief executive unilaterally to denote public lands as national monuments, to transfer such southwestern icons as Bandelier, Bryce Canyon, Gila Cliffs, and Zion to the Park Service. In Mather, the Forest Service had met its match.[16]

Yet the agency prevailed in Idaho. Partly that was a result of its more adroit response to challenges to its control, but was also due to its concession that recreation should have an equal footing in the Sawtooth. As happened in other western forests, the agency touted its advocacy of wilderness preserves, and of hunting, hiking, and fishing. Its strategy garnered editorial support and a closing of the ranks with the state's congressional delegation. The Forest Service even collaborated with the Park Service to absorb Redfish Lake and its environs, which President Wilson had withdrawn from use in anticipation of a new park, into the national forest. This "vigorous interagency competition," historian Douglas Dodd has argued, "left central Idaho's rugged and beautiful Sawtooth Mountain region better protected for the future."[17]

Those protections received a serious test in the late 1960s. With its discovery of a rich molybdenum deposit at Castle Peak in the White Cloud Mountains, the American Smelting and Refining Company sought to capitalize on its rights embedded in the controversial Mining Law of 1872. Through that law, Congress had declared that all mineral deposits on public lands were "free and open for exploration and purchase." Because there was no protective legislation for the White Cloud site that trumped this claim, the Forest Service had no recourse to stop the company.

The public, however, did. As the controversy grew up over the proposed mine's despoliation of the surrounding woodlands and watersheds, opponents crafted a counternarrative to blunt the pro-jobs argument of the Idaho mine's proponents. Tourism, they argued, would be of greater benefit in the long run, and they pushed for a national recreation area (NRA) designation to upgrade the Forest Service's stewardship authority over the White Clouds. Idaho Senator Frank Church dusted off an earlier bill to create a Sawtooth NRA that would include Castle Peak as a part of its 756,000-acre expanse, legislation that Congress enacted in 1972. The land seemed safe.[18]

Nothing about the Sawtooth is ever quite as secure as its supporters would like. So to resolve any lingering doubts about whether its protections will long endure, they have sought an increased number of wilderness areas. In 2002, Representative Mike Simpson sponsored the Boulder-White Clouds Wilderness Bill to designate 332,000 acres within the NRA as wild. When that failed because motorized users, bikers, and snowmobilers equated wilderness with loss of access, its proponents developed a 570,000-acre national-monument initiative for Boulder-White Clouds that incorporated motorized access within prescribed areas. Worried that President Barack Obama would use his Antiquities Act authorities to unilaterally create the monument, in the summer of 2015 Congress passed legislation designating three new wilderness areas totaling more than 275,000 acres; the president signed the legislation that August. His signature partly fulfilled a process in the Sawtooth that Jean Conly Smith had launched in 1912, an ongoing reinvention that Aldo Leopold gave voice to in his wilderness ode: "All history consists of successive excursions from a single starting-point, to which man returns again and again to organize yet another search for a durable scale of values."[19]

Iconic in the mountain scenery of the West, Sawtooth National Forest in central Idaho is best known here at Redfish Lake, with Grand Mogul and Mount Heyburn piercing the sky in the background. Congress designated this and parts of neighboring Salmon-Challis and Boise National Forests as a national recreation area in 1972. This halted industrial mining proposals in the adjacent White Cloud Mountains, otherwise allowed by the Mining Law of 1872. The recreation area also established a program of easement acquisition for Sawtooth Valley ranchlands that were otherwise being gridded into subdivisions and sold for vacation homes squarely within the spectacular views.

Flathead National Forest

Wilderness areas, at least those officially designated in the national forests, bear some wonderfully evocative names: Peru Peak (Green Mountain National Forest), Raccoon Branch (Jefferson), Big Gum Swamp (Osceola), and Garden of the Gods (Shawnee). Then there is Strawberry Crater (Coconino), Agua Tibia (Cleveland), and Hells Canyon (Wallowa-Whitman). Flathead National Forest upholds this tradition of denoting its wildlands after redolent geographic features, but sandwiched in between its Great Bear and Scapegoat Wilderness Areas is the Bob Marshall Wilderness, more affectionately known as "the Bob."

The indefatigable Marshall earned this honor. Indeed, his Forest Service colleagues called him the "Rocky Mountain Greyhound" for his rapid hikes through high-country wilderness, including the austere and rugged mountainous area his name adorns. Marshall had mastered the quick-tempo pace on youthful sprints up Adirondack peaks. The steeper Rockies offered greater challenges but did not slow his gait, even when he shouldered 70 pounds of equipment.[20]

Trained as a forester, he noted shifts in terrain, ecosystem, and habitat during his treks. As a wilderness enthusiast, he was captivated by the untrammeled. Like John Muir before him, Marshall believed mountaineering was a tonic for urban jitters: "People cannot live generation after generation in the city, without serious retrogression, physical, moral and mental."[21]

Marshall joined the Forest Service in 1925 and worked for the next three years conducting social-science research at the Northern Rocky Mountain Forest Experiment Station in Missoula, Montana. He allied himself with Aldo Leopold and Arthur Carhart when they proposed that the Forest Service set aside pristine lands, and helped rebut those foresters dismissive of "elitist" wilderness advocates. Democracy was meaningless if it did not protect minority prerogatives, Marshall countered, including those for the few "who have an overwhelming longing to retire periodically from the encompassing clutch of mechanistic civilization." Believing that the "enjoyment of solitude, complete independence and the beauty of undefiled panoramas is absolutely essential to happiness," in 1935 Marshall joined Leopold and other committed conservationists in establishing the Wilderness Society, an enduring reflection of their collective faith in nature as a preserve of liberty.

Marshall extended his faith in the national forests' democratic promise to the Native American people and the oft-marginal lands they inhabited. In 1934, he became director of the Indian Forest Service in the Department of the Interior. His key contribution was to develop a plan whereby reservations would regain control of their natural resources and, through conservative management, reclaim their sovereignty. Five years later he returned to the Forest Service to head the new division of Recreation and Lands with the intention of promoting new wilderness protections. He died that same year, at age 38. Given his devoted activism on behalf of the wild, there was no question that the land he

The South Fork Flathead River flows through the Bob Marshall and Great Bear Wilderness Areas of Flathead National Forest, among the largest roadless complexes outside Alaska.

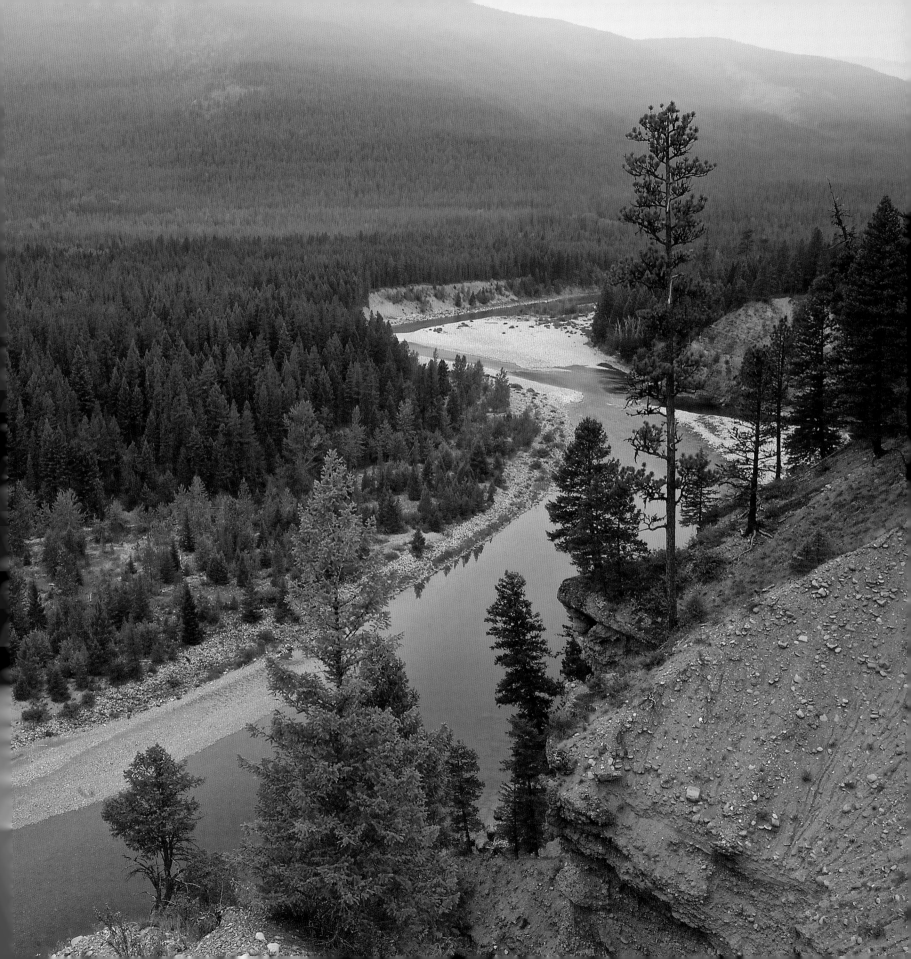

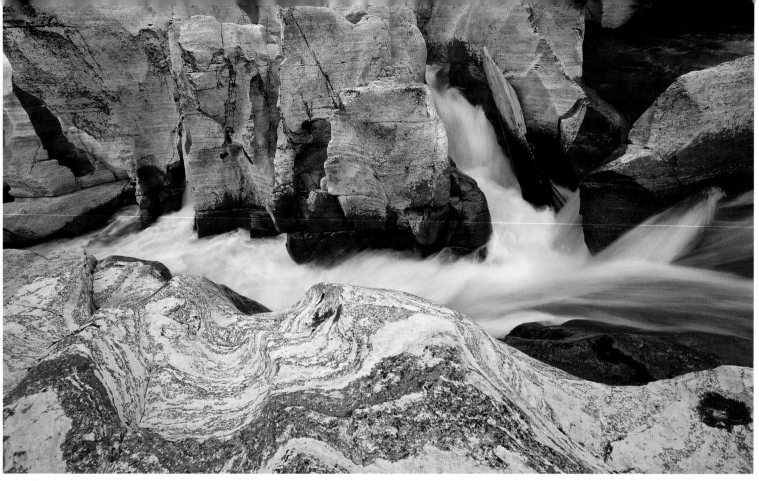

loved—the Bob Marshall Wilderness Area—should bear his name.

That may have been among the least controversial actions taken in the Flathead, a 2.4-million-acre sweep of northwestern Montana that envelops Flathead Lake. Serving as Glacier National Park's western boundary, it also abuts the Lolo, Kootenai, and Lewis and Clark National Forests, and straddles the Continental Divide. Its creation as a forest reserve in 1897 was divisive. An 1891 proposal to set aside these lands to protect the upper reaches of the Missouri and Columbia Rivers had been shelved after meeting with a storm of protest: "I regard such suggestions as emanating from the brain of a mad man," fumed the state's surveyor general. Reaction was no less irate six years later when President Grover Cleveland formally established the Flathead. Angered mining operators, timber owners, and local politicians schemed to get the declaration rescinded; their opposition complicated the forest's operations for decades.[22]

Even the Great Fires of 1910 generated political heat. These infernos consumed three million acres across Idaho and Montana, including portions of the North and South Forks of the Flathead River. Having failed to snuff out the monstrous, hurricane wind–driven blaze, the Forest Service itself should be extinguished, its critics demanded. The agency, for its part, made firefighting its major focus in the Flathead and elsewhere, ultimately adopting the so-named 10:00 a.m. rule, by which the agency committed to suppressing fires the morning after they were spotted.[23]

Other resource issues proved as contentious. Postwar dam-development projects in the Flathead—some constructed, others not—roiled local politics and brought considerable national scrutiny to the otherwise-remote Flathead. At the same time, the Forest Service accelerated timber harvests across the national forest system, and the Flathead became embroiled in the ensuing debate.

These late 20th-century tensions have not fully dissipated. That said, they have unleashed some creative and collaborative policy making designed to defuse some long-standing points of contention. In the Whitefish Range, which rises above the Montana communities of Whitefish and Columbia Falls, it had been impossible to balance the apparently intractable demands of hikers, snowmobilers, bikers, loggers, environmentalists, hunters, rafters, and ranchers over this 330,000-acre swath of the forest. The agency hoped to break away from the traditional management approach—"The old way was to wait for the Forest Service to start a planning process," said Michael Jamison of the National Parks Conservation Association, "then go in and ask for the world and argue against others getting anything." Instead, an array of contending groups formed the Whitefish Range Partnership in search of a new way of managing their disagreements. The group spent a year building trust and forging consensus about the best path forward. Out of their deliberations emerged a zoning approach to land management such that logging, biking, and wilderness did not impinge on each other.[24]

This breaking of a long-standing logjam would have pleased Bob Marshall, knowing as he did how new approaches to management can lead to deeper reflections. "Anyone who has stood upon a lofty summit and gazed over an inchoate tangle of deep canyons and cragged mountains, of sunlit lakelets and black expanses of forest," he wrote as if describing the Flathead, "has become aware of a certain giddy sensation that there are no distances, no measures, simply unrelated matter rising and falling without any analogy to the banal geometry of breadth, thickness, and height."[25]

OPPOSITE, TOP: The South Fork Flathead River jets through a four-foot bedrock slot marking Meadow Creek Gorge. This stream is one of the West's finest strongholds for bull trout, which require very cold water, many miles of dam-free flow, and isolation from hatchery-bred rainbow and brown trout.

OPPOSITE, BOTTOM: Forest fires in 2003 burned both sides of the North Fork Flathead River here above the Glacier Rim access area. Throughout the West, wildfires have become larger, hotter, and more numerous with the warming climate and drier summers. Adding to these hazards, a century of fire suppression has left a tinderbox buildup of dead branches and accumulated fuel, while logging has extracted large trees that had cast cooling shade and were relatively fire-resistant, with their thick bark and long trunks free of lower limbs that were otherwise vulnerable to flames and a "fire ladder" effect. In their place, thickets of small trees prone to crown fires and super-heated blazes have multiplied.

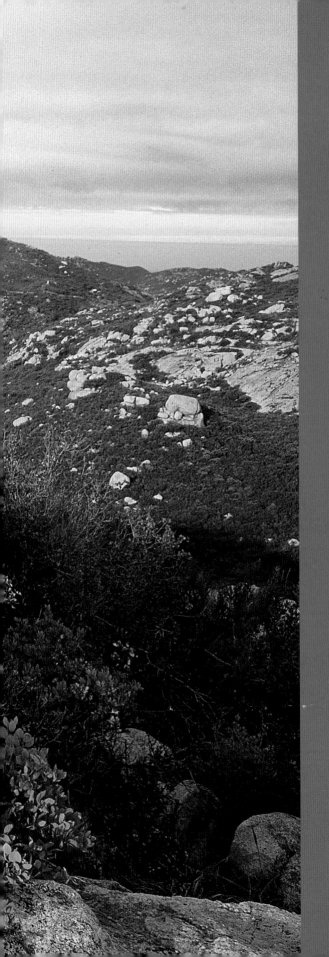

CALIFORNIA

1 STATE

18 NATIONAL FORESTS

1 NATIONAL GRASSLAND

21 MILLION ACRES

24.6 MILLION VISITORS

For a moment forget that California contains 38 million people and counting—more than the rest of the West combined. Here is the second-greatest concentration of national forests in America (next only to the Northern Rockies, though the north-south extent of public land in California is even longer). Here is the country's greatest geographical and biological diversity spanning from sea level to the highest peak outside Alaska, also from rain forest to Mojave Desert.

Southern California's forests rise as the most extensive wildland-urban interface on Earth. Inyo National Forest is like the craggy front of the famed Tetons, but this eastern Sierra escarpment rambles on, relentlessly mesmerizing for 200 miles. Eight Sierra Nevada national forests are wonders of the natural world. Northern California sprouts more conifer species than anywhere else, and the concentration of wild rivers there exceeds that of every other region.

But California *does* have 38 million people, and the perils of a warming climate pose threats that really count: the Scripps Institution of Oceanography projects that the Sierra Nevada snowpack, which now serves a majority of the state's population and its economic engine of agriculture, could diminish by 80 percent by the end of this century.

Photographing the national forests of California was the ultimate opportunity for beauty and brilliance. The Sierra Nevada are the most luminous mountains. The rivers are white-on-green cascades. The Big Sur Coast is the ultimate collision of land and sea. The north's bewilderment of uplift includes grinding glaciers on Mount Shasta and tangles of tributaries through seven distinct geological terranes where the Klamath River careens Pacific-bound.

— TIM PALMER

PREVIOUS SPREAD: In Cleveland National Forest of Southern California, Lyons Peak marks the horizon, seen from neighboring Lawson Peak. Beginning with the Santa Ana Mountains southeast of Los Angeles, three distinct sections of the Cleveland extend almost to the Mexican border and serve millions of Californians in growing cities nearby. OPPOSITE: On a morning hazed in warm light by distant forest fires, the Middle Fork Feather River streams past the mouth of its South Branch in Plumas National Forest—the northernmost of eight national forests along the Sierra Nevada's sky-scraping backbone.

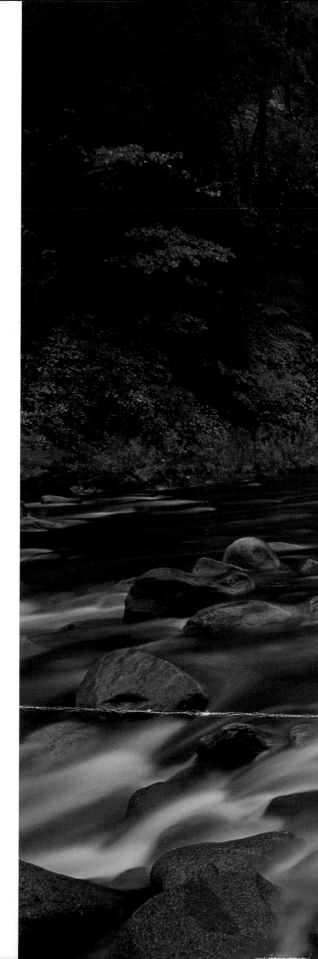

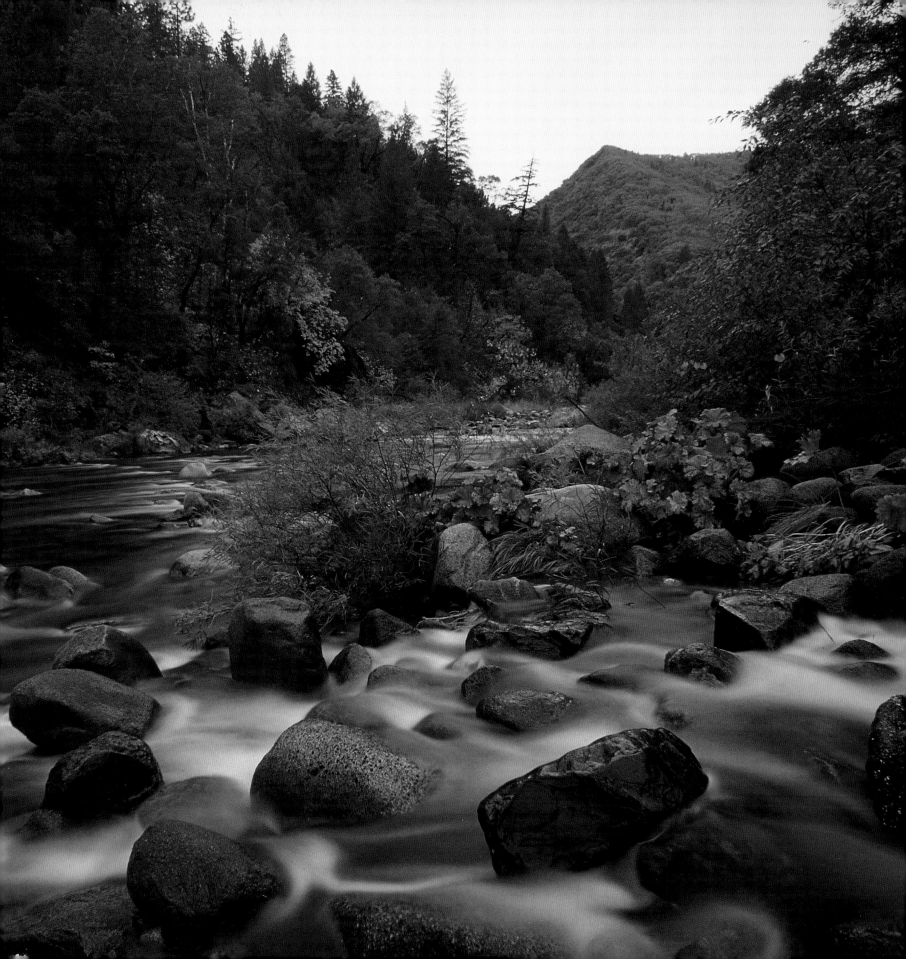

Mountains define California. The southern Cascades and Klamaths rumple the state's northern counties. The coastal ranges, which run more than 600 miles between Humboldt and Santa Barbara Counties, lie between the craggy Pacific coast and interior high ground that establish the valleys containing some of the nation's richest agricultural land. Farther

south, the San Gabriels, Santa Anas, and San Bernardinos, along with the peninsular ranges of San Diego, delineate the great basins that once were home to a highly productive citrus industry but now contain some of the most densely compact urban populations in the country.

Then there is the Golden State's massive central mountain range, the Sierra Nevada. The mountains' height and breadth establish the hydraulic conditions for all life on either side of the rough terrain that John Muir anointed as the Range of Light. "There are few real boundaries in nature, and this is one of the most astounding," observed Rebecca Solnit. "From the west, you can hike up a green mountain slope and come to the divide, where you look over at the beginning of a thousand miles or more of desert, stand in patches of deep snow from the winter before, and look at a terrain that receives only a few inches of moisture a year." This geophysical reality has profound implications for how water moves within the state, with most of it draining into the Pacific; the scant amount trickling off the eastern slopes pools into such "salty lakes like Mono" or into "sinks and subterranean spaces, into thin air."[1]

Given the impressive place-establishing nature of the Sierra and the other California mountains, it is not surprising that when the national forest system came into being in the late 19th century that almost all of this elevated area, and not incidentally the watersheds it created, was placed under the Forest Service's regulatory control. Today, California's 18 national forests welcome swarms of visitors, one-sixth of whom recreate in the Angeles alone, perhaps the most urbanized national forest in America.

Unparalleled as playgrounds, the California national forests also reflect some of the tensions confronting the larger system. The swelling population of the southern counties, for example, has pressed ever closer to the forests' boundaries. This crowded human presence poses serious challenges to the maintenance of indigenous chaparral ecosystems and the biodiversity they sustain. Because these landscapes are also fire adapted, that means millions of Californians are living in areas that historically have burned and will continue to do so. This has significantly hampered the Forest Service's ability to manage what it calls the wildland-urban interface.

OPPOSITE: The Kern River plunges through Sierra Nevada foothills along Highway 178 in Sequoia National Forest, which extends from canyon-bottom drylands up to austere high country at the Sierra crest. Within this forest, Congress in 2000 designated 38 groves of sequoia trees as Giant Sequoia National Monument, with management remaining under the Forest Service.

FOLLOWING SPREAD: A thunderstorm brews over Hawkins Peak and the upper West Fork of the Carson River in Humboldt-Toiyabe National Forest.

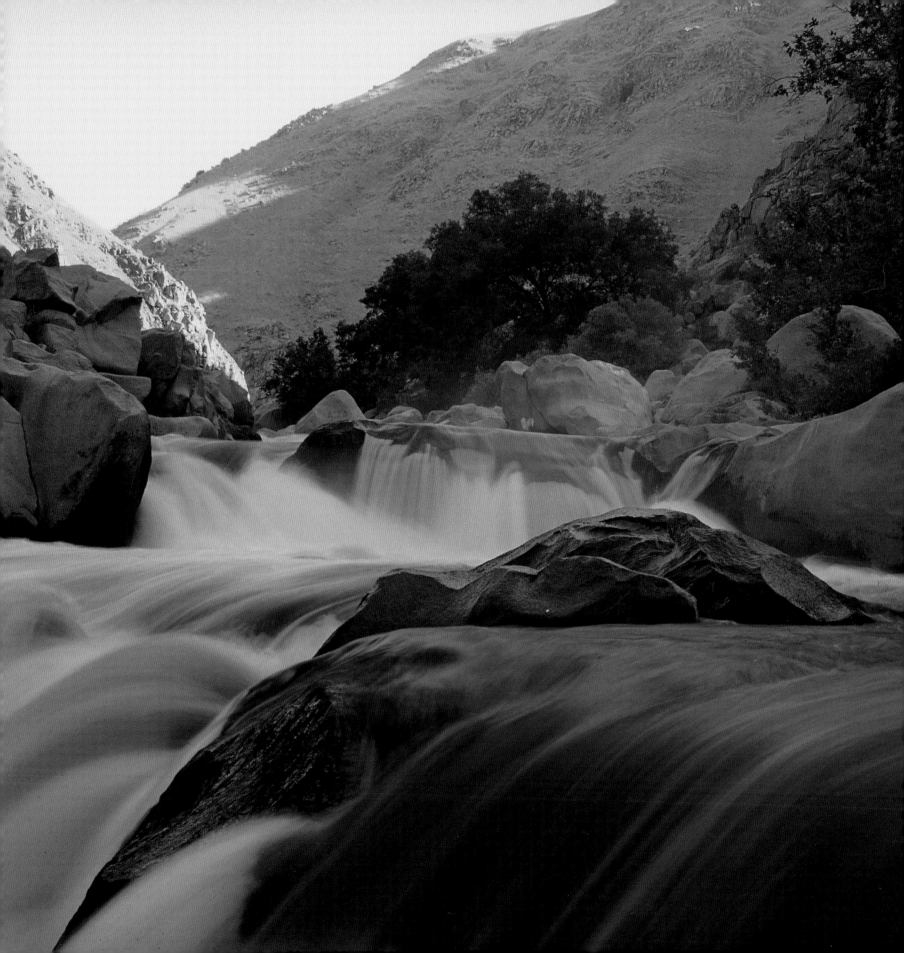

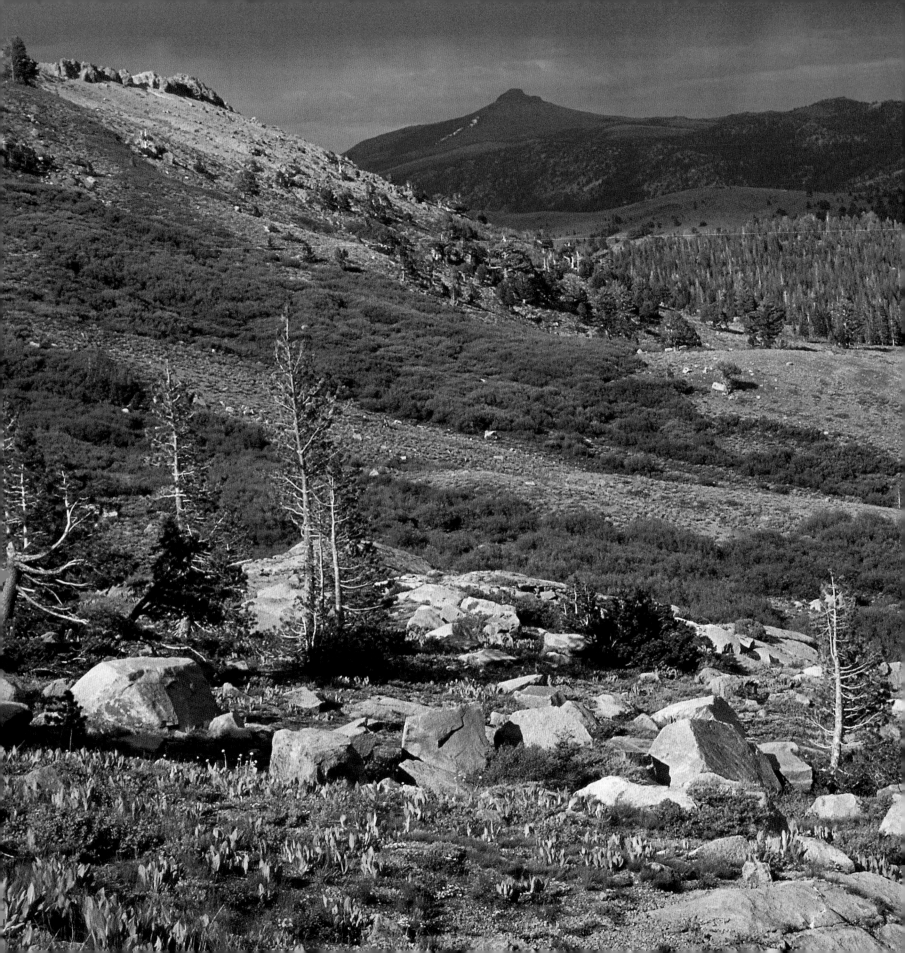

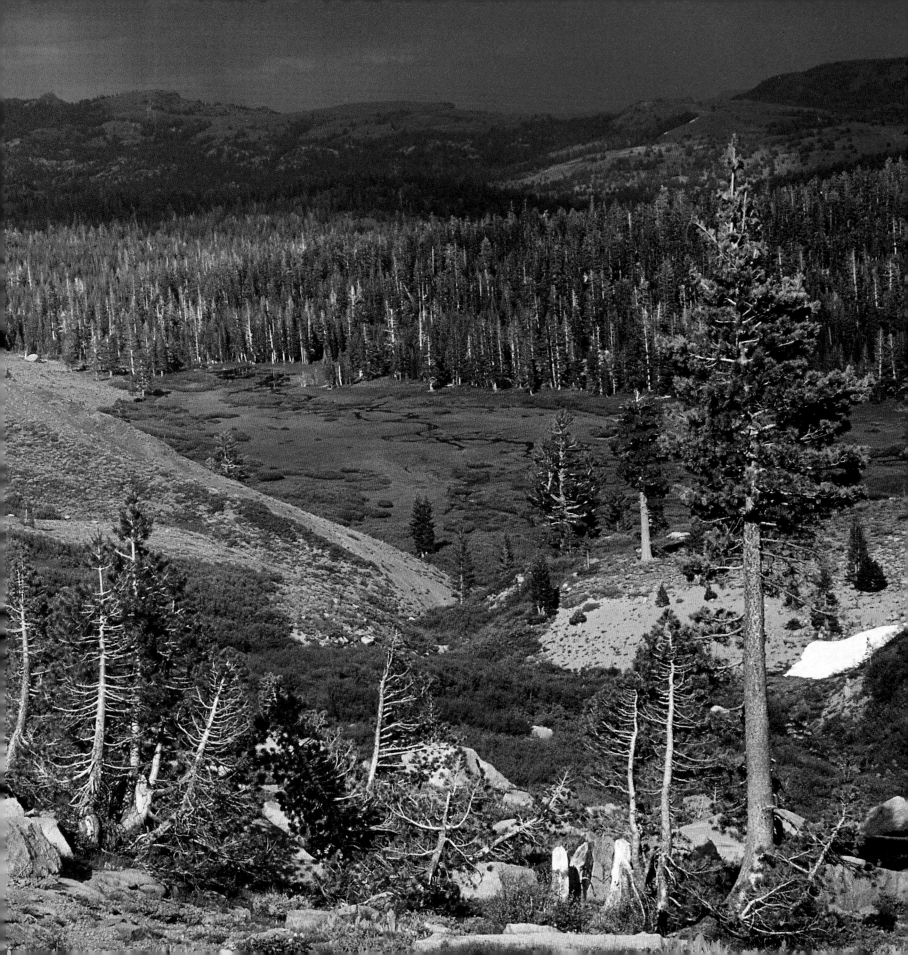

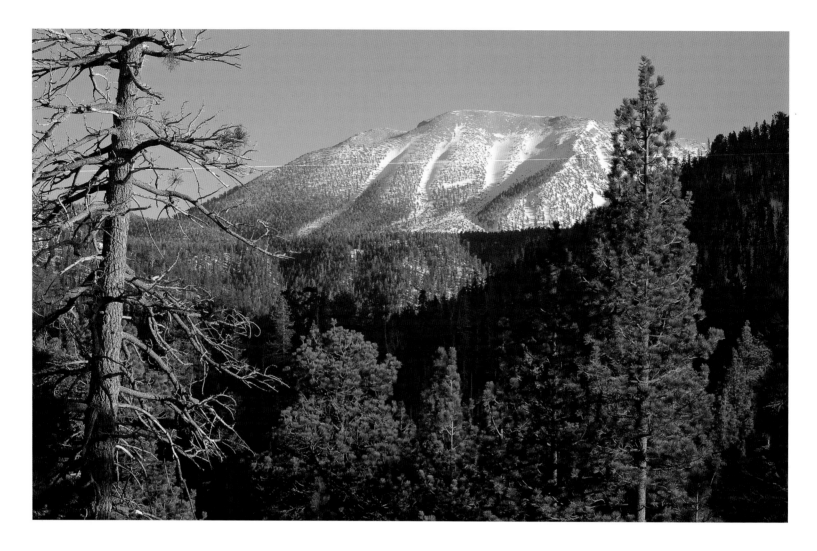

With scarcely a light in view at night from some aspects of the peak, Mount San Gorgonio rises above urban Southern California in San Bernardino National Forest. Fresh snow whitens the summit, seen from a trail south of Highway 38. Runoff here is a principal water supply for millions of people; throughout the West, national forests and other public lands provide 90 percent of the water that is used by cities and farms.

Its managerial efforts are just as difficult in the more inaccessible forests, among them the Mendocino, Los Padres, Lassen, and Shasta-Trinity. Part of what troubles its stewardship in these and other California forests is that they have become the epicenter of illegal marijuana production in the United States; this black-market economy is having a devastating effect on the Golden State. Wielding axes, shovels, and saws to dig up and chop down native plants and trees, and spraying herbicides and pesticides to control production and predators, those who construct these plantations, or "grows," as they are called, are damaging local flora and fauna, compromising soil health and water quality, and endangering public safety.

Climate change is also disrupting the resilience of these environments and the ecosystem services they provide, most notably water. Because its mountains capture precipitation flowing off the Pacific, much of California has been blessed with a fairly reliable flow of water. The Sierra Nevada have been a critical factor in this dynamic. In Solnit's choice phrasing, they "scrape off the

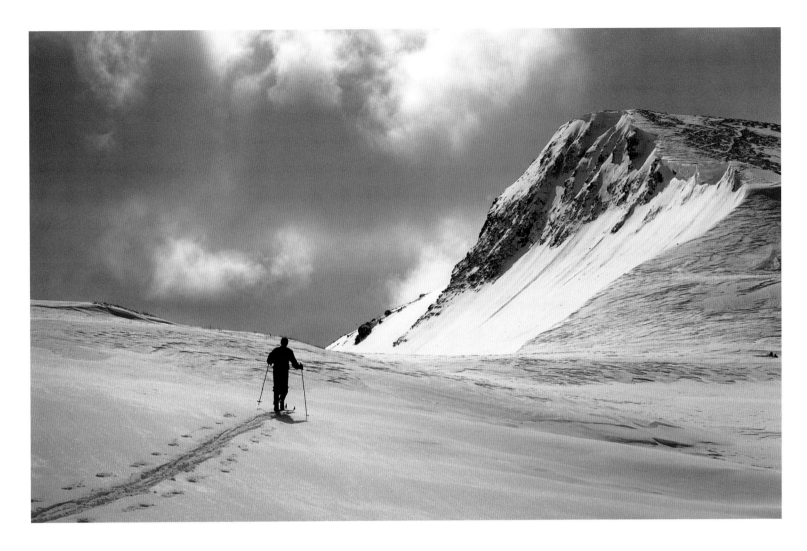

Pacific clouds and keep everything east of it arid." Whether they will continue to perform this hydrological function as jet-stream-driven storms shift north, and weather patterns become more variable, is open to question. Doubtful too is whether the Sierra will remain a snow-packed reservoir slowly releasing water to the valleys below as winter warms into spring. Data from the California Department of Water Resources indicate that the Sierra's historic snowpack levels and thus the water they contain, which have been so critical to maintaining the state's agricultural productivity and urban economies, have been decreasing in depth and density. By the mid-21st century, the mountains' snowpack is projected to decline by 25 percent and by the end of the century may have lost upward of 80 percent. This would have catastrophic consequences for forest health and riparian ecosystems, and prove disastrous for the 25 million people depending on this once-bounteous flow.[2]

That is another way of saying that the mountains of California, and the many national forests that straddle them, will remain critical bellwethers.

Alexander Gaguine skis toward the Elephants Back on the wind-blasted crest of Carson Pass, south of Highway 88 in Eldorado National Forest. Notorious for its snowfalls, Sierra Nevada high country usually sports 12 feet of consolidated snow by springtime. This natural reservoir slowly melts to feed the reservoirs, farms, and cities of Californians from Sacramento to Los Angeles, but annual snow accumulations are becoming less and less owing to global warming.

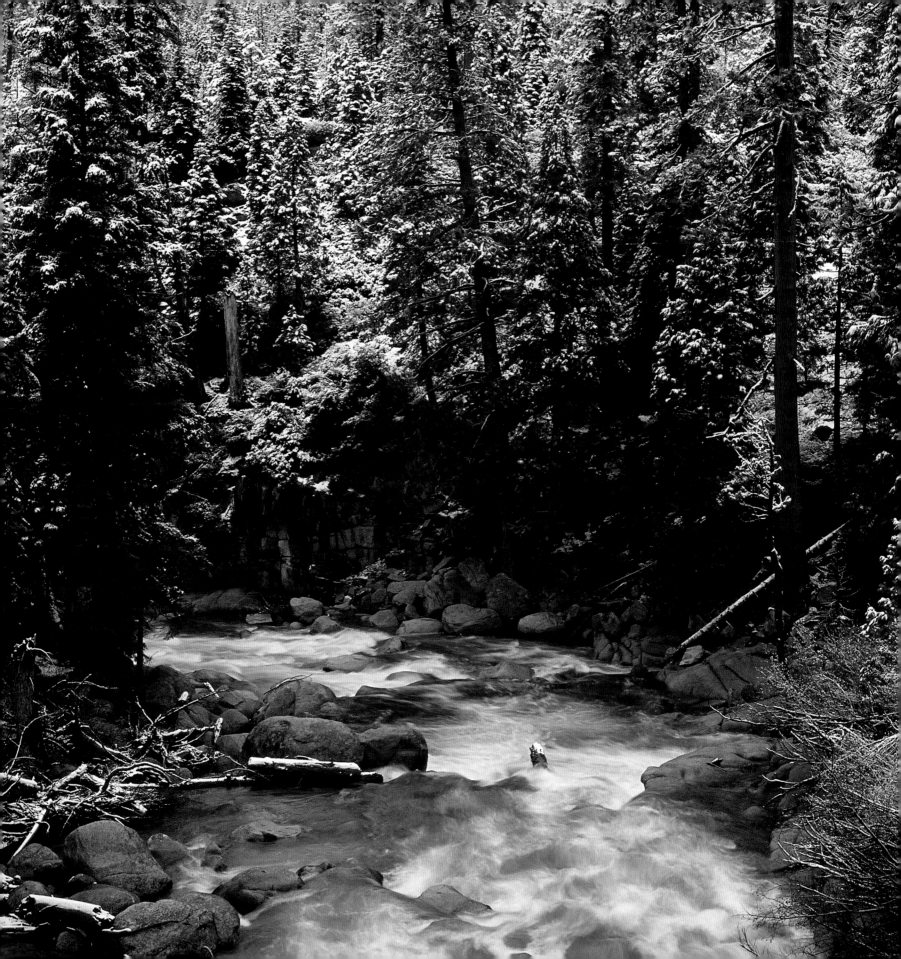

OPPOSITE: The Middle Fork Stanislaus River rushes through a springtime snowstorm and down the wooded west slope of the Sierra Nevada in Stanislaus National Forest.

RIGHT, TOP: In Mendocino National Forest, Douglas firs and incense cedars warm to morning light in the Yolla Bolly Mountains. Little known beyond the local area, this national forest, only 60 miles north of San Francisco Bay, stretches along 80 miles of California's interior Coast Range without the single crossing of a paved road.

RIGHT, BOTTOM: Ponderosa pines thrive on the floodplain of Hat Creek, a classic fly-fishing stream of Lassen National Forest in northeastern California. Fed by groundwater originating on the snowy slopes of Mount Lassen, the stream enjoys cold steady flows that will become increasingly important in the age of global warming. A geologic panoply, this national forest includes hot springs, cinder domes, and volcanic upheavals.

FOLLOWING SPREAD, LEFT: On the Hotlum Glacier of Mount Shasta, Nettie Purdue tightens the slack of her safety line before venturing farther on a crevasse-ridden icefall in Shasta-Trinity National Forest. The 14,161-foot Shasta is the second-highest peak in the Cascade Range; its 10 glaciers provide essential late-season runoff to the Sacramento and McCloud Rivers long after snowmelt on the lower flanks of the mountains has waned.

FOLLOWING SPREAD, RIGHT: In Six Rivers National Forest, peaks of the Siskiyou Mountains rise at the headwaters of the Smith River, which tumble Pacific-bound with legendary clarity, forested shores, and enduring salmon and steelhead.

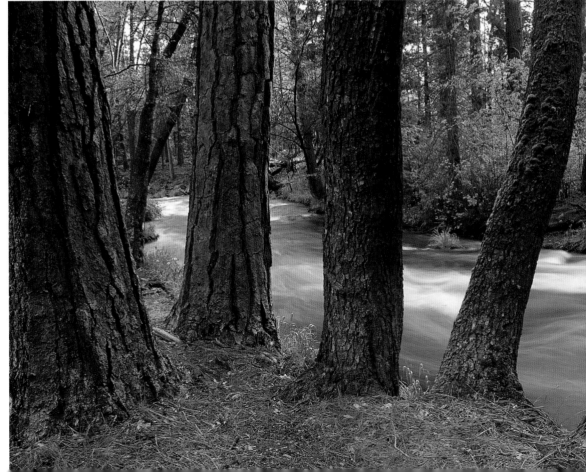

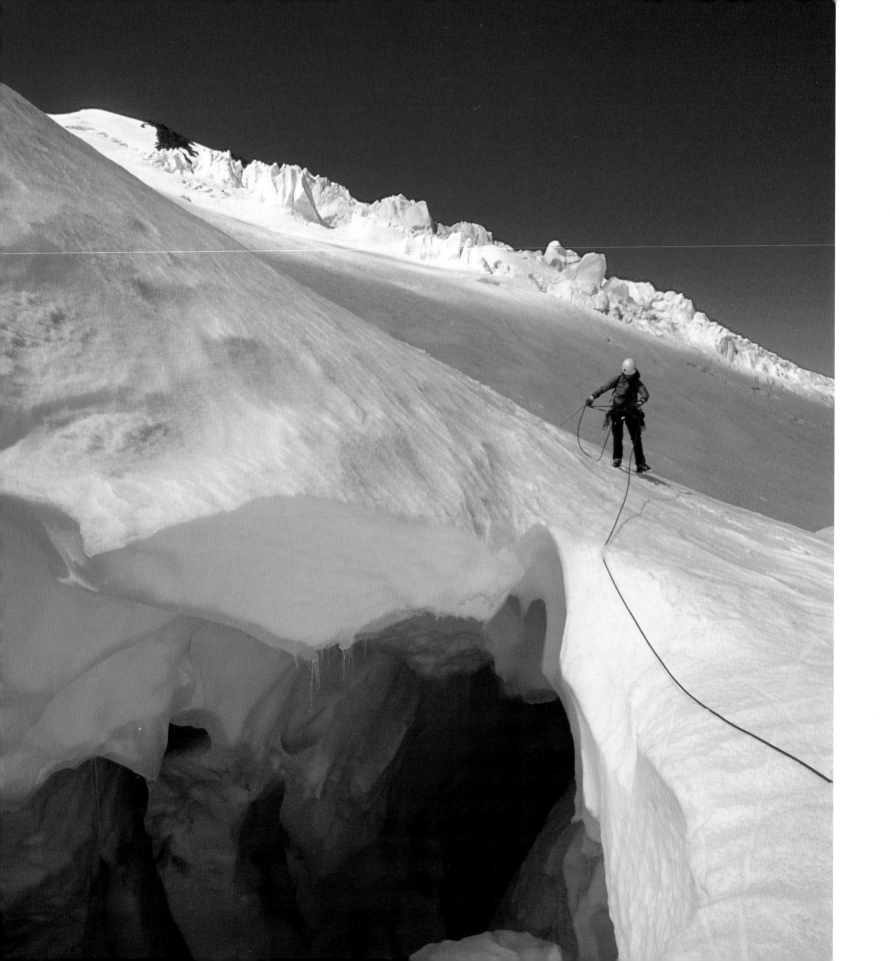

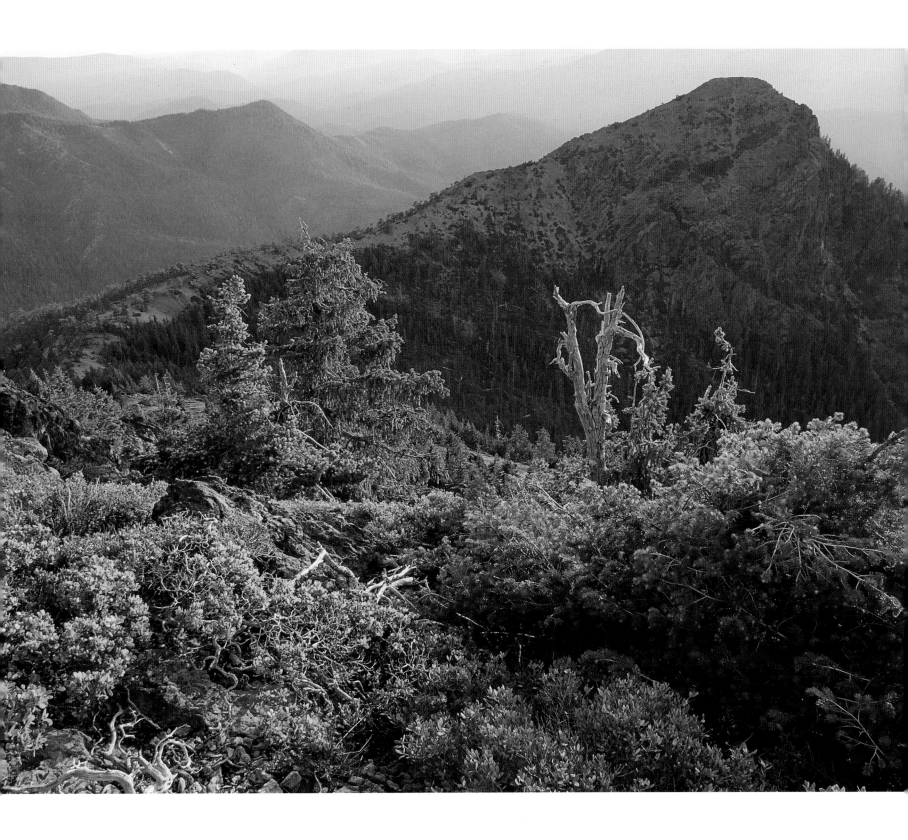

Angeles National Forest

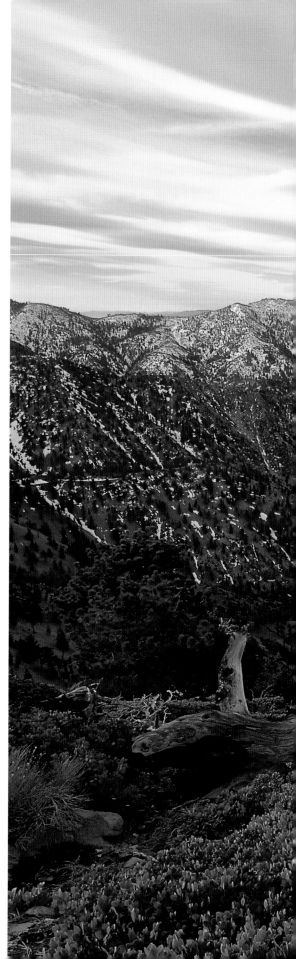

Manzanita with scattered ponderosa pines cling to rocky slopes of Mount San Antonio in Angeles National Forest. Trails to the 10,068-foot peak resemble high-country routes in the Rocky Mountains, but the vertical relief—equaled in few other places—starts at nearly sea level. Designated in 1892, this was America's second national forest.

Mount Wilson may not be the tallest peak in the San Gabriel Mountains—the craggy range that serves as the spine of the Angeles National Forest, frames the northern backdrop to metropolitan Los Angeles, and annually lures millions of visitors to its boulder-strewn creeks, rugged trails, and windswept peaks—but for early 20th-century humorist Mina Deane Halsey, Mount Wilson was plenty high enough. Reaching its 5,700-foot summit, she joked, was "the nearest station to Heaven yours truly ever expects to get."[3]

That's because she prayed she would never again have to ride a mule up the mountain's rocky, switchback trail, a rough-and-tumble terrain that decades earlier John Muir had dubbed "thornily savage" and "rigidly inaccessible." Halsey would come to share the great naturalist's wary insight. "The trip up Mt. Wilson makes me heave many sighs," she wrote. "In fact, I heaved so many sighs for weeks after that trip, that I had a hard time making anyone believe I had a good time. But I did." It's just that she had a difficult time recollecting its joys due to an unnamed burro. "It takes four—five—six or seven hours to get up the trail, and it only took *me* somewhere around forty minutes to come down. Of course most people don't hurry so on the down trip, but some things are forced upon us in this world, and that jackass of mine certainly knew his business." The many jolts and bruises notwithstanding, and despite the self-deprecating jokes she wrung from them, Halsey conceded that there "were some wonderful sights along the way," including a glorious sunset at the trail's end.[4]

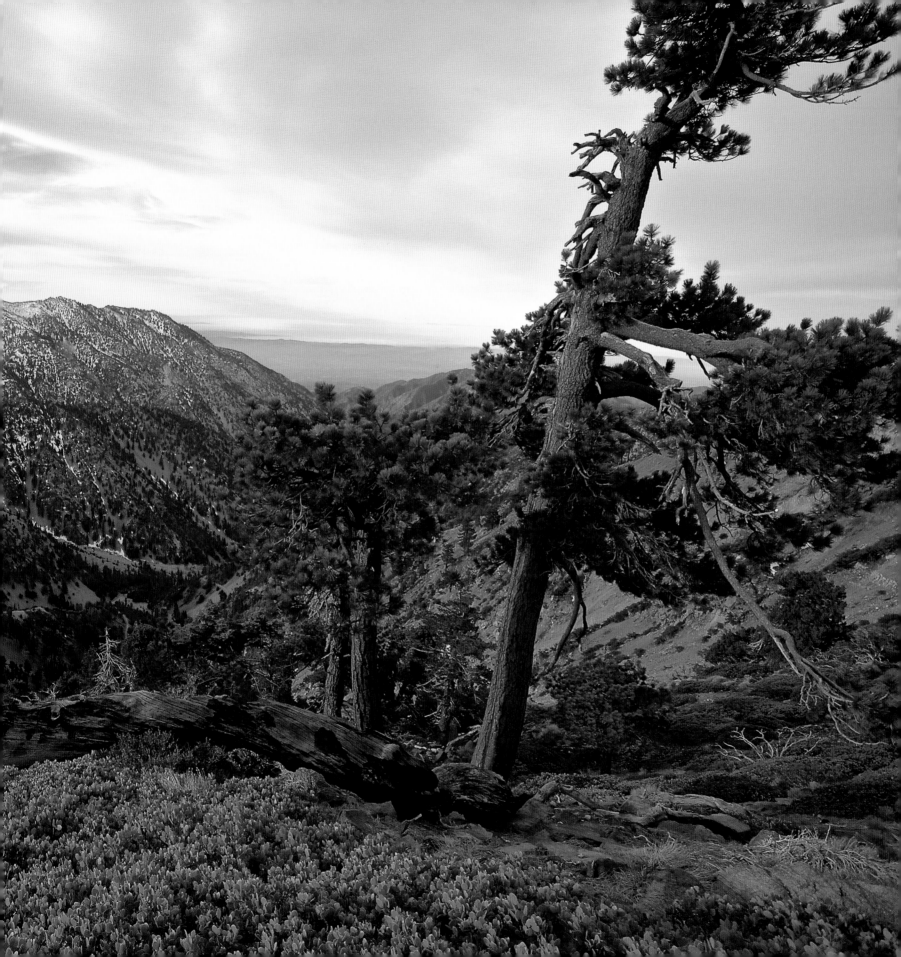

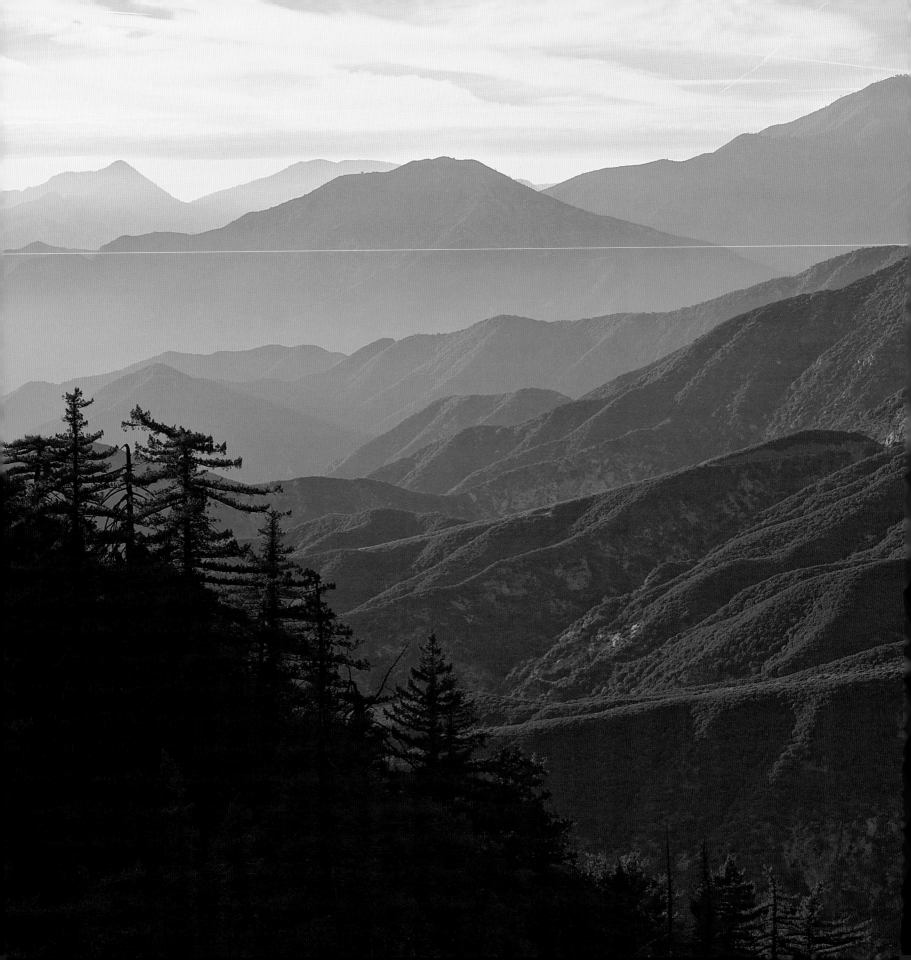

That she made the trek at all is a testament to the powerful place of outdoor recreation in local culture. High-country tourism in Southern California got its start in the 1880s, as Los Angeles's population boomed and record-breaking numbers of snowbirds boarded trains in Chicago, Baltimore, or New York to experience the region's balmy winter. Residents new and old, permanent and temporary, transformed the San Gabriels into a playground. The trail Halsey would ride upon followed a path that indigenous peoples first blazed centuries earlier, which was later widened to accommodate two-way traffic. Other routes were newly cut through chaparral-choked canyons and crested many of the more accessible mountains. To reach the stables, hotels, lodges, restaurants, and campgrounds constructed along these routes, the adventuresome rode the Pacific Electric streetcar directly to the trailhead. This rail-to-trail infrastructure sustained and stimulated what would be called the region's "Great Hiking Era."

Much of this development preceded the December 1892 creation of the San Gabriel Timberland Reserve, the first to be established in California (in 1908, the Forest Service renamed it the Angeles National Forest). Given its recreational lure and legacy, it is surprising that the energetic bustle of tourists, hikers, hoteliers, and outfitters did not figure more often in the petitions seeking the initial reserve status for the San Gabriels. Those urging the Department of the Interior, which at that time managed these public lands, to create a reserve instead pushed for federal regulation of its most critical resource—water—not tourism.

Forest advocate and real estate developer Abbot Kinney was among the first to urge the protection of these mountainous watersheds. "Native growths of brush and chaparral, scrub oak, greasewood, sagebrush" increasingly were being "removed from the land by clearing and fire," he wrote in 1880, adding that all the "mesas are bare of verdure." These environmental alterations left downstream communities and agriculture more vulnerable to winter flooding and summer drought. Kinney concluded in an 1886 report from the State Board of Forestry, on which he served, that "the destruction of the forests in the southern counties means the destruction of the streams, and that means the destruction of the country."[5]

Six years later, prominent citizens, grassroots organizers, irrigation districts, and chambers of commerce, as well as local congressional representatives, successfully appealed to Interior Secretary John W. Noble to address this problem. The secretary submitted to President Benjamin Harrison a proclamation creating the San Gabriel Timberland Reserve. It became one of 15 reserves Harrison established using the Forest Reserve Act of 1891 that had granted the chief executive authority to designate "public reservations."

In so acting, the president was setting the stage for a radical new conception of the purposes of the public domain, those federal lands the government owned in the western states and territories. Hitherto, Congress's ambition had been to sell or give away these many millions of acres to homesteaders, farmers, loggers, and miners—not to say railroad corporations—to encourage settlement and development. By the late 19th century, this policy had gained an array of detractors. Communities worried about the rapid depletion of local forests and grasslands, for example, found common cause with conservationists and scientists concerned that damaged environments could not be regenerated, with a corresponding loss of a sustainable economy.

These and other engaged citizens advocated for a more robust nation-state to intercede to

Seen from Glendora Ridge Road, the San Gabriel Mountains in Angeles National Forest overlook the Los Angeles urban area.

protect the public lands and the resources they contained. The government's protective presence would produce important results, asserted one of the petitions submitted in favor of the San Gabriel Timberland Reserve, ensuring that "the water would be preserved in the mountains, the snow saved from being speedily melted, the waters protected from pollution by large droves of cattle and sheep."

The ideas that managing nature upstream to sustain human interests downstream, and that Washington could and should resolve local disputes over resource allocation and consumption, signaled a broader desire for a more efficient and effective federal government. The call for making public life more orderly, rational, and manageable was a hallmark of Progressive Era reform and activism. Emblematic of this era's ethos was the establishment of the initial forest reserves, as well as the later formation of the Forest Service to manage them.

The San Gabriel Mountains revealed how fire could complicate this benign scenario. The range's topography and ecology have conspired against the human desire to exclude fire from this landscape. Muir, during a three-day hike in 1875, recorded some of the features that have frustrated firefighters ever since: sheer-walled canyons, treacherously loose soils, and ridges "weathered away to a slender knife-edge," the whole thickly covered in a "bristly mane of chaparral." Its hazards carried a warning, Muir wrote: "The whole range, seen from the plain, with the hot sun beating upon its southern slopes, wears a terribly forbidding aspect. From base to summit all seems gray, barren, silent—dead, bleached bones of mountains."[6]

This terrain comes alive when it erupts in flame. At lower elevations, the dominant plant community is the fire-adapted chaparral. It pro-

vides a combustible fuel that if ignited on days of high wind, low humidity, and intense heat can create firestorms of immense and swirling power. Not everyone who has lived within the Los Angeles Basin has seen these flames as detrimental to their way of life. The Tongva people used fire to manage hillside ecosystems to produce more highly prized plants and animals. The Spanish did the same to promote grasslands for their livestock. These two groups knew enough not to live within the fire zones—the foothills, notched canyons, and upland slopes. Not so for late 19th-century outdoor enthusiasts and those seeking domestic solitude from the burgeoning city below. For these newcomers, fire became a problem that must be solved.

Their concerns were captured in newspaper accounts of the frequent conflagrations. In 1878, as fire blew up above Pasadena, the *San Francisco Chronicle* reported that "5 canyons were desolated … [and a] tongue of flames could be seen licking its way up the San Gabriel range of mountains," a destructive image the *Los Angeles Times* replicated when the local skies turned black with smoke. "Ten-Mile Wall of Flame Rushing on Ridge Route," one headline screamed.[7]

Public outcry turned political, generating demands for more robust firefighting forces at the local, state, and federal levels. Later, two governmental agencies would spend much of their tiny budgets each summer and fall trying to stamp out fire. One was the Forest Service, which managed the Angeles after its creation in 1905, and the other was the Los Angeles County Board of Forestry, which was founded in 1911 and oversaw one million acres of adjacent lands. A century later, their work continues to consume their time and money. "The story of ranger activity in the Angeles National Forest," one local historian commented, "is a story primarily of fire control."[8]

Ancient lodgepole pines are sculpted by storms but continue to grow in the dry, harsh elements on the west face of Mount San Antonio in Angeles National Forest. Known locally as "Mount Baldy," this landmark is seen from downtown Los Angeles on smog-free days.

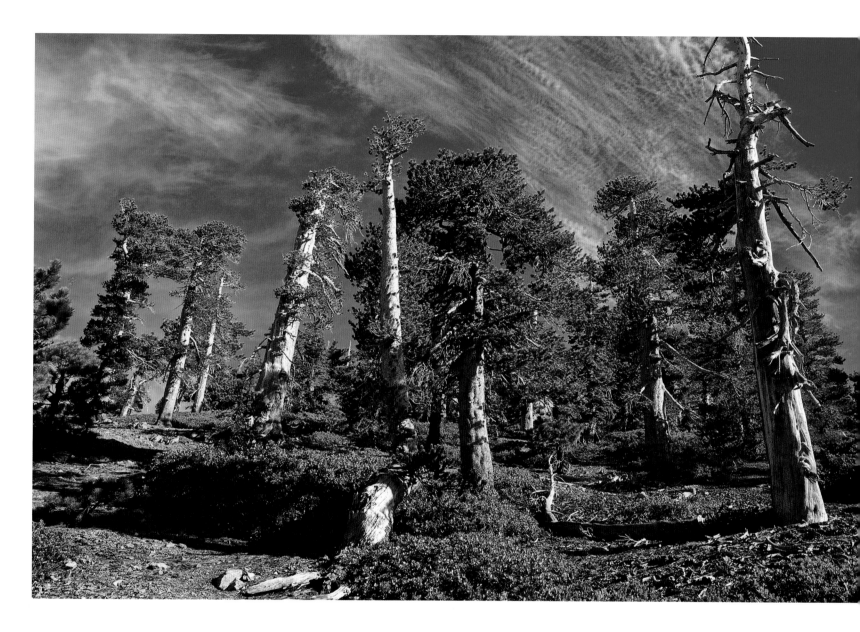

That is still true, but contemporary fire suppression comes with even greater pressure: hundreds of thousands of people now live in close proximity to the national forest, making their protection job one. Notwithstanding the advent of innovative firefighting tools, controlling fire remains as partial a solution as it was years ago. By their very nature, these lands burn.

Yet for all the Angeles's dangers, which escalate each winter when post-fire, debris-filled floods churn down the ravines and scour everything in their path, millions take advantage of this jagged landscape's recreational opportunities. Perhaps like Halsey, they too test themselves against its daunting wildness, and, laughing, tell stories about how they have come up short.

Los Padres National Forest

Los Padres National Forest meets the stormy Pacific at Plaskett Creek. The Big Sur Coast is one of America's most dramatic shorelines, formed where the North American and Pacific Continental Plates collide to form tumultuous topography along the San Andreas Fault. The western flank of Cone Peak fills the background. South of Canada, this is our highest mountain rising so close to the ocean—5,155 feet in 3.4 miles.

Robinson Jeffers, the poet laureate of California's rough Central Coast, wrote penetratingly, definitively of this iconic land. "The shining ocean below lay on the Shore," he observed in his poem "Cawdor," "Like the great shield of the moon come down, rolling bright rim / to rim with the earth. Against it the multiform / And many-canyoned coast-range hills were gathered into one / carven mountain." As Jeffers brought this terrain to life—green hills studded with oak and pine that seem to pitch into the Pacific, white waves crashing against black rock—he warned in "The Place for No Story" that "No imaginable / Human presence here could do anything / But dilute the lonely self-watchful passion."[9]

Jeffers would be shocked by how some humans have despoiled this coast's staggering beauty. Fronting more than 200 miles of the Pacific, with nearly 900,000 acres designated as wilderness, the 1.75-million-acre Los Padres National Forest draws nearly two million visitors a year. Some of them are up to no good. Follow the narrow trails running east from the pounding waves, snaking up creek, ravine, and canyon into the Coast and Transverse Ranges; in winter, stealthy figures move up these remote, fog-wrapped paths seeking relatively flat ground accessible to a thin trickle or rush of water. They dump their bulky backpacks, weighed down with tools, food, poison, plastic piping, and tents, and begin cutting trees and clearing the ground. Then they set to work laying out waterlines, building check dams, and digging into the soil before planting thousands of cannabis seeds.

Within weeks, marijuana is growing in the warm California sun, fed with diverted stream-flow and fertilizers, and protected from predators by the thick application of rodenticides and other toxicants. The drug cartels running these illegal grows have been targeting U.S. public lands generally, and in particular the Golden State's 20 million acres of national forests, and doing so with devastating effect. "Marijuana growing on public lands has been going on for 30-plus years, but they have just expanded dramatically," observed Daryl Rush, a special agent in the Forest Service's Law Enforcement and Investigations unit. "Every forest is impacted and the majority of our workload is on marijuana investigations on the forest."[10]

The Los Padres is among those most battered. In 2013 alone, officers discovered 47 trespass grows, uprooted 181,139 marijuana plants (the most in the state), and removed the following material:

- Infrastructure: 19,710 pounds
- Restricted poisons: 138 ounces
- Fertilizer: 4,595 pounds
- Common pesticides: 12 gallons
- Waterlines: 29,599 feet (5.6 miles)
- 20-pound propane bottles: 48
- 16-ounce propane bottles: 54
- Car batteries: 7
- Dams/reservoirs: 12

That same summer, strike forces were active in the Cleveland National Forest (nine grows yielding 16,579 plants), the Angeles (27 sites budding with 76,400 plants), and the San Bernardino

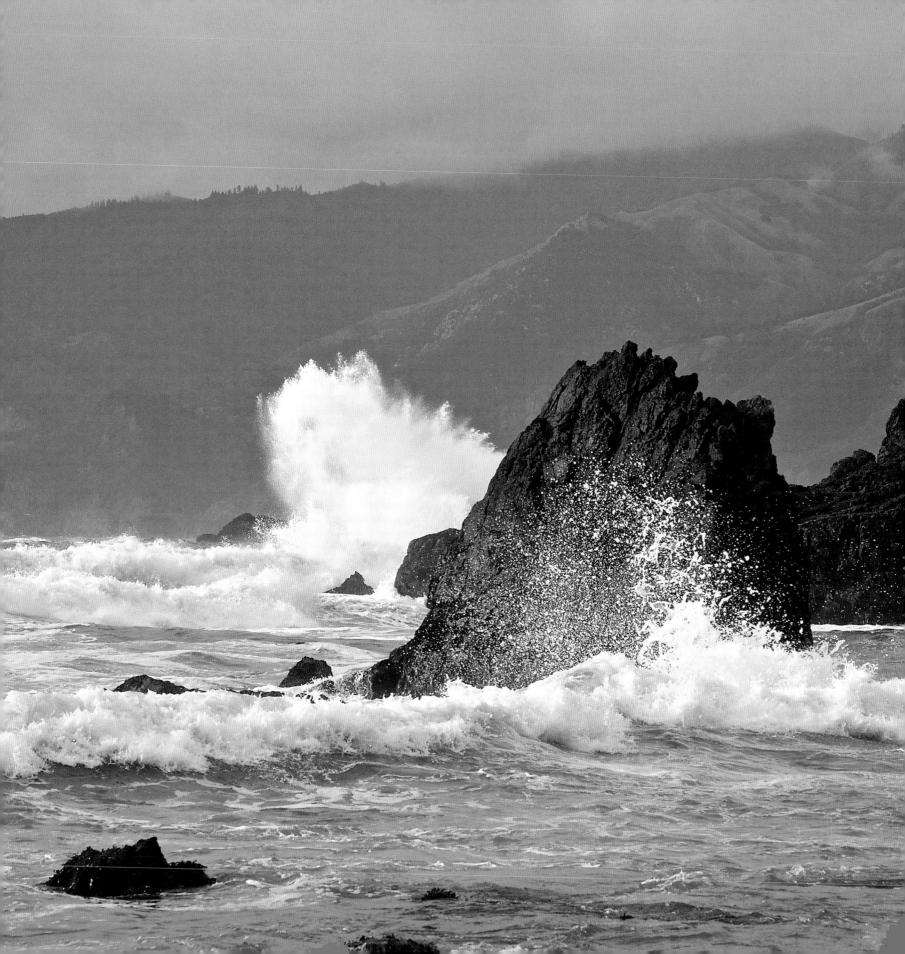

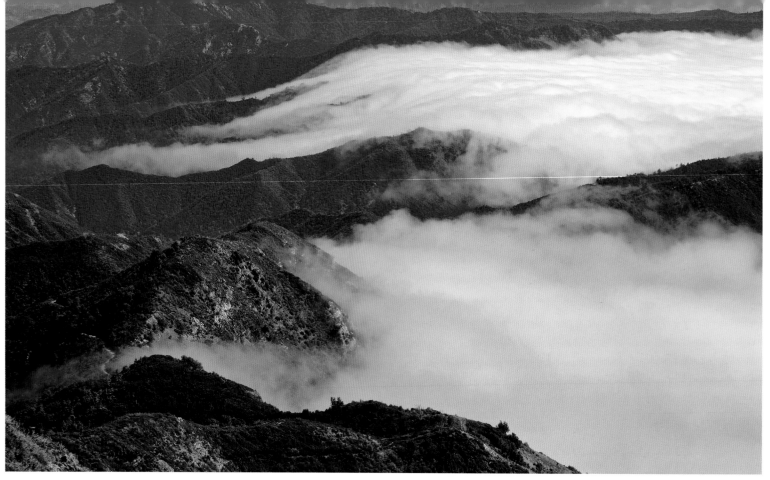

(114,095 plants on 21 sites). Other hard-hit forests included the Sequoia (113,737 plants), Shasta-Trinity (158,261), Sierra (96,052), and Plumas (74,009).

The reality in these forests is much worse than the data suggest. Given the difficulty in detecting these illegal sites, hidden by tree canopies and accessible only by climbing into rugged backcountry, officers can make but a small dent in growing operations statewide. Indeed, in 2012 the Forest Service reported that more than 83 percent of the 1,048,768 plants eradicated from national forests were in California, making it the national epicenter.

Compounding this bad news is all those canisters, boxes, bags, and bottles of pesticides, herbicides, and rodenticides, a wickedly toxic brew, what Rachel Carson decried as "elixirs of death," which poison soil and work their way into the biota—terrestrial, riparian, and marine.[11]

Consider what has happened to the Pacific fisher. Despite its name, the furry and furtive mammal does not live in, or near, the coast but instead occupies the same remote, closed-canopy forests that growers are degrading, among them the Los Padres. UC Berkeley's Sierra Nevada Adaptive Management Project autopsied fisher carcasses from Northern and Central California and determined that nearly 80 percent had been poisoned by anticoagulants, the source of which is undoubtedly marijuana plantations.

The fisher's vulnerability is intensified due to the interwoven nature of its diet, which consists of small mammals, birds, and fruit, and which contributes to its intake of toxicants. The same is true for the prey that eagles, owls, and vultures, as well as mountain lions and foxes, consume. The Los Padres, among other beautiful national forests, is becoming lethal to the biodiversity it is meant to sustain.

The threat that well-armed trespass growers pose to hikers and rangers cannot be discounted, either. The number of weapons confiscated from the sites, including high-powered assault rifles, has spiked in recent years. This dangerous situation is creating a chilling effect, limiting people's access to the Great Outdoors, to the splendid recreational opportunities these national forests offer to millions of Californians.

Safety will never be fully achieved by the important, if ad hoc, campaign to root out illegal marijuana grows. There are too many of these sites, and they are too difficult to locate, to ensure their complete destruction. Besides, the demand for marijuana, and the cash to be made from it, is so great that cartels have little incentive to alter their business model. It is unlikely that they will be deterred by the well-intentioned decision the U.S. Sentencing Commission reached in 2014 to strengthen sentencing guidelines for those caught on these trespass grows; charges may now include environmental damage.

To disrupt growers' brutal impact on watersheds, hillsides, and woodlands may require a massive infusion of fiscal and human resources. Or it may necessitate a political solution like the states of Colorado and Washington have reached; one ramification of their citizens' decision to legalize marijuana could be the regeneration of their national forests and other public lands, which in the past also contained numerous illegal marijuana sites.

Whatever decision voters and policy makers reach, their goal must be the protection and restoration of the national forests, and their complex biodiversity, manifold recreational opportunities, and legitimate economic operations. By enabling these compromised lands to spring back to life we would also fulfill Jeffers's moral imperative: "It is time for us to kiss the earth again."[12]

OPPOSITE, TOP: Los Padres National Forest encompasses much of the Santa Lucia Range of the Big Sur Coast. The forest also enfolds an even larger mountainous estate southward at the geological trainwreck where the Santa Ynez Range—running east-west toward the coast at Santa Barbara—confronts the Sierra Madre and San Rafael Ranges, which angle northward. Throughout, chaparral of manzanita, ceanothus, and chamise has evolved with frequent fires through the ages and resprouts quickly after burning.

OPPOSITE, BOTTOM: Sculptural limbs of a California sycamore thrive on the ocean-facing slant of Los Padres National Forest north of Ragged Point.

Sierra National Forest

Marking the boundary between Sequoia National Forest to the south and Sierra National Forest to the north, the Kings River is extraordinary by any measure. It flows with the greatest undammed vertical drop in America, has one of the wildest watersheds in the West, and has cut the continent's deepest canyon—more than 8,000 feet from mountain peaks to river bottom on both sides of the Middle Fork. Threatened with damming in 1987, this section of river was congressionally designated a "special management area" to protect its free-flowing quality.

The dust billowed up from the large herd of sheep that Pierre Grimaud and his partner P. J. Carajous drove into Sierra National Forest (on land now part of Sequoia National Forest). That choking cloud signaled forest supervisor William B. Greeley that the Forest Service's grazing regulations were about to receive a significant legal challenge.

Although Grimaud may not have known that his actions would play a major role in helping to set the conditions by which subsequent generations of Americans would use this particular forest, or that they would end up saving the national forest system, Greeley, who later served as agency chief, had an inkling of their import. Forewarned that powerful local livestock interests were seeking a test case in hopes of undercutting the agency's regulatory authority, he was ready when the bleating herd trampled onto federal property. He dispatched a clutch of rangers to ask Grimaud for his agency-issued permit. When the shepherd admitted he did not have one, he was on his way to court.[13]

Yet so complex was this moment—raising as it did constitutional questions about Congress's ability to delegate administrative authority to the executive branch—that *United States v. Grimaud* took four years of legal wrangling before the dust settled. Finally, on May 3, 1911, the U.S. Supreme Court determined that Grimaud was guilty as charged.[14]

The Basque shepherd could not play the innocent. He and his peers across California had borne witness to the establishment of the first forest reserves, sanctioned under the 1891 Forest Reserve Act. Among the very first western public lands to receive this new designation were those in Southern and Central California. Presidents Harrison and Cleveland set aside units of what would become the Angeles National Forest in December 1892 and the Sierra National Forest in February 1893. The latter covered a six-million-acre stretch of the western slope of the Sierra Nevada, running from Kern County in the south to Tuolumne in the north.

The federal presence expanded four years later when Congress passed the Organic Act of 1897, which granted management of these lands to the Department of the Interior, at that time the nation's sole custodian of the public domain. As part of this process, rangers were hired, and regulations were announced that allowed people the use of the reserves' various resources, whether animal, vegetable, or mineral. The Forest Service widely published its related rules and fees, which is precisely why Grimaud and his backers decided to test them.[15]

They were like many in the West who found this new regime unacceptable, accustomed as they had been to using federal lands without charge or oversight. Newspapers joined the fray, stoking the region's anger with scathing editorials and mocking cartoons. Miners, loggers, and ranchers challenged the agency's authority directly, through political agitation, and indirectly, by furtively panning for gold, cutting timber on the sly, and sneaking cattle, goats, and sheep on and off protected ranges.

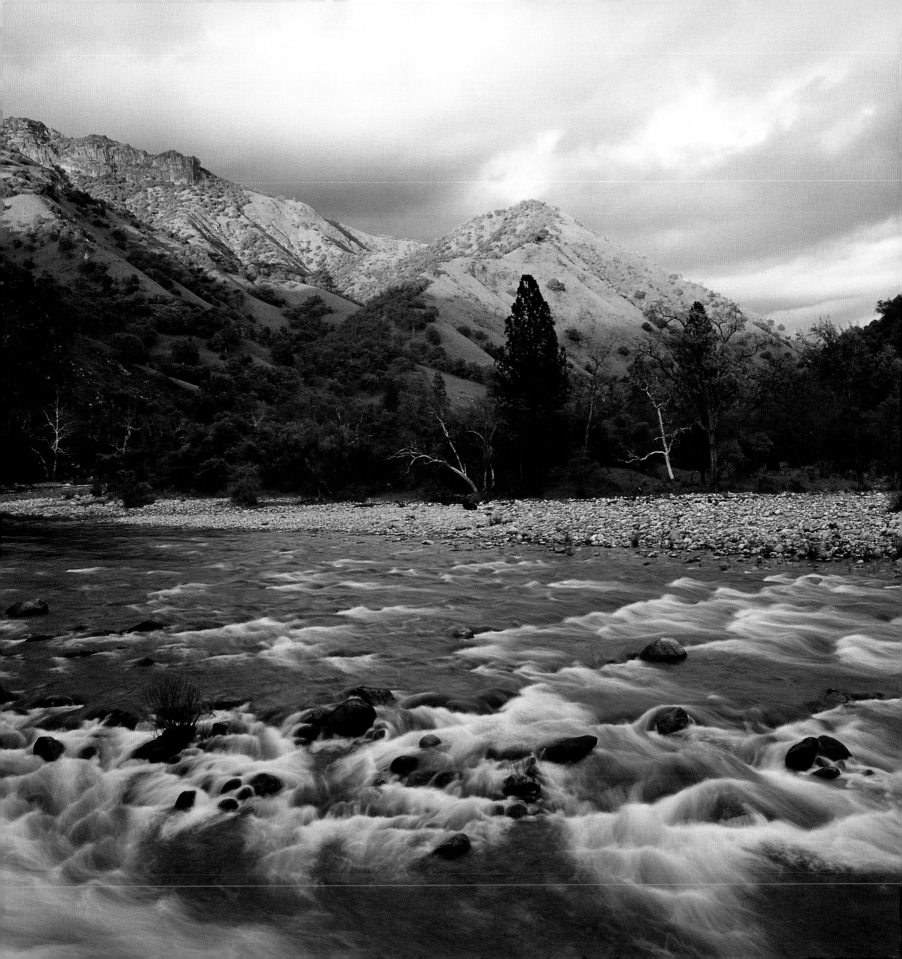

California sheepherders like Grimaud were particularly adept at this deceptive practice, for it was built into their annual cycle of grazing. In the winter months, their large flocks chewed up the Southern California rangelands in the coastal mountains and valleys. By spring, they had headed for greener pastures, roaming north through Owens Valley, then eating their way up into the alpine meadows by the height of summer. They then mowed down the western slope of the Sierra on their long march back to their winter base. Along this lengthy migration there was little respect paid to the distinctions between public lands and private property, no care about trespass, little thought to the resultant devastation. "The Kern Plateau," wrote geologist Clarence King in 1871, "so green and lovely on my former visit in 1864, was now a gray sea of rolling granite ridges, darkened at intervals by forest, but no longer velveted with meadows and upland grasses. The indefatigable shepherds have camped everywhere, leaving hardly a spear of grass behind

them." Fed up, communities all along the hoof-hard trails petitioned the federal government for redress, and the speed with which the region's forest reserves were created to protect and regenerate these bruised lands is itself a reflection of the pressing need to control the damage.[16]

Grimaud's actions in running his sheep up into the Sierra Forest Reserve was thus part of a larger pattern of the use and abuse of the region's grasslands. In 1902 alone, the Department of the Interior estimated, 60,000 sheep had trespassed on the Sierra Reserve. Grimaud also knew what he was doing, and was called out by none other than Justice Joseph Rucker Lamar, who delivered the Supreme Court's unanimous opinion. Grimaud, he wrote,

> *did knowingly, willfully, and unlawfully pasture and graze, and cause and procure to be pastured and grazed, certain sheep … without having theretofore or at any time secured or obtained a permit or any permission for said pasturing or grazing of said sheep or any part of them, as required by the said rules and regulations of the Secretary of Agriculture.*[17]

Grimaud's case turned less on his uncontested willfulness than on his lawyers' creative defense of his actions. They rejected the charge that their client's behavior constituted a public offense against the United States because when Congress voted in support of the relevant forest legislation and accompanying ordinances it had acted unconstitutionally. These "rules and regulations," they alleged, were "an attempt by Congress to delegate its legislative power to an administrative officer." If so, then such delegation was unconstitutional, and Grimaud could not have committed a crime because there was no crime to commit.

After the case had gone through a series of appeals, the Supreme Court determined once and for all that "authority to make administrative rules is not a delegation of legislative power." Grimaud's violation was punishable as a public offense.

This protracted argument may seem arcane, but it is not. Had the Supreme Court sided with Grimaud and with Fred Light, subject of a parallel case, the one-two punch would have knocked out the managerial authority of the Forest Service. That was exactly the end result the Colorado state legislature hoped for when it underwrote all the legal fees of cattleman Light, charged with letting his animals roam in Colorado's White River National Forest. The Supreme Court decisions dashed these hopes.[18]

These clear victories for the Forest Service have not stopped western legislators or resource extractors from continuing to dispute federal regulation and ownership of the public lands. Ever since 1911, a series of "sagebrush rebellions" have roiled regional politics, generating lawsuits frivolous and furious, hostile congressional hearings, and, occasionally, violence. In the 1980s, Nye County (Nevada) commissioners rammed bulldozers into Forest Service fencing to lay claim to the lands beyond, and vigilantes took pot shots at agency offices and booby-trapped official vehicles. Threats of violence and refusals to pay permitting fees have continued to dog Forest Service rangers and their peers in the Bureau of Land Management to sustainably steward the nation's grasslands. Their courage and commitment to the two agencies' missions, and the legal context in which they operate, are most laudable.[19]

To date, none of these attempts has dislodged the precedent-setting reality that Grimaud established after driving his flock into the Sierra National Forest, an act that ensured that the national forest system would long endure.

Redwood trunks and Pacific dogwood brighten an afternoon in the Nelder Grove of Sierra National Forest north of Bass Lake. While the best known of these largest trees on Earth reside in Sequoia and Kings Canyon and Yosemite National Parks, exquisite groves are also found in Sequoia, Sierra, Stanislaus, and Eldorado National Forests.

Inyo National Forest

With its extravaganza of geology, biology, and hydrology, Inyo National Forest on the eastern side of the Sierra Nevada sports ancient bristlecone pines, volcanic calderas, the landlocked wonder of Mono Lake, plunging streams, and deep snows on Mammoth Mountain and countless other peaks—all at a fault-block escarpment rivaling that of Grand Teton National Park but 10 times as long. Protected wilderness runs continuously longer than in any other terrain south of Canada. Topping it off at 14,494 feet, Mount Whitney is America's tallest peak outside Alaska. Its summit, glowing at sunrise here with a skiff of autumn snow, rises from the Alabama Hills west of Lone Pine.

The Inyo National Forest is a land of extremes. Its serrated mountains, glacier-carved sheets of granite, and dry air can stunt growth for those plants and animals hardy enough to inhabit these eastern Sierra wildlands. In these disadvantages lies these organisms' advantage. Not a lot of competitors can survive the temperature swings from ice cold to blazing hot or the rapid oscillations between deluge and drought. That may well explain why the Inyo is home to one of oldest known plants on Earth—the Great Basin bristlecone pine.

An unforgiving land, this region has witnessed as well some of the more tragic moments in American history. Along its lower slopes and benches, and from the creeks and streams that carry snowmelt down into the valleys that pool into Owens Lake, the Paiute people drew sustenance. They hunted, fished, and gathered in the canyons and flatlands, and manipulated watercourses to develop the area's first irrigated agriculture. The 1848 Gold Rush disordered their world, bringing swarms of miners and farmers to the region; the U.S. Army then drove the Paiute out and into tiny reservations. White settlers set about expanding the original canal networks to water row crops and fruit orchards, but their practices increased alkalinity. The decreased productivity made it difficult for farmers to make ends meet by the early 20th century. That is when Los Angeles snapped up most local water rights and, with the construction of an aqueduct, channeled it 220 miles south to the City of Angels. Desiccation set in, further limiting regional economic opportunities.

As the land dried out, dust spiraled skyward. The airborne grit caused considerable suffering to Japanese Americans who were interned at the Manzanar War Relocation Center, located in the shadow of the eastern slope of the Sierra. Dust storms formed one of the most penetrating memories of their imprisonment in the Owens River Valley. Each afternoon, winds rushed across the desert and the exposed bottom of Owens Lake, much depleted to quench Los Angeles's deepening thirst. As it swept up loose particulate matter, the turbulent air swirled into thick clouds. Arriving in the midst of one of these "eerie" storms, George Fukasawa recalled that the "dust was blowing so hard you couldn't see more than 15 feet ahead. Everybody that was out there had goggles on to protect their eyes from the dust, so they looked like a bunch of monsters from another world or something."[20]

There was no escaping these storms' gritty presence. They blew into the paper-thin barracks built quickly with green wood cut out of nearby Inyo National Forest, which as it dried left large gaps in walls and floorboards. Each morning the prisoners' sheets, clothes, and food, their noses and mouths, were coated in fine white grime. "Down in our hearts we cried and cursed this government every time when we were showered with sand," Joseph Yoshisuke Kurihara vented. "We slept in the dust; we breathed in the dust; and we ate the dust."[21]

The imprisoned gained little solace looking west to the Sierra, whose sharp edges and imposing hard-rock front reinforced their barbed-wire

216 ◆ AMERICA'S GREAT NATIONAL FORESTS, WILDERNESSES, AND GRASSLANDS

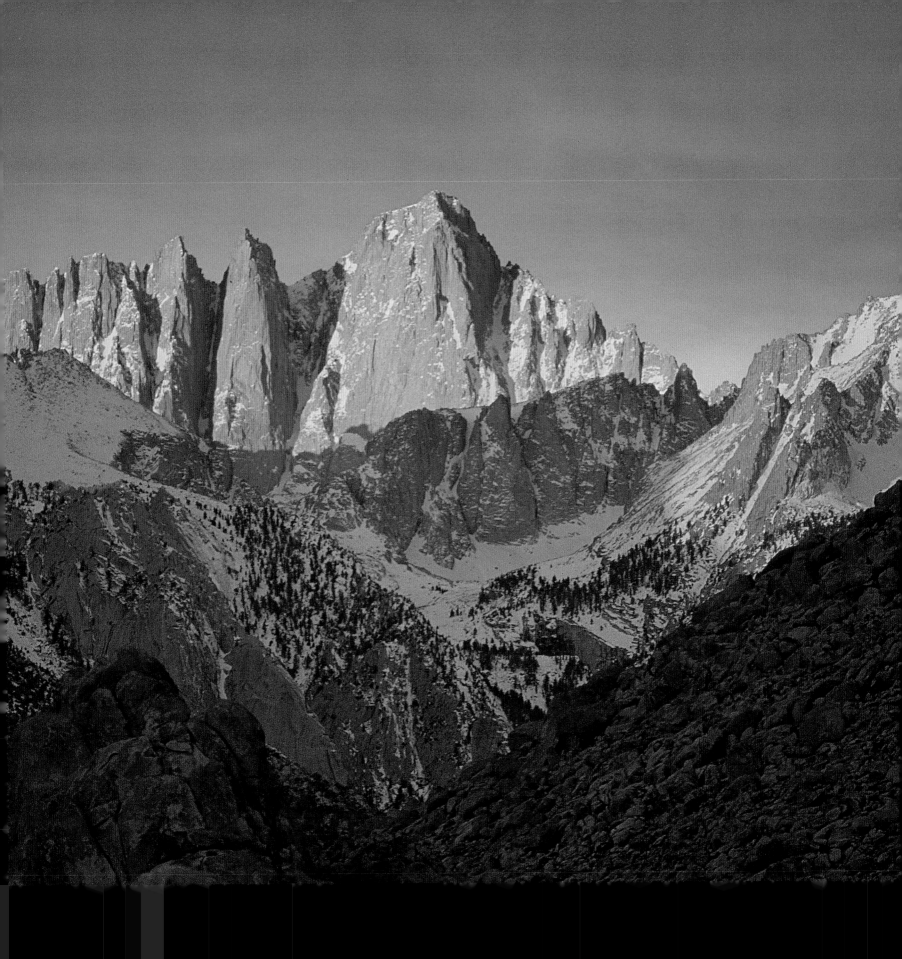

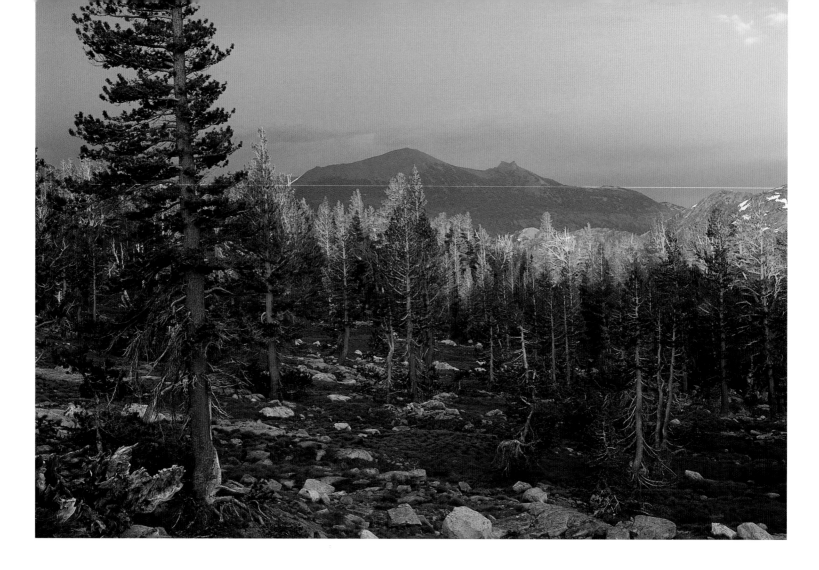

incarceration. Ansel Adams evoked their captivity in some of the photographs he took of the site during the war. One in particular, which Adams shot from a guard tower, used the prison's main street to frame the middle ground, a dust-filled roadway that carries viewers' eyes across the camp, over the bare, alluvial fan sweeping down from Mount Williamson. Although he was not allowed to show armed guards or fences, Adams did not need to. Here, people and place were inescapably hemmed in.[22]

Another road in another context makes it clear that Adams also envisioned the Inyo as a liberating landscape. One of his postwar photographs illustrated a new edition of Mary Hunter

Austin's *The Land of Little Rain* (1903), itself a brilliant ode to the eastern Sierra. This striking image of Buttermilk Country Road shows a narrow, dirt-packed curve swinging left that brings into focus Basin Peak, sunlit and shadow-filled. Here, the open lane beckons, offering a wandering freedom into wilderness, which is "not only a condition of nature," Adams advised, "but a state of mind & mood & heart."[23]

Capturing this same sensibility is Austin's text, but there is nothing paved over about her experience hiking up a slot canyon in the Inyo. Its pinewoods are "somber, rooted in the litter of a thousand years, hushed, and corrective to the spirit," she wrote. "The trail passes insensibly

into them from the black pines and a thin belt of firs. You look back as you rise, and strain for glimpses of the tawny valley, blue glints of the Bitter Lake, and tender cloud films on the farther ranges. For such pictures the pine branches make a noble frame."[24]

For their evocative framing of the wild, their detailing of these pyramidal mountains "running out into long shark-finned ridges that interfere and merge into other thunder-splintered sierras," Adams and Austin have been memorialized. The Ansel Adams Wilderness Area spans the Inyo and Sierra National Forests and Mount Mary Austin is located to its south, in the John Muir Wilderness Area. This paired siting is fortuitous and funny. In different ways, Austin and Muir made the Sierra the Sierra, but their one interaction left Austin jotting down this impression of Muir: "a tall, lean man with the habit of talking much, the habit of soliloquizing." Joining this legendary group is Gifford Pinchot, the Forest Service's first chief. To the northwest of Austin's home base of Independence, California (a small town tucked below the forest and Mount Whitney, the tallest mountain in the Lower 48), is an important pass along the Pacific Crest Trail. It, and a nearby 11,417-foot peak, are named after Pinchot. In this formidable stretch of high country, key figures in American environmental culture are well represented.[25]

Most winters, that elevated ground also lures in tens of thousands of skiers. Mammoth Mountain Ski Resort, like its peers across the West, would not exist without the right climatological factors and topographical features—plenty of snow and a varied terrain to slalom down. Critical to their development too has been the Forest Service. Its multiple-use orientation made it possible for skiing to become an industry in the United States after World War II. Mammoth has been one of the beneficiaries of this public policy. Its founder, Dave McCoy, was a Los Angeles Department of Water and Power hydrographer, which meant he measured snow depth to predict runoff. Noticing that Mammoth Mountain in wet years can receive upward of 400 inches of snow, in the early 1950s he secured a permit from the Inyo National Forest to develop what has become a very active resort year-round. Residents of Los Angeles, the nation's second-largest city, not only get some of their water from the Inyo, but often recreate in the deep snowfields from which much of that nurturing flow comes.[26]

As memorable as these human markers are, nature's impress on the Inyo National Forest is even more striking. The bristlecone pine, for example, may well be the only tree anywhere that has a LEED-certified, solar-powered interpretative center dedicated to its life history; it is located in the White Mountain Ranger District. Much of our fascination with this species is its ability to root in some of the Inyo's most inhospitable terrain; it stands sentinel-like on wind-blasted ridgelines and draws nutrients out of thin, limestone soils. Under these adverse conditions, the fact of the tree's survival is remarkable enough. Factoring in how long some of these gnarled, twisted individuals can live—4,000 years and counting—and its endurance is amazing. It is also enlightening, for the bristlecone's tree rings have gained considerable renown. By closely analyzing the tree's growth marks in relation to climate variations, researchers have created a continuous tree-ring chronology dating back 10,000 years. This record has allowed scientists to recalibrate flaws in radiocarbon dating such that they, archaeologists, and historians have been able to backdate ecological systems, cultural diffusion, and social structures.[27]

Around every turn in Inyo National Forest, the past is present.

At Inyo National Forest, lodgepole pines catch evening sunlight through a clearing thunderstorm north of Mammoth Mountain.

Klamath National Forest

NORTHERN CALIFORNIA

The Klamath River is a centerpiece of Klamath National Forest and its bewildering amalgam of topography across Northern California. The third-largest river entering the Pacific on the West Coast south of Canada, the Klamath is essential to the salmon and steelhead that comprise a renowned commercial, sport, and Indian fishery. All this is threatened by diversions for agriculture in the Klamath's upper basins and from its major branch, the Trinity River. The network of chilled, intact tributaries veining the national forest is essential to the health of the main stem and the fish that depend on the cold inflow of those forested streams.

W. H. McCarthy, assistant fire ranger in the Klamath, was a little perplexed and quite willing to pass the buck to W. B. Rider, the forest's supervisor. After interviewing three candidates for the vacant lookout position at Eddy's Gulch, he deemed two of them unacceptable and the third, despite having all the requisite qualifications, was "no gentleman."

This individual's gender was the issue: "The novelty of the proposition which has been unloaded upon me, and which I am now endeavoring to pass up to you, may perhaps take your breath away, and I hope your heart is strong enough to stand the shock," McCarthy wrote Rider on May 12, 1913. "One of the most untiring and enthusiastic applicants which I have for the position is Miss Hallie Morse Daggett, a wide-awake woman of 30 years." Having grown up in the Siskiyou Mountains, Daggett "knows and has traversed every trail on the Salmon River watershed, and is thoroughly familiar with every foot of the District." Daggett, an "ardent advocate of the Forest Service . . . is absolutely devoid of the timidity which is ordinarily associated with her sex as she is not afraid of anything that walks, creeps, or flies." That she came from a well-respected family did not hurt; Daggett's ability to rough it was balanced by being "a perfect lady in every respect."[28]

Rider must have been impressed, for within two weeks Daggett had her appointment papers to serve as a seasonal forest guard at Eddy's Gulch, occupying the tower situated at the summit of Klamath Peak (elevation: 6,444 feet). Having given McCarthy her "solemn assurance" that she

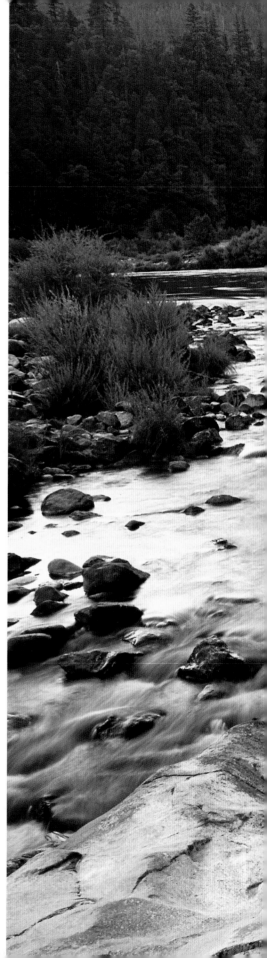

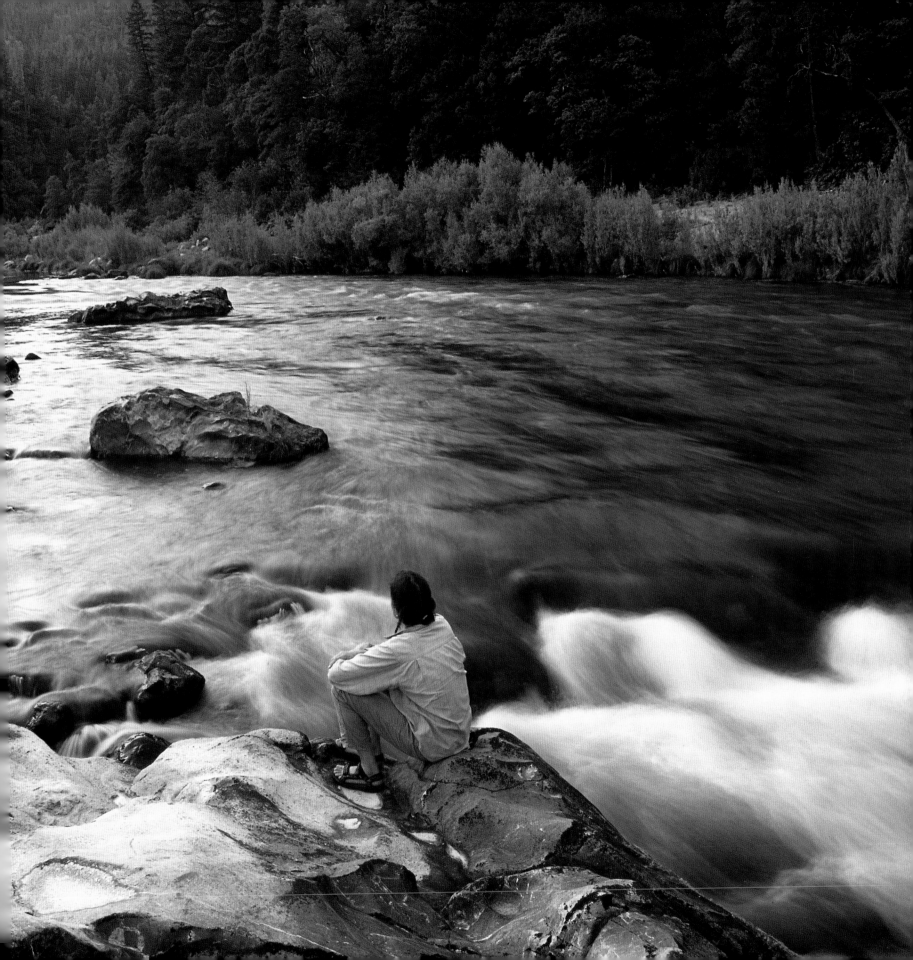

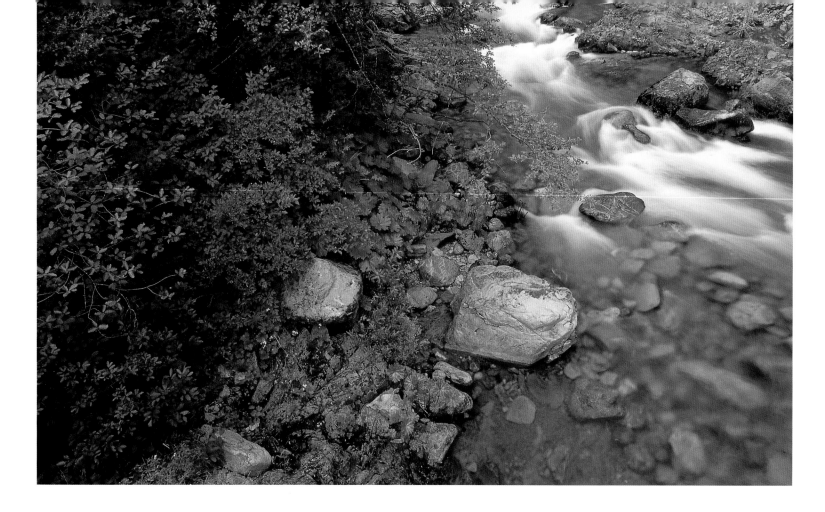

would stay with "her post faithfully until she is recalled," she made good on that promise, returning to Eddy's Gulch for the next 15 years. The media marveled at her willingness to endure such a solitary vigil—one newspaper dubbed her a "modern Joan of Arc"—but Daggett loved the landscape she scanned each day in search of tell-tale whiffs of smoke. To her east lay snow-capped Mount Shasta; to her west, on a clear day, she could glimpse the glittering Pacific. Hers was a perfect aerie: "I can think of no better description of [Klamath Peak] than the hub of a wheel, with the lines and ridges as spokes, and an unbroken rim of peaks circling around it. Some eternally snow-capped, and most of them higher than itself."[29]

Daggett's ability to spot fires, like that of her peers scattered across the Klamath, was an essential element of the Forest Service's renewed commitment to smother any fire anywhere. The devastating 1910 conflagrations in Washington, Idaho, and Montana had prompted an increase in the number of towers and lookouts and the stringing of telephone wires between them and ranger stations to facilitate communication. Raised in the fire-prone Siskiyous, Daggett "grew up with a fierce hatred of the devastating fires, and welcomed the force which arrived to combat them." Until she retired in 1927, she contributed significantly to fire detection and suppression in the Klamath.[30]

Daggett knew that her appointment as the first woman to do fieldwork "was rather in the nature of an experiment, and naturally felt that there was a great deal due the men who had been willing to give me the chance." In time that novelty wore off as more and more women secured jobs throughout the agency. Not all were

met with the same "liberal-mindedness and courtesy" that had been Daggett's experience. Few worked in the field, and as a result none achieved line-officer status until Geri Larson became deputy forest supervisor in Tahoe National Forest in 1978; the next year the first female district ranger, Wendy Milner Herrett, was assigned to the Blanco Ranger District in White River National Forest. This low green ceiling generated allegations of gender discrimination, pay differentials, and hostile workplaces. Fifty years after Daggett's hiring, in 1973 a group of women working in California filed a class-action lawsuit against the agency's hiring and promotion practices for women and minorities. Six years later, the Forest Service agreed to a consent decree that required it to align its labor force with that of the state of California.

In practical terms, this meant that women must constitute more than 43 percent of Forest Service employees at all levels and pay scales. The Klamath benefited from this agreement. In 1986 wildlife biologist Barbara Holder became its deputy forest supervisor, and shortly thereafter became its supervisor, a position she held until 1998.[31]

At the same time that personnel battles were forcing California forests to confront questions of gender, a more localized, if as complicated, issue blew up in the Klamath—salmon. From her Klamath Peak perch, Daggett had spent hours looking down on the river named for the anadromous fish, one of the main tributaries of the Klamath River. The entire watershed, from its source in the high deserts of eastern Oregon down its meandering 263-mile length through the temperate forests of the Siskiyous and Cascades, is prime salmon spawning ground. For thousands of years, native peoples have depended on the fish as a rich source of protein and as a central ingredient in their spiritual life. That way of life

eroded after the Bureau of Reclamation drained lush wetlands in Oregon's Malheur Basin to promote irrigated agriculture. Later the bureau, U.S. Fish and Wildlife Service, and power companies built diversion channels and dams to control the river's flow for a variety of purposes, with one key consequence: these structures blocked what had been the third-largest salmon run on the Pacific coast.[32]

This intense manipulation of the Klamath precipitated decades of political turmoil, as tribes, utility corporations, commercial fisheries, environmentalists, ranchers and farmers, and recreationists fought bitterly with one another and government agencies to assert their perceived rights to fish, water, streamflow, or energy, to a river controlled or set free. It was not until the mid-2000s that some semblance of a working agreement emerged for the restoration of the river upstream, including the removal of several hydro-dams, which was expected to aid the downstream recovery of once-historic runs of salmon. By 2014, the coalition had hammered out a more complete resolution that to date awaits congressional approval.[33]

Although these debates happened largely beyond the Klamath National Forest's boundaries, it was not incidental to them. Indeed, the undammed Salmon River became a model of, and litmus test for, the high level of riparian health that many desired for the entire watershed. Its flow, and not incidentally its salmon runs, received state protection in 1972 under California's Wild and Scenic Rivers Act. A decade later it received similar federal designation, legislation that forestalled any attempt to impound its waters. That has made it possible see what Daggett once saw from Eddy's Gulch Lookout, a surge of white water tumbling down the Salmon River toward the Klamath and then on to the sea.

With headwaters in the Marble Mountain Wilderness of Klamath National Forest, the North Fork of the Salmon River flows through the biologically rich meeting grounds of the Siskiyou and Coast Ranges. Along with the main stem Salmon River, the North and South Forks are both protected as Wild and Scenic Rivers.

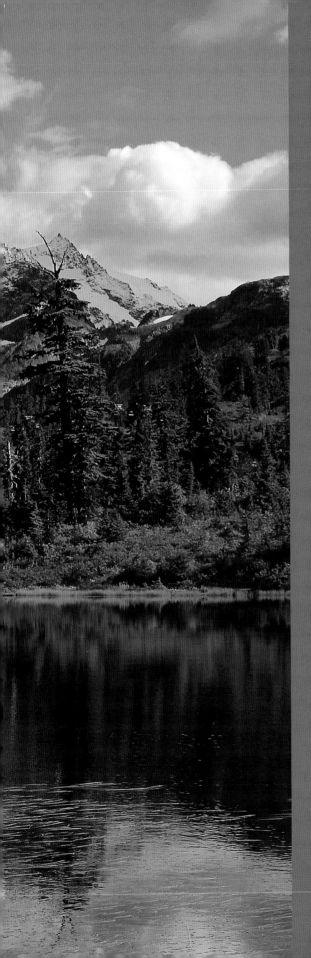

THE PACIFIC
NORTHWEST
& ALASKA

3 STATES

19 NATIONAL FORESTS

1 NATIONAL GRASSLAND

45.8 MILLION ACRES

17.1 MILLION VISITORS

If one can imagine a grand climax to this tour of America's national forests, that finale comes with the geography, splendor, and scale of the Pacific Northwest and Alaska. Here the density of wonder is amped up in showcases of mountains, seashores, deserts, canyons, glaciers, and forests. Especially forests. Where one might travel for hundreds of miles elsewhere without an abrupt or obvious change in view, in the Pacific Northwest the nuggets of discovery seem to lie around each bend: trees of tremendous girth here, waterfalls there; a herd of elk grazing just above the tide line, a colony of sea lions barking just below. And in Alaska, everything is extreme: the height of mountains, the rainy darkness of forest, the thickness of glaciers, the distance between human outposts.

Timber harvest had been a nearly universal use of national forest land nationwide—even if sales were chronically below-cost—but in some parts of the Northwest, the timber really paid off. Douglas fir, western red cedar, ponderosa pine, and other clear-grained monarchs provided for the workhorse industry of the region for decades. Then, increasingly rare old growth of these same species gave rise to the most intense movement in America to spare remaining trees of ancient vintage. While 90 percent of the old-growth timber was cut, the 10 percent that remained was enough to inspire many people to preserve what was left.

Photographing here was like visiting a grand buffet of scenic wonders: today, will it be glaciers or volcanoes? Grandfather firs eight feet across or bigleaf maples whose lichens and mosses equal four times the biomass of their leaves? And in Alaska, the remoteness and challenges of what native people call the "Great Land" made the capture of every photo an adventure to be remembered.

— TIM PALMER

PREVIOUS SPREAD: Dusted with the first snows of autumn, Mount Shuksan rises monolithically from Picture Lake in Washington's Mount Baker-Snoqualmie National Forest 12 miles south of the Canadian border. OPPOSITE: Deep within Oregon's Deschutes National Forest, Whychus Creek sprays over Chush Falls and onward through its gorge of volcanic rock.

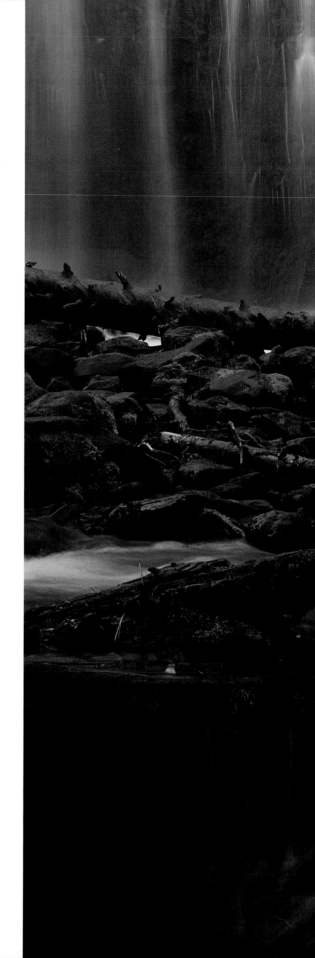

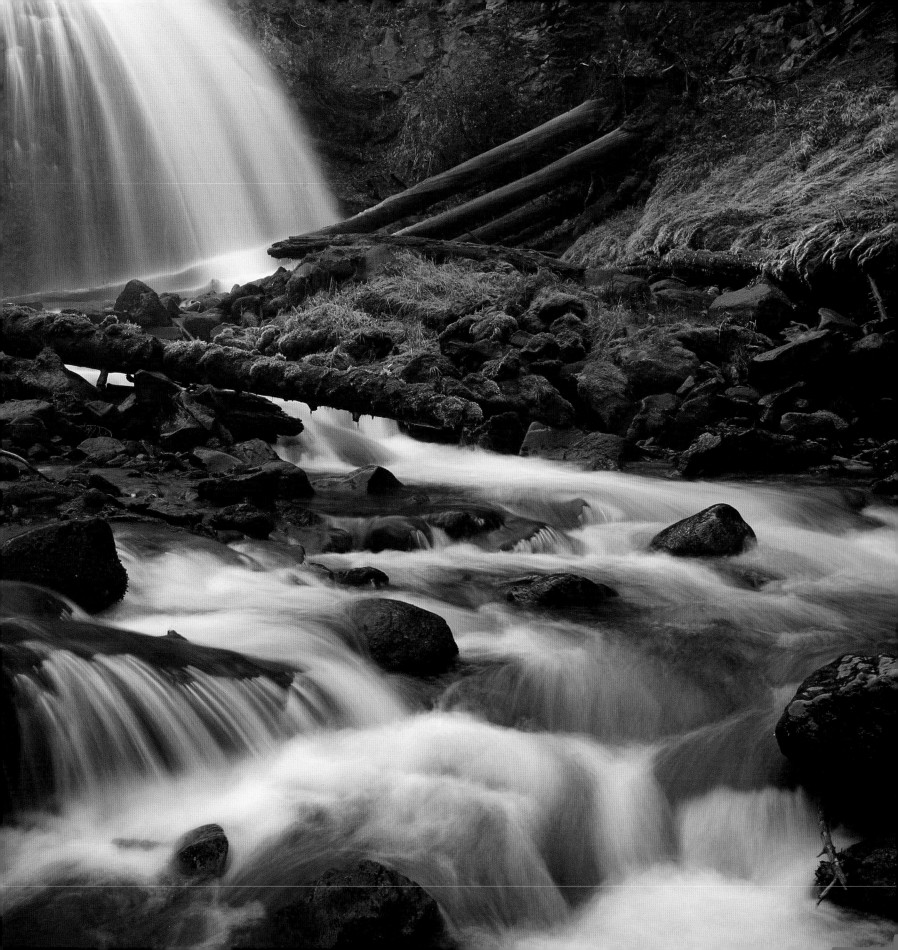

How do we locate meaning in any single spot, let alone in a landscape as vast and diverse as this region? How do we distill its essence, come to know its moods, or take its measure? Not by measuring, implied Oregon-based writer and critic Barry Lopez in *River Notes: The Dance of Hurons.* In his short story "The Bend," a figure seeks to apprehend

A misty stand of grand fir covers the summit of Marys Peak in Siuslaw National Forest. More than 96 percent of Oregon's Coast Range timberlands were logged, and most are now being logged again. The majority of the lands are in timber industry ownership, but here at Siuslaw National Forest concerns for erosion-induced landslides and endangered species in the 1990s brought about a new management paradigm including protection of riparian corridors and the closing of unneeded logging roads. From a 1980s crisis of overharvest that could not be sustained, Forest Supervisor Jim Furnish and others reinvented Siuslaw as an aspiring model of restoration.

the curve in the river, to "grasp it for private reasons," an aspiration that becomes an obsession, and leads him to hire scientists to calculate its structure. They "reduce the bend in the river to an elegant series of equations" that fill a series of thick tomes, but once stacked in a corner began to "harden," resembling the "gray boulders in the river" from which these data had been abstracted. With this transmutation, the narrator recognizes that it is through the senses, by touching, listening, and observing, that the river's flow is best experienced: "from above, to a hawk, the bend must appear only natural, and I for the moment inseparably a part, like a salmon or a flower."[1]

It is not by happenstance that this character's integration comes in the form of the Pacific Northwest's and Alaska's most heralded and keystone species. Salmon, and the water and woods that make up their habitat, are integral to the region's ecosystems and are markers of their health and vitality, and of the human life they sustain.

"That river was my life," remembered Billy Frank, a Nisqually tribal activist who lived along the eponymous river in west-central Washington. "You understood it right from when you were a

little boy. The winter floods, the spring floods, the low summer water"—these shifting river levels kept time with fish migrations. "There was a relationship between your life as a little boy and the salmon. You knew that every year the salmon came back. Spring salmon, summer salmon, fall salmon, then the winter run of chum salmon," an unending cycle.[2]

Until, that is, the pattern was disrupted. Beginning in the late 19th century, and varying only in the intensity of development, watersheds from Oregon to Alaska were commodified. Logging, mining, and grazing damaged streambeds and riparian habitat, and it was to slow down some of this destruction that many of the region's national forests were created in the late 19th and early 20th centuries. Compounding the rate of environmental change was the construction of dams bottling up innumerable waterways for irrigation, domestic consumption, barge transportation, and hydropower. The mighty Columbia River, which drains portions of Oregon's Umatilla and Mount Hood National Forests, as well as Washington's Gifford Pinchot, Okanagan-Wenatchee, and Colville, is much dammed, as are

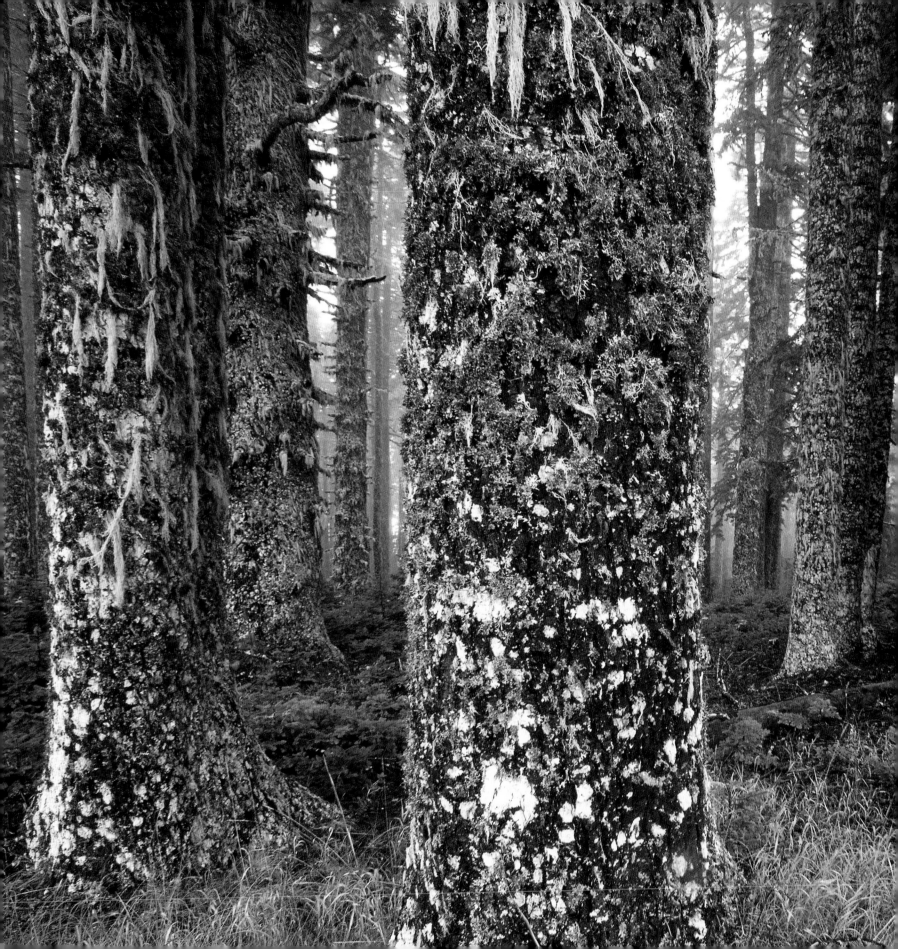

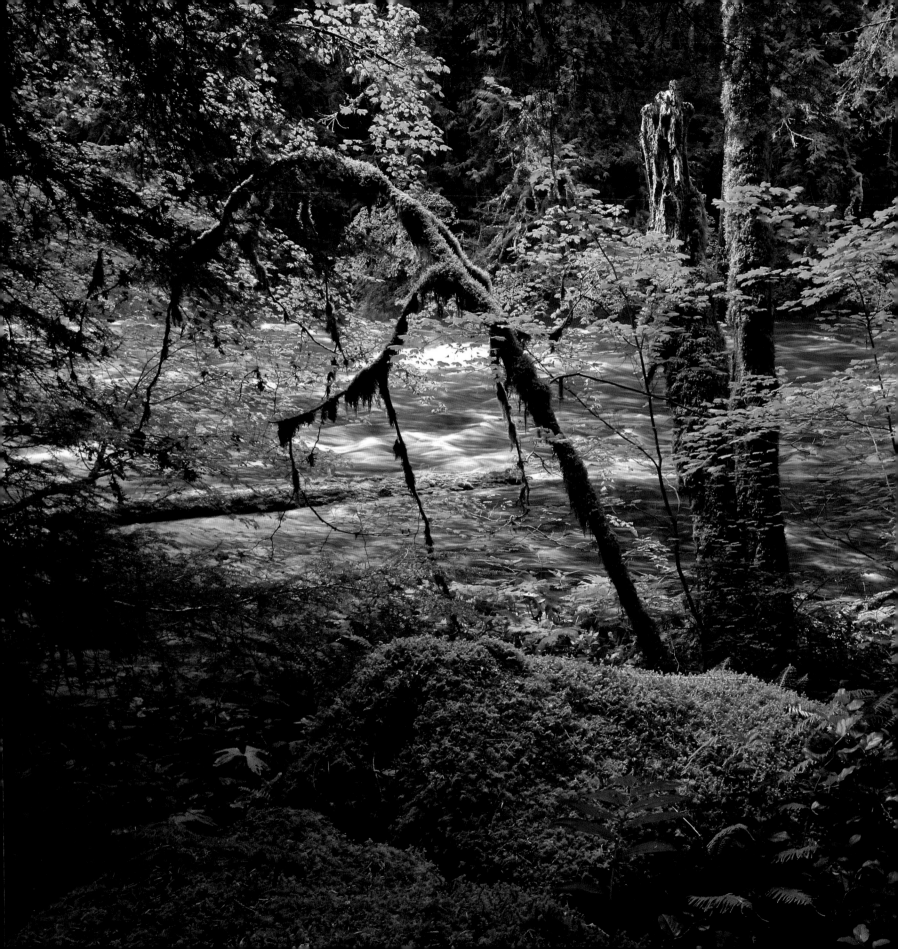

OPPOSITE: Willamette National Forest in Oregon has been one of the largest timber producers in the national forest system, but here along the McKenzie River, old-growth hemlock and Douglas firs remain while vine maples dazzle with green. Throughout the national forests occupying the west side of the Cascade Mountain crest, concern over habitat for endangered species led to the Northwest Forest Plan of 1994. This put much of the rare remaining old growth off-limits to logging and limited cutting along streams. Though successful in resolving socially rending conflicts of the time, the plan's provisions are under recurrent attack by advocates of increased logging.

ABOVE: Though the Coast Range and Cascade Mountains covering the western third of Oregon include the most productive forest, smaller ranges also glean rain and snow driven eastward by storms off the Pacific, and support conifers, such as these ponderosa pines in Ochoco National Forest. Through the past century, virtually all the timber was logged here and throughout the Blue Mountain complex to the east, leaving thickets of overcrowded young pines prone to intense conflagrations of wildfire. Efforts to thin this forest and then reintroduce controlled burning are gaining support as the way to reinstate habitat and timber-rich forests of the prelogging past that were less prone to super-heated blazes.

its forested tributaries. Each of these dams has further compromised the salmon's life chances. In the Pacific Northwest, the fish has been extirpated along many stretches of creek and river that bore witness to its migration for millennia.

Bringing the fish back meant challenging the legal, political, and economic decisions that had led to its decimation. The postwar rise of the American Indian Movement and the passage of federal legislation to protect threatened and endangered species and Wild and Scenic Rivers set the stage for a series of lengthy battles over indigenous fishing rights, dam removals, and river restoration. The national forests in the Pacific Northwest and Alaska were not the sole focus of these protests and lawsuits, but the Siuslaw and Gifford Pinchot, Olympic, Mount Baker-Snoqualmie, and Tongass National Forests were headwater sources for many of the region's once-robust salmon runs. When the agency promoted clearcutting on its lands beginning in the 1950s, the rapid removal of forest cover undercut water quality and riparian corridors, despoiling what remained of the fish's traditional spawning grounds. This dynamic began to change in the late 1980s. Court rulings granting native peoples greater rights to salmon fishing came in conjunction with other legal rulings that stopped massive timber harvests so as to protect the northern spotted owl. The Forest Service and state agencies began to revise their management

In the Fremont-Winema National Forest of south-central Oregon, the Chewaucan River curves through a savanna of ponderosa pines and grass as it drops toward landlocked Lake Abert. Once a haven for redband trout, the Chewaucan was reduced to nothing by ranchland diversions and infected with exotic fish that displaced the natives, but restoration efforts have gained traction with hopes of reinstating a trophy trout fishery.

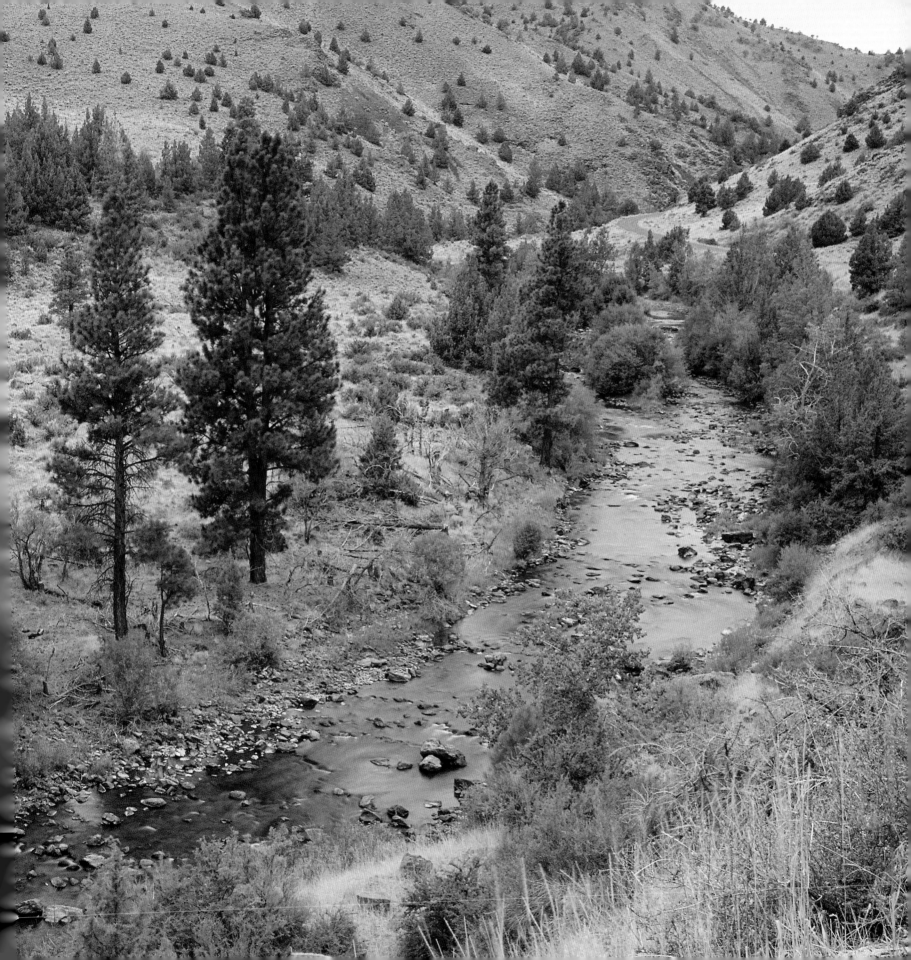

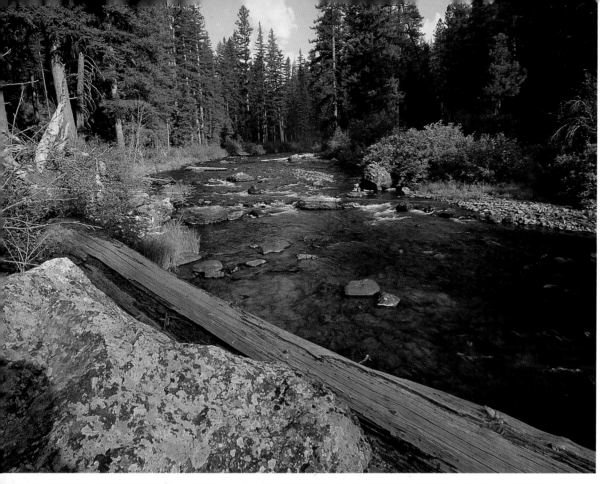

LEFT, TOP: The Malheur River is most often seen at its overdrawn lower reaches along Oregon Route 20, but its headwaters in Malheur National Forest flow through canyons bristling with ponderosa pines and arrow-straight larches shading water that nurtures rare bull trout. This trail is reached from Middle Ford, northeast of Burns, Oregon.

LEFT, BOTTOM: The west side of the Snake River's Hells Canyon lies within Wallowa-Whitman National Forest in Oregon. This elegant glade lies along a major Snake tributary, the Imnaha River, where Forest Service efforts have succeeded in thinning pine forests and reintroducing controlled burns. The goal is to reinstate a pine and grass savanna that characterized this landscape before the harvest of fire-resistant old-growth pines and before attempts to suppress all fires inadvertently led to thick stands of young trees vulnerable to intense fires.

OPPOSITE: Fresh winter snow makes for a thrilling telemark-ski descent in the Blue Mountains of northeastern Oregon's Umatilla National Forest.

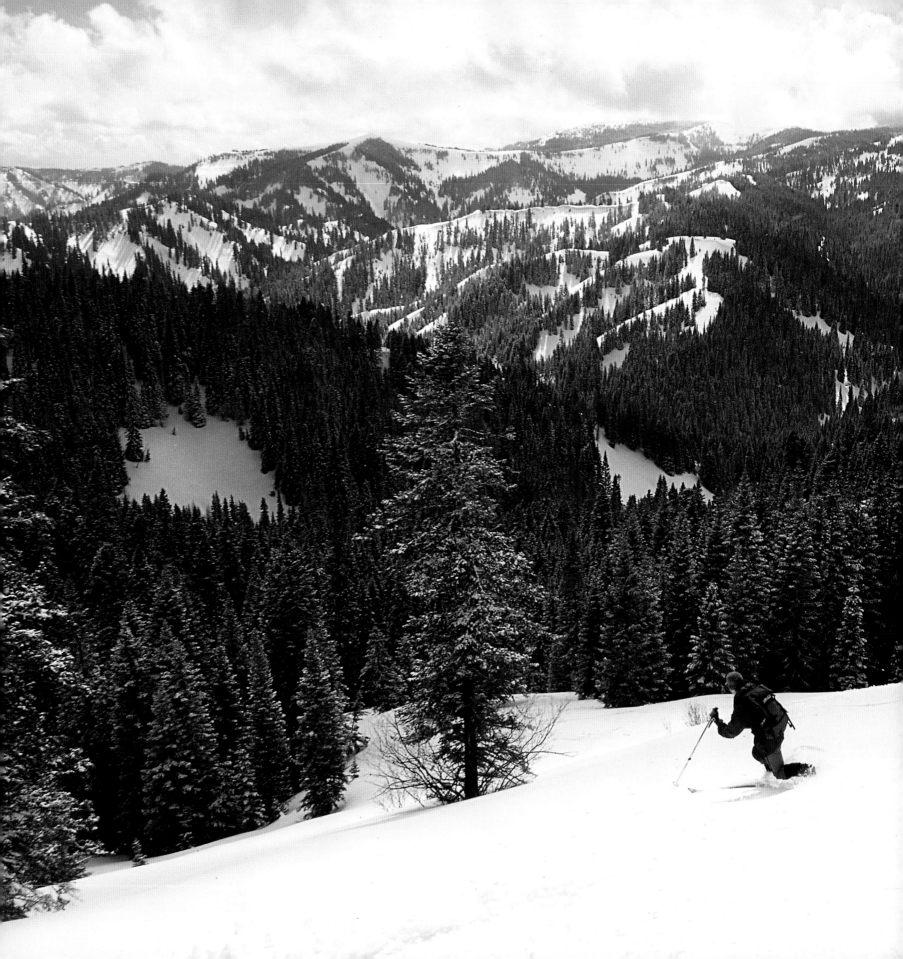

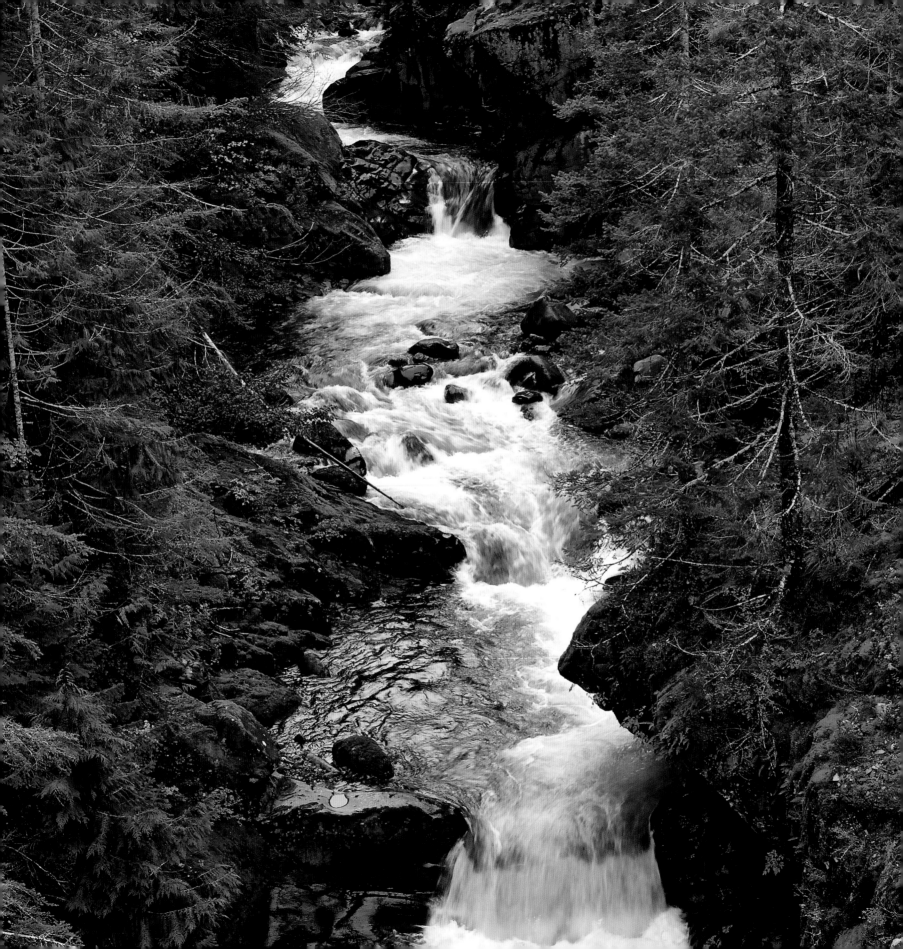

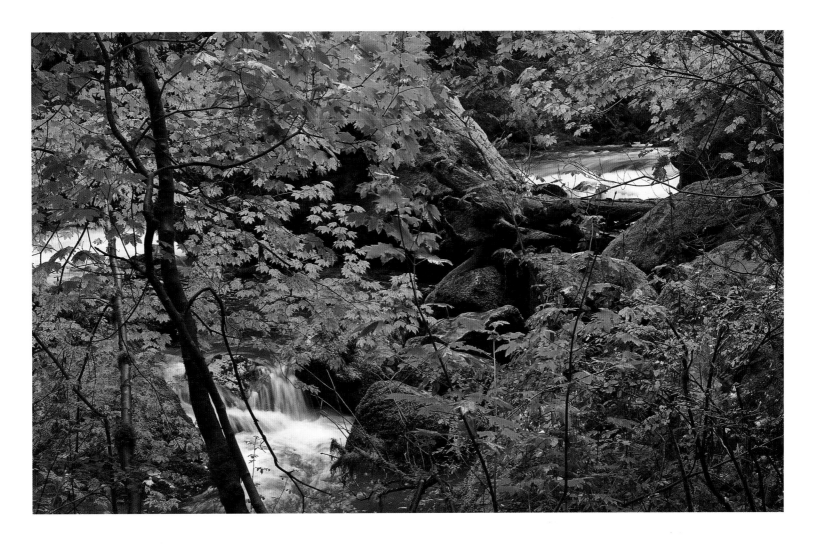

policies to include ecological restoration as part of their missions.

The federal agency's decision to remove some dams is part of this recovery process. In 2009, the Hemlock Dam in the Gifford Pinchot National Forest was torn down to restore the creek's formerly substantial steelhead population. On the once salmon-rich Skokomish watershed, Olympic National Forest is partnering with the Skokomish tribe, Olympic National Park, and nonprofit organizations to rehabilitate an extensive reach of the Skokomish River that had been cleared for a reservoir that was never built. Resurrection Creek in Chugach National Forest in Alaska, the site of devastating hydraulic placer mining, is also undergoing extensive repair through a collaborative partnership. And in Siuslaw National Forest, the Forest Service purchased a mobile home site built in an estuary, taking it down, as well as removing assorted culverts, ditches, and dams to return fish, birds, and tidal flows to the marshland. These small, necessary steps may not fully bring back the salmon to historic runs in great numbers, but they will give the fish a fighting chance to reclaim their central place in these waters and in our imagination.

OPPOSITE: Below these waterfalls in Washington's Olympic National Forest, the Hamma Hamma River fishery has critical spawning grounds for pink, chum, coho, and Chinook salmon as well as steelhead and sea-run cutthroat trout.

ABOVE: Vine maples thrive along the Duckabush River of Olympic National Forest. With more than 100 inches of precipitation a year, the Olympic Peninsula is the best example of a temperate rain forest outside Alaska.

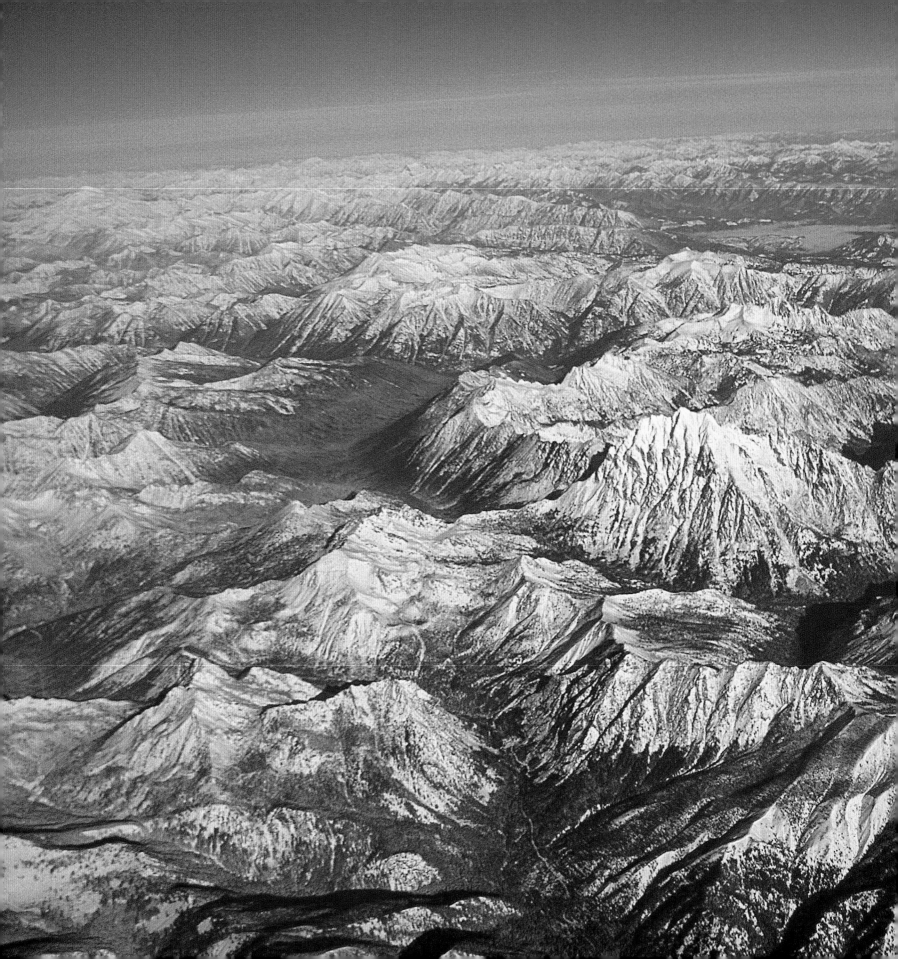

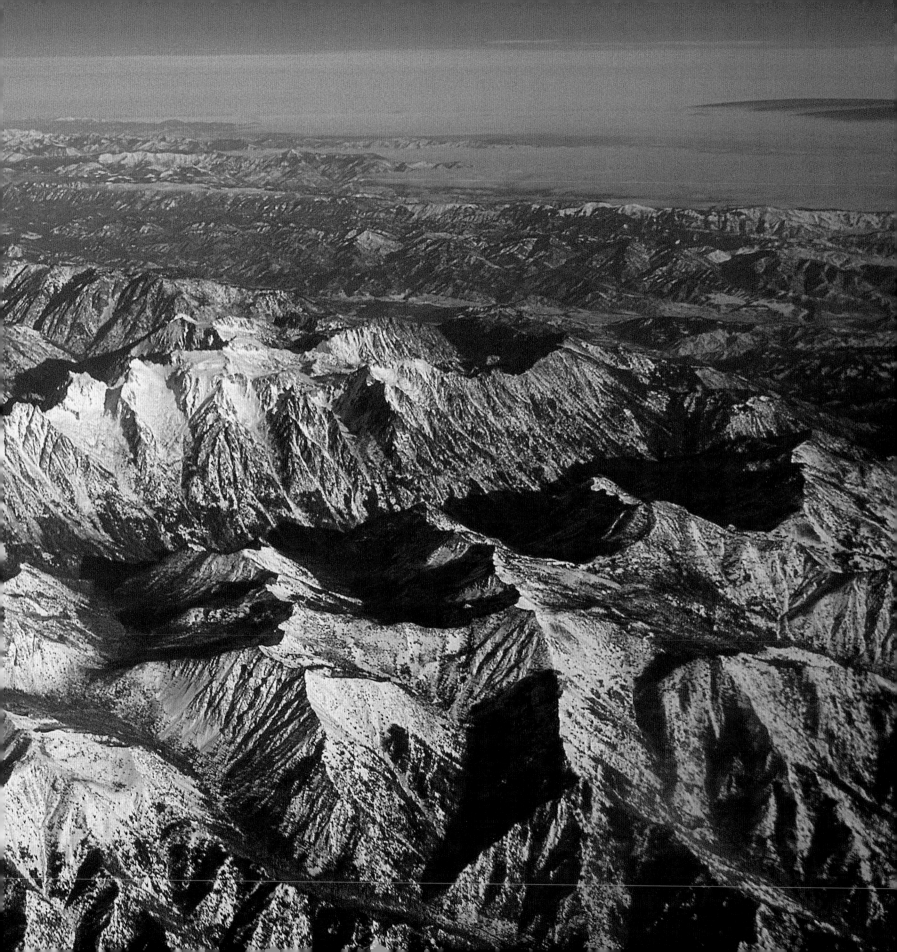

240

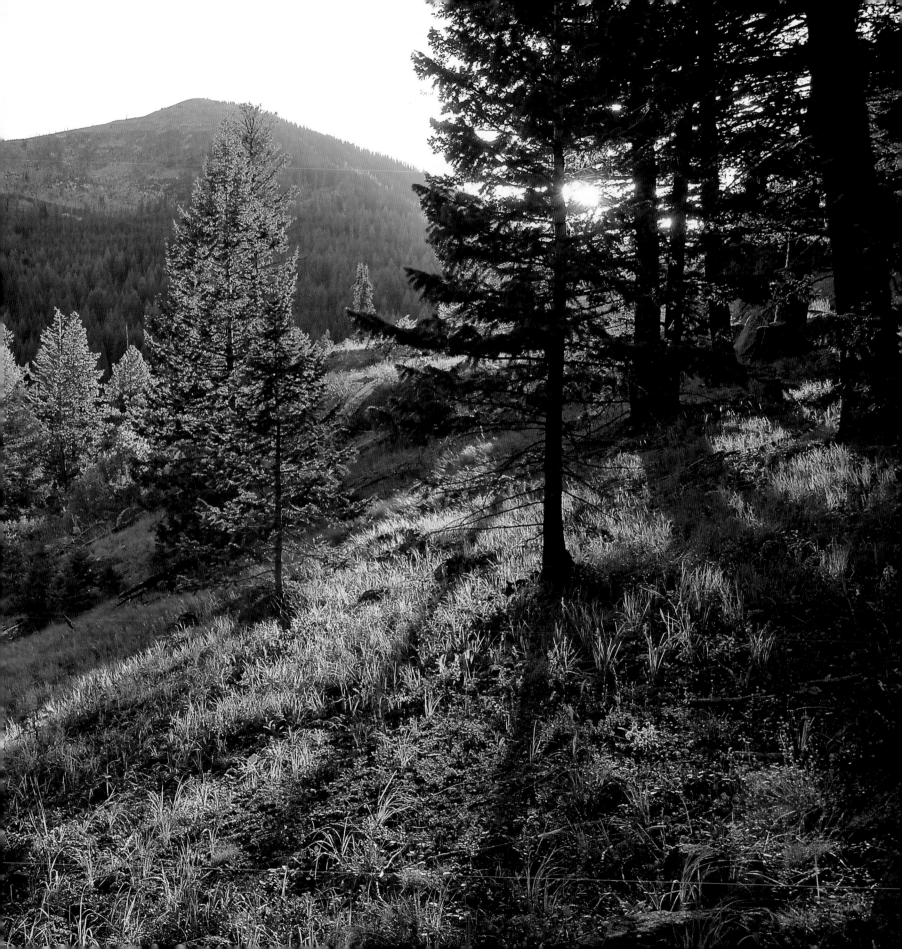

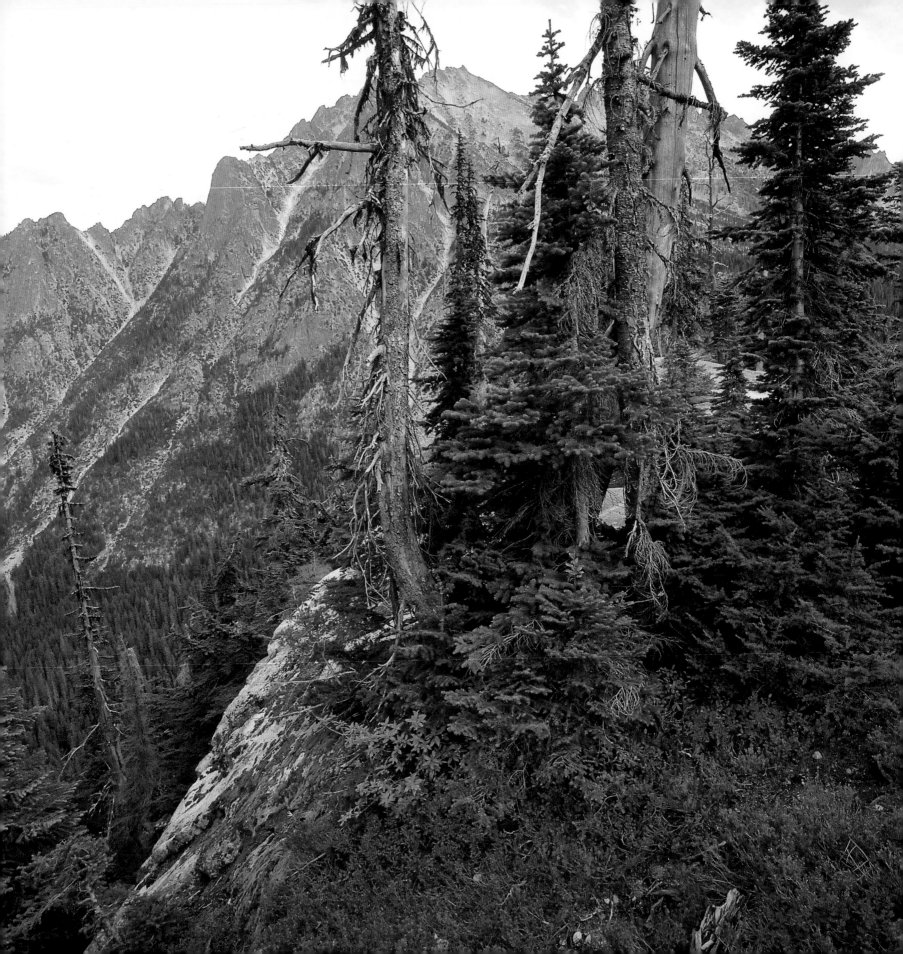

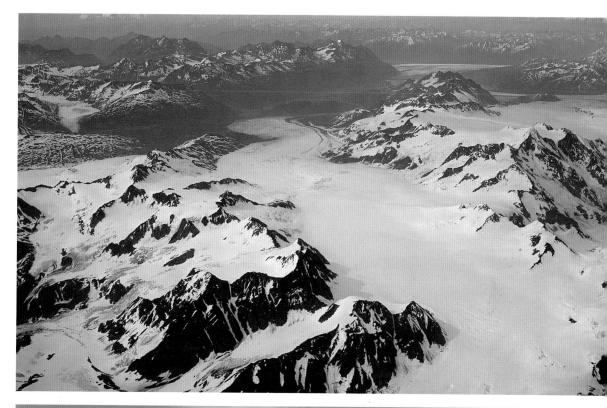

OPPOSITE: Highway 20 crosses the formidable backbone of the North Cascade Range at Washington Pass in Washington's Okanogan-Wenatchee National Forest. Kangaroo Ridge rises sawtoothed to the east while mountain hemlocks, subalpine firs, and red huckleberries brighten the foreground.

RIGHT, TOP: Chugach National Forest's six million acres arc across 200 miles of the Gulf of Alaska and Prince William Sound and exhibit breathtaking wonders of America's north, from rain forests to Arctic peaks. Like a view to ice ages of the past, this photo shows immense glaciers east of Anchorage.

RIGHT, BOTTOM: Glacier-carved Kenai Lake is one of many in Chugach National Forest, spectacular in its long arc across Alaska's south-central coast. In a class by themselves, this and Tongass National Forest include 12 percent of all national forest acreage nationwide and symbolize America's last frontier.

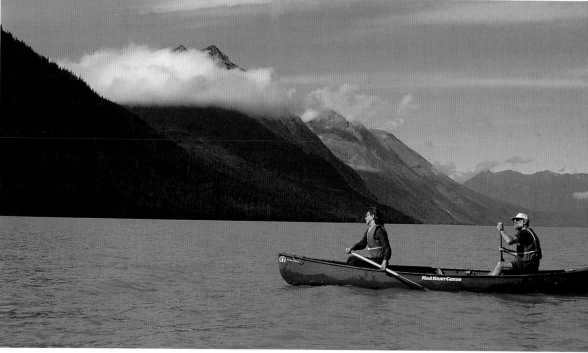

Rogue River-Siskiyou National Forest

The good citizens of Ashland, Oregon, did not like the way their water looked or tasted. Bear Creek, a tributary of the Rogue River as it cuts through southwestern Oregon, was befouled and turbid, they argued, because of extensive sheep grazing on public lands lying within the upper reaches of the local watershed. The people appealed to their elected officials and petitioned Congress for the establishment of a forest reserve, better to control grazing, and in 1893 their activism was rewarded. That year, President Grover Cleveland signed off on the designation of roughly 18,000 acres as the Ashland Forest Reserve; in time it would be folded into Rogue River-Siskiyou National Forest.[3]

The fight over this forest's natural resources was replicated in countless communities bordering public lands throughout the American West. In this case, downstream interests prioritized water quality, even though they ate lamb and mutton. Their upstream opponents, by contrast, privileged livestock and the grass these quadrupeds consumed, even though they drank water from the same supply as those who defended its purity.

There was nothing unusual about the tension it produced. Generating similarly complicated responses was the late 20th-century timber wars, pitting environmentalists and recreation interests against timber companies and mill towns. This multi-decade-long brawl tore apart the Pacific Northwest. In the Rogue River-Siskiyou National Forest, like the Deschutes in central Oregon and the Wallowa-Whitman in the Beaver State's northeastern corner, those who wielded chainsaws loved recreating on the lands they harvested, undercutting their pleasure even as they received a valuable paycheck. Meanwhile the wood they shipped to lumber mills helped drive down construction costs for the houses and apartments in which their critics lived. The fraught situation became only more knotty after the 1994 Northwest Forest Plan essentially shut down the regional timber economy. In its wake, mills closed, towns emptied out or suffered sky-high unemployment, and the Forest Service struggled to reinvent itself after decades of focusing almost solely on timber production.

Fire management offers another example of the crosscutting tensions that have informed public discussion about the public lands. In mid-July 2002, after a series of lightning strikes, a number of small fires erupted in the Rogue River-Siskiyou National Forest. Several of them merged into what became known as the Biscuit Fire, a major conflagration that was not contained until late that December. It charred nearly 500,000 acres, including a substantial portion of the Kalmiopsis Wilderness. Even as the land smoldered, competing visions of how it should recover emerged. The state's congressional representatives, Forest Service leadership, and some academic foresters proposed a massive salvage-logging operation to be followed by extensive replanting as the most efficient way to reclaim what fire had torched. For others, including such Forest Service researchers as Jerry Franklin, an architect of the Northwest Forest Plan and a key proponent of what was known as New Forestry, argued that the very naturalness of fire required a hands-off approach.

The Rogue River-Siskiyou National Forest has produced vast amounts of timber for local sawmills, but here a stand of old-growth Port Orford cedar is sequestered in a remote recess that was designated as the Copper Salmon Wilderness in 2009. The rare cedars are imperiled by an exotic fungus introduced from nursery stock imported from Asia. Trees are infected through fungus-tainted water—principally coming from mud that's spread throughout the forest road system on the tires of log trucks and cars.

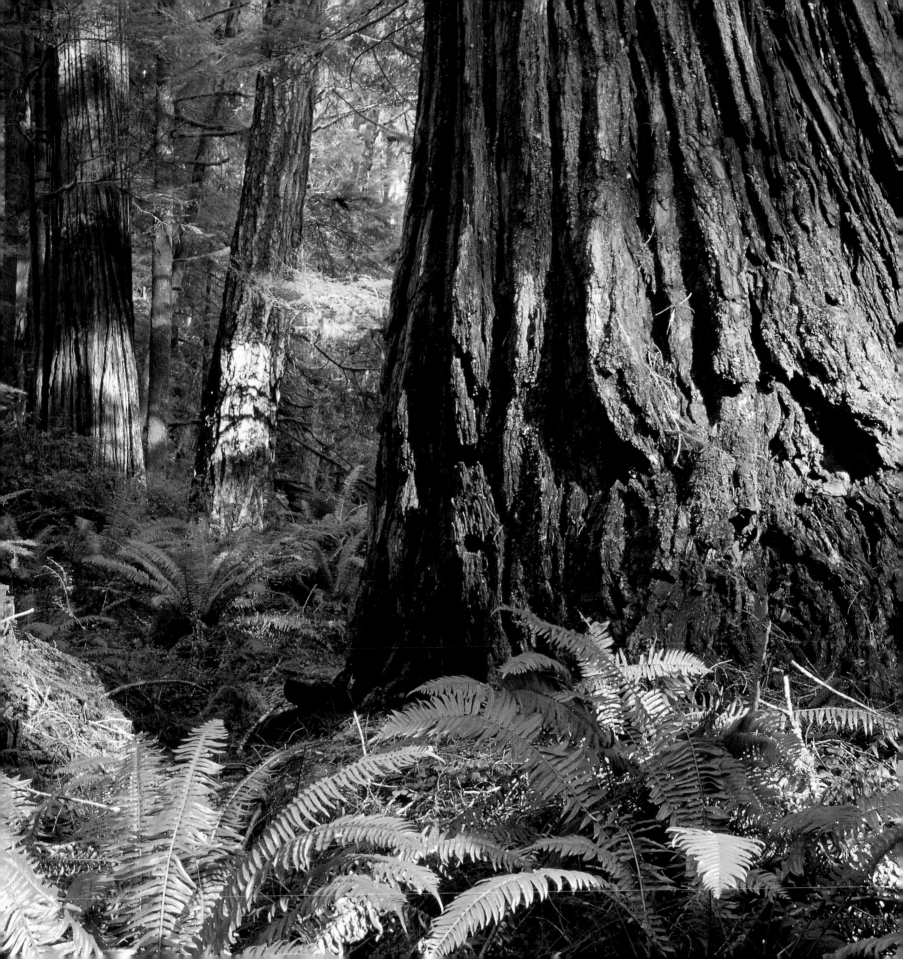

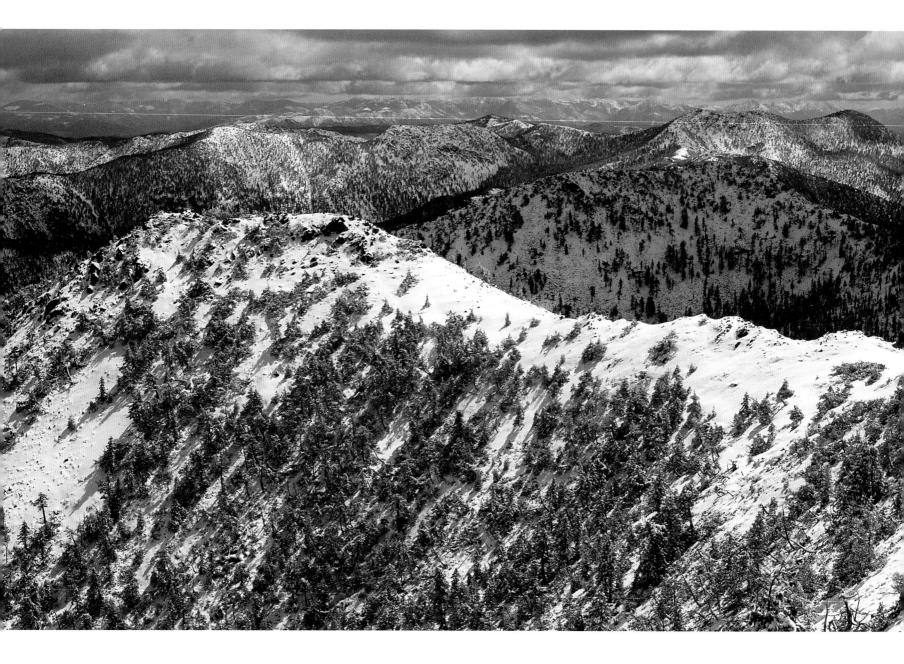

From his perspective, allowing natural regeneration to occur unimpeded was critical to the maintenance of these fire-adapted ecosystems, and their continued resilience—which he defined as the "ability to absorb stress or change without significant loss of function." As such, and not for the first time, Franklin testified in a blunt rebuttal of his employer's decision: "Salvage almost never makes a positive contribution to ecological recovery," a position that later research largely bore out.[4]

Padding through this contested ground was a male gray wolf, soon to be heralded by his

digital handle, OR-7. Born in 2009 in northeastern Oregon and a member of the Imnaha pack, the wolf was collared with a radio transmitter two years later. Sometime in September 2011, he left his home and headed southwest in search of a mate and territory. By spring 2014 he had located both in the Siskiyou. In between, OR-7 wandered 1,200 miles across much of Oregon and Northern California; the journey made him the first known wolf to roam the Golden State since the species had been wiped out in the 1920s. Although no one caught a glimpse of him as he loped through the state, OR-7 nonetheless achieved celebrated status among those for whom the gray wolf's recovery, however incomplete, signified the welcome prospect of ecological restoration writ large. For ranchers, the wolf's meandering presence was a worrisome prospect, for they viewed his return as a threat to their flocks and herds.[5]

It was this threat, perceived and real, that had engineered the wolf's demise as a keystone species in the wild. No sooner had European colonists arrived in North America than they unleashed a brutal assault on wolves. These attacks were justified as protection for the domesticated animals left to graze on the meadows, in the woods, and on the plains. This "antiwolf consensus" has survived despite upheavals in other parts of American culture, argued historian Jon T. Coleman, because people "embedded their hatred of wolves in stories, rituals, and institutions built to withstand historical change." The killing spree reached new heights in the late 19th century with the "bureaucratization of wolf control." That is when livestock interests secured sustained federal support finally to eliminate wolves and related predators. The old U.S. Biological Survey (now the USDA Wildlife Services) offered bounties to those who killed wolves, an action the 1931 Animal Damage Control Act later codified. This

legal license dovetailed with the ongoing cultural bias that conservationist Aldo Leopold once embraced. "I thought that fewer wolves meant more deer," he wrote in *A Sand County Almanac*, and "that no wolves would mean hunter's paradise." He would come to understand that the opposite was true after observing the population explosion of white-tailed deer in the Kaibab National Forest in northern Arizona that then overgrazed the forest. "In the end, the starved bones of the hoped-for deer herd . . . bleach with the bones of the dead sage."[6]

With the passage of the Endangered Species Preservation Act (1966), updated with the Endangered Species Act (1973), Congress started to embrace Leopold's later perspective. Listed as an endangered species in 1974, wolves have recovered, especially in the Bridger-Teton and other national forests in the Northern Rockies. By December 2013, according to the U.S. Fish and Wildlife Service, gray wolf restoration in that region had achieved such a level—1,691 wolves in 320 packs with 78 breeding pairs—that by "every biological measure the [Northern Rocky Mountain] wolf population is recovered and remains secure under state management." It then delisted the wolf, with the caveat that it would track its progress, and promptly re-list it if its numbers declined.[7]

Even as they decried this decision, wolf advocates were heartened by the news of OR-7's peregrinations. They were then thrilled when he reentered Oregon's Rogue River-Siskiyou National Forest and research cameras captured images of a female wolf in close proximity. Even better news arrived in June 2014. Two cubs were spotted on camera, the start of a new pack. Soon enough, the pack's howls, like an "outburst of wild defiant sorrow," will echo across the southern Cascades, a re-wilding of this once-wild land.[8]

Though known more for summer heat than winter snow, Kalmiopsis Wilderness of Rogue River-Siskiyou National Forest lies deep in white here at the summit of Vulcan Peak. Exquisite wilds of the Chetco River hide in the canyons below. Along with the surrounding terrain of the Klamath-Siskiyou Mountain complex, this area has the greatest diversity of conifers in the world and, owing to unusual serpentine soils weathered from ancient seafloor strata, a host of endemic plant species thrive.

Mount Hood National Forest

President Franklin Roosevelt put great stock in the Timberline Lodge. Standing before an estimated crowd of 12,000 gathering on Mount Hood for its late September 1937 dedication, he singled out the handiwork of enrollees in the Civilian Conservation Corps, whose artisanship created the magnificent wood-and-stone lodge with commanding views of the surrounding countryside. Ever the politician, Roosevelt extolled the artisans' efforts, citing the words on the bronze plaque commemorating that moment. The hotel stood "as a monument to the skill and faithful performance of workers on the rolls of the Works Progress Administration."[9]

Sited at 6,000 feet, the lodge also offered an unparalleled overview of the national forests' multiple purposes. Peer east, Roosevelt urged the audience, and gaze out on Oregon's "great livestock raising areas." Look north "toward Portland and the Columbia River, with their great lumber and other wood using industries" which reveal the part "National Forest timber will play in the support of this important element of northwestern prosperity."[10]

As important as the forest's economic contributions was the array of environmental services that Mount Hood and the contiguous Willamette National Forest offered. They "husband our water at the source," the president affirmed; "they mitigate our floods and prevent the erosion of our soil." Given where he was, it is not surprising that Roosevelt simultaneously underscored the recreational opportunities these beautiful public lands provided one and all. Americans are "coming to realize that the summer is not the only time for play. I look forward to the day when many, many people from this region of the Nation are going to come here for skiing and tobogganing and various other forms of winter sports." But he was particularly excited that Timberline Lodge would be a beacon, drawing citizens to revel in the mountain's four seasons of fun, not least those from "the outermost parts of our Nation, travelers from the Middle West, the South and the East, Americans who are fulfilling a very desirable objective of citizenship—getting to know their country better." In the midst of the dispiriting Depression, Roosevelt believed that the nation that played together, stayed together.[11]

Millions of visitors have made good on his word, staying at the lodge, skiing and snowboarding on Mount Hood's groomed trails, hiking and camping in its old-growth forests and alpine meadows, and fishing and hunting and just plain lounging. Like other forests adjacent to major metropolitan areas, Mount Hood National Forest has been Portland's playground from the moment of its 1892 designation as the Bull Run Forest Reserve. These lands were set aside to protect the city's main source of drinking water, and given one of Portland's nicknames, Stumptown, it is clear why it needed protection.

Even while its citizens demanded clean water flowing downhill, they were moving uphill to recreate in the one-million-acre forest, and in such large numbers that even Forest Service Chief Henry Graves took notice. What was happening in Portland was happening across the

Crowning this national forest at 11,240 feet, Mount Hood rises as the highest Oregon summit, visible on a clear day to everyone in the city of Portland. The south side of the mountain and the Sandy Glacier are seen here from timberline at Paradise Park.

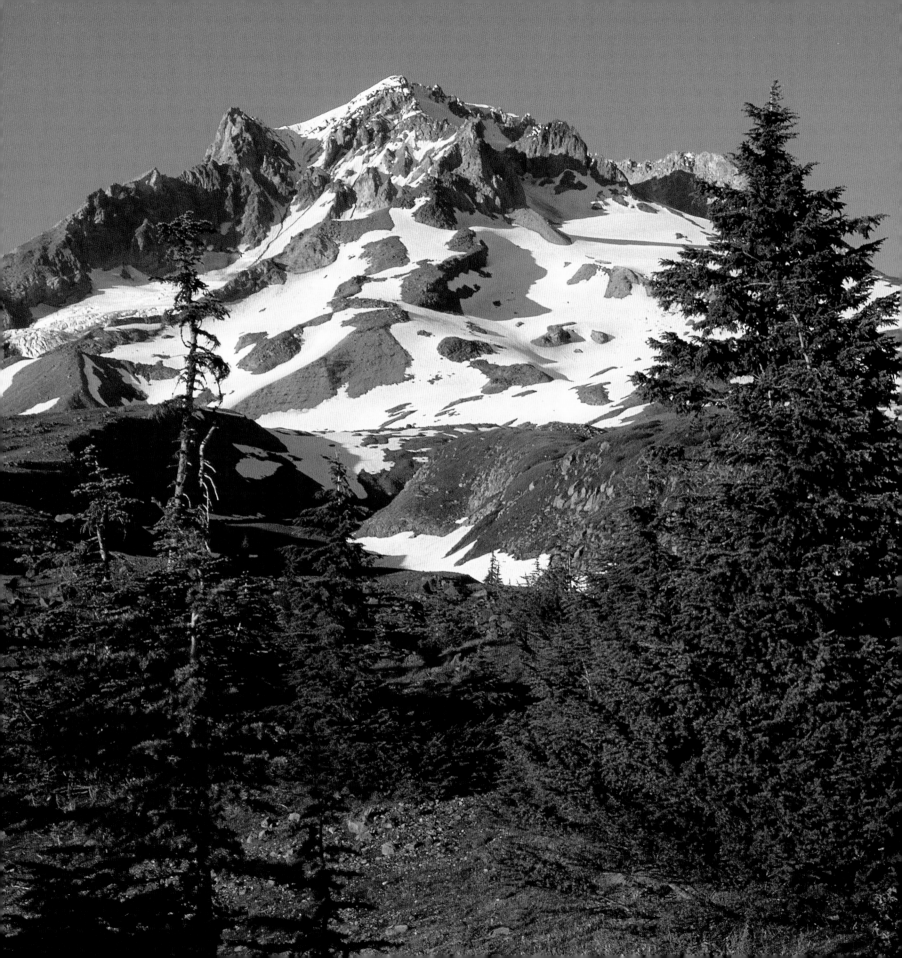

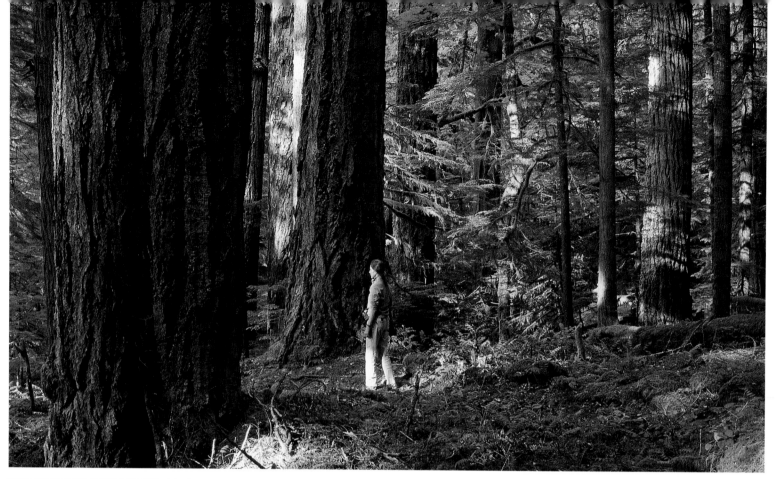

United States. In 1913, with a total of 1.5 million "pleasure-seekers" descending on the national forest system, Graves identified the spike in demand as especially impacting forests "near cities of considerable size. Hundreds of canyons and lake shores are now filled with camps and cottages built on land use of which is obtained through permits of the Forest Service." This surge of interest compelled agency leadership to recalibrate the balance between uses and users. In certain areas, visitors' needs would take priority. The "exclusion of stock [and] the prohibition of use of certain canyons for [stock] driveways," were among the actions Graves believed necessary to enhance the recreational experience. That included, strikingly, "provisions in timber sales for very light cutting, or no cutting at all, close to lakes and elsewhere where it is desirable to preserve the natural beauty of the location unmarred, for the enjoyment of the public."[12]

Graves took this concept seriously, testing its applicability in the Mount Hood National Forest, at the time the second-most-visited forest in the country, trailing only the Angeles in Southern California. In addition to availing themselves of the mountain itself, Oregonians picnicked on the steep, sheer banks of the Columbia Gorge, which the Columbia River carved through the Cascades. With the completion of the Columbia River Highway, the rush was on. Business interests were particularly concerned that sizeable crowds would despoil the site and lobbied Graves to preserve its scenic values. In 1915 he recommended the designation of Columbia Gorge Park, comprising nearly 14,000 acres along 22 miles of the river; no homesites would be permitted, no timber cut. This was a first for the agency, and its responsibilities for the site have expanded along with the area's size. The Columbia River Gorge National Scenic Area, which since 1986 has been comanaged by the Forest Service and the Columbia Gorge Commission, encompasses 292,500 acres and spans both sides of the river.[13]

Despite this promising initiative, the Forest Service was reluctant to prioritize recreation on other sites. The agency was ambivalent when such recreational landmarks as Glacier (1910) and Rocky Mountain (1915) National Parks were cut out of surrounding national forests. Once the Park Service was established in 1916, the Forest Service continued to lose ground. In the Pacific Northwest, for instance, it fought bitterly but unsuccessfully to retain what would become Olympic National Park. In 1968, after another protracted interagency dispute, North Cascades National Park and two national recreation areas were sliced out of the Mount Baker-Snoqualmie National Forest.[14]

There were simultaneous efforts to redesignate portions of the Mount Hood National Forest, too, but these efforts have dissipated. Perhaps this was a result of the collapse of timber production in the region's national forests in the aftermath of the 1994 Northwest Forest Plan, perhaps because recreation has replaced timber as the most significant use of these public lands. That is not the only thing that has changed since Roosevelt's visit to Timberline Lodge. Were he to stand at the site of his dedicatory speech, he would see to the immediate east that ranching has given way to urbanization. To the west, agriculture continues to dominate the Willamette Valley, with a new crop, grapes, coming to the fore. Portland is no longer Stumptown. Meanwhile, Mount Hood National Forest has had to adapt to all those visitors—now four million annually—that the president encouraged to play there, and while playing to "realize the privileges which God and nature have given to the American people."[15]

Gifford Pinchot National Forest

It was as if people did not know what to call these federal lands just north of Portland, Oregon, across the Columbia River in Washington. Originally named for the mighty ocean that lies 100 miles west, the Pacific Forest Reserve (1893) morphed into the Mount Rainier Forest Reserve (1897), only to lose its mountain moniker to become the Rainier National Forest in 1907. That tag did not stick: the next year, 1.3 million acres were peeled off to form the Columbia National Forest, a designation identifying it with the river on its southern boundary. The river remains, the landscape, too. The forest still straddles the volcanic Cascades, and one of its major peaks is Mount St. Helens. It is home to receding glaciers that feed into the White Salmon River, the forest's only official Wild and Scenic River (with another 13 under consideration, all of which flow through vast sweeps of old-growth ponderosa pine, Douglas fir, cedar, and hemlock). But the site was renamed once again in July 1949, this time becoming the Gifford Pinchot National Forest.

The Forest Service's decision was understandable. Pinchot had died in 1946, and to commemorate its first and most-galvanizing leader, the agency opted to rename a national forest in his honor, officially doing so at an October 1949 public rededication of the forest.[16]

Among those addressing the throng was Pinchot's widow, Cornelia Bryce Pinchot. She eulogized her husband in terms one would expect, extolling his belief that conservation "was never a vague, fuzzy aspiration. It was concrete, exact, dynamic. The application of science and technol-

ogy to our material economy for the purpose of enhancing and elevating the life of the individual. The very stuff of which democracy is made." She also did something out of the ordinary, worrying that contemporary conservationists, many of whom shared the dais with her, were failing to uphold her spouse's convictions. Mere technical achievements—the number of board feet logged, the amount of soil erosion halted, the kilowatts of hydropower generated, subjects of the preceding speeches that day—would do little to advance the people's rights or expand their opportunities. Safeguarding those principles, ensuring that conservation remains "more than ever a philosophy of dynamic democracy," was the most effective way for the nation to achieve a "more perfect freedom."[17]

The forest supervisors of the Gifford Pinchot National Forest discovered just how dynamic democracy could be after changing the harvesting regimes operating at the time of the forest's rededication. Those who attended the event received a pamphlet outlining then-current management practices: ponderosa stands on the drier, eastern slopes were cut according to a careful "tree selection" system that "opens up the forest so that the thrifty, young trees will develop more rapidly," promoting natural regeneration. On wet western slopes, the agency allowed companies to clearcut 40- to 80-acre blocks of Douglas fir. In 1949, the forest's allowable cut was 200 million board feet, though it only harvested 93 million.[18]

The numbers serve as an important baseline, for by the 1950s they began to skyrocket nation-

The glow of sunset reflects off new snow on Mount Adams, one of the Cascade Range's stratovolcanoes, seen from Forest Road 23 north of Trout Lake in Gifford Pinchot National Forest.

252 ◆ AMERICA'S GREAT NATIONAL FORESTS, WILDERNESSES, AND GRASSLANDS

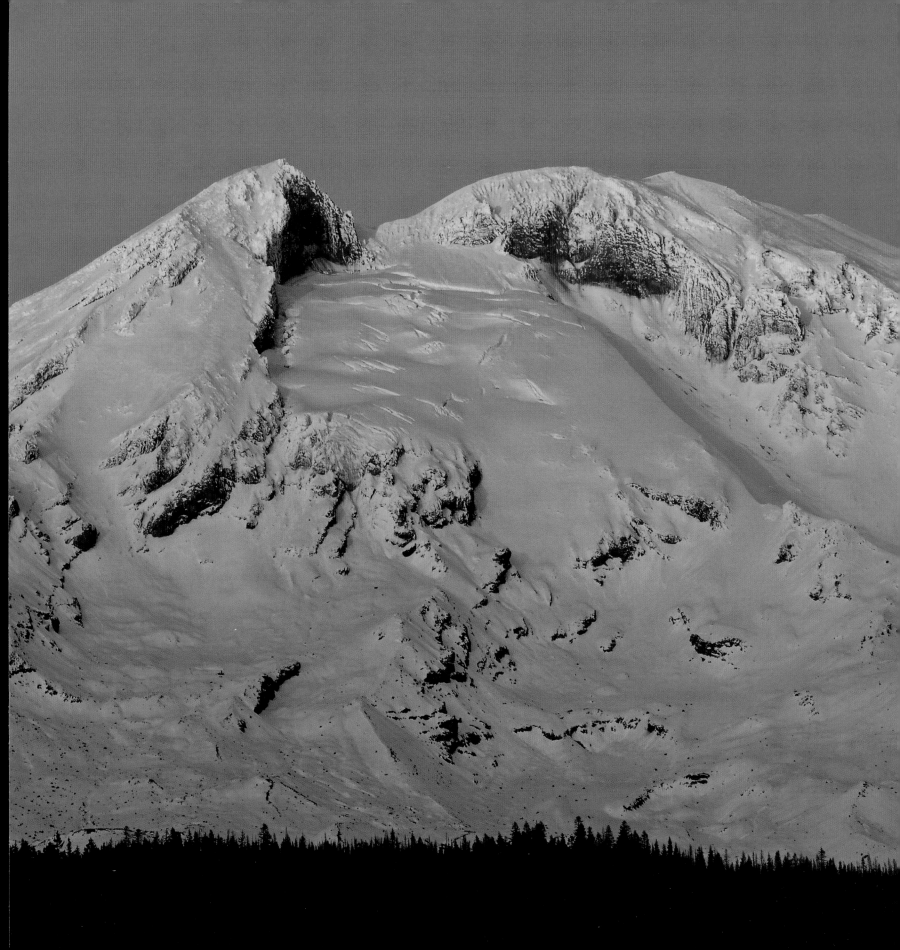

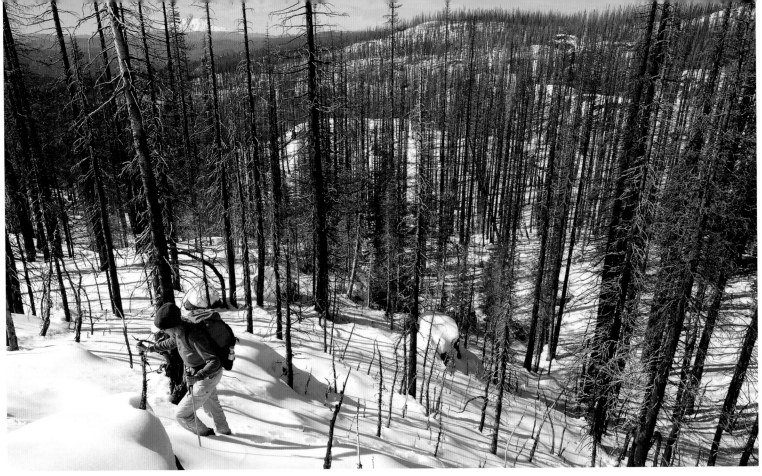

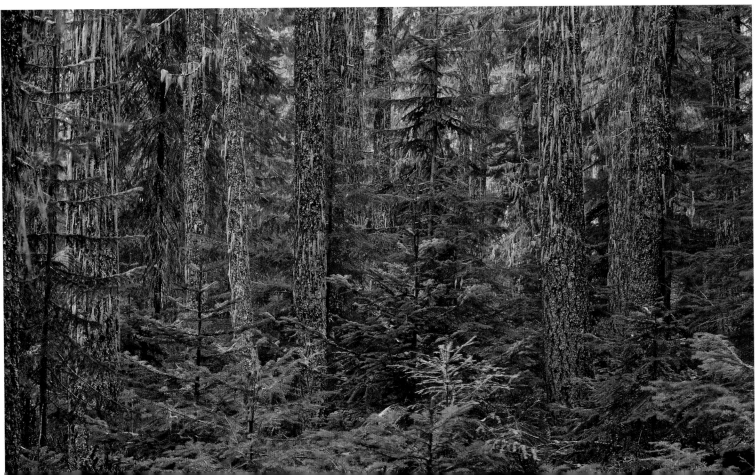

ally. Early in that decade, Congress demanded increased harvesting. "There was never a week," Chief Richard McArdle (1952–62) recalled, "that I wasn't being beat upon to raise the amount of timber which could be cut." A pummeled agency complied, first increasing each forest's allowable harvest and then, with its scientists' concurrence, allowing the clearcutting of substantial blocks of all species regardless of topography. Using bulldozers, chainsaws, and heavy-duty trucks rolling over an ever-expanding road network, timber flowed off the national forests. In 1945, the annual harvest was roughly two billion board feet, in 1953 it topped 5.1 billion, and eight years later it stood at 8.3, peaking in the late 1960s around 12 billion.[19]

The sawdust flew in the Gifford Pinchot, too. In 1956, 236 million board feet came off the forest, topping out at 559.5 million board feet in 1968, and large harvests continued through the 1980s. Pushback against the so-called "Oh My God" clearcuts was almost immediate. The agency believed this reaction was aesthetic only, and left "beauty strips" to screen motorists. It was harder to fool biologists and ecologists concerned about the resulting damage to watersheds, wildlife, and wildland. They knew that the singular focus on timber was damaging the land's biodiversity and resilience. "Forests were managed less as interconnected ecological systems," Chief Michael Dombeck wrote, and "more as complicated machines that demanded engineering skills and technological mastery." This is precisely the technocratic agenda Cornelia Pinchot had feared would dominate the agency.[20]

The agency's new emphasis on clearcutting generated a powerful countermovement that was particularly active in the Pacific Northwest. Environmental activists launched an escalating series of protests and lawsuits, culminating in the 1994 Northwest Forest Plan that essentially shut down the timber program to protect forest health and endangered species like the northern spotted owl. In 2011, only 25 million board feet were harvested in the Gifford Pinchot National Forest.[21]

Amid these bitter struggles, on May 18, 1980, Mount St. Helens blew up, unleashing a debris-filled avalanche, searing pumice flows, gaseous winds, and an ominous, ash-choked mushroom cloud. Within moments, more than 140 square miles of trees were knocked over, or if left standing, killed. In the devastating wake of the eruption, the Forest Service developed plans to salvage timber and revegetate the forest. Scientists and citizens, many of whom had fought for decades against the agency's harvesting procedures, rallied in favor of national-monument designation for the now-shattered mountain and environs. Their goal was to set aside Mount St. Helens as a living laboratory, and while the agency was not opposed to the idea, it tussled with opponents over its size. It proposed an 85,000-acre site, which Congress expanded in 1982 when it created the Mount St. Helens National Volcanic Monument, dedicating its 110,000 acres to research, education, and recreation.[22]

Those who studied or played on this moonscape learned how quickly nature revived. In a matter of days after the eruption, animals tracked across the desolation, and soon plants pressed up through the volcanic debris, a reclaiming that emerged out of the biological legacy of downed trees, buried seeds, and fungal spores distributed by birds, amphibians, and other surviving organisms. In this story of an ecosystem reassembling itself lies a parallel narrative about the evolving character of conservationism itself, which Cornelia Pinchot asserted must be "reinvigorated, revived, remanned, and revitalized by each successive generation."[23]

OPPOSITE, TOP: Recent fires have charred the corridor of the Pacific Crest Trail near Horseshoe Meadows on the southwestern flank of Mount Adams. On the horizon, Mount St. Helens erupted in 1980 with a pyroclastic explosion blasting volcanic ash across the Northwest and lowering the once-elegantly symmetrical summit by 1,300 feet.

OPPOSITE, BOTTOM: Hiked by thousands every year, the Pacific Crest Trail traverses this moss-draped forest of western hemlock and grand fir as it approaches the sky-bound rise of Mount Adams in Gifford Pinchot National Forest.

Mount Baker-Snoqualmie National Forest

Towering over northern Washington State, and visible from Seattle and Tacoma north to Vancouver, British Columbia, Mount Baker's geographical siting and 10,871-foot elevation make it an unparalleled snow-catcher. Its sheer mass, glistening glaciers, and deep snowfields have seized the imagination of those who have sought to capture its essence. The indigenous people of the Pacific Northwest call it Koma Kulshan (white sentinel). When they first gazed on this lofty volcano, among the tallest of the Cascades, Spanish explorers compared it to the white robes Carmelite monks favored, anointing it La Gran Montaña del Carmelo. Far more prosaic is the name by which it is now officially known: Mount Baker. The person for whom the peak is named, Joseph Baker, was a lowly third lieutenant on HMS *Discovery*, and his commander, George Vancouver, credited him for being the first to spot the mountain. "About this time a very high conspicuous craggy mountain . . . presented itself, towering above the clouds," Vancouver noted in his journal, and "as low down as they allowed it to be visible it was covered with snow." To Mount Baker's south lay "a long ridge of very rugged snowy mountains, much less elevated, which seemed to stretch to a considerable distance," a range that to the mariner's eyes looked very much like "detached islands."

Vancouver was not wrong, for ecologically the Cascades, which run north-south from British Columbia to Northern California, function like an archipelago. As they block precipitation streaming off the Pacific, the chain's western slope, on which the 1.7-million-acre Mount Baker-Snoqualmie National Forest is located, is dominated by old-growth Douglas fir. On its eastern slope, site of the Okanogan-Wenatchee National Forest and North Cascades National Park, ponderosa pine predominates. The Cascades' rain shadow not only shapes this speciation but also more generally divides Washington, Oregon, and Northern California between a wetter west and a drier east.

The variation is astounding: in Washington, the west side of the Cascades receives about 100 inches of precipitation a year, while on the east side precipitation can be measured in the single digits. This difference helps explain why the slopes, canyons, and valleys contained within the Mount Baker-Snoqualmie National Forest are so thickly wooded. These dense forests offer a hint as to why timber companies, such as the Minnesota-based Weyerhaeuser Company, having logged out the Great Lakes and the Upper Midwest, moved their operations to forest-rich Washington in 1900. Their arrival was coincident with the creation of the federal forest reserves, bringing together two different forms of land management that would define the state's lumber-based economy for much of the 20th century.

Until World War II, most harvesting took place on private lands, usually at lower elevations due to easy access and the ability to move logs to mills and markets. After the war, private-land harvest slowed and the national forests took up the slack. That is when the Forest Service, to meet congressionally mandated harvest targets that determined agency budgets, began clear-cutting. By the 1980s, so much wood was being

Huckleberries have turned maroon along the Ptarmigan Ridge Trail at Mount Baker while clouds swirl with the first impending storm of autumn. The next day it snowed six feet.

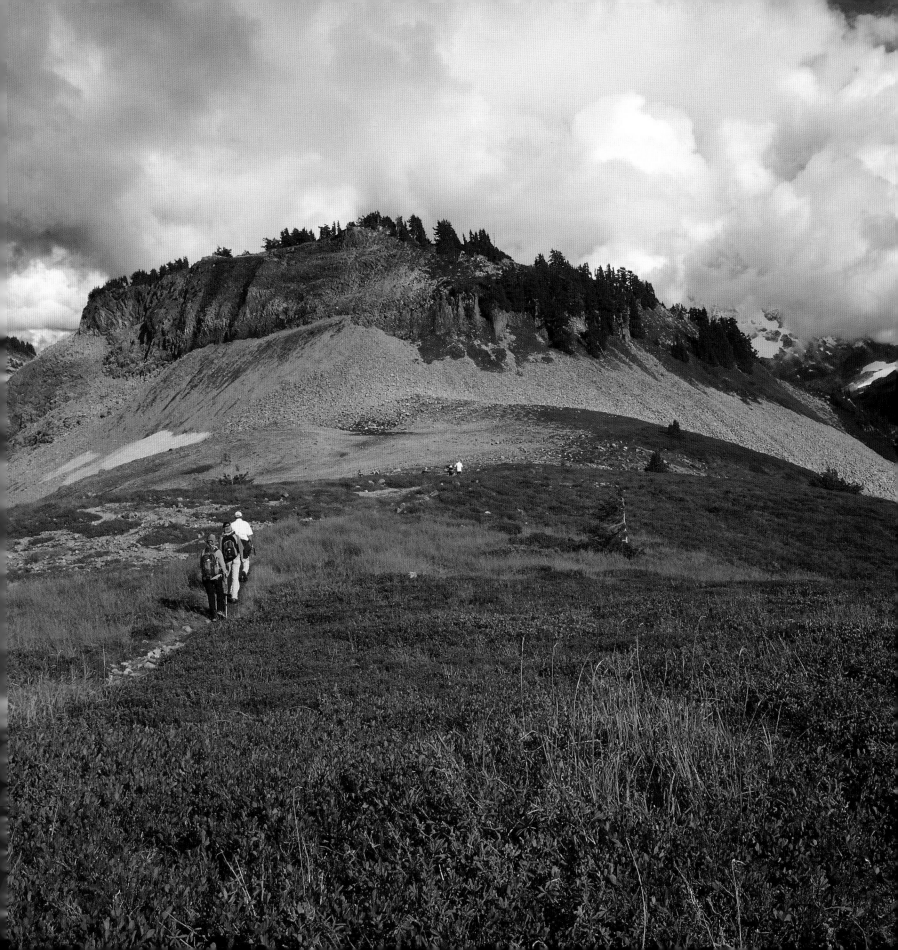

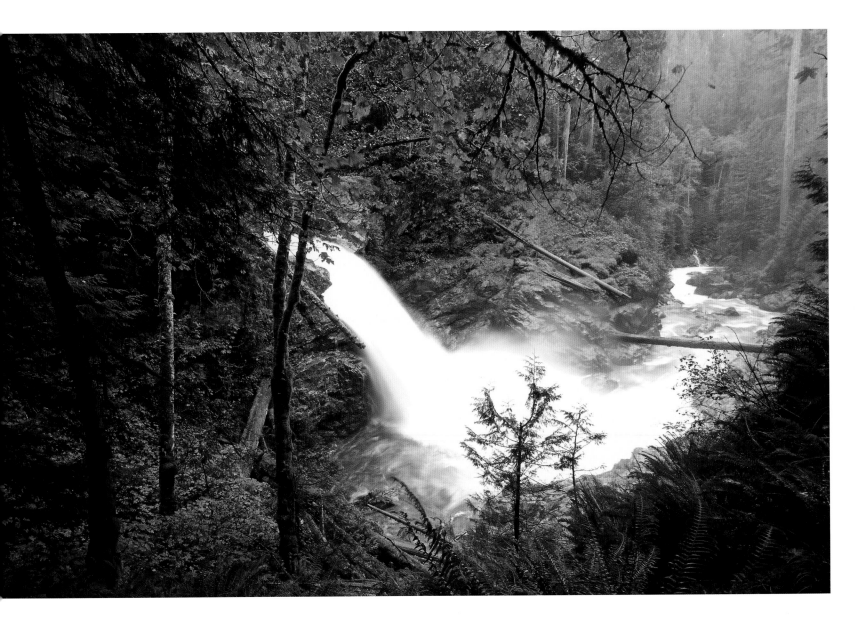

cut in the Pacific Northwest national forests that the region became, in the words of Dombeck, the "breadbasket of the Forest Service timber program—supplying about half of all timber harvested from the National Forest System."[24]

The impact of these harvests on the Mount Baker-Snoqualmie is revealed in a U.S. Geological Survey study of spatial change across the north-ern Cascades between 1973 and 2000. Overall, "mechanical disturbances," that is, logging, altered 10.7 percent of landscape cover. But on portions of the Mount Baker-Snoqualmie, the percentage change ranged from a low of 8.7 to a high of 24.5. These mega-harvests required more forest roads, bridges, and other infrastructure, adding to the fragmentation of once-intact ecosystems.[25]

Yet even as the Ronald Reagan administration and its congressional allies ramped up demands in the mid-1980s for greater cutting in the national forests, a number of forces converged that would upend this ambition. A growing body of dissent arose within the Forest Service's biologists, hydrologists, and wildlife managers hired to keep the agency in compliance with federal environmental regulations such as the Endangered Species Act and Clean Water provisions. They reported that escalating harvests on lands already heavily cut were having (and would continue to have) a deleterious impact on forest health. A group of these dissenters—many of whom were stationed in the Pacific Northwest—established the Forest Service Employees for Environmental Ethics to challenge the agency's actions.

More directly confrontational were grassroots and national environmental organizations, who staged protests at logging sites and in mill towns, and who also filed federal lawsuits to halt timber sales. Although met with counterprotests from mill workers and loggers, environmentalists ultimately prevailed because in the early 1970s a bird winged its way into the debate. The northern spotted owl inhabits the very old-growth forests of the Pacific Northwest that the Forest Service had set aside for intense production. When researchers discovered this link between the bird's life history and the forests slated for harvest, they urged the agency to preserve portions of its habitat. The Forest Service failed to do so, a failure that would come back to haunt it.

In the interim, the spotted owl was listed as a threatened species, a status that emboldened the Forest Service's critics and gave the federal judiciary grounds to intervene. To resolve the conflict, in 1990 the Interagency Scientific Committee was created and charged with developing a credible conservation strategy for the spotted owl. Chaired by Jack Ward Thomas, a wildlife biologist and future Forest Service chief, the committee called for the end of timber cutting over large swaths of these forests to ensure the owl's survival. The agency dawdled, and in 1991 federal district court judge William Dwyer, citing a "deliberate and systematic refusal to follow the law," halted all timber sales in the region until the Forest Service (and the Bureau of Land Management) could demonstrate their compliance with federal statutes. Two years later, newly inaugurated President Bill Clinton convened the Northwest Forest Summit, the outcome of which was to reduce timber harvest levels in this region by upward of 80 percent. One tool by which this was achieved was the creation of habitat conservation areas, such that 90 percent of the White River District of the Mount Baker-Snoqualmie National Forest has been set aside.[26]

The northern spotted owl continues to struggle, however, because of a new competitor, the more aggressive and adaptable barred owl. Over the last decades it has expanded its range from east of the Mississippi River, and has been muscling the spotted owl out of its protected habitat. In Oregon's Siuslaw National Forest, where the barred owl once was rare, it now occupies half of the known spotted owl nesting sites. Only 10 spotted owl sites remain of an estimated 80, and similarly sharp declines have occurred across the Pacific Northwest. This has led Eric Forsman, whose research originally identified clearcutting's impact on spotted owl habitat, to predict "a long steady decline in the numbers of Spotted Owls. Even virtual extinction in the northern part of the range of Washington and Oregon."[27]

Forsman's grim prediction reflects how complicated and unpredictable ecosystems are, and how partial is our understanding of their ever-shifting dynamics.

A North Fork Sauk River waterfall mists the deep hemlock and cedar forests of the North Cascades. This stream and the main stem Sauk, Suiattle, Cascade, and Skagit are designated Wild and Scenic Rivers and provide some of the best remaining salmon habitat in the Northwest.

Tongass National Forest

ALASKA

Tongass is by far the nation's largest national forest, complete with brown bears, wolves, humpback whales, and salmon, extending a remarkable 500 miles north to south—the distance from San Francisco to Mexico. Heavily subsidized logging has occurred across large swaths of that terrain, but other mountains such as this one north of Juneau remain uncut as the greatest temperate rain forest on Earth.

Three issues dominate contemporary discussions about the Tongass National Forest—wood, water, and fish. The forest's colossal scale is matched by the intensity of debates over these three resources. At nearly 17 million acres (almost the size of West Virginia), the Tongass is the largest national forest in the United States, encompassing approximately 80 percent of southeastern Alaska. Its magnificent scenery and staggering levels of biodiversity are set within thick forests, hundreds of islands, and 18,000 miles of coastline. Its defenders are legion. Whenever a Tongass timber lease is announced, it is as if the Forest Service has sent up a distress flare. Disputing parties converge to argue over the impact that harvesting old-growth forests will have on the Tongass's water and fish.

George Perkins Marsh forged this tight link in the 1860s. He did not live to see the creation of the first forest reserves, let alone the national forest system, and he never visited Alaska. The well-traveled American diplomat thus had no firsthand experience with the Tongass's almost impenetrably dense stands of spruce, hemlock, and cedar that nurture the world's largest salmon runs. Yet he wrote the book about why these ecological connections matter.

Against the backdrop of the Civil War, Marsh's *Man and Nature; or, Physical Geography as Modified by Human Action* (1864) raised the specter of a cataclysm to come. "Man is everywhere a disturbing agent," Marsh argued. "Wherever he plants his foot, the harmonies of nature are turned to discord." Swinging an ax would have

the same effect: "felling of the woods has been attended with momentous consequences to the drainage of the soil," for in the process of clearing forests "indigenous vegetable and animal species are extirpated." Fearing for humanity's future, he urged Americans to become dedicated stewards of the land and themselves. "We have now felled forest enough everywhere, in many districts far too much. Let us restore this one element of material life to its normal proportions, and devise means for maintaining the permanence of its relations to the fields, the meadows, and the pastures, to the rain and the dews of heaven, to the springs and rivulets with which it waters the earth."[28]

An early adopter of Marsh's insights about the necessity to restore woodlands, George Bird Grinnell popularized them through his editorial column in *Forest and Stream*, a leading journal devoted to the emerging conservation movement. In 1882, he distilled Marsh's concepts into 13 simple but profound words: "No woods, no game; no woods, no water; and no water, no fish." Habitat was everything. This ecological conviction was palpably manifest in 1899 while Grinnell cruised Alaska's waters as a member of the famed Harriman scientific expedition. He found that the brutal dispossession of the indigenous people, combined with the massive slaughter of seals and the greed-driven fisheries, were horrifying examples of frontier pillage. Especially troubling was the behavior of the canning industry in southeastern Alaska, located in the inlets and bays of what is now the Tongass. Chasing "eagerly for everything that is within their reach," an angered

260 ♠ AMERICA'S GREAT NATIONAL FORESTS, WILDERNESSES, AND GRASSLANDS

Grinnell wrote, the industry's motto "seems to be, 'If I do not take all I can get, somebody else will.'" In Alaska, he witnessed a disturbing update of Marsh's cautionary tale of woe.[29]

Grinnell turned to his close friend President Theodore Roosevelt to protect Alaska. His was an easy request, given Roosevelt's steadfast opposition to the rampant despoliation of the Lower 48: "We do not intend that our natural resources shall be exploited by the few against the interests of the many," Roosevelt asserted, "nor do we intend to turn over to any man who will

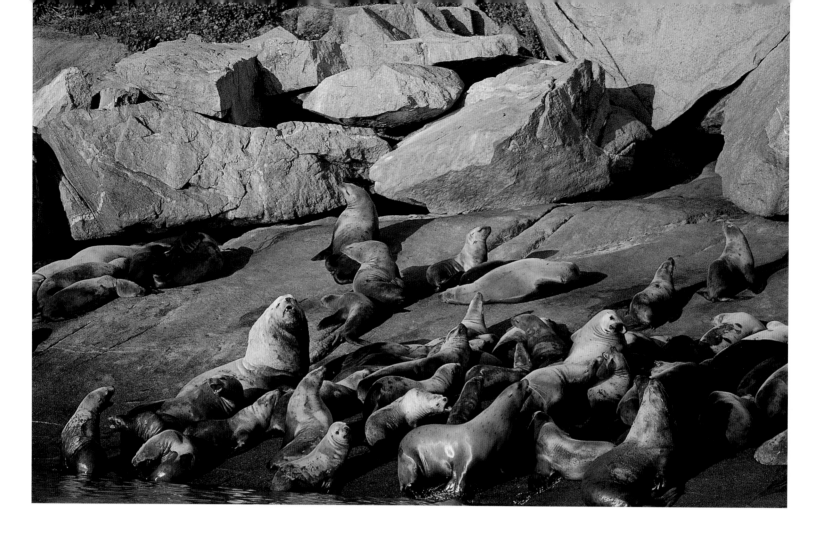

wastefully use them by destruction, and leave to those who come after us a heritage damaged by just so much." Having closely read the Harriman expedition's reports, Roosevelt was already primed to act. "Natural resource management wasn't going to be a free-for-all under his administration," observed historian Douglas Brinkley. "Alaska would become America's permanent wilderness zone."[30]

Roosevelt made good on his word, too. In 1902, he set aside the Alexander Archipelago Forest Reserve. Five years later, the president created the Tongass National Forest, and in 1908 the two units merged. As happened elsewhere, not all Alaskans believed Forest Service Chief Gifford Pinchot's assertion that "the permanent success of the industries of Alaska can best be secured

through the establishment of the forest reserves." Imagine their delight in 1910 when President William Howard Taft fired Pinchot for insubordination. His termination resulted from the chief forester's public denunciation of the administration's attempt to open up coal fields in the Chugach National Forest, a nearly seven-million-acre domain hugging Prince William Sound to the Tongass's north. So excited were the citizens of tiny Cordova, Alaska, located in the Chugach, that a jeering crowd burned Pinchot in effigy.[31]

The opposition was happier with the agency's subsequent attempt to jumpstart local economic development by incentivizing the creation of a local pulp-and-paper industry. It took three decades for this initiative to come to fruition, a

delay driven by the long distances between Alaska and national markets. Those spatial constraints remained constant even after mills in Ketchikan and Sitka were established. These plants proved less than profitable despite the Forest Service's offer of cheap timber at generous terms. In the 1990s, their leases were not renewed and the firms were shut down. Logging continues, to be sure, but on a much smaller scale than once envisioned.[32]

One reason for this has been the still-unresolved issues of Native American claims to lands within the Tongass. Their rights were not acknowledged in the 1867 treaty with Russia that brought Alaska into the Union, and were ignored when Roosevelt designated the forest reserves. It took Franklin Roosevelt's Interior Secretary Harold Ickes to raise the issue. He worked assiduously to establish reservations for the Tlingit and Haida people, but resigned in 1946 before enabling legislation could be enacted. The next year, Congress passed the Tongass Timber Act, which the Forest Service favored because it supported the fledgling pulp industry and because it was silent on native land rights. "For the Forest Service and advocates of Alaska statehood," historian Stephen W. Haycock observed, "the primacy of modern capitalist development in the Tongass . . . was more important than the protection and safeguard of potential Indian land rights and resources, which they interpreted as a threat to that development."[33]

When they turned a deaf ear to the plight of those for whom the Tongass was ancestral land, the agency and Congress opened the way for a series of corrective lawsuits. Out of them emerged the 1971 Alaska Native Claims Settlement Act. Among its other provisions, the act granted new native corporations ownership of 44 million acres in the state, half a million of which were in the Tongass. Over the next two decades, these corpo-

rations clearcut most of the timber that had been part of the national forest.

Also cutting into the Forest Service's timber base was the Alaska National Interest Lands Conservation Act (1980), which protected 5.4 million acres from development in the forest. After nearly a decade of seesawing lawsuits aimed at constraining timber harvests in the Tongass, in 2011 another 2.3 million acres were denoted as "roadless," making it impossible to log or mine within that expanse.

Time and again, one of the central factors in these enduring disputes has been salmon, and how logging has helped cripple their historic runs by damaging the watersheds on which they depend. Since the early 21st century, the Tongass National Forest and its many partners have restored miles of compromised riparian habitat. These efforts are never-ending, however, in good part because timber sales are also a facet of the national forest's objectives. In the spring of 2014, for example, critics rallied against the 6,200-acre old-growth Big Thorne timber sale on Prince of Wales Island. They argued that such sales are no longer necessary for the local economy because the wood-products industry has been supplanted by tourism and fishing. These two booming industries need these forests to stay as forests. Tourism, for example, lures more than 600,000 annually to the region, many arriving on cruise ships plying the Inland Passage of southeastern Alaska. For them, the dense, green Tongass serves as an inviting arboreal background to the deep-blue waters. Commercial fisheries catching wild salmon make an even larger economic contribution, pumping billions into the state's coffers. Because "salmon need those trees to spawn," a local fisherman opined, "this means we need those trees." Marsh and Grinnell could not have put it any better.[34]

Sea lions congregate on the shorelines of Alaska's Inside Passage south of Haines. Here Tongass National Forest includes wildlands rising from sea level to cathedral groves of Sitka spruce and on to ice fields rimmed by the rocky spires of nunataks.

Photographer's Notes

TIM PALMER

With a subject as vast as our national forests, covering more than eight percent of America and including a remarkable array of landscapes in 44 different states, my selection of approximately 200 photos for this book involved a lot of discretion. Overwhelmed with possibilities, I followed several guidelines as I photographed and chose the images you see here.

First, historian Char Miller, book packager Scott Tilden, and I applied our accumulated expertise, firsthand experience, and some advisory guidance to select 30 national forests for focused treatment in the text, and as a priority I shot photos in those places. But I also took pictures in every forest I could visit. A full roster was not possible given the size restraints of our book, but we've included pictures of 104 different national forests in all regions of the country.

Full coverage of even a single forest is difficult owing to geographies and ecosystems as diverse as these. Complicating matters, national forest land is managed in vastly different ways ranging from pristine wilderness to clearcuts, mining pits, picnic grounds, second homes, ski resorts, and reservoirs filling former river valleys. Instead of an endlessly eclectic assortment of this cross section of resource use, I focused on nature. Natural systems, after all, are the fundamental building blocks on which all other activities and management decisions are based. And, though many uses have their appointed locations across federal land, most people are drawn to places of natural beauty, as was I while touring this remarkable public estate. With an informed historical perspective, various aspects of resource development, along with the economies, community dependencies, environmental dilemmas, and ethical controversies accompanying it, are not covered in the photos but are sagely addressed by Char Miller in the text.

I sought the quintessential images in each forest and also those that showed the most stunning beauty, revealing geology, and intricate biology, all the while keeping an eagle eye for the variety and distinctiveness that makes one region different from others. I was drawn to images that suggest how the land supports an entire community of life.

One of my desires as a photographer is to illustrate not just what nature *is*, but also what it *does*. Thus, you'll see the play of light, the movement of water, the buildup of storms, the rotting of trees, the sudden appearance of a moose or grouse, the falling of snow, the cycle of seasons. Perhaps you'll recognize in these photos a window to the passage of time and to some of the dynamic ways of the world around us—a vision uniquely available through our public lands.

While I regard the process of finding and capturing each photo as an art, I'm more a photojournalist by disposition. To say this another way, I strive to show what is real, exactly as it is. I do this to be truthful, and also to avoid leading people to expect a landscape that's ridiculously more dazzling than what exists. I often judiciously aimed my camera to avoid what might be seen as clutter in roadcuts, power lines, parked cars, and so forth, but I did not digitally alter the composition of any photo. I made only minor adjustments in aperture to compensate for difficult lighting and to correct color from the bland record of "raw" digital data. I avoided the gross color enhancement and other post-shutter manipulation that's common if not ubiquitous in publishing today. What you see on these pages is essentially what I saw on the ground.

However, I didn't just randomly shoot for representative photos. Rather, I sought the greatest beauty I could find. While the most common scene in a typical national forest is a mountainside thickly covered by second-growth trees, I sought to reveal exceptional landscapes. I searched for old-growth trees in rare protected groves, and for big views in sweeping vistas from tantalizing outcrops of rock. If you stick to convenient midday outings, you'll miss the elegant light I found by exploring at sunrise and also by lingering out there through dinnertime. If you limit your travel to the road, you'll bypass the extravaganza I found by tramping even a short distance into the hills, snowfields, swamps, and prairies.

I hope you already trust me in this regard, but let me confirm here what should be obvious: every photo was taken in, or of, a national forest. No "generic" photos of similar or nearby landscapes, trees, animals, or other features are shown (it's far easier to photograph wildlife, I must say, in national parks). Furthermore, for most of the photos, the entire content constitutes national forest. However, in a few cases part of the scene includes small amounts of private property or a distant background that is managed by other agencies.

Let me admit to some aesthetic and geographical leanings. I'm unabashedly fond of big old-growth trees and scenes that portray the complexity of natural forest ecosystems. I like the warm light of sunrise and sunset, the colors of autumn, the blizzard of waterfalls, the exuberance of alpine high country, and the day's closure of a moon creeping up on the horizon. In these respects, I think I'm just like a lot of other people.

And like others, I'm irresistibly drawn to the liveliness, vitality, and freshness of water. So you'll see streams, rivers, and lakes within their national forest settings. This was artistically and journalistically irresistible, and also fitting, if not essential, to any volume about national forests. Watershed protection, in fact, was one of Congress's three key reasons for establishing the original forest reserves in 1897, and this goal has been bolstered by later

legislation. I'm happy to report that—after decades of neglect—the importance of protecting the waters of our forests has regained status as one of the primary guideposts in federal land management. In a very fundamental way, water is central to the life, integrity, and imagery of the forests themselves, so it's fitting that waters flow through the photos as well.

In my pictures you'll see dead trees as well as live ones. Like the 19th-century landscape painter Thomas Cole, I find striking beauty in the starkly bold remains of a tree whose life was well lived. More important, dead trees are essential to the cycles of life and integral to the perpetuation of forests; vital elements are eventually reclaimed by the soil and dedicated to the nourishment of new growth. More distressing, dead trees appear to be more commonplace today than in other recent eras owing to the troublesome convergence of exotic insects and pathogens that are attacking our native forests wholesale; consider the hemlock woolly adelgid, emerald ash borer, and beech bark disease that have invaded Appalachian forests. Plus, owing to the perils of global warming, once-limited pests such as pine bark beetles in the Rocky Mountains are running amok. In addition, wildfires are a consequence of climate change, and recent burns have left vast acreages blotched with dead trees among survivors in mosaics of black and green.

My personal experience with this public lands estate dates to a job as a landscape architect at Sawtooth National Forest in the summer of 1969. With engaging duties Monday through Friday and an opportunity to roam the Idaho mountains every weekend, it was a formative year, shaping my life in the way that great landscapes can do. Decades of exploring and picture taking followed.

The photo collection here draws on images I captured through those years with Fuji Velvia slide film, Canon A-1 cameras, and fixed focal-length lenses. But most of these pictures were taken with a Canon 5-D digital camera and L-series lenses, 17 to 200mm, shot principally during an eight-month nationwide tour in 2013 with my wife, author Ann Vileisis. She was an integral part of this odyssey, essential for everything from good ideas about where to go, picture scouting while I was engrossed in a shot ("Over here, quick, over here!"), driving while I pored over maps and guidebooks, and otherwise being indispensable in my life in every way.

We drove, hiked, canoed, rafted, bicycled, and skied to the places you'll see. First, from our home on the coast of southern Oregon, we journeyed south in early spring. We crossed the Southwest and southern plains through the first buds of green-up, and then entered the Deep South as the trees leafed out in a humid canopy. After a tempting sojourn to our only tropical rain forest in Puerto Rico, we zigzagged northward through my boyhood home territory of the Appalachians in its full blooming glory of May. Then we traversed the upper Midwest and a few national grasslands on the Great Plains, pursued wondrous horizons of the Rockies all summer, and reluctantly wrapped up with the Cascades and Coast Ranges in the tangy sweetness but increasing moisture of autumn. Other trips focused on the challenges of Alaska, the flaming autumn foliage of New England, and the rich geographic tapestries of California and Oregon, where I had worked for years on other books. While many shots were taken near roads and easily visited sites, I also relished the opportunity to go deep into remote country and document extraordinary landscapes stewarded as wilderness or roadless areas by the Forest Service.

Though responsible for enormous acreage, this agency of rich founding heritage has been hamstrung by budget cuts and strapped with forest fires in the age of climate crisis. This difficult job is vexed by the proliferation of vacation homes built in harm's way where wildfire catastrophe is not a matter of *if* but *when*. While the lion's share of the agency's budget is now shunted into fire suppression and spent saving private structures that relatively few people have built in remote terrain, recreation maintenance and accommodation of the rest of the public to this extraordinary estate has been trimmed to the bone. Just when our society needs these lands the most for escape from the urbanizing world and for ecosystem services essential to the water we drink and the air we breathe, managers are challenged in ever-greater ways.

For me, roaming our national forests for eight months with my camera in hand brought another ongoing controversy sharply into focus. Our public lands are under continuous siege by corporate, individual, and some local government interests that seek to "privatize" the wealth that all Americans now share. The movement to wrest federal land from federal managers is nothing less than an attempt to take this wondrous birthright away from all Americans. Far from the hindrance or burden that antigovernment interests across the West sometimes claim, I—and others using far more scientific and economic rigor than I—have found that our federal lands estate is one of the finest, most economically beneficial, and democratically desirable aspects of life in these regions today.

It's my hope that the images in this book will help more people become aware of the value of our national forests, of the recreation promises they provide, the wildlife they sustain, the ecosystems they nourish, and the beauty they reveal to all who are willing to get out and look.

Acknowledgments

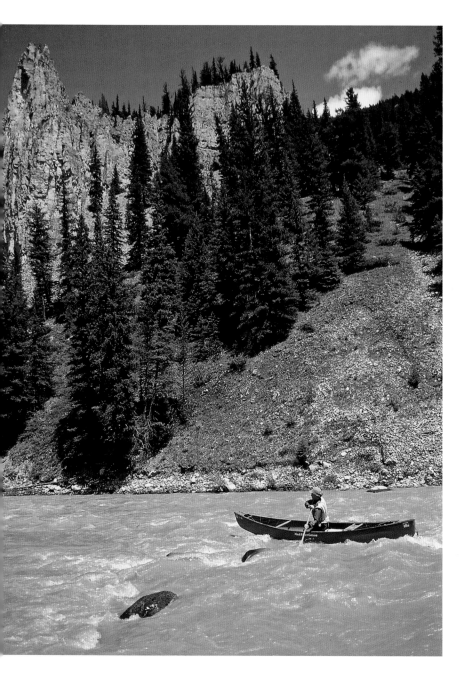

Although we have known one another for almost two decades, this is the first time that we have collaborated on a project. It would be hard to top the experience—from the first time we sat down with a map of the United States spread out before us and began to chart Tim's travels and select the landscapes that have become the subject of this book, the process has been magical. Making it even more so has been Scott Tilden. We are grateful to him for conceiving the idea for this book, writing a persuasive proposal, aiding in background research, and shepherding it through a long publishing journey with insight, determination, and lofty spirit.

A stroke of manifestly good fortune occurred when Scott approached Jim Muschett, associate publisher of Rizzoli, who adopted our endeavor with professional interest and enthusiasm; we are also grateful to his colleagues Jessica Napp, Susi Oberhelman, and Candice Fehrman for their dedicated efforts on our book's behalf. Al Sample, Jennifer Yeager, and the staff of the Pinchot Institute for Conservation were essential partners in helping with financial and administrative support, which they undertook with fantastically good cheer.

This project was funded in part by the United States Forest Service under U.S. Government contract #AG-3187-K-10-0026, support that has been vital to its completion. We are indebted to Chief Tom Tidwell and Deputy Chief Leslie Weldon for their unwavering support of the book. Untold numbers of Forest Service staff helped Tim with key local information during his nationwide photographic tour; he is especially grateful to Tinelle Bustam of El Yunque National Forest. Char was the beneficiary of countless conversations with agency colleagues who unstintingly shared their time and insights. As generous and supportive were Steve Anderson, Jamie Lewis, Eben Lehman, and Cheryl Oakes at the Forest History Society, the key archive for all things forest.

Judi Lipsett, Char's wife, edited the entire manuscript, tightening its prose and strengthening its narrative engagement; she also allowed him to commandeer the dining room table for the duration of the project, a gift of incalculable value. He is thankful too for the critical research assistance that Jennifer Schmidt and Emma Fullem, now alumna of the Environmental Analysis Program at Pomona College, provided. Tim's wife, author Ann Vileisis, played an essential and inseparable role in the eight-month journey they embarked on to collect many of the images you see in this book—and, for that matter, in many of the travels that came earlier. Because of Ann, this experience was not only good work but also the most rewarding form of fun imaginable.

Notes

INTRODUCTION

1 One of these national monuments is under National Park Service jurisdiction, but the Forest Service manages it; another is jointly managed with the Bureau of Land Management; Gerald W. Williams, "National Monuments and the Forest Service," November 18, 2003.

2 Wilderness Act, Public Law 88-577 (1964), http://www.wilderness.net/NWPS/legisAct.

3 Bob Marshall quoted in *NOLS Wilderness Ethics: Managing and Valuing Wild Places* (Mechanicsburg, PA: Stackpole Books, 2006), 543; Robert Marshall, *The People's Forests* (Iowa City: University of Iowa Press, 2002), 171–88; Robert Marshall, "The Problem of the Wilderness," *Scientific Monthly*, February 1930, 141–48.

4 Gifford Pinchot, *Breaking New Ground*, 4th ed. (Washington, DC: Island Press, 1998), 505.

5 Richard McArdle quoted in "Land of Many Uses," Kaibab National Forests: 2013 Accomplishment Report; Theodore Roosevelt, "A Confession of Faith," in *The Works of Theodore Roosevelt*, National Edition, vol. 17 (New York: Scribner, 1928), 293–94.

6 John F. Reiger, *American Sportsmen and the Origins of Conservation* (Corvallis: Oregon State University Press, 2000); Douglas W. McCleery, *American Forests: A History of Resiliency and Recovery* (Durham, NC: Forest History Society, 2011), xiii; George Perkins Marsh, *Man and Nature; Or Physical Geography as Modified By Human Action* (New York: Scribner, 1864), 36.

7 David Lowenthal, *George Perkins Marsh: Prophet of Conservation* (Seattle: University of Washington Press, 2000); on Franklin Hough and Nathaniel Egleston, see Char Miller, "Amateur Hour: Nathaniel H. Egleston and Professional Forestry in Post-Civil War America," in *Forest History Today*, Spring/Fall 2005, 20–26; Char Miller, "Wooden Politics: Bernhard Fernow and the Quest for a National Forest Policy, 1876–1898," in Harold K. Steen, ed., *The Origins of the National Forests: A Centennial Symposium* (Durham, NC: Forest History Society, 1992); Char Miller, *Gifford Pinchot and the Making of Modern Environmentalism* (Washington, DC: Island Press, 2001).

8 Miller, *Gifford Pinchot*, 55–56; Charles Sprague Sargent, *The Silva of North America*, 12 vols. (Boston: Houghton Mifflin, 1901); Donald Worster, *A Passion for Nature: The Life of John Muir* (New York: Oxford University Press, 2008); John F. Reiger, "Pathbreaking

Conservationist: George Bird Grinnell," in *Forest History Today*, Spring/Fall 2005, 16–19.

9 Michael Williams, *Deforesting the Earth: From Prehistory to Global Crisis* (Chicago: University of Chicago Press, 2003), 315–17.

10 That a projected "timber famine" did not occur is a reflection of good forest management but also of the nation's shift to coal and later petroleum to fuel its economy. F. P. Baker, "Forestry," in *Reports of the United States Commissioners to the Paris Universal Exposition, 1878*, vol. 3 (Washington, DC: Government Printing Office, 1880), 423; Donald J. Pisani, "Forests and Conservation, 1865–1890," in Char Miller, ed., *American Forests: Nature, Culture, and Politics* (Lawrence: University Press of Kansas), 18.

11 Baker, "Forestry," 423.

12 Bernhard Fernow was the third head of the U.S. Division of Forestry, and left public service in 1898 to start the Forestry School at Cornell University: Andrew Denny Rodgers, *Bernhard Eduard Fernow: A Story of American Forestry* (Durham, NC: Forest History Society, 1991); earlier that same year Carl Schenck opened the Biltmore Forest School in Asheville, North Carolina: Carl Schenck, *Birth of Forestry in America: The Biltmore Forest School, 1898–1913* (Santa Cruz, CA: Forest History Society and the Appalachian Consortium, 1974); Henry Graves, a close friend of Gifford Pinchot, served as associate chief and chief of the U.S. Forest Service, and was the first dean of the Yale Forest School: http://www.foresthistory.org/aspnet/people/graves/graves.aspx; Pinchot, *Breaking New Ground*, 29.

13 Harold K. Steen, *The U.S. Forest Service: A History* (Seattle: University of Washington Press, 1976), 32.

14 Gifford Pinchot, "Forestry Abroad and at Home," *National Geographic*, August 1905, 344, 388; Char Miller, "Neither Crooked nor Shady: The Weeks Act, Theodore Roosevelt, and the Virtue of Eastern National Forests, 1899–1911," *Theodore Roosevelt Association Journal* 33:4 (Fall 2012): 15–24.

15 Char Miller, "Will the Forest Service Celebrate its Bicentennial? Managing the National Forests and Grasslands in an Age of Climate Change," in Daniel Kemmis, ed., *Challenges Facing the Forest Service: A Critical Review* (Missoula, MT: O'Connor Center for the Rocky Mountain West, 2008), 12–21.

16 Jack Ward Thomas, "The Future of the Forest Service–Who Will Answer an Uncertain Trumpet?" in Kemmis, ed., *Challenges Facing the Forest Service*, 30–38.

17 Char Miller, *Seeking the Greatest Good: The Conservation Legacy of Gifford Pinchot* (Pittsburgh: University of Pittsburgh Press, 2013), 154–76; "Regarding the Promulgation of Regulations Concerning Roadless Areas within the National Forest System," statement of Michael Dombeck, chief of the Forest Service, November 3, 1999; USDA Forest Service, "Fiscal Year 2014 Budget Overview," April 2013.

18 Tim Palmer, *Trees & Forests of America* (New York: Abrams, 2003), 11.

THE EAST & MIDWEST

1 Robin W. Kimmerer, "The Giveaway," in Kathleen Dean Moore and Michael P. Nelson, eds., *Moral Ground: Ethical Action for a Planet in Peril* (San Antonio, TX: Trinity University Press, 2010), 141, 144.

2 John Smith, "A Description of New England (1616)," in Michael P. Branch, ed., *Reading the Roots: American Nature Writing before Walden* (Athens: University of Georgia Press, 2004), 53–54.

3 Henry David Thoreau, "Civil Disobedience," in Carl Bode, ed., *The Portable Thoreau* (New York: Penguin Books, 1975), 130.

4 Kimmerer, "The Giveaway," in *Moral Ground*, 145.

5 *Audubon Magazine*, May/June 2010, 56–57.

6 Rev. John E. Johnson, "The Boa Constrictor of the White Mountains, Or the Worst 'Trust' in the World," pamphlet, July 4, 1900; reprinted in *New England Homestead*, December 8, 1900, 3–5.

7 Ibid., 6, 11.

8 Ibid., 4; *New England Homestead,* November 24, 1900, 508.

9 Weeks Act (1909), http://www.foresthistory.org/ASPNET/Policy/WeeksAct/WeeksBill.pdf.

10 Char Miller, "Neither Crooked nor Shady: The Weeks Act, Theodore Roosevelt, and the Virtue of Eastern National Forests, 1899–1911," *Theodore Roosevelt Association Journal* 33:4 (Fall 2012): 15–24; Sherman Adams, *The Weeks Act: A 75th Anniversary Appraisal*, Newcomen Publication No. 1274 (New York: The Newcomen Society of the United States, 1987), 14.

11 Stephen Pyne, *Fire in America: A Cultural History of Wildland and Rural Fire* (Princeton: Princeton University Press, 1982), 349–50; Stephen Pyne, *America's Fires: A Historical Context for Policy and Practice* (Durham, NC: Forest History Society, 2010), 30.

12 Adams, *The Weeks Act*, 16–19.

13 *Audubon Magazine*, May/June 2010, 57.

14 "About the Forest," http://www.fs.usda.gov/main/allegheny/about-forest.

15 Ben Moyer, "An invasive insect threatens to eradicate Pennsylvania's state tree," *Pittsburgh Post-Gazette*, December 22, 2013.

16 *A Citizens' Wilderness Proposal for Pennsylvania's Allegheny National Forest* (Warren, PA: Friends of Allegheny Wilderness, 2008).

17 "Superior National Forest," http://www.foresthistory.org/ASPNET/places/Superior_NF/index.aspx.

18 Tom Wolf, *Arthur Carhart: Wilderness Prophet* (Boulder: University Press of Colorado, 2008), 62–63, 66–67, 72–74.

19 Arthur Carhart, "Preliminary Prospectus: An Outline Plan for the Recreational Development of the Superior National Forest," U.S. Forest Service, 1922; Wolf, *Arthur Carhart*, 117–20, 140–44, 235–36.

20 Carhart, "Preliminary Prospectus"; William Jardine, "The Policy of the Department of Agriculture in Relation to Road Building and Recreational Use of the Superior National Forest, Minnesota," U.S. Forest Service, September 17, 1926.

21 Sigurd Olson, *The Meaning of Wilderness: Essential Articles and Speeches* (Minneapolis: University of Minnesota Press, 2001), 153.

22 Chris Niskanen, "The Wilderness Beyond: In the Far Reaches of the Boundary Waters Lie Primitive Management Areas, Where the Going Is Tough, but the Reward Is Pristine Solitude," *St. Paul Pioneer Press*, May 30, 2004, C14.

23 Charles E. McGee, "Clearcutting and Aesthetics in the Southern Appalachians," *Journal of Forestry* 68:9 (September 1970): 541–42; Kathryn Newfont, *Blue Ridge Commons: Environmental Activism and Forest History in Western North Carolina* (Athens: University of Georgia Press, 2012), 130–38.

24 Newfont, *Blue Ridge Commons*, 135.

25 West Virginia Division of the Izaak Walton League of America, Inc. v. Butz, No. 74-1387 (4th Cir., August 21, 1975).

THE SOUTH

1 Kimberly K. Smith, *African American Environmental Thought: Foundations* (Lawrence: University Press of Kansas, 2007), 93.

2 William E. Shands and Robert G. Healy, *The Lands Nobody Wanted* (Washington, DC: Conservation Foundation, 1977), 25; Robert G. Pasquill Jr., *Planting Hope on Worn-Out Land: History of the Tuskegee Land Utilization Project, Macon County, Alabama, 1935–1959* (Montgomery, AL: NewSouth Books, 2008), 36–43.

3 Smith, *African American Environmental Thought*, 95–97.

4 Gifford Pinchot to parents, August 26, 1892; Gifford Pinchot to James Pinchot, September 8; September 18, 1892, Gifford Pinchot Papers, Library of Congress; Gifford Pinchot, *Breaking New Ground*, 4th ed. (Washington, DC: Island Press, 1998), 66–67.

5 "Pisgah Forest Purchased," *American Forestry* 20:1 (January 1914): 425–29.

6 Carl Schenck, *Birth of Forestry in America: The Biltmore Forest School, 1898–1913* (Santa Cruz, CA: Forest History Society and the Appalachian Consortium, 1974), 90.

7 Pinchot, *Breaking New Ground*, 68–69; Schenck, *Birth of Forestry in America*, 29, 35–37, 40–42, 62.

8 Nathan Havill, Michael E. Montgomery, and Melody A. Keena, "Hemlock Woolly Adelgid and Its Hemlock Hosts: A Global Perspective," in Brian Onken and Richard Reardon, eds., *Implementation and Status of Biological Control of the Hemlock Wooly Adelgid* (Washington, DC: U.S. Forest Service Publication FHTET-2011-04), 4–5.

9 Henry Clepper, *Professional Forestry in the United States* (Baltimore: Johns Hopkins University Press, 1971), 233.

10 Al Hester, "Establishing the Francis Marion: National Forest History in South Carolina's Lowcountry, 1901–1936," *Forest History Today*, Spring/Fall 2011, 61.

11 Jacqueline L. Haymond, Donald D. Hook, William R. Harms, eds., *Hurricane Hugo: South Carolina Forest Land Research and Management Related to the Storm* (Asheville, NC: USDA Forest Service, Southern Research Station, GTR SRS-5, September 1996).

12 John C. Gifford, "The Luquillo Forest Reserve, Porto Rico," *U.S. Department of Agriculture Forestry Bulletin* 54 (Washington, DC: Government Printing Office, 1905), 8.

13 Ibid., 17.

14 Noel F. R. Snyder, et al., *The Parrots of Luquillo: Natural History and Conservation of the Puerto Rican Parrot* (Los Angeles: Western Foundation of Vertebrate Zoology, 1987), 273.

15 James R. Meeker, Timothy J. Haley, Saul D. Petty, and Jerry W. Windham, "Forest Health Evaluation of Hurricane Katrina Damage on the De Soto National Forest," Report 2006-02-02, November 2005.

16 De Soto Ranger District, De Soto National Forest, Collaborative Forest Landscape Restoration Program Proposal, February 2011.

17 James E. Fickle, *Mississippi Forests and Forestry* (Oxford: University Press of Mississippi, 2001), 160–61.

18 Ray M. Conarro, *The Beginning: Recollections and Comments* (Atlanta: USDA Forest Service, Southern Region, 1989), 2–30.

19 Christopher Johnson and David Govatski, *Forests for the People: The Story of America's Eastern National Forests* (Washington, DC: Island Press, 2012), 145–66; Fickle, *Mississippi Forests and Forestry*, 160–61.

20 Johnson and Govatski, *Forests for the People*, 165–66.

THE SOUTHWEST & GREAT BASIN

1 Willa Cather, *The Professor's House* (Lincoln: University of Nebraska Press, 2002), 232–33, 235, 239, 306–07.

2 Ibid., 173.

3 C. Otto Lindh quoted in Robert D. Baker, Robert S. Maxwell, Victor H. Treat, and Henry C. Dethloff, *Timeless Heritage: A History of the Forest Service in the Southwest* (College Station, TX: USDA Forest Service, FS-409, August 1988), chapter 3.

4 David Correia, *Properties of Violence: Law and Land Grant Struggle in Northern New Mexico* (Athens: University of Georgia Press, 2013).

5 Gifford Pinchot, *The Use of the National Forests* (Washington, DC: USDA Forest Service, 1907), 25.

6 Laura Falk McCarthy, "Water Source Protection Funds as a Tool to Address Climate Adaptation and Resiliency in Southwestern Forests," in V. Alaric Sample and R. Patrick Bixler, eds., *Forest Conservation and Management in the Anthropocene*, general technical report (Fort Collins, CO: U.S. Department of Agriculture, Forest Service, 2014).

7 Ibid.

8 Aldo Leopold, *A Sand County Almanac* (New York: Oxford University Press, 1949), 129–32; Leopold is paraphrasing Thoreau, who actually wrote that "in wildness is the preservation of the world" in Henry David Thoreau, "Walking," *The Atlantic*, June 1, 1862.

9 Susan Flader, "Searching for Aldo Leopold's Green Fire," *Forest History Today*, Fall 2012, 26–34; Aldo Leopold, "Wilderness and Its Place in Forest Recreation Policy," *Journal of Forestry* 19:7 (November 1921): 718–19.

10 Ibid., 721.

11 Roderick Frazier Nash, *Wilderness and the American Mind*, 5th ed. (New Haven, CT: Yale University Press, 2013), 182–99; William B. Cronon, "The Trouble with Wilderness; Or Getting Back to the Wrong Nature," in Char Miller and Hal K. Rothman, eds., *Out of the Woods: Essays in Environmental History* (Pittsburgh: University of Pittsburgh Press, 1997), 28–50.

12 Thomas W. Swetnam and John H. Dieterich, "Fire History of Ponderosa Pine Forests in Gila Wilderness, New Mexico," paper presented at the Wilderness Fire Symposium, Missoula, Montana, November 15–18, 1983.

13 Susan Flader, *Thinking Like a Mountain: Aldo Leopold and the Evolution of an Ecological Attitude toward Deer, Wolves, and Forests* (Madison: University of Wisconsin Press, 1994), 29.

14 David Leighton, "Street Smarts: Northwest-side street named in honor of Croxen, a man who lived a life out of a Hollywood western," *Arizona Daily Star*, March 29, 2014; interview with Fred W. Croxen, *The Early Days: A Sourcebook of Southwestern Region History*, compiled by Edwin A. Tucker, Cultural Resources Management Report No. 7, September 1989, http://www.foresthistory.org/ ASPNET/Publications/region/3/early_days/1/sec9.htm.

15 *The Early Days*, http://www.foresthistory.org/ASPNET/ Publications/region/3/early_days/1/sec8.htm.

16 Gifford Pinchot, *Breaking New Ground*, 4th ed. (Washington, DC: Island Press, 1998), 177–82.

17 Ibid., 180–82.

18 *The Early Days*, http://www.foresthistory.org/ASPNET/ Publications/region/3/early_days/1/sec8.htm.

19 Adam M. Sowards, "Reclamation, Ranching, and Reservation: Environmental, Cultural, and Governmental Rivalries in Transitional Arizona," *Journal of the Southwest* 40:3 (Autumn 1998): 352.

20 "Regionwide Drought Policy and Guidelines," Billy Stern et al. to Judith Dyess, Rangeland Management Staff, USDA Forest Service, Southwestern Region, May 11, 2004.

21 Aldo Leopold, "Grass, Brush, Timber, and Fire in Southern Arizona," *Journal of Forestry* 22:6 (June 1924): 7.

22 John Muir, *The Mountains of California* (New York: The Century Company, 1894), 316.

23 Ibid.

24 Ibid., 324.

THE SOUTHERN ROCKIES

1 "2013 Aerial Survey Results," U.S. Forest Service: Region 2; "2011 Aerial Detection Survey," U.S. Forest Service: Region 2.

2 Theodore Roosevelt, "With the Cougar Hounds," *Scribner's Magazine*, October 10, 1901, 417–19.

3 Jason Blevens, "Even when skier visits fall, Colorado resort revenue climbs," *Denver Post*, May 28, 2014.

4 *White River National Forest: Golden Anniversary* (Washington, DC: USDA Forest Service, October 11, 1941), 4.

5 Ibid., 16.

6 U.S. Forest Service, *Western Bark Beetle Strategy: Human Safety, Recovery, and Resiliency*, July 11, 2011.

7 Virginia Cole Trenholm, *The Arapahoes, Our People* (Norman: University of Oklahoma Press, 1970), 3–32; Robert V. Hine and John Mack Faragher, *Frontiers: A Short History of the American West* (New Haven, CT: Yale University Press, 2008); Clyde A. Milner II, Carol A. O'Connor, and Martha A. Sandweiss, *The Oxford History of the American West* (New York: Oxford University Press, 1994), 691.

8 William Newton Byers, "Bierstadt's Visit to Colorado," *Magazine of Western History*, January 1890, 237–40.

9 Carmen Rafdal, "The Perspective Inspired by Chicago Basin," October 25, 2013, http://www.14ers.org/blog/ the-perspective-inspired-by-chicago-basin/.

10 *Water and the Forest Service* (Washington, DC: USDA Forest Service, FS-660, January 2000), 1–7.

11 J. W. Powell, *Report on the Lands of the Arid Region of the United States with a More Detailed Account of the Lands of Utah* (Washington, DC: Government Printing Office, 1876), 92–98.

12 Ibid., 74, 92, 97.

13 David A. Prevedel and Curtis M. Johnson, *Beginnings of Range Management: Albert F. Potter, First Chief of Grazing, U.S. Forest Service, and a Photographic Comparison of his 1902 Forest Reserve Survey in Utah with Conditions 100 Years Later* (Ogden, UT: USDA Forest Service, 2005), 5–12, 19–24.

14 Ibid., 23.

15 Thomas G. Alexander, "From Rule-of-Thumb to Scientific Range Management: The Case of the Intermountain Region of the Forest Service," in Char Miller, ed., *American Forests: Nature, Culture, and Politics* (Lawrence: University Press of Kansas, 1997), 179–82.

16 Shaun R. Nelson, ed., *History of the Uinta National Forest: A Century of Stewardship* (Ogden, UT: USDA Forest Service, 1997), 30–34.

17 *Collaborative Group on Sustainable Grazing for U.S. Forest Service Lands in Southern Utah, Final Report and Consensus Recommendations*, December 2012, 7–14; Sarah Gilman, "Ranchers, enviros and officials seek a middle path on public-land grazing," *High Country News*, February 17, 2014. Not everyone was pleased by this collaboration's innovative results: Devan Chavez, "Commission protests forest service activity over grazing; call for county involvement," *St. George News*, January 21, 2015.

18 Linea Sundstrom, "Mirror of Heaven: Cross-Cultural Transference of the Sacred Geography of the Black Hills," *World Archaeology* 28:2 (October 1996): 187; "Sacred Ground," http://www.fs.usda.gov/Internet/FSE_ DOCUMENTS/stelprdb5117582.pdf.

19 Frank Pommersheim, "The Black Hills Case: On the Cusp of History," *Wicazo Sa Review* 4:1 (Spring 1988): 18–23. The Black Hills National Forest contains in total 1,534,164 acres, 202,295 of which are in Wyoming.

20 Richmond L. Clow, "Timber Users, Timber Savers: The Homestake Mining Company and the First Regulated Timber Harvest," in Char Miller, ed., *American Forests: Nature, Culture, and Politics* (Lawrence: University Press of Kansas, 1997), 73.

21 Gifford Pinchot, *Breaking New Ground*, 4th ed. (Washington, DC: Island Press, 1998), 107, 130, 172–77; Char Miller, *Gifford Pinchot and the Making of Modern Environmentalism* (Washington, DC: Island Press, 2001), 156–59.

22 Pinchot, *Breaking New Ground*, 176–77; Clow, "Timber Users, Timber Savers," 81–82.

23 Black Hills National Forest Collaborative Forest Landscape Restoration Project, http://www.fs.fed.us/ restoration/documents/cflrp/2011Proposals/Region2/ BlackHills/BlackHillsProposal.pdf.

THE NORTHERN ROCKIES

1 Elers Koch, *Forty Years a Forester: 1903–1943* (Missoula, MT: Mountain Press, 1998), 43.

2 Ibid., 190.

3 U.S. Forest Service, "Western Bark Beetle Strategy: Human Safety, Recovery, and Resiliency," July 11, 2011.

4 Koch, *Forty Years a Forester*, 192.

5 U.S. Forest Service, "A Brief History of the Gros Ventre Slide Geological Area."

6 Theodore Roosevelt, Address, March 26, 1903.

7 Arthur Carhart, *Recreation Plans: Superior National Forest*, unpublished report, 1921.

8 Lyndon B. Johnson, "Special Message to the Congress on Conservation and Restoration of Natural Beauty," February 8, 1965; Sandra L. Johnson, "An Overview of the National Trails System Act," Congressional Research Service, December 11, 1998.

9 Francis Tarpon, "Grand Tetons," WanderLearn with Francis Tarpon, 2007; Andrew Tilin, "The Onion vs. Mr. Magoo," *Backpacker*, June 2008.

10 Olaus Murie quoted in David Harmon, *At the Open Margin: The NPS's Administration of the Theodore Roosevelt National Park* (Medora, ND: Theodore Roosevelt Nature and History Association, 1986), appendix F; Melody R. Holm, "Oil and Gas Resources on the Thunder Bay National Grassland, Wyoming," U.S. Forest Service: Rocky Mountain Region, June 1, 2001.

11 John Copeland Nagle, *Law's Environment: How the Law Shapes the Places We Live* (New Haven, CT: Yale University Press, 2010), 132.

12 William D. Rowley, *U.S. Forest Service Grazing and Rangelands: A History* (College Station: Texas A&M University Press, 1985), 227.

13 Ibid., 230.

14 Grant Smith, "U.S. Seen as Biggest Oil Producer After Overtaking Saudi Arabia," *Bloomberg*, July 4, 2014; Theodore Roosevelt IV, "Preserve Our National Parks: Fracking threatens the beauty and serenity of Theodore Roosevelt National Park, among others," *USA Today*, August 23, 2013; Becca Clemons, "North Dakota oil boom brings worry to Theodore Roosevelt National Park," *Los Angeles Times*, November 2, 2013.

15 Douglas W. Dodd, "A National Park for the Gem State? The Forest Service, the National Park Service, and the Sawtooth National Park Campaign, 1911–1926," *Idaho's Yesterdays* 50:1 (Spring 2009).

16 Hal K. Rothman, "'A Regular Ding-Dong Fight': The Dynamics of Park Service–Forest Service Controversy during the 1920s and 1930s," in Char Miller, ed., *American Forests: Nature, Culture, and Politics* (Lawrence: University Press of Kansas, 1997), 109–24.

17 Dodd, "A National Park for the Gem State?"

18 John Osborn, "Creating the Sawtooth National Recreation Area," 1979, http://waterplanet.ws/documents/790501/.

19 Rocky Barker, "Recreation is a key to Boulder-White Clouds monument support in Blaine County," *Idaho Statesman*, March 30, 2014; Barker, "A pact for Boulder-White Clouds," *Idaho Statesman*, March 12, 2014; Aldo Leopold, *A Sand County Almanac* (New York: Oxford University Press, 1949), 200.

20 Phil Brown, ed., *Bob Marshall in the Adirondacks: Writings of a Pioneering Peak-Bagger, Pond-Hopper, and Wilderness Preservationist* (Saranac Lake, NY: Lost Pond Press, 2006).

21 James M. Glover, *A Wilderness Original: The Life of Bob Marshall* (Seattle: Mountaineers Books, 1986), 238.

22 Kathryn L. McKay, *Trails of the Past: Historical Overview of the Flathead National Forest, Montana, 1800–1960*, 1994.

23 Elers Koch, *When the Mountains Roared: Stories of the 1910 Fires*, R1-78-30 (Washington, DC: USDA Forest Service, 1978).

24 Rob Chaney, "Longtime Whitefish Range adversaries celebrate accord on land use plan," *Missoula Missoulian*, November 23, 2013.

25 Robert Marshall, "The Problem of the Wilderness," *Scientific Monthly*, February 1930, 141–48.

CALIFORNIA

1 Rebecca Solnit, "Diary," *London Review of Books* 25:19 (October 9, 2003).

2 "Climate Change," California Department of Water Resources, http://www.water.ca.gov/climatechange/.

3 Mina Deane Halsey, *A Tenderfoot in Southern California* (New York: J. J. Little & Ives Co., 1912), 65–67. On October 10, 2014, President Barack Obama designated 346,177 acres of the Angeles National Forest as the San Gabriel Mountains National Monument, a designation that depended in good measure on the history of this remarkable forest.

4 Ibid.; John Muir, *Steep Trails*, ed. by William Frede Bade (Boston: Houghton Mifflin, 1918), chapter 11.

5 W. W. Robinson, *The Forest and the People: The Story of the Angeles National Forest* (Los Angeles: Title Insurance and Trust Company, 1946), 22–25.

6 Muir, *Steep Trails*, chapter 11.

7 *Los Angeles Times*, July 14, 1924; September 2, 1924.

8 Robinson, *The Forest and the People*, 36.

9 *The Selected Poems of Robinson Jeffers* (New York: Random House, 1937), 186; 358.

10 Daryl Rush quoted in "Marijuana Grows and Restoration," RESTORE, episode 14, video.

11 Rachel Carson, *Silent Spring* (Boston: Houghton Mifflin, 1962), 15.

12 *The Selected Poems of Robinson Jeffers*, 576.

13 William B. Greeley, *Forests and Men* (Garden City, NY: Doubleday, 1952), 79–81; William D. Rowley, *U.S. Forest Service Grazing and Rangelands* (College Station: Texas A&M University Press, 1985), 66–68.

14 U.S. v. Grimaud (1911), http://supreme.justia.com/cases/federal/us/220/506/.

15 Greeley, *Forests and Men*, 80.

16 Clarence King, *Mountaineering in the Sierra Nevada* (New York: Scribner, 1915), 351.

17 U.S. v. Grimaud (1911), http://supreme.justia.com/cases/federal/us/220/506/.

18 Light v. U.S. (1911), http://supreme.justia.com/cases/federal/us/220/523/.

19 In 2014, Nevada rancher Cliven Bundy, after decades of refusing to pay his grazing fees totaling more than $1 million, staged an armed confrontation with the Bureau of Land Management to halt it from taking his cattle off the federal range: Jaime Fuller, "Everything you need to know about the long fight between Cliven Bundy and the federal government," *Washington Post*, April 15, 2014.

20 Jeanne Wakatsuki Houston and James D. Houston, *Farewell to Manzanar* (New York: Bantam Books, 1973), 23–24.

21 Ibid.

22 Library of Congress, "Ansel Adams' Photographs of Japanese-American Internment at Manzanar."

23 Ansel Adams quoted in Robert Turnage, "Ansel Adams: The Role of the Artist in the Environmental Movement," *The Living Wilderness* 43:3 (March 1980).

24 Mary Hunter Austin, *The Land of Little Rain* (Boston: Houghton Mifflin, 1903), 95–97.

25 Mary Hunter Austin, *Earth Horizon* (Boston: Houghton Mifflin, 1932), 298.

26 Dave McCoy, "How I Did It: Dave McCoy, Mammoth Mountain," *Inc.*, December 1, 2008.

27 USDA Forest Service, "Ancient Bristlecone Pine Natural History," http://www.fs.usda.gov/detail/inyo/learning/nature-science/?cid=stelprdb5138621.

28 Rosemary Holsinger, "A Novel Experiment: Hallie Comes to Eddy's Gulch," *Women in Forestry* 5:2 (Summer 1983).

29 Ibid.; "Eddy's Gulch," Forest Lookouts: Siskiyou County, http://californialookouts.weebly.com/siskiyou-county.html.

30 Ibid.

31 "Hallie M. Daggett: Early Woman Lookout," *American Forestry* (ca. 1914); James G. Lewis, *The Forest Service and the Greatest Good: A Centennial History* (Durham, NC: Forest History Society, 2005), 171–78; Barbara Holder, interview, April 11, 2006, Region Five History Project, http://bancroft.edu/ROHO/projects/usfs/transcripts.html.

32 Nancy Langston, *Where Land and Water Meet: A Western Landscape Transformed* (Seattle: University of Washington Press, 2003); Char Miller, ed., *River Basins of the American West: A High Country News Reader* (Corvallis: Oregon State University Press, 2009), 164–98.

33 Char Miller, ed., *River Basins of the American West*, 182–98; Jacques Leslie, "Oregon's Klamath River Basin One Step Closer to Historic Dam Removal," *Earth Island Journal*, April 17, 2014.

THE PACIFIC NORTHWEST & ALASKA

1 Barry Lopez, *River Notes: The Dance of Herons* (New York: Avon Books, 1990), 87–90.

2 Charles Wilkinson, *Messages from Frank's Landing: A Story of Salmon, Treaties, and the Indian Way* (Seattle: University of Washington Press, 2000), 29.

3 Gerald W. Williams, *The U.S. Forest Service in the Pacific Northwest: A History* (Corvallis: Oregon State University Press, 2009), 40; Lawrence Rakestraw, "Sheepgrazing in the Cascade Range: Minto v. Muir," *Pacific Historical Review* 27:4 (November 1958): 371–82.

4 Anna Marie Gillis, "The New Forestry: an ecosystem approach to land management," *BioScience* 40:8 (September 1990): 558–62; Jeff Barnard, "Logging after kills seedlings, increases fire danger," *AP/Casper Star-Tribune*, January 5, 2006; Evan J. Frost and Robert Sweeney, "Fire Regimes, Fire History, and Forest Conditions in the Klamath-Siskiyou Region: An Overview and Synthesis," (Ashland, OR: World Wildlife Fund, Klamath Siskiyou Ecoregion Program, December 2000).

5 "OR-7: A Lone Wolf's Story," California Department of Fish and Wildlife, https://www.dfg.ca.gov/wildlife/nongame/wolf/OR7story.html.

6 Jon T. Coleman, *Vicious: Wolves and Men in America* (New Haven, CT: Yale University Press, 2004), 5, 12; Aldo Leopold, *A Sand County Almanac* (New York: Oxford University Press, 1949), 130–31; Dan Binkley, Margaret M. Moore, William H. Romme, and Peter M. Brown, "Was Aldo Leopold Right about the Kaibab Deer Herd?" *Ecosystems* 9 (2006): 227–41.

7 U.S. Fish and Wildlife Service, "Gray Wolves in the Northern Rocky Mountains," June 6, 2014.

8 Zach Urness, "Wolf OR7 has pups in Siskiyou National Forest," *Salem Statesman-Journal*, June 4, 2014; quote from Leopold, *A Sand County Almanac*, 129.

9 Franklin D. Roosevelt, Address at Timberline Lodge, September 29, 1937.

10 Ibid.

11 Ibid.

12 William C. Tweed, "A History of Outdoor Recreation Development in the National Forests, 1891–1942" (Clemson, SC: Clemson University Department of Parks, Recreation, and Tourism, 1989), 2–3.

13 Ibid., 3–4; Columbia River Gorge National Scenic Area, http://www.fs.usda.gov/crgnsa.

14 Michael McCloskey, *In the Thick of It: My Life in the Sierra Club* (Washington, DC: Island Press, 2005), 40–45.

15 Roosevelt, Address at Timberline Lodge, September 29, 1937.

16 Lyle F. Watts, "The Greatest Good of the Greatest Number," *Journal of Forestry* 48:2 (February 1950): 81–83.

17 Cornelia Bryce Pinchot, "Address at the Dedication of the Gifford Pinchot National Forest, October 15, 1949," *Forest History Today*, Spring 1999, 38–42.

18 "A Few Forest Facts: Gifford Pinchot National Forest," USDA Forest Service, Northwest Region, 1949, 4–6.

19 Paul W. Hirt, *A Conspiracy of Optimism: Management of the National Forests Since World War Two* (Lincoln: University of Nebraska Press, 1994), xliv, 132–34.

20 Michael P. Dombeck, Christopher A. Wood, and Jack E. Williams, *From Conquest to Conservation: Our Public Lands Legacy* (Washington, DC: Island Press, 2003), 30.

21 Greg Hanscom, "Life after Old Growth," *High Country News*, September 27, 2004; Paul Spencer, "Feel-good report on Gifford Pinchot premature," *The Columbian*, November 20, 2011.

22 Harold K. Steen, *An Interview with Ralph Max Peterson*, revised ed. (Durham, NC: Forest History Society, 2002), 204–08.

23 "Mount St. Helens 30 Years Later: A Landscape Reconfigured," USDA Forest Service, Science Update, Issue No. 19, Spring 2010; Pinchot, Address at the Dedication of the Gifford Pinchot National Forest, October 15, 1949, 42.

24 Dombeck, et al., *From Conquest to Conservation*, 38.

25 Tamara S. Wilson, "North Cascades Ecoregion Summary," December 13, 2012.

26 Dombeck, et al., *From Conquest to Conservation*, 34–44.

27 Charles Bergman, "A Time to Kill?" *BirdwatchingDaily.com*, October 1, 2012; Craig Welch, "The Spotted Owl's New Nemesis," *Smithsonian Magazine*, January 2009.

28 George Perkins Marsh, *Man and Nature; or, Physical Geography as Modified by Human Action* (New York: Scribner, 1864), 36, 328–29.

29 George Bird Grinnell, "Spare the Trees," *Forest History Today*, Spring/Fall 2005, 19; on the Harriman expedition, see Ken Chowder, "North to Alaska," *Smithsonian Magazine*, June 2003; George Bird Grinnell, *Alaska 1899: Essays from the Harriman Expedition* (Seattle: University of Washington Press, 1995), 344–48.

30 Douglas Brinkley, *The Quiet World: Saving Alaska's Wilderness Kingdom, 1879–1960* (New York: HarperCollins Publishers, 2011), 47.

31 James Mackovjak, *Tongass Timber: A History of Logging and Timber Utilization in Southeast Alaska* (Durham, NC: Forest History Society, 2010), 45–62; Char Miller, *Gifford Pinchot and the Making of Modern Environmentalism* (Washington, DC: Island Press, 2001), 206.

32 Ibid., 166–99.

33 Ibid., 213; Stephen W. Haycock, "Economic Development and Indian Land Rights in Modern Alaska: The 1947 Tongass Timber Act," in Char Miller, ed., *American Forests: Nature, Culture, and Politics* (Lawrence: University Press of Kansas, 1997), 156.

34 John W. Schoen and Erin Dovichin, eds., *The Coastal Forests and Mountains Ecoregion of Southeastern Alaska and the Tongass National Forest: A Conservation Assessment and Resource Synthesis* (Anchorage: Audubon Alaska and the Nature Conservancy, 2007); Brendan Jones, "Fish Need Trees, Too," *New York Times*, May 22, 2014, A29.

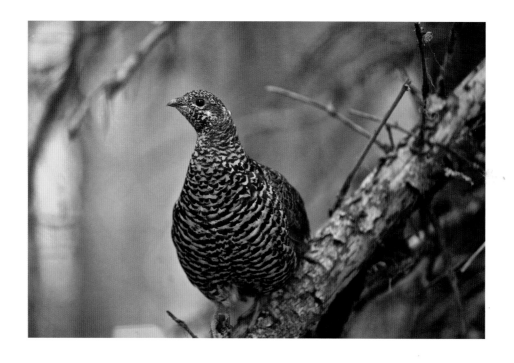

First published in the United States of America in 2016

Rizzoli International Publications, Inc. | 300 Park Avenue South | New York, NY 10010 | www.rizzoliusa.com

Associate Publisher: James Muschett | Project Editor: Candice Fehrman | Book Design: Susi Oberhelman | Map Illustration: James Daley

We wish to express our gratitude to Furthermore, a program of the J. M. Kaplan Fund, for their grant, which helped enable the publication of *America's Great National Forests, Wilderness, and Grasslands*.

2016 2017 2018 2019 / 10 9 8 7 6 5 4 3 2 1

Printed in China | ISBN-13: 978-0-8478-4915-4 | Library of Congress Catalog Control Number: 2015951918

Page 1: A fresh winter snowstorm blankets Douglas firs and western hemlocks along the upper Rogue River in the Rogue River-Siskiyou National Forest of Oregon, where a thin corridor of striking beauty is protected as one of America's premier Wild and Scenic Rivers.; Pages 2–3: The Williams Mountains rise as a subrange of the Rockies to the west of Independence Pass in Colorado's White River National Forest. From these heights at the Continental Divide and down to broad valleys, desert edges, and even the Pacific Ocean, America's 154 national forests span 193 million acres belonging to all Americans.; Pages 4–5: The moon rises over Temple Crag in the Palisades area of Inyo National Forest in California; Page 266: Waterways offer views and perspectives that are not possible from land. Here I paddle down the Gallatin River in Custer Gallatin National Forest in Montana (photo taken by Ann Vileisis). Above: A blue grouse perches among the conifers of Montana's Flathead National Forest.

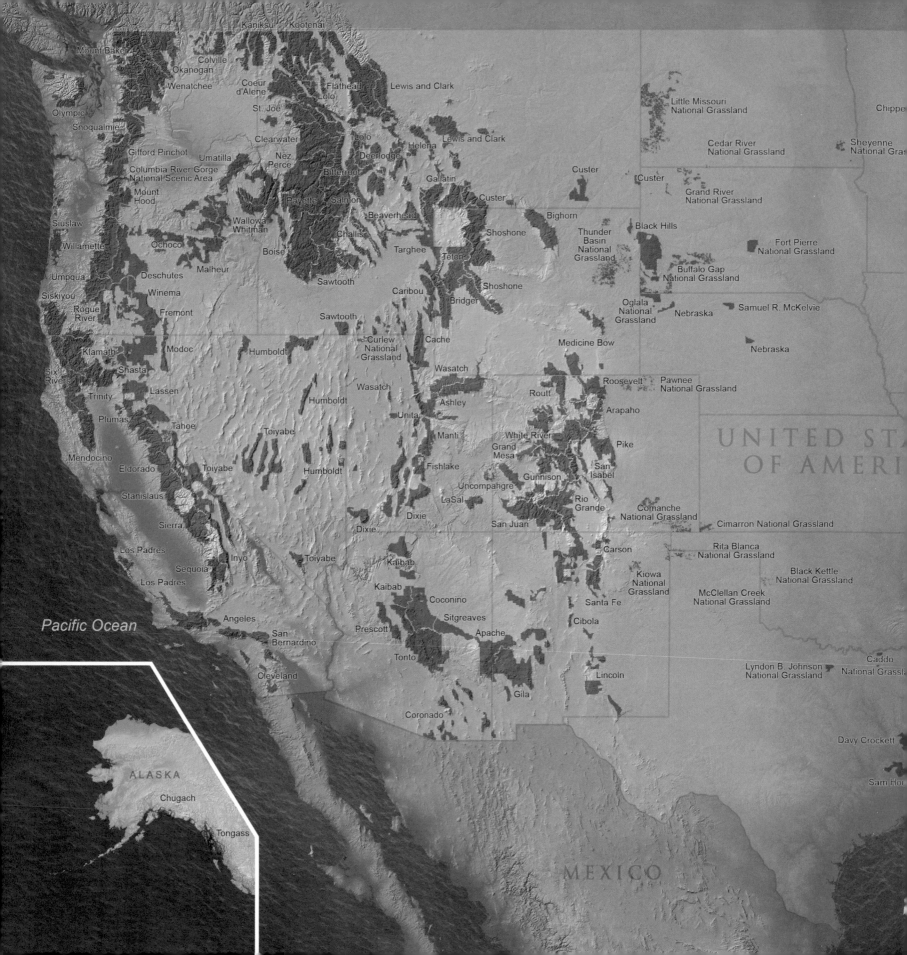